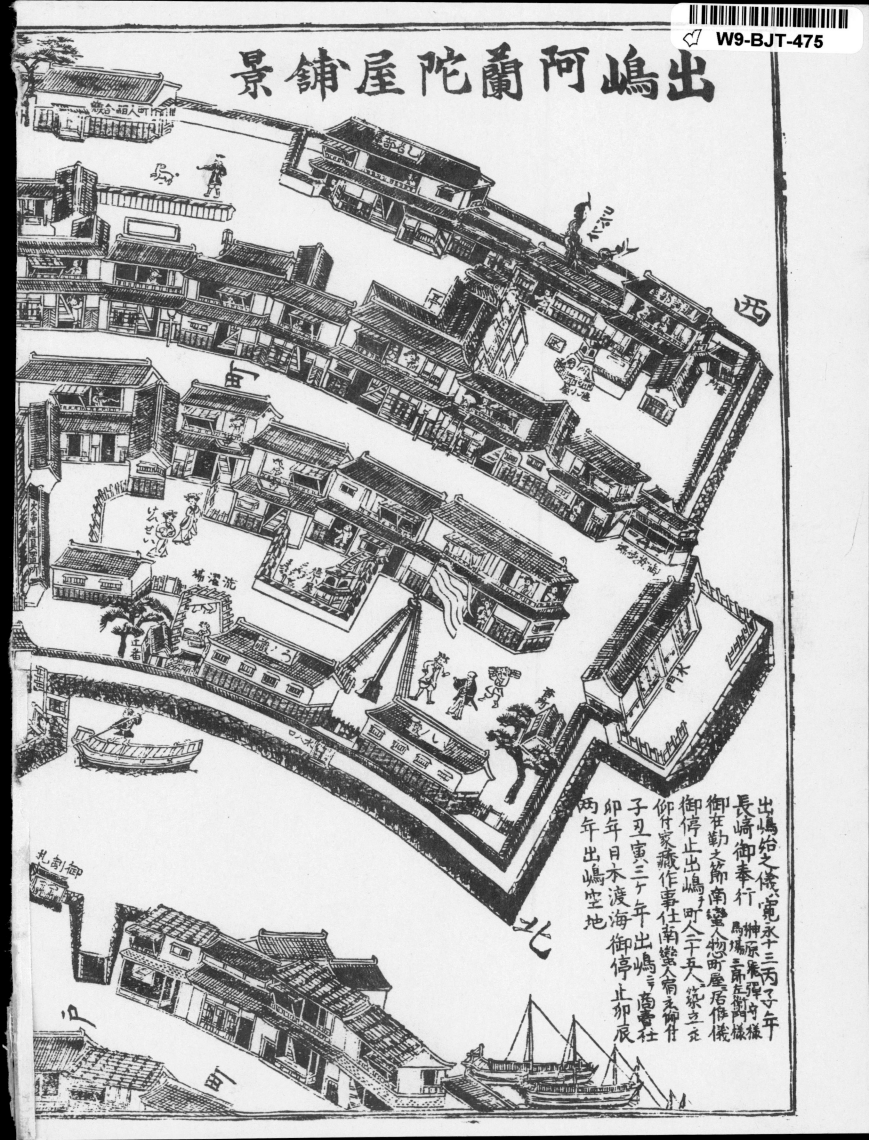

出嶋阿蘭陀屋舗景

A COLLECTION OF NAGASAKI COLOUR PRINTS AND PAINTINGS

Showing the Influence of Chinese and European Art on that of Japan

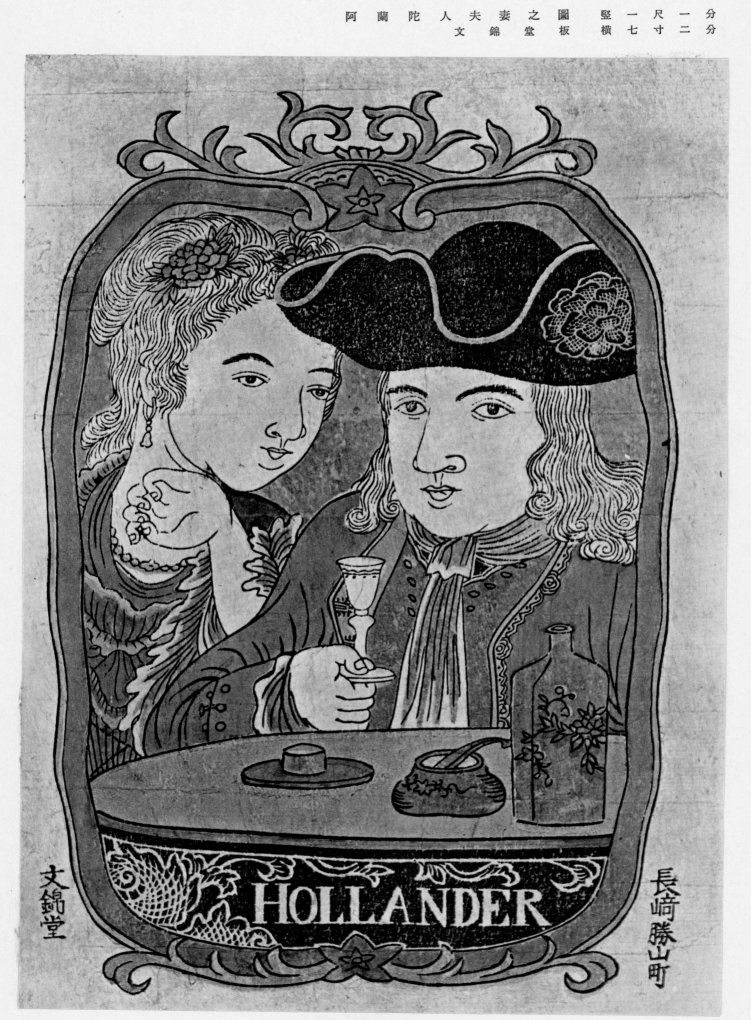

HOLLANDER

A Dutch Couple
From a Nagasaki colour-print published by Bunkindo.
Height 30.7 cm. Width 22 cm.

A COLLECTION OF NAGASAKI COLOUR PRINTS AND PAINTINGS

Showing the Influence of Chinese and European Art on that of Japan

by N. H. N. MODY

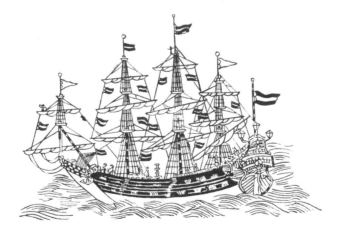

CHARLES E. TUTTLE COMPANY: PUBLISHERS

Rutland, Vermont & Tokyo, Japan

Representatives
Continental Europe: BOXERBOOKS, INC., *Zurich*
Australasia: PAUL FLESCH & CO., PTY. LTD., *Melbourne*
Canada: M. G. HURTIG LTD., *Edmonton*

Published by the Charles E. Tuttle Company, Inc.
of Rutland, Vermont & Tokyo, Japan
with editorial offices at Suido 1-chome, 2–6
Bunkyo-ku, Tokyo, Japan

Copyright in Japan 1969 by Charles E. Tuttle Co., Inc.

Library of Congress Catalog Card No. 69–11088

First Tuttle edition published 1969

PRINTED IN JAPAN

TO
THE MEMORY OF
MY FATHER
Sir H. N. MODY, Kt.

TABLE OF CONTENTS

FOREWORD TO THE NEW EDITION

It must have been in 1940 when I was briefly stationed in the American Consulate, Osaka, as a vice consul that I bought from J. L. Thompson & Co., (Retail) Ltd., Kobe, the two-volume publication by N. H. N. Mody titled *A Collection of Nagasaki Colour Prints and Paintings Showing the Influence of Chinese and European Art on that of Japan.*

That sumptuous publication released in 1939 was limited to an edition of 200 sets, of which mine was No. 74. The price paid was 145 yen, then a very respectable sum for a junior vice consul. At the going exchange rate, it amounted to almost $35. In contrast, it may be noted that prices of from $500 to $600 have recently been paid at London book auctions for sets of this excessively rare publication.

I had already started to collect Japanese woodblock prints of historical interest and had acquired a few Nagasaki prints (which even then were becoming scarce and high priced) and many more Yokohama prints, mainly because they were more readily available and moderately priced. I still have in my collection a number of very attractive Yokohama prints of foreigners, foreign ships, scenes of Yokohama, and such foreign cities as Washington, London, and Paris. I acquired prints in those days from J. L. Thompson & Company, the manager of which was H. J. Griffiths, a scholarly and kind English gentleman who encouraged me to learn all I could about the prints I was collecting.

Prewar Kobe residents will recall Griffiths' store which was a treasure house for rare books on the Far East—old maps, prints, and the firm's own publications, largely dealing with Japan and the West, which long ago became collector's items. Thus it was entirely appropriate for J. L. Thompson & Company to co-sponsor publication of the Mody book, together with the prestigious London firm of Kegan Paul, Trench, Trubner & Co., Ltd.

I still recall the excitement and thrill experienced when I first paged through the two volumes of the Mody book. An entirely new world opened up for me. For here were pictured the finest Nagasaki prints, paintings, screens, maps, and a wide variety of other art objects showing the influence of China and the West on the art of Japan. These were the cream of the crop from the remarkable and sizable collection amassed by Mody here in Japan over a period of many years.

Art lovers, historians, and other serious students of Japan will forever be grateful to Mody for underwriting the publication of this book. In the first place, there was the very appreciable cost involved in acquiring the treasures depicted in his book. He then paid Japanese scholars and art dealers for the expert knowledge required fully to appreciate what he had collected. Finally, wishing to share his remarkable collection with others and to leave a testament of his love for Japan and things Japanese, he spared neither trouble nor expense in his endeavor to produce a work worthy of the subjects treated.

Indicative of Mody's sensitivity and dedication is the selection of the Japanese title for his book. Mr. Hashimoto Kansetsu, former well-known Kyoto artist, selected the two Chinese ideographs of Ko Kō that is used in the title. As explained at the end of the second volume, where a Japanese translation of the Introduction to the book appears, these two ideographs in combination mean "ancient fragrance" or "the fragrance of old and far off things."

For valuable background information on Mody, I am indebted to Harold S. Williams who knew

both Mody and Griffiths in the prewar days in Kobe. Williams, who resides in Shioya, Kobe, is the author of three books published by Charles E. Tuttle Company, namely, *Foreigners in Mikadoland* (1963), *Shades of the Past: Indiscreet Tales of Japan* (1959) and, *Tales of the Foreign Settlements in Japan* (1958). He is a frequent contributor of articles on the early days of the foreign settlements in Japan. These appear under the imprimatur of "Shades of the Past" in various publications, including *The Journal* of the American Chamber of Commerce in Japan.

According to Williams, Mody was a son of Sir Navuroji Mody, a Parsee Indian and one of the pioneers of Hongkong, a big shareholder in the Hongkong & Shanghai Bank, and founder of Hongkong University. He came to Hongkong around 1861 to enter the services of a firm of Indian bankers and opium merchants. Three years later he set up his own opium business which he subsequently gave up to turn his attention to dealings in stocks and shares and to exchange brokerage. His partner was Sir Paul Chater, prominent in Hongkong affairs. The elder Mody had many business interests, and was widely known for his generosity and support of charitable institutions; he was a racing enthusiast, had his own stables, and was appreciated in the foreign community as a prince of good fellows.

Why his son, with a family background of success and prominence in Hongkong, elected what appears to have been self-exile in Japan is a mystery. Obviously he had funds for indulging in what even in those years must have been a very expensive hobby.

Writes Williams: "Mody was a wealthy and scholarly Parsee gentleman, a bachelor and an introvert. He did not mix with the foreign community. He seemed to have few friends. His acquaintances were mainly art dealers and scholars. If I recall correctly he was living in the Kanto for a while, but came to Kobe after the earthquake of 1923 and stayed at the Pleasanton Hotel, then located opposite the Ikuta Police Station. About 1925 he moved to the Oriental Hotel where he occupied three rooms until the time of his death about 1943."

It was at the Oriental Hotel, in 1940 or 1941, that I had the honor of calling on Mody who had consented to see me at the request of Griffiths. I remember being greeted by a tall and handsome Indian gentleman probably in his late sixties, whose reserve thawed when he found that my appreciation for his prints and other art objects showed signs of promise. I recall vividly how he glowed rather than gloated over his treasures, and how he fondly and almost reverently handled them. He certainly gave the impression of being the trustee rather than merely the owner of his prints and other items.

Mody seemed pleased that I had brought along the two volumes of his book, and after we had spent several hours looking at selected items from his collection, he graciously agreed to write something on the title page of the first volume. I cherish what he wrote: "To Mr. Boehringer, a collector after my own heart. N. H. N. Mody." Looking back, I find it difficult to see why I deserved that tribute unless it was that I never asked what he had paid for a given item or from whom he had purchased it.

I had no premonition then that Mody had only a few more years to live and that his priceless collection would be destroyed several years after his death. According to Williams: "Following Mody's death [or perhaps it was following the outbreak of war, because of his nationality] his art collection was in the custody of the Sumitomo Trust & Banking Co. Ltd., which bank had been appointed custodian of certain enemy property, and was stored in the Morimoto Warehouse in Kobe, where it was destroyed by fire in the air raids of 1945. My notes indicate that he was buried in the Shuhoga-hara Foreign Cemetery in Kobe."

Williams admits the possibility that perhaps not all of the Mody Collection was lost. That point is a subject which I hereby suggest that he investigate.

Today's collector will have difficulty finding and acquiring many of the items shown in the Mody book. A very limited number of Nagasaki prints are still available but at prices which the average

collector will find prohibitive. The other items are even harder to come by, mainly because they are so avidly sought after, not only by foreign collectors but also by many Japanese collectors.

Prints and other material of the kind portrayed in the Mody book may be seen now and then at special exhibits or museums. Especially recommended in this regard is the Ikenaga Collection, which survived the 1945 Kobe air raids and which may be seen, together with other art objects, in the Kobe Bijutsu Kan (Kobe Fine Arts Museum). In Tokyo, the Suntory Museum, on the top floor of the Palace Building, occasionally has exhibits featuring pre-Meiji and Meiji era prints and other items in this field.

Through the enterprise of the Charles E. Tuttle Company, which is reproducing Mody's book, a wider public now has the opportunity to appreciate its significance as a monumental contribution toward a better understanding of the influence of Chinese and European art on that of Japan.

CARL H. BOEHRINGER

PREFACE

Up to little more than a decade ago, colour-prints made and published in Nagasaki, known as Nagasaki-ye, had awakened little or no interest on the part of connoisseurs and collectors in Japan, while, so far as the writer is aware, no mention of Nagasaki-ye had been made in any European work prior to the publication of Captain C. R. Boxer's book, "Jan Compagnie in Japan" (The Hague: 1936), in which there is a lengthy section dealing with the pictorial arts of Japan, including Nagasaki-ye as well as paintings in oils and water-colours. In view of the wide and long-continued appreciation of the colour-prints produced by the Yedo artist-craftsmen, this neglect of the Nagasaki colour-prints, so excellent in themselves and so important historically, is somewhat remarkable. So far as Japanese collectors are concerned, interest in Nagasaki-ye seems to have been created by Professor Kuroda's essay in his "Seiyo no Eikyo wo uketaru Nippongwa", published in Kyoto in 1924. This was followed, in 1926, by "Nagasaki Hangwa Shu" and "Zoku Nagasaki Hangwa Shu", both by Mr. T. Nagami. A third publication dealing with Nagasaki-ye was Mr. T. Ikenaga's Catalogue, "Hosaibankwa Daihokan" (2 vols.). Whether due to these publications or not, a sudden interest in Nagasaki-ye has manifested itself among Japanese collectors, and there is in Japan at the present time such a demand for these colour-prints that the prices asked for them have soared to almost unbelievable heights. While this sudden increase in monetary values is to be deprecated, the appreciation of the merits of Nagasaki-ye that it betokens is to be welcomed.

I trust that the reproductions of Nagasaki-ye, and paintings in colour and in collotype, contained in these two volumes, together with the detailed descriptions, and the introduction to the subject that I have ventured to write, will be of interest to art-lovers both in Japan and abroad and will result in a wider and fuller appreciation of these long-neglected works of art, especially in countries where they are still but little known.

I have to thank Mr. Hashimoto Kwansetsu, the well-known Kyoto artist, for selecting the Japanese title and designing the Japanese title-page; Mr. S. Kitabatake, Chief Librarian of the Kyoto Library, for kindly furnishing extracts from early Japanese books and manuscripts dealing with Nagasaki-ye and Japanese paintings, and for literary advice regarding the Japanese text; and Mr. H. Inada for his help in connection with the translation of the English text into Japanese. I have also to thank Mr. H. Langley for considerable help in producing these two volumes.

N. H. N. M.

January, 1939

LIST OF ILLUSTRATIONS

List of Illustrations

List of Illustrations

List of Illustrations

List of Illustrations

List of Illustrations

List of Illustrations

List of Illustrations

List of Illustrations

INTRODUCTION

NAGASAKI COLOUR PRINTS

JAPANESE painters are classified into the following schools: Buddhist, Tosa, Kano, Shijo, Maruyama, Ganku, Chinese and Ukiyoye. The colour–print designers of the second half of the 18th century and the early to middle 19th century belong to the Ukiyoye School. Nagasaki–ye were an off–shoot of the Ukiyoye school and may be described as woodcut polychrome prints, printed and published in Nagasaki. Originally, the customers of the colour–print artist almost all came from the poorer classes, and these prints, costing only a few sen each at the time of their publication, became the household treasures of the common people.

The early colour–prints made in Yedo—now Tokyo—were called Nishiki–ye, or "Brocade Pictures." The subjects of such prints were popular actors of the day, fashionable courtesans and beauties of the Yoshiwara, dancers, wrestlers, and geisha girls. They also portrayed scenes from the theatre and the tea–house, temple festivals, gay boating–parties on the Sumida–gawa, the fifty–three stations of the Tokaido road, and included landscapes, bird and flower studies, etc. The subjects treated were often coarse and vulgar and, at times, were even obscene.

Nagasaki, situated in the province of Hizen, and surrounded by hills and mountains on three sides, has one of the most picturesque harbours in the world. Nagasaki–ye depict subjects connected with the port and harbour of Nagasaki and deal chiefly with Dutch and Chinese shipping and with the interesting visitors to be seen at the Dutch and Chinese factories. They also portray birds, camels, elephants and other fauna imported into Nagasaki by the Dutch and the Chinese. Except in the case of a few prints depicting Maruyama beauties and their Dutch and Chinese patrons, no Japanese subjects were treated. The writer has come across four prints only that portray Japanese figures. This is in strong contrast to the colour–prints made in Osaka, Kyoto, and Yedo.

Nagasaki–ye dealing with the Christian religion were prohibited by the Shogunal Government. This prohibition is in line with the notice–boards (Plate 203), prohibiting Christianity and inviting informers, to be seen in different parts of the country from 1641 to 1878 (Meiji 10).

Nagasaki–ye are not generally signed by the artists, though a few late prints are signed by Tani Ho, Kogetsukwan, Isono Bunsai and his wife Seko.

The black–and–white prints were called Sumi–ye; the early hand–coloured prints, in which lacquer was used to heighten the colour, were called Urushi–ye, and all other polychrome prints were called Nishiki–ye. Yedo colour–prints were as a rule of uniform size while Nagasaki–ye are of different sizes, some of them being 100 cm in height and 54 cm in width. Unlike Yedo prints, Nagasaki–ye have a long account of the subjects treated in the print. They resemble Yedo–ye in that they were printed on paper of poor quality and were sold at ridiculously low prices to travellers, business men, scholars, artists, and other visitors to the port. They were known as Nagasaki–Miyage, or "Souvenirs from Nagasaki".

Nagasaki–ye show a good deal of foreign influence, some of the subjects treated evidently being taken from Dutch copper–plate engravings, while others, such as the Shōhō World Map, were probably copied from the Chinese originals of the last decade of the Ming dynasty.

Introduction

The designers of Nagasaki-ye are not known, although Mr. Nagami Toshitaro is of opinion that they were minor and poorer officials of the Dutch and Chinese factories who took to print designing in order to supplement their ordinary income.

The Shōhō (1644–1648) World Map and woodcut of 42 types of foreigners is considered by Japanese scholars and collectors to be the earliest Nagasaki colour-print. This map is inscribed: "Published at Nagasaki harbour in the Hinoto Tori (Cock) year of the Shōhō era."

The writer is at variance with some collectors who have questioned the genuineness of the Shōhō map on the ground that there is no such year in the Shōhō era. Undoubtedly there was a mistake in the cyclical date, but that is no reason for rejecting the claim that the map was published in Nagasaki. The map was probably printed for a special purpose and not for selling to ordinary visitors, tourists, etc., visiting Nagasaki. Some collectors are of opinion that the map was printed in Kyoto or Yedo in order to escape the wrath of the Shogunal Authorities, who were always suspicious of anything connected with the Christian religion. The objection of the Shogunate was to the Christian religion *per se* and not to the foreign subjects treated. The Jesuits and other foreign missionaries were at the beginning exceptionally well treated, but as time went on they made themselves thoroughly detested by interfering in the internal affairs of the country. Finally the Shogunal Government came to the conclusion that they were a danger to the country and expelled them. The Dutch and the Chinese were, however, allowed to stay in Nagasaki.

Foreign influence and culture, particularly Portuguese and Dutch, found its way into Japan through the port of Nagasaki and penetrated far and wide, and it is reasonable to suppose that large and skilfully drawn maps were made in Nagasaki under the guidance of Chinese wood-block artists. We must also remember that the Chinese were at that time in advance of the Japanese in wood-cut prints, though at a later period the latter far outstripped the former.

The most important objection to the authenticity of the Shōhō map is the length of time that elapsed before a dated map of Nagasaki was again published. This later map was published by Toshimaya in the fourteenth year of the Horeki era (1746), that is, more than 100 years after the publication of the Shōhō map. This, it is quite true, is a strong argument against the Shōhō map being published in Nagasaki. But at the same time we must take into consideration the fact that several undated maps were published in Nagasaki to fill up, as it were, the gap between the publication of the Shōhō map and the map of Nagasaki published by Toshimaya in the fourteenth year of the Horeki era.

The writer has made the most interesting and important discovery that a dated map of Nagasaki, published in Nagasaki, appeared in the second year of the Horeki era (1752), the map being inscribed: "Nagasaki Higashihamo-cho Shoshi Chikujuken Nakamura Sozaburo Kaihan." This map was, therefore, made and published at least a decade prior to what has hitherto been regarded as the oldest dated map of Nagasaki after the Shōhō map.

What is usually regarded as the oldest undated map of Nagasaki, published in Nagasaki, is the map illustrated in Plate 26 of this collection. The Empo (1673–1680) map of Nagasaki, published in Yedo, was a reduced reproduction of this map, and it is reasonable to suppose that the earlier map was printed some time during the Kwanbun period (1661–1672). The name of the publishing firm is not known. In the lower part of the map there is a table giving the distance of various places from Nagasaki, which is a plain indication that the map was printed in Nagasaki.

The second-oldest undated map printed and published in Nagasaki is a map of the oldest shrine in Japan entitled: "Jindai no Edzu." The Jindai shrine was greatly damaged by the

great earthquake in the second year of Kwanbun (1662). It was later on repaired and restored, and this shrine map was probably printed in Nagasaki in the Hoyei era (1704–1710) in commemoration of this event.

The third and fourth undated maps of Nagasaki, printed in Nagasaki, were published by Chikujuken Nakamura Sanzo and are believed by collectors to have been made before the Enkyo 2 (1745) map of Nagasaki published in Kyoto. The first Chikujuken map was probably published during the Genbun era (1736–1740), the second being published a few years later, say 1741–1743, during the Kwanpo era.

From the foregoing it is reasonable to conclude that there is little or no evidence to cast any doubt on the authenticity of the Shōhō World Map and that we may safely accept this map as being the oldest dated map of Nagasaki, printed and published in Nagasaki.

It is interesting to note that the earlier maps of Nagasaki from Shōhō to Horeki 14 (1764), like the earlier prints before 1800, were invariably of large size and were printed and published at long intervals, while dated maps of Nagasaki after 1764 frequently appeared. For example, in the first year of the Kyowa era (1801) five dated maps of Nagasaki were published by four different publishers in the same year.

A description of the two famous colour-prints—one showing a Dutch factory and the other a Chinese factory—may be given here. The Deshima print bears various inscriptions which are worked into the picture in such a way as almost to seem an integral part of the picture itself. These inscriptions may be done into English as follows:

The first arrival of the Hollanders was in the 7th year of the Keicho era (1602). They landed at Sakai, Izumi province, in the time of the Shogun Tokugawa Ieyasu. The date of their second arrival was in the 14th year of the Keicho era (1609), during the shogunate of Tokugawa Hidetada. The Daimyo Matsuura Hoin was Governor of Hirado and Hasegawa Sahiyoe was Governor of Nagasaki.

In the 13th year of the Kwanyei era (1636), the construction of Deshima from reclaimed land was completed, and twenty-five houses were built for the Portuguese (Nambanjin) and leased to them for three years (1636–1638). In the Rabbit year (1639), trade with the Portuguese was prohibited, and in the Dragon year (1640) Deshima was evacuated.

In the 18th year of the Kwanyei era (1641), the Dutch people living in Hirado were transferred to Deshima in Nagasaki. At that time, Baba Saburozayemon was Governor and Higaki Heiyemon Sub-Governor of Nagasaki. The Hollanders paid 55 *kwan* of silver per annum to the authorities as rent for a house. They continued to visit Nagasaki for a period of 145 years till the 9th year of the Anyei era (1780).

The dimensions of Deshima are as follows: from the eastern corner to the southern, a little over 35 *ken;* from the southern corner to the western, a little over 118 *ken;* from the western corner to the northern, a little over 35 *ken;* from the northern corner to the eastern, a little over 96 *ken.*

The inscriptions on the print showing a Chinese factory (Tojin Yashiki Kei) are not nearly so numerous as they are in the Deshima print. They may be translated as follows:

At first the Chinese people used to live in the regular town of Nagasaki and were free to walk in any part of the town. In the first year of the Genroku era (1688), when Yamaoka Jubei was Governor and Miyagi Shume Sub-Governor of Nagasaki, it was decided that the Chinese people should live in houses built in the valley known as Kojima Juzenji, extending for 100 square *ken.* They continued to

live there for 93 years, until the 9th year of the Anyei ra (1780).

In addition to the foregoing inscriptions, the name and address of the publisher, Toshimaya Bunjiyemon, Ķatsuyama-cho, Nagasaki, are printed in the left-hand bottom corner of both prints.

The colour-prints of the Dutch and Chinese factories described above are not only of great historical interest but have considerable artistic merit as well.

Isaac Titsingh was the earliest European collector of Nagasaki-ye. Titsingh was in the service of the Dutch East India Company for fourteen years, and when he left Nagasaki for Europe he managed to get copies of these two prints, in spite of the prohibition of the Shogun covering all maps, views, etc., of Nagasaki.

The central part of the Dutch-factory print gives a bird's-eye view of Deshima which is remarkable for the accuracy of its detail as well as for the picturesqueness of the scene as a whole. This part of the print distinctly shows: different types of houses standing side by side, a Dutch captain under a sunshade held by a Javanese slave, a Hollander with his Japanese interpreter, courtesans in their open dwellings, etc.

The companion print shows a group of Chinese on their way to a Tenko temple and a few courtesans apparently wending their way home.

The style of drawing exemplified in these two prints, according to Professor Kuroda, closely resembles the drawings that appear in geographical books of the Ming dynasty. In later times, this style became quite the fashion in various Japanese publications such as illustrated guide-books to places of historical or scenic interest. The colouring is in Toshimaya's own characteristic style in which shades are gradated by means of finely-drawn oblique lines, the predominating colours being vermillion, green, yellow and grey. Of these colours, vermillion alone was applied by hand.

The following publishers of Nagasaki colour-prints may be noted: Hariya, Toshimaya, Bunkin-do, Yamatoya, Masunaga, Ushibukaya, Baiko-do (Bunsho-do), Shiun-do, Koju-do, Rinkwado, Sasaya, Imamiya, Ogiya, Wataya, etc.

PAINTINGS OF THE NAGASAKI AND OTHER SCHOOLS

The history of Japanese painting begins with the introduction and the propagation of Buddhism, which took place during the 6th and 7th centuries of the Christian era. The Buddhist priests, trained in the monastries, were the earliest teachers, and, since both in China and in Japan writing—executed, of course, with a brush—and painting are two branches of one and the same art, the Buddhist priests were also the earliest painters. Though the religious influence at first exercised by the Buddhist priests quickly died out, it had nevertheless far-reaching effects. It was the seed from which sprang the great schools of Japanese painting.

For a proper appreciation of Chinese and Japanese art, the conventions employed must be accepted and understood. Light and shade and all forms of realism are entirely absent, there being no attempt at chiaroscuro. Purity of line is insisted on, while overcrowding and all excess of detail are alike shunned. "Throughout the course of Asian painting," says Mr. Laurence Binyon, "the idea that art is the imitation of nature is unknown or known only as a despised and fugitive heresy. A Chinese critic of the sixth century, who was also an artist, published a theory of æsthetic principles which became a classic and received universal acceptance, expressing as it did the deeply rooted instincts of the race. In this theory it is rhythm that holds the permanent place; not, be it observed, imitation of Nature, or fidelity

Introduction

to Nature, which the general instinct of the Western races makes the root-concern of art."

The subjects of early Nagasaki painting were for the most part of a religious nature. The Christian seminaries of Ariye in Hizen, Arima and Kyushu were noted for the painters they produced as well as for their Occidental teachers, of painting in the European style. The mural paintings that adorned Christian churches, which were all the work of native Christian artists, won the wondering admiration of all who saw them for the first time, however familiar such visitors might be with the frescoes of Europe. Thus the production of the early examples of painting in the European style coincided in point of time with the active propagation of the Christian faith.

The extermination of Japanese Christians took place in the 17th century, and naturally painting in oils suffered a like eclipse. No Japanese oil painting executed between 1650 and 1750 is known to have survived, and the art of oil painting was not revived until the end of the 18th century. Indeed, the names of most of the painters of the European school were actually forgotten. The sole exception was Yamada Emonsaku. He was one of the leading rebels in the beleaguered castle of Amakusa in the Shimabara rebellion of 1637-1638. Repenting of his part in the rebellion, he attempted to communicate with Matsudaira Izu no Kami Nobutsuna, the commander of the Shogunate forces. He adopted the ingenious method of tying a letter to an arrow and shooting it in the direction of the besieging army. He was detected in this act and was imprisoned in the castle. He would probably have been executed as a traitor to his side had it not been that in the nick of time the castle fell. He was pardoned by the Shogunate leader and was allowed to continue his painting in oils. Not unnaturally, his later works were not of a religious character. Yamada Emonsaku died in Nagasaki, at Ogawa-cho, in the first year of the Meireki era (1655).

It is a matter of historical fact that not everything connected with the Christian religion was destroyed when Christianity was officially condemned and ordered to be uprooted and utterly eradicated. Many Christian tokens and other evidences of the place Christianity formerly held in the life of the people survived the general destruction and are indeed still extant. For example, in the British Museum there is a Japanese screen showing Jesuit fathers welcoming a Portuguese ship.

According to the Nagasaki Seminden (Biographies of early Nagasaki worthies), painters such as Ikushima Saburosa, Nozawa Kyu-u and Kita Genkei were all well versed in European painting. Nishikawa Joken, in his Nagasaki Yawagusa of 1720, also refers to oil painters in Nagasaki of the Portuguese (Namban) and the Dutch (Komo) schools.

The Chinese school was another strong influence in Japanese art. The origin of its influence may be traced back to the downfall of the Ming dynasty in China in 1662, just as the Renaissance in Europe may be traced back to the fall of Constantinople in the 15th century. And as scholars fled from Constantinople to Italy, so Chinese scholars and artists sought refuge in Japan in order to escape the turmoil and the social and political unrest that followed the decline and fall of the Ming dynasty. Itsunen, a Chinese priest, came over to Japan in the first year of the Shōhō era (1644). He was the third abbot of the Kofukuji, a temple in Nagasaki, and he introduced the pure Chinese style of painting. He spent twenty-five years in Japan and died in Nagasaki in the seventh month of the eighth year of the Kwanbun era (1669). From his school came the two famous painters, Kawamura Jakushi and Watanabe Shuseki, both of Nagasaki.

Chin Nam Pin, So-shigan and Hosaiyen represented the realistic branch of the Ming school, and they established studios in Nagasaki, Kyoto and Yedo. Chin Nam Pin came to Nagasaki in the 16th year of the Kyoho era (1731) and returned to China in 1733. He painted

Introduction

birds and flowers and was considered the ablest exponent of this style of art.

The following Japanese artists were known as early painters of the Nagasaki Namban school: Ishizaki Gentoku, Araki Genkei, Ishigaki Gensho, Ishizaki Genkei, Matsui Genchu, and Araki Genyu, pupil of Gentoku, while Ishizaki Yushi, Doi Yurin, Araki Jogen, Kaburagi Bairei and Ishizaki Yusai, son of Ishizaki Yushi, represented the Araki School of Nagasaki painters.

Araki Genkei was born in Nagasaki in the eleventh year of the Genroku era (1698) and was one of the most famous painters of the Nagasaki school. In the nineteenth year of the Kyoho era (1734), he was appointed official painter of foreign-style paintings and had been in that position for more than thirty years when he retired in the third year of the Meiwa era (1766). He adopted Araki Genyu as his son, and he also became the official painter and an art connoisseur.

Araki Genyu learnt painting from Ishizaki Gentoku and also from Dutch painters in Deshima. He died in the eleventh year of Kwansei (1799), aged 67.

Araki Jogen was the adopted son of Araki Genyu and learnt painting from his adoptive father. According to Professor Kuroda, he was about forty years old in the tenth year of Bunkwa (1813). He produced his best work during the years 1804–1830.

Ishizaki Yushi was the actual son of Araki Genyu and learnt foreign-style painting from his father. He excelled in Japanese calligraphy and had many pupils and followers. He died in the third year of Koka (1846), aged 75.

Wakasugi Isohachi was an independent artist. In the Imamiya shrine in Kyoto there is a painting in oils representing two Dutch men-of-war and signed by this artist.

Kawara Keiga, Taguchi Rokoku, his son, Matsui Kensan and Isono Bunsai were all painters in the Western style.

It may here be remarked that the above-mentioned Nagasaki artists all painted in oils on glass, after the Chinese manner, and that they also introduced Doro-e, or mud pictures, so called because they were done with muddy water-colour pigments mixed with chalk. Glass-painting and Doro-e were known as " Geté-mono ", or art for peasants.

We now come to three independent artists of the modern school: Hiraga Gennai, Maruyama Okyo and Shiba Kokan.

Hiraga Gennai (1723–1779) was a celebrated artist in the European style, his work including both water–colours and oil-paintings. He was also interested in pottery and copied on Japanese ceramics the designs, glazes and enamels of the late Ming period. A native of Yedo, he visited Nagasaki several times.

Maruyama Okyo (1733–1795) was influenced by the realism of Chin Nam Pin and by the impressionism of Buson's and Taigado's paintings. He was one of the most distinguished painters in the Western style and helped to create and establish the new school by his teaching as well as by his paintings. In the end, however, he developed a style that was his own and not that of any school. He spent the greater part of his life in Kyoto, where he died, his tomb being in the cemetry of the Goshinji, a temple in Kyoto.

Shiba Kokan (1738–1818) was born in Yedo. He visited Nagasaki twice and studied the foreign method of painting as well as acquiring the art of copper–plate engraving. Having learnt from the Dutch the principles of perspective and light and shade, he painted portraits quite in the European manner. Shortly before he died, he painted one of his best pictures, and, according to Japanese custom, composed a death poem, which reads as follows: "Kokan dies because he is very old: to the common people he leaves a common drawing (Ukiyoye)."

PLATES

PLATE 1

金地異國人物圖掛物
筆者不詳
竪五尺六寸
横一尺七寸八分

Various Types of Foreigners
Detail from a painting in colour on gold
ground. Probably painted by an artist of the
early Kano school.
Height 167 cm. Width 54 cm.

PLATE 2

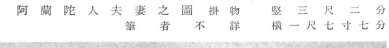

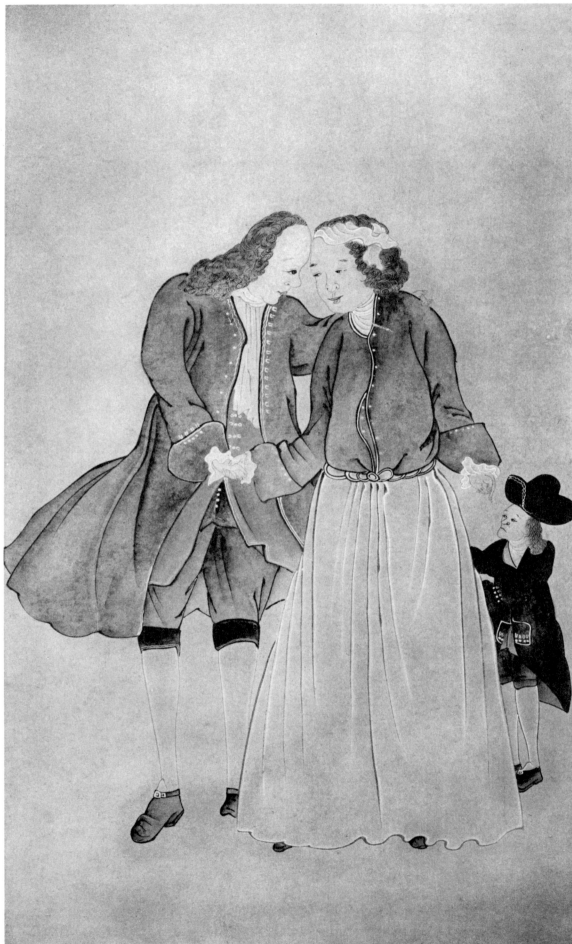

A Dutch Couple
Painting in colour on paper. Unknown Artist.
Height 91.5 cm Width 53.5 cm.

PLATE 3

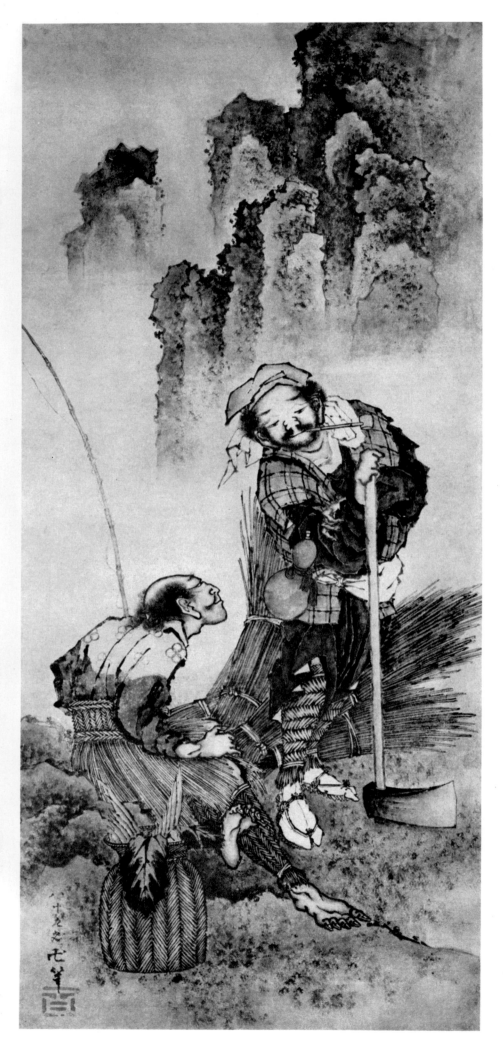

漁樵問答之圖　掛物

北斎一寸五分筆

竪四尺一寸五分

横一尺八寸五分

Gyosho Mondo

From a painting in colour by Hokusai. A dispute between a fisherman and a woodcutter. The fisherman extolled the virtues of the fish, while the wood-cutter stubbornly insisted on the high value of the wood. At the end of the day, after a heated dispute, a reconciliation took place. The woodcutter suddenly exclaimed: "Do not sell your fish to raise money; I will dispose of my wood, and then we will have a merry time." The woodcutter sold the wood and bought some food and saké, and the feast continued till the early hours of the morning. The original story is of Chinese origin.

Height 126 cm. Width 56 cm.

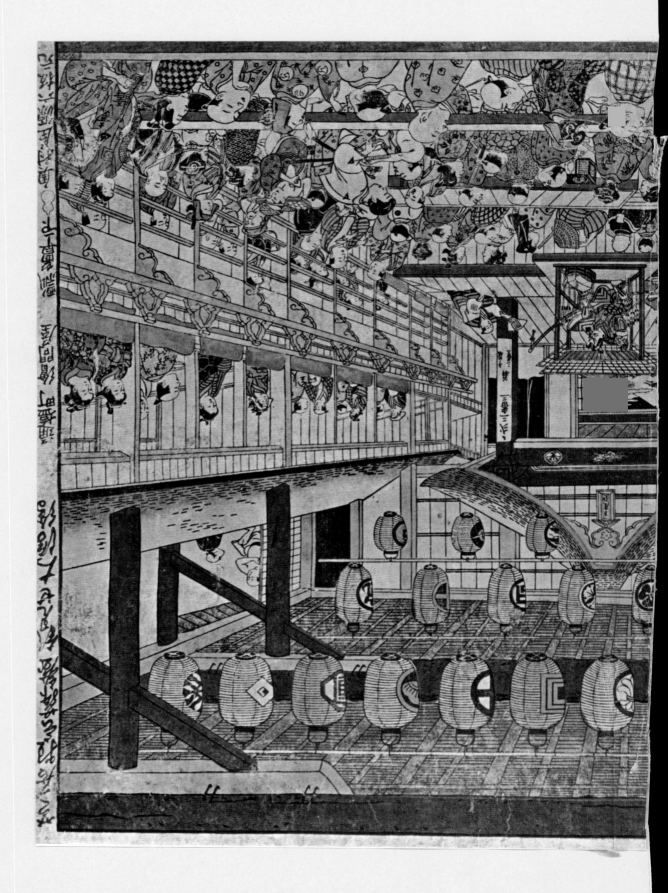

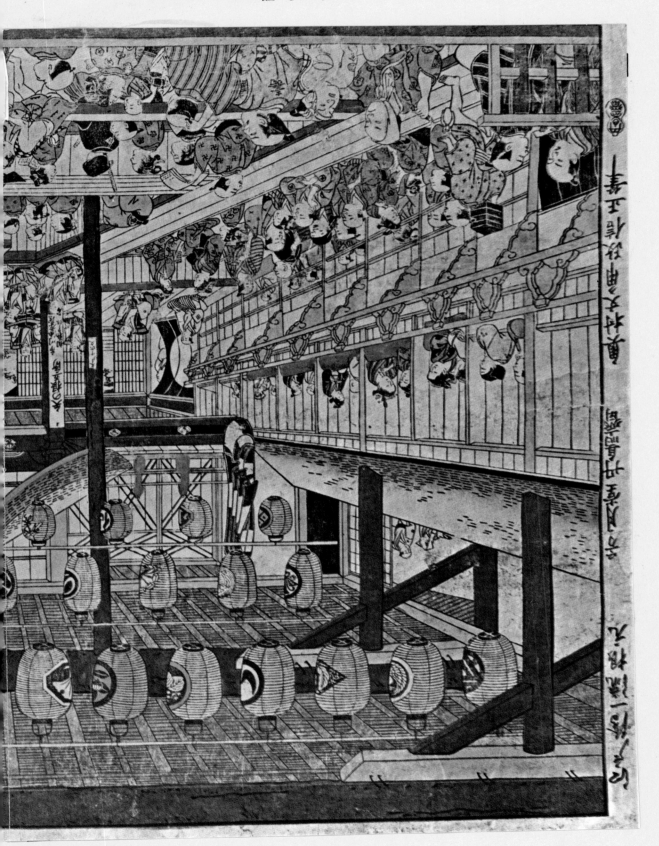

Interior of a Theatre

From a hand-coloured print after Okumura Masanobu (*circa* 1685-1764).
Masanobu was the first Ukiyoye artist to make use of European perspective, which he probably learned from Dutch copper-plate engravings.
As Yedo-ye preceded Nagasaki-ye in point of time, a few of the former are reproduced here for purposes of comparison.
Height 45 cm. Width 67.5 cm.

PLATE 4

PLATE 5

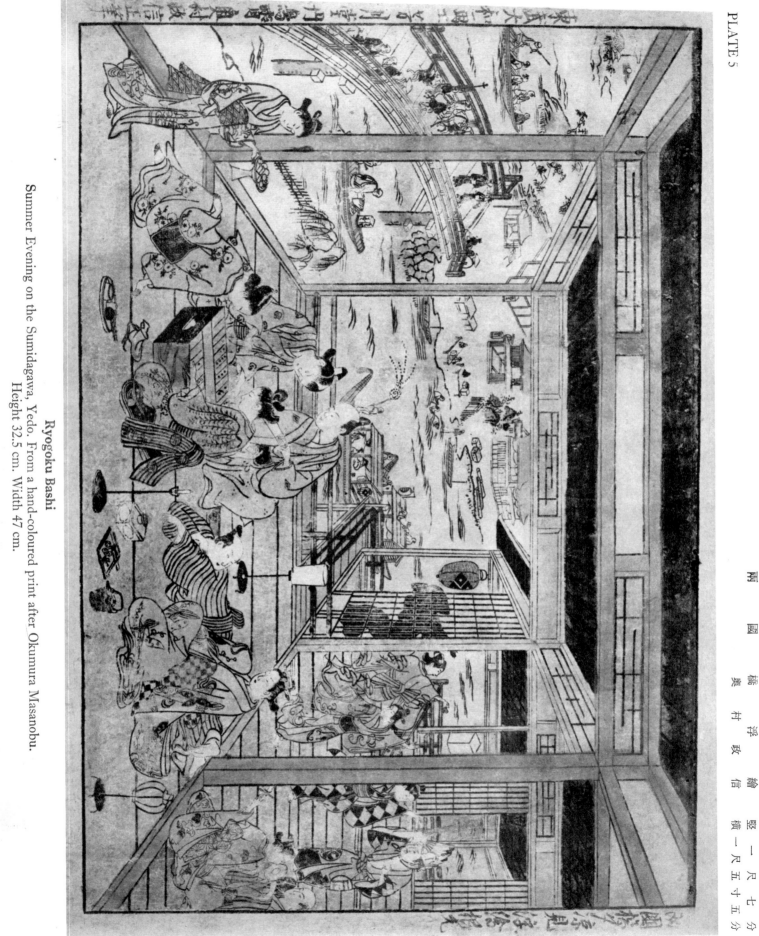

Ryogoku Bashi

Summer Evening on the Sumidagawa, Yedo. From a hand-coloured print after Okumura Masanobu.

Height 32.5 cm. Width 47 cm.

兩　國　橋　祥　浮　繪　豎　一　尺　七　分

奥　村　政　信　横　一　尺　五　寸　五　分

PLATE 6

南蠻人と象之圖
奧村政信
竪二尺二寸七分
横五寸八分

Portuguese Figure-Subject and an Elephant
From a hand-coloured "pillar-print" after Okumura
Masanobu. This print is considered by competent au-
thorities to be the earliest pictorial representation of a
foreigner in a Japanese colour-print.
Height 68.5 cm. Width 17 cm.

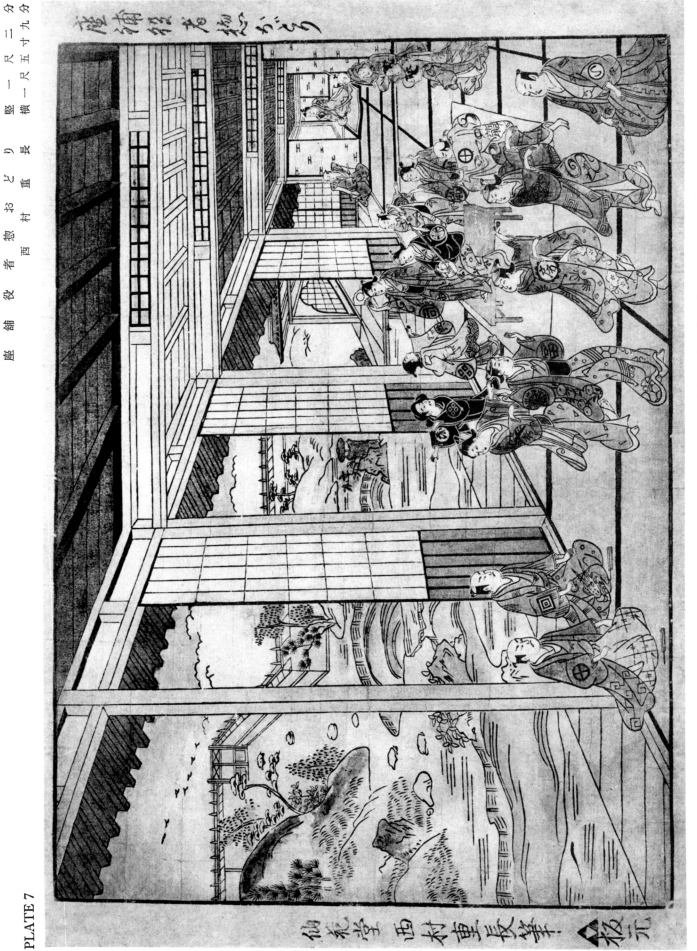

PLATE 7

Musical Entertainment with Five Dancing Girls and a Shamisen

From a hand-coloured print after Shigenaga (1697–1756).

Height 34 cm. Width 48 cm.

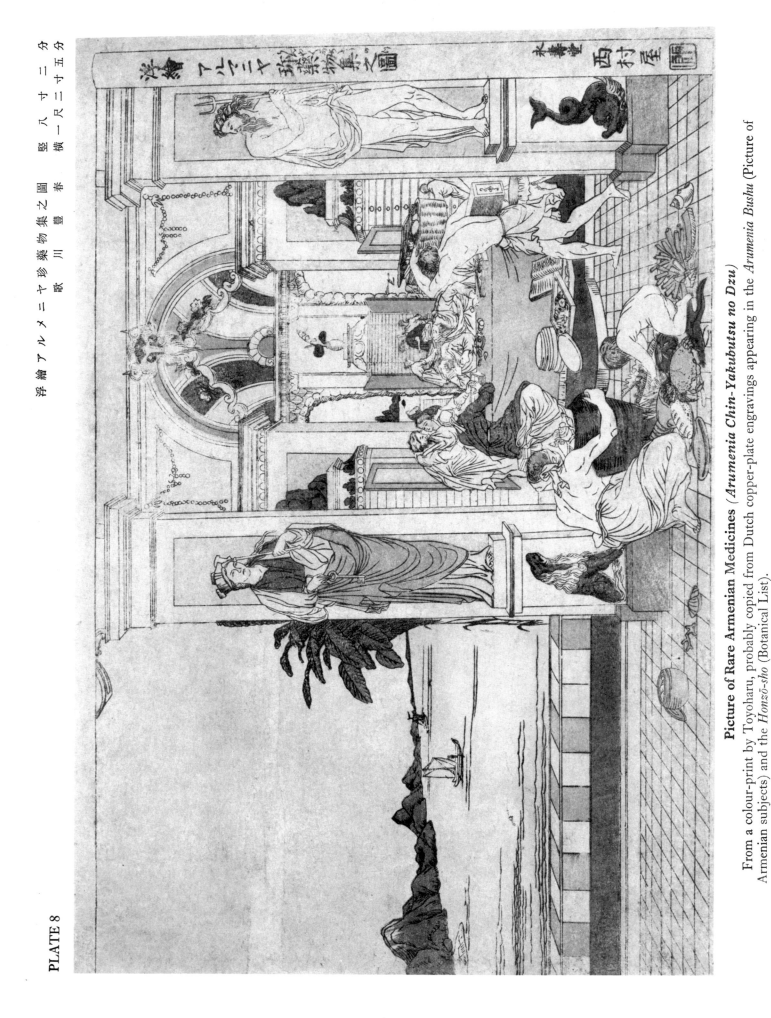

PLATE 8

浮繪アルメニヤ珍藥物集之圖　歌川豐春　堅八寸三分　横一尺二寸五分

Picture of Rare Armenian Medicines (*Arumenia Chin-Yakubutsu no Dzu*)

From a colour-print by Toyoharu, probably copied from Dutch copper-plate engravings appearing in the *Arumenia Bushu* (Picture of Armenian subjects) and the *Honzō-sho* (Botanical List).

Height 25 cm. Width 38 cm.

PLATE 9

浮繪和蘭陀國東南湊圖　歌川豐春畫　竪八尺三寸一分
　　　　　　　　　　　　　　　　横一尺三寸四分

A Dutch Scene
From a colour-print after Utagawa Toyoharu.
Height 24 cm. Width 37 cm.

PLATE 10

汐　干　の　つ　喜　多　川　歌　麿　竪　八　寸　九　分
横　一　尺　二　寸　五　分

A Walk at Low Tide

From the *Shiohi no Tsuto* (Shells at Ebb Tide) by Kitagawa Utamaro. Eight double-page colour-plates (*circa* 1780–1788).
Height 27 cm. Width 38 cm.

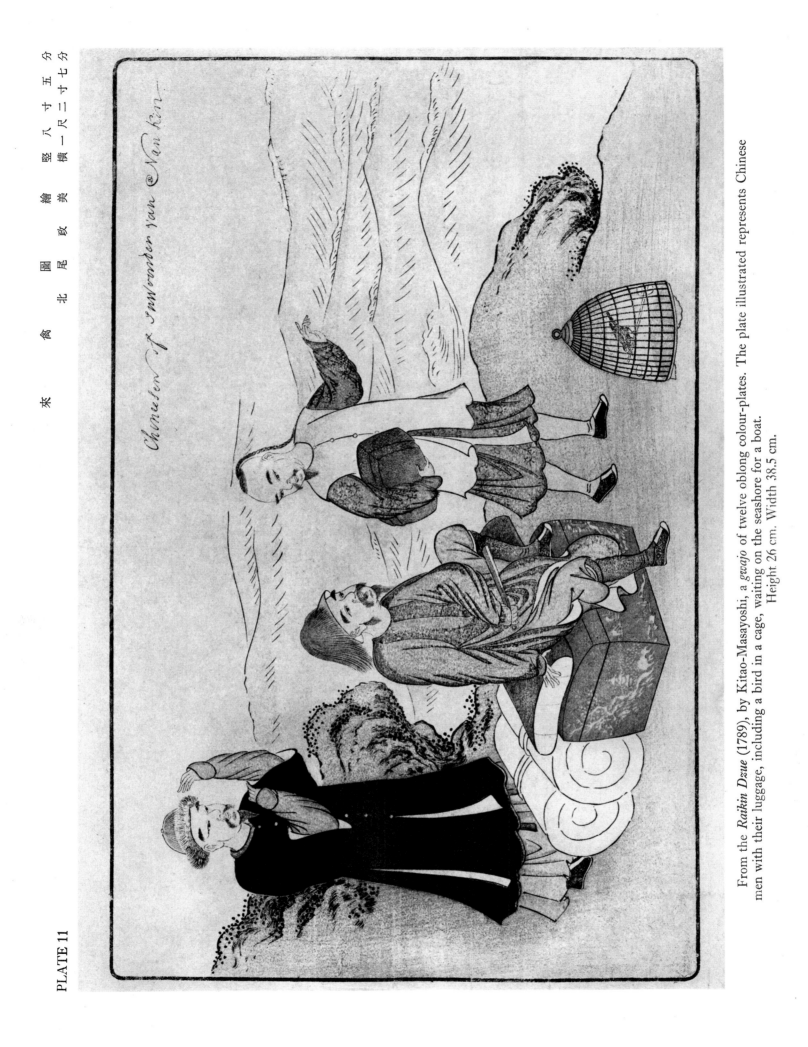

PLATE 11

Chinesen of Immorden van @Nan kin

來 禽 圖 尾 政 繪 美 竪 八尺一横 五分 二寸七分

From the *Raikin Dzue* (1789), by Kitao-Masayoshi, a *gwajo* of twelve oblong colour-plates. The plate illustrated represents Chinese men with their luggage, including a bird in a cage, waiting on the seashore for a boat.
Height 26 cm. Width 38.5 cm.

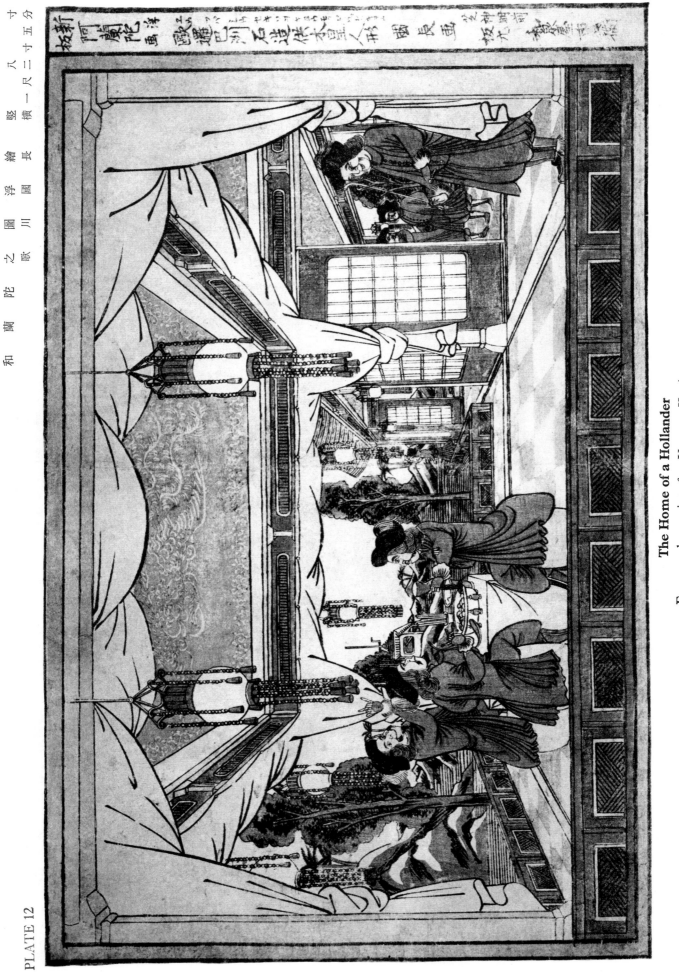

PLATE 12

The Home of a Hollander
From a colour-print after Utagawa Kuninaga.
Height 25.5 cm. Width 38 cm.

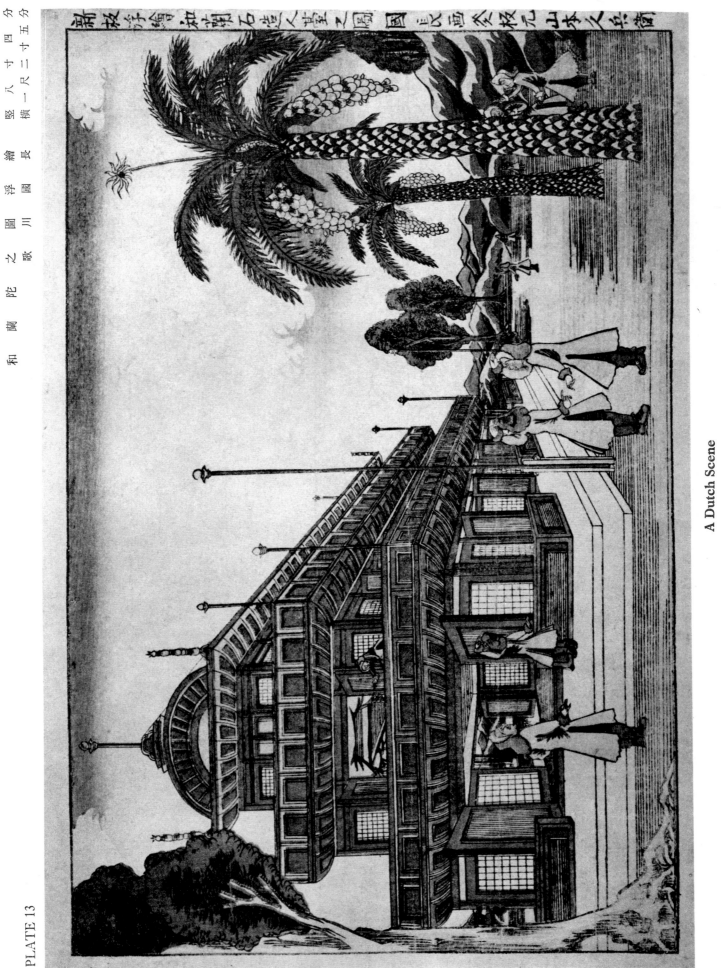

和 蘭 陀 之 圖 浮 繪 國 川 歌

PLATE 13

A Dutch Scene
From a colour-print after Utagawa-Kuninaga.
Height 24 cm. Width 35 cm.

PLATE 14

安藝の宮嶋之圖　堅八寸三分
阿蘭陀フランスカノ伽藍圖　横二尺二寸一分

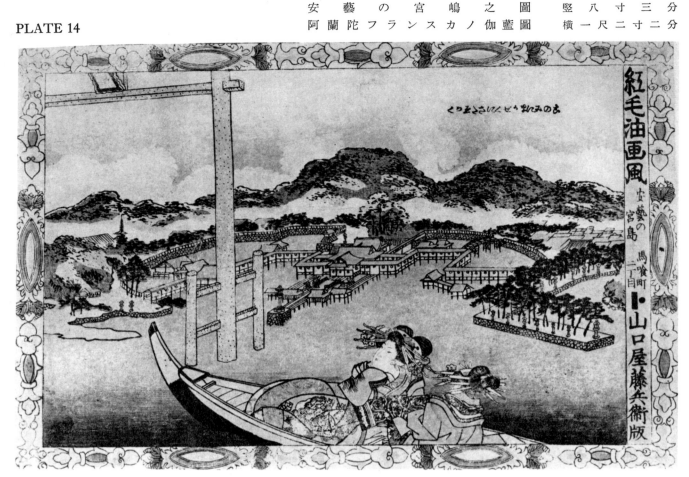

Fig. 1　Miyajima with Two Beauties in a Boat
From a Japanese colour-print. Unknown Artist.
Height 25 cm. Width 37 cm.

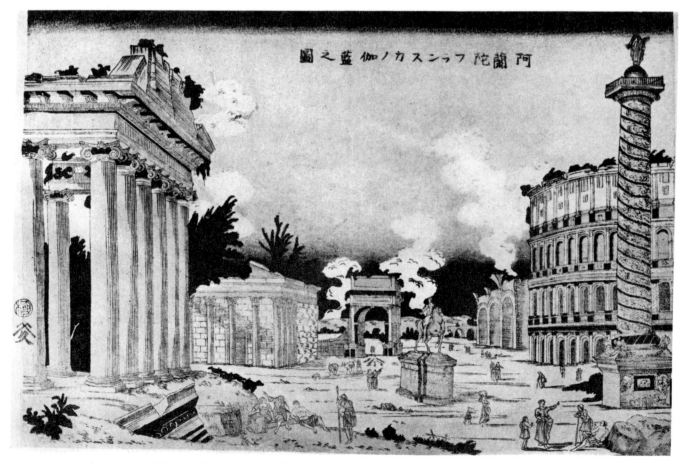

Fig. 2　Picture with Perspective, Showing Dutch Influence
From a colour-print after Hoku-ju.
Height 25 cm. Width 37 cm.

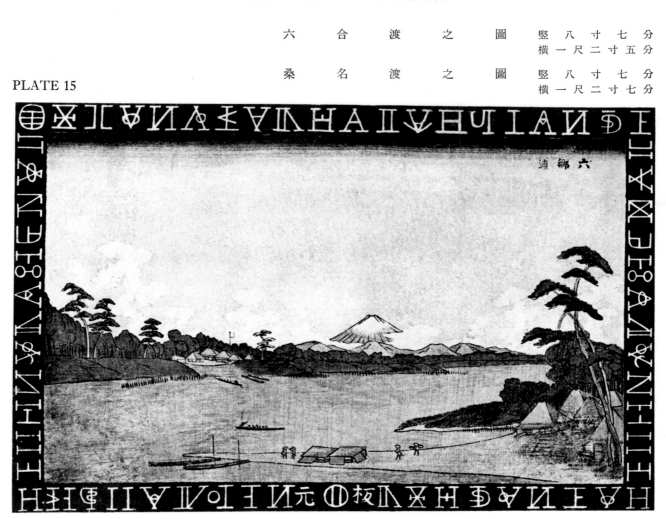

Fig. 1 The Ferry over Rokugo River; Sunset

From a Japanese colour-print. Unknown Artist.
Height 26.5 cm. Width 38 cm.

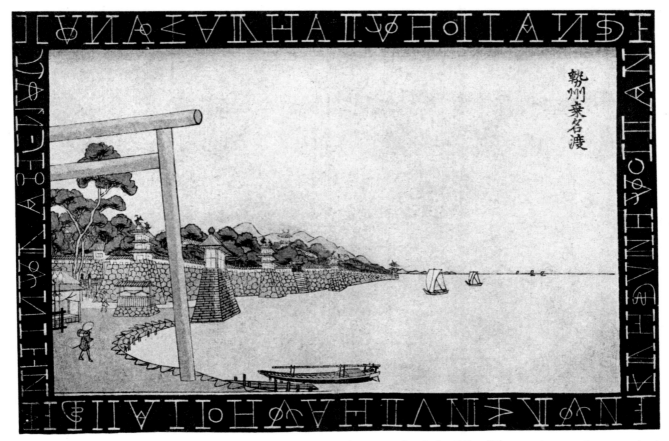

Fig. 2 The Seven-Ri Ferry, Kuwana, at the mouth of the Kiso River, at sunset.

Unknown Artist.
Height 26.5 cm. Width 38.5 cm.

PLATE 16

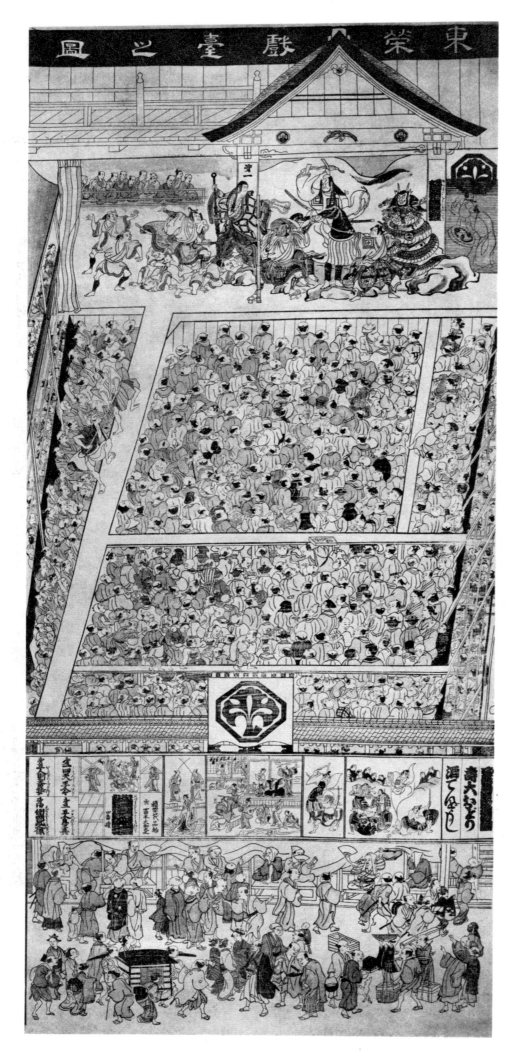

東榮戲臺之圖

東
榮
戲　筆
臺　者
之　不
圖　詳
掛
物

橫　竪
一　四
尺　尺
九　二
寸　寸
三　九
分　分

Interior of a Theatre

From a Japanese colour-print. Un-
known Artist.
Height 130 cm. Width 58.5 cm.

PLATE 17

亞 墨 利 加 大 船 之 圖　竪 二 尺 三 寸 八 分
五 雲 亭 貞 秀　横 二 尺 四 寸

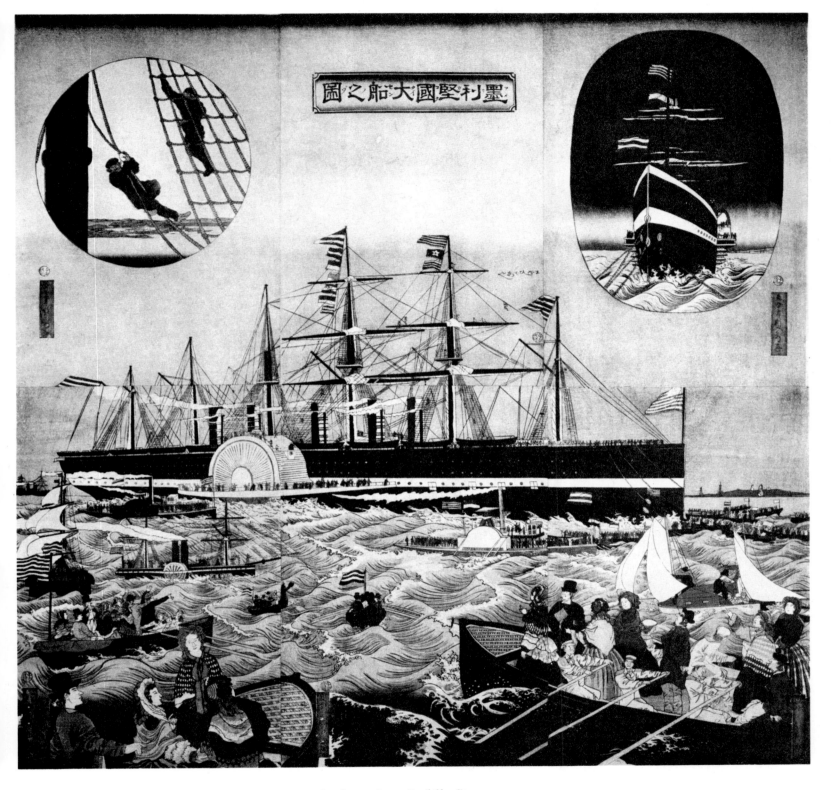

An American Paddle Steamer
From a colour-print after Gountei Sadahide.
Height 72 cm. Width 72.5 cm.

PLATE 18

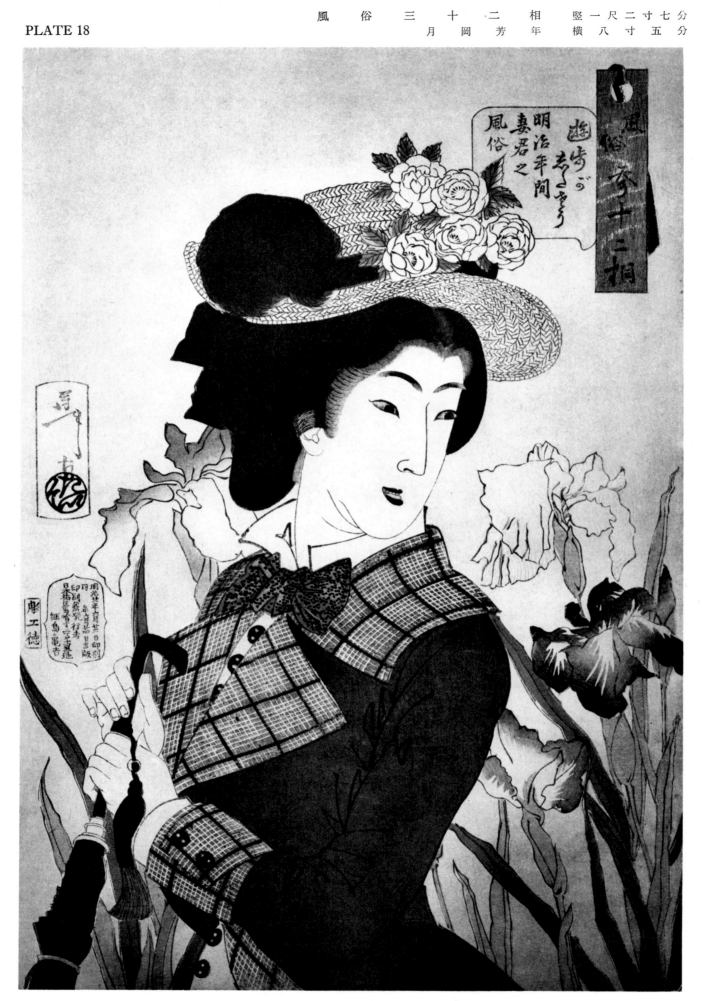

A Modern Japanese Lady in European Costume
From a colour-print after Tsukioka Yoshitoshi.
Height 38.5 cm. Width 26 cm.

PLATE 19

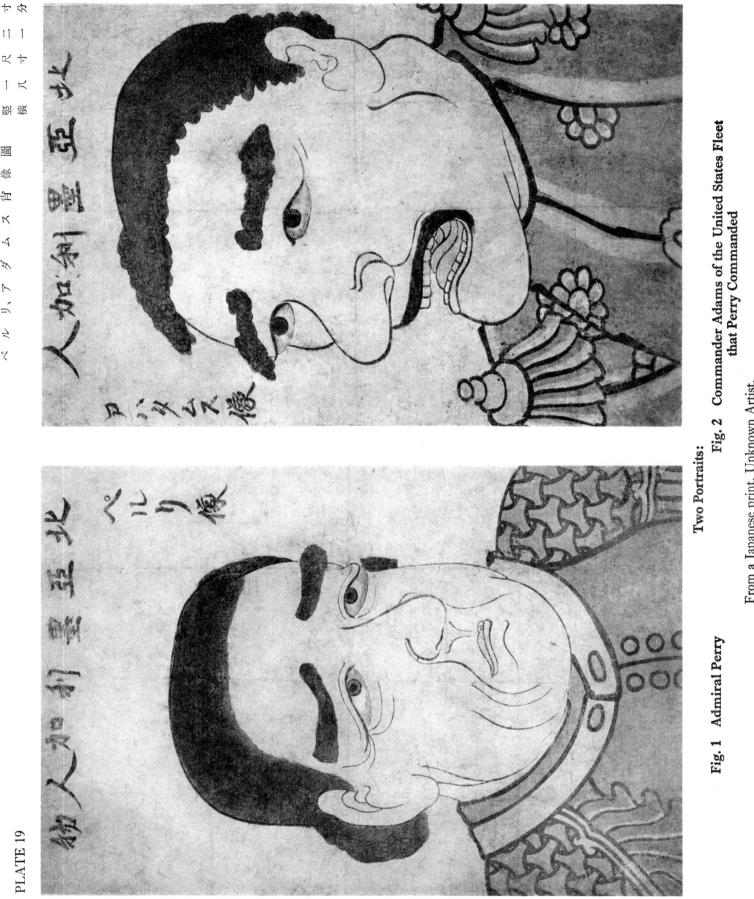

ペルリ、アダムス肖像圖　縦　一尺二寸
　　　　　　　　　　　横　八寸一分

Two Portraits:

Fig. 1　Admiral Perry

Fig. 2　Commander Adams of the United States Fleet
that Perry Commanded

From a Japanese print. Unknown Artist.
Height 36 cm. Width 24.5 cm.

PLATE 20

An Elephant

From the Niju-Shink: Twenty-four examples of Filial Piety, by Yamaguchi Shigeharu. Twenty-four double-page colour-plates. Height 26 cm. Width 39 cm.

PLATE 21

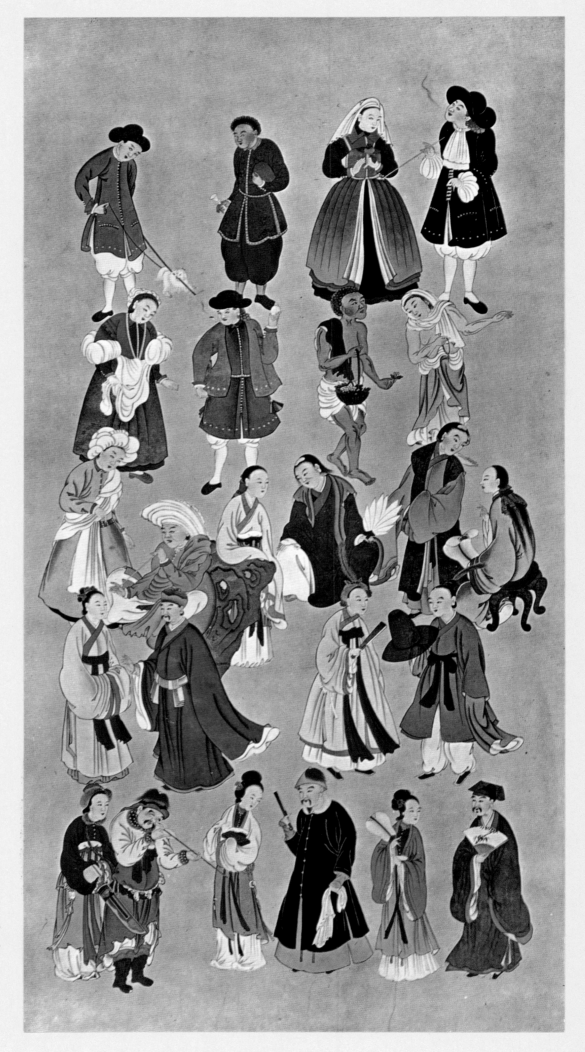

異
國
人
物
之
圖
掛
物

筆
者
不
詳

豎
三
尺
六
寸

横
一
尺
八
寸
一
分

Various Types of Foreigners
Painting in colour on paper.
Unknown Artist.
Height 109 cm.
Width 55 cm.

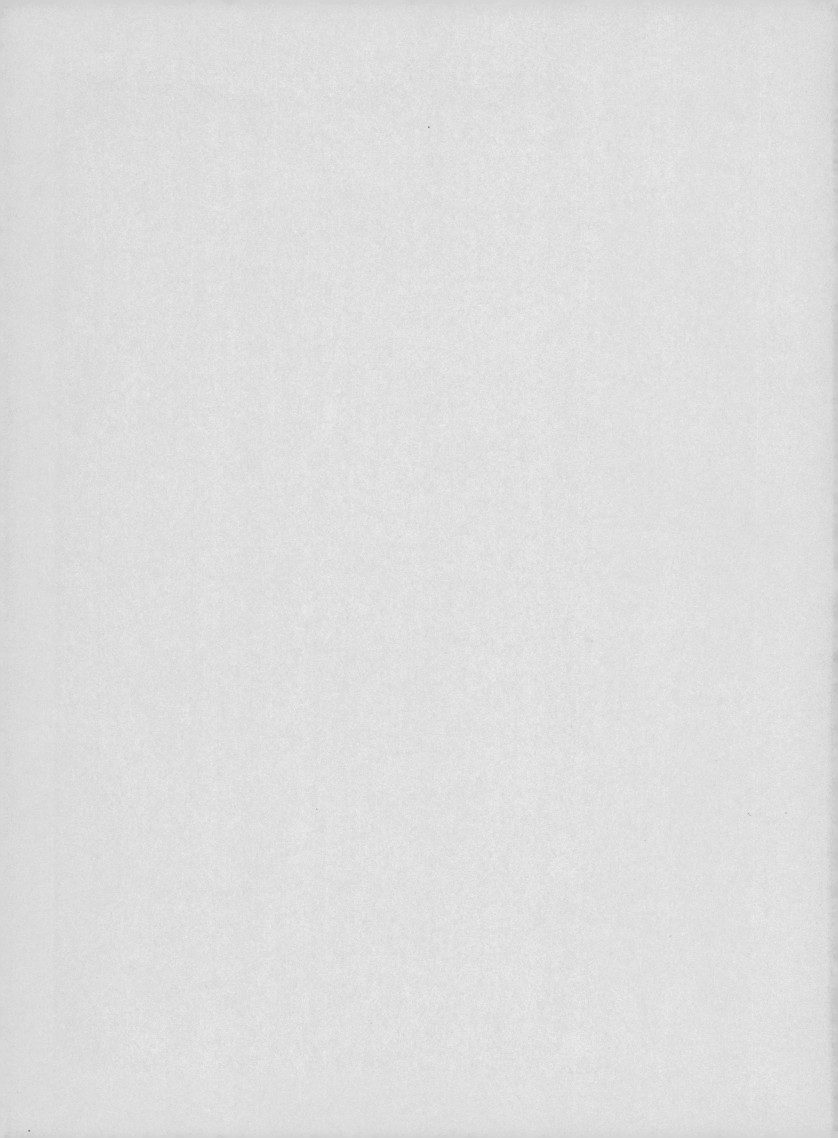

PLATE 22

朝 鮮 人 行 列 之 圖　竪 六 寸 三 分
横 一 尺 七 寸 五 分

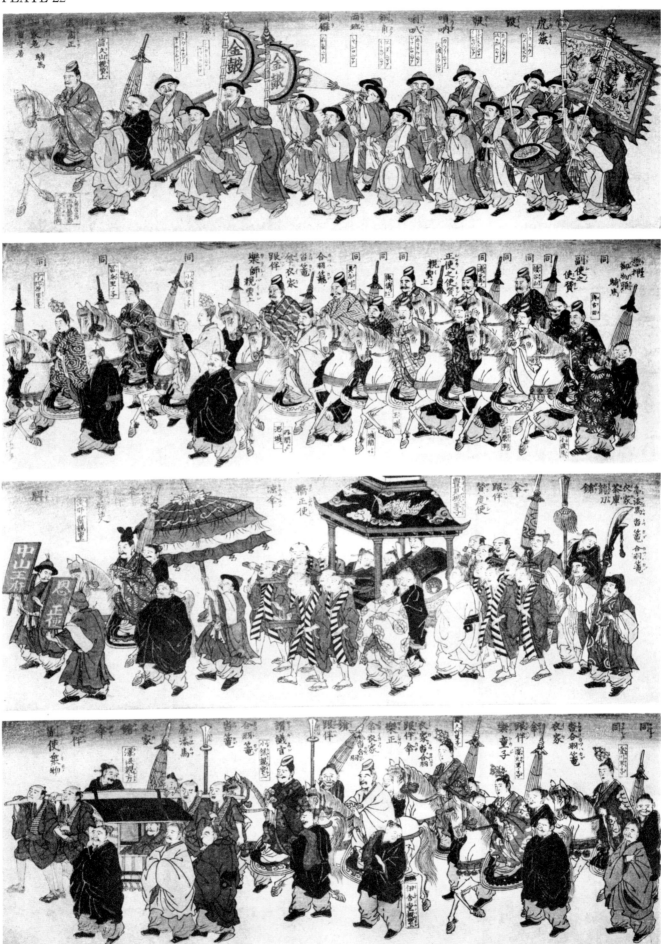

Korean Embassy to Japan
From a colour-print. Unknown Artist.
Each height 19 cm. Each width 53 cm.

PLATE 23

萬　國　總　圖
異　國　人　物　圖　正保板

堅四尺一寸九分
横一尺八寸五分

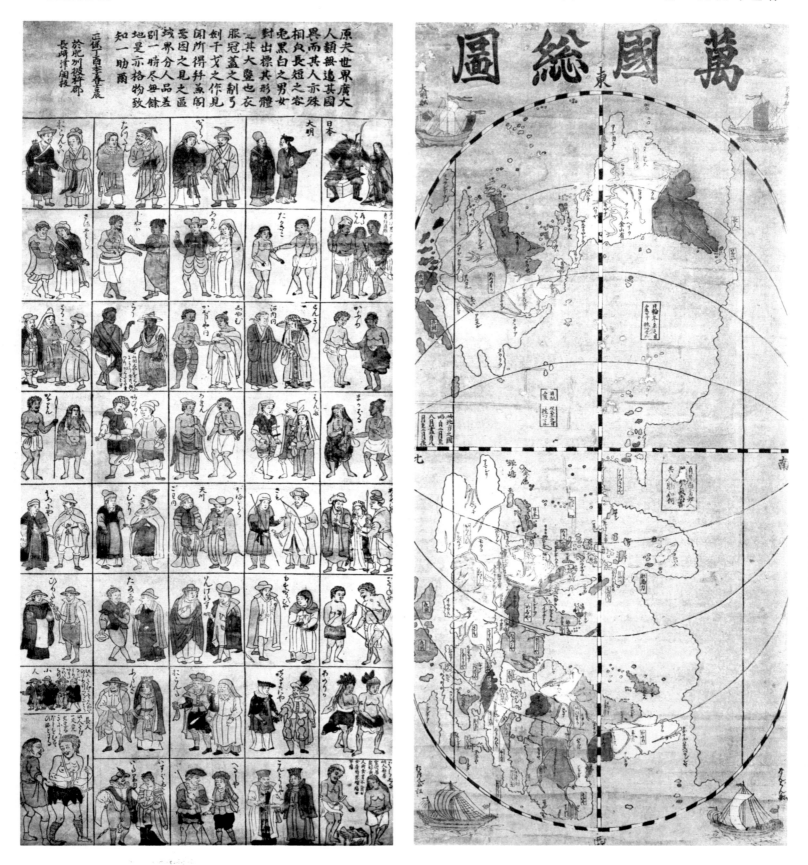

Fig. 1　Forty-two Types of Foreigners　　　　**Fig. 2　Shōhō Map of the World**
From an early hand-coloured Nagasaki colour-print.
Height 127 cm. Width 56 cm.

PLATE 24

Fig. 1 Various Types of Foreigners

Fig. 2 Shōhō World Map

This map is a reproduction of the Shōhō map on a smaller scale, printed on one sheet of paper and published by Hayashi of Kyoto in the 11th year of the Kwanbun era (1671).

From an early hand-coloured Nagasaki colour-print.

Height 40 cm. Width 56 cm.

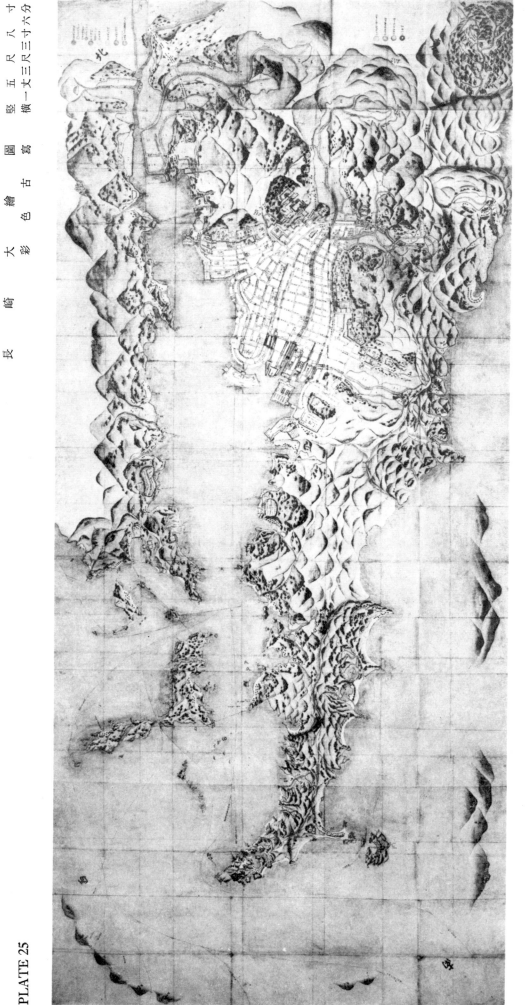

PLATE 25

長崎大彩色古圖鬘　竪五尺八寸
横一丈三尺三寸六分

Nagasaki O Edzu

Map of Nagasaki Harbour. Painting in colour on paper, *circa* 1646.

Height 178.5 cm. Width 405 cm.

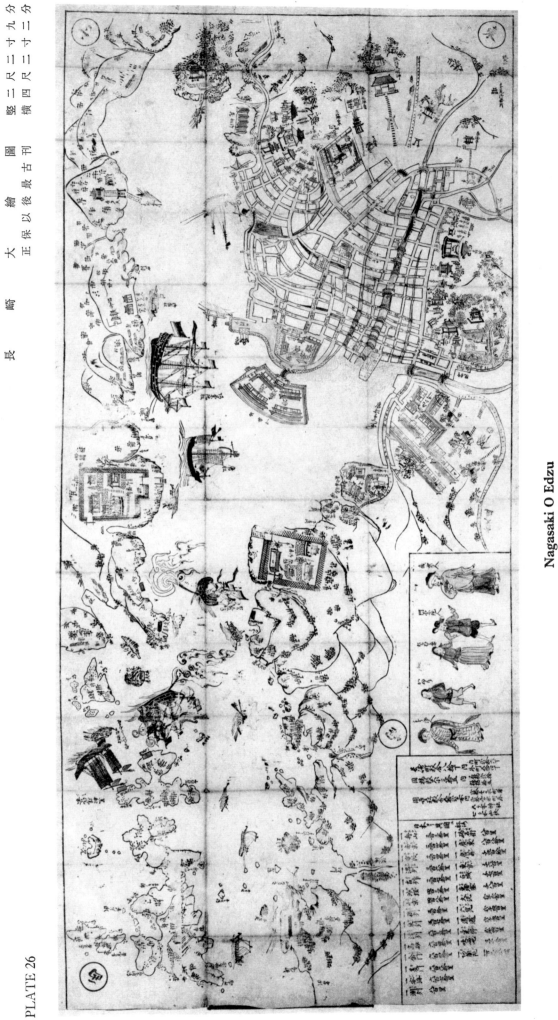

長　崎　大　絵　圖　刊古最後以保正

竪二尺二寸九分　横四尺二寸三分

PLATE 26

Nagasaki O Edzu

Woodcut of Nagasaki Harbour. This is considered to be the oldest map of Nagasaki after the Shōhō World Map.
Height 69.5 cm. Width 128 cm.

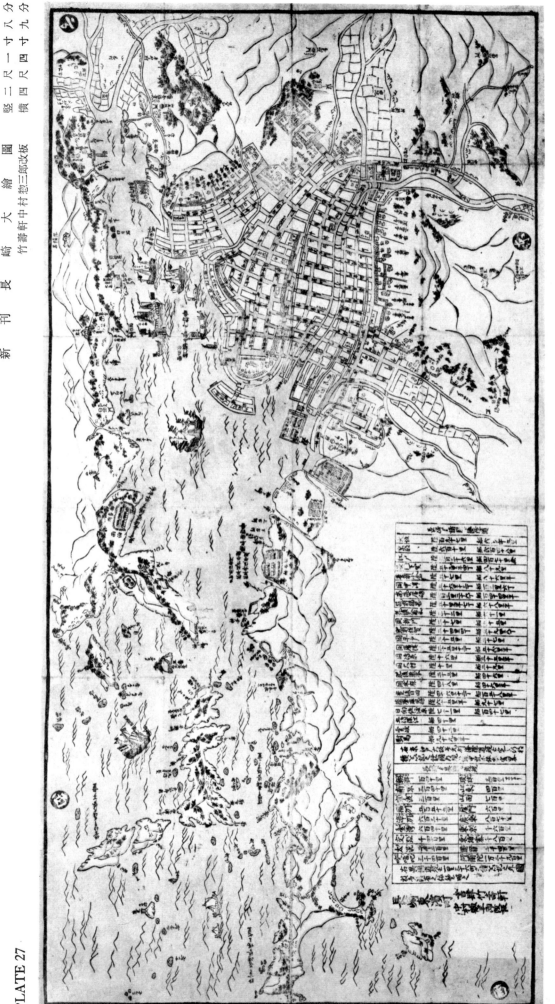

PLATE 27

Shinkan Nagasaki O Edzu

Woodcut of Nagasaki Harbour published by Chikujuken Nakamura Sozaburo Kaihan.
Height 66.2 cm. Width 136 cm.

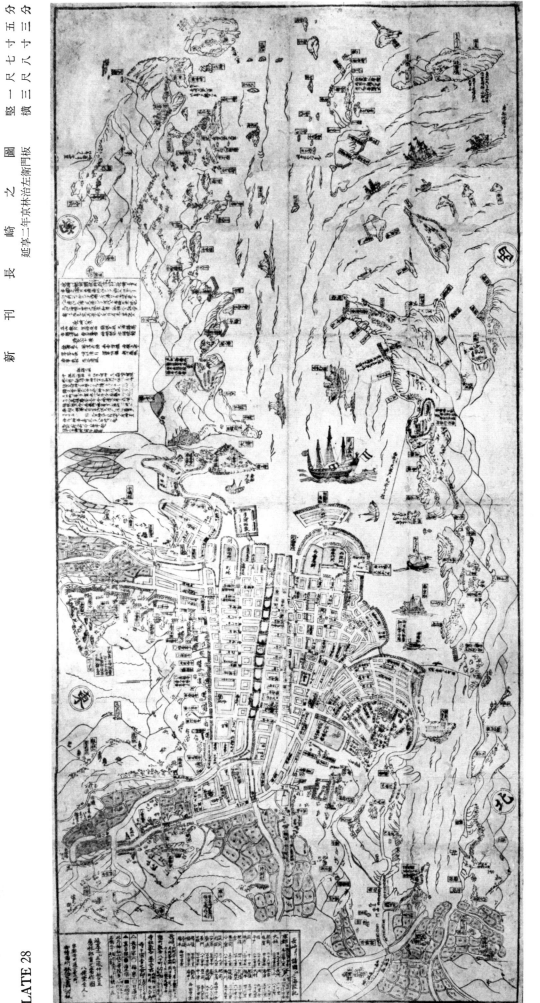
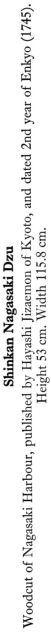

PLATE 28

新刊　長　崎　之　圖　　竪一尺七寸五分
延享二年京林治左衞門板　　横三尺八寸三分

Shinkan Nagasaki Dzu

Woodcut of Nagasaki Harbour, published by Hayashi Jizaemon of Kyoto, and dated 2nd year of Enkyo (1745).
Height 53 cm. Width 115.8 cm.

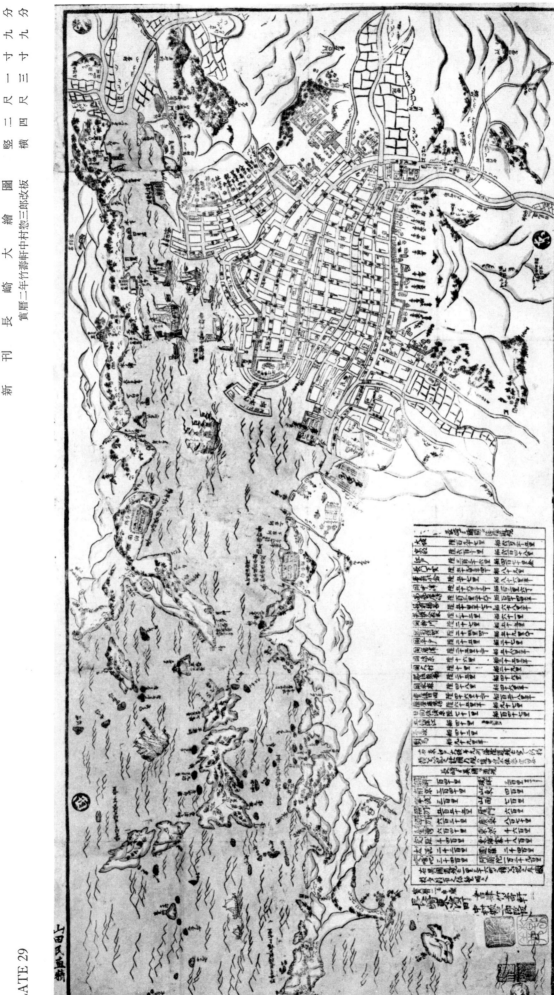

PLATE 29

新刊　長崎　大　繪　圖

寶曆二年竹壽軒中村惣三郎改板

竪　三　尺　一　寸　九　分
横　四　尺　三　寸　九　分

Shinkan Nagasaki O Edzu Kaihan

Woodcut of Nagasaki Harbour, published by Chikujuken Nakamura Sozaburo Kaihan, and dated 2nd year of Horeki (1752).

Height 66.5 cm. Width 133 cm.

PLATE 30

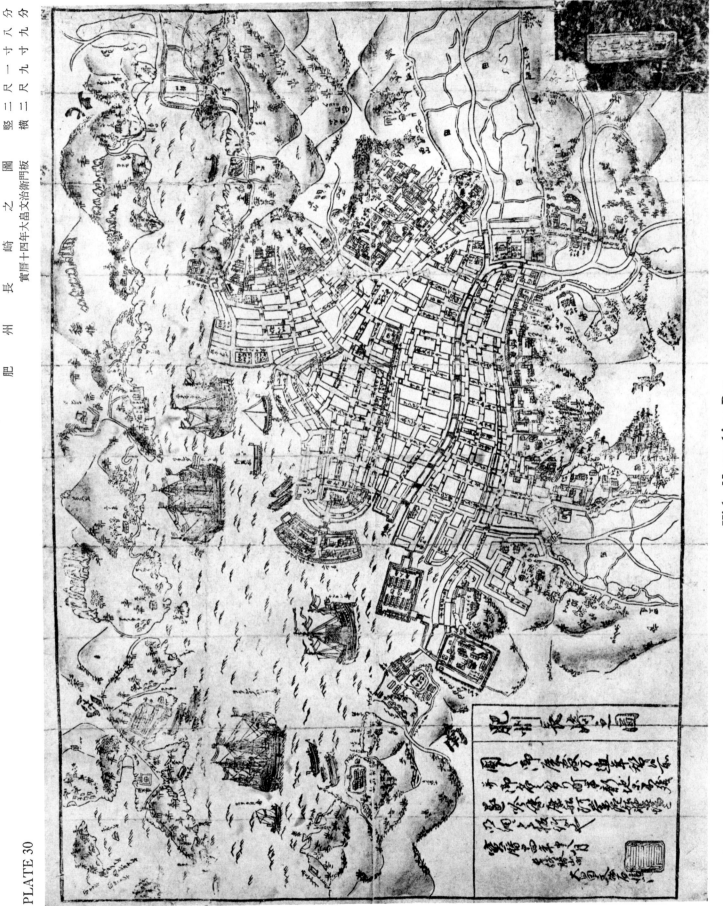

肥　州　　長　崎　　之　　圖　　竪三尺一寸八分
　　　　　　　　　　　　　橫三尺九寸九分
　　　　寳曆十四年大畠文治衛門板

Hishu Nagasaki no Dzu

Woodcut of Nagasaki Harbour, published by Obatake Bunjiemon, dated the 14th year of Horeki (1764).
Height 66.3 cm. Width 90.5 cm.

PLATE 31

肥　州　　長　崎　圖　　竪三尺一寸八分
　　　　　安永七年大畠文治兵衛板　　横三尺九寸九分

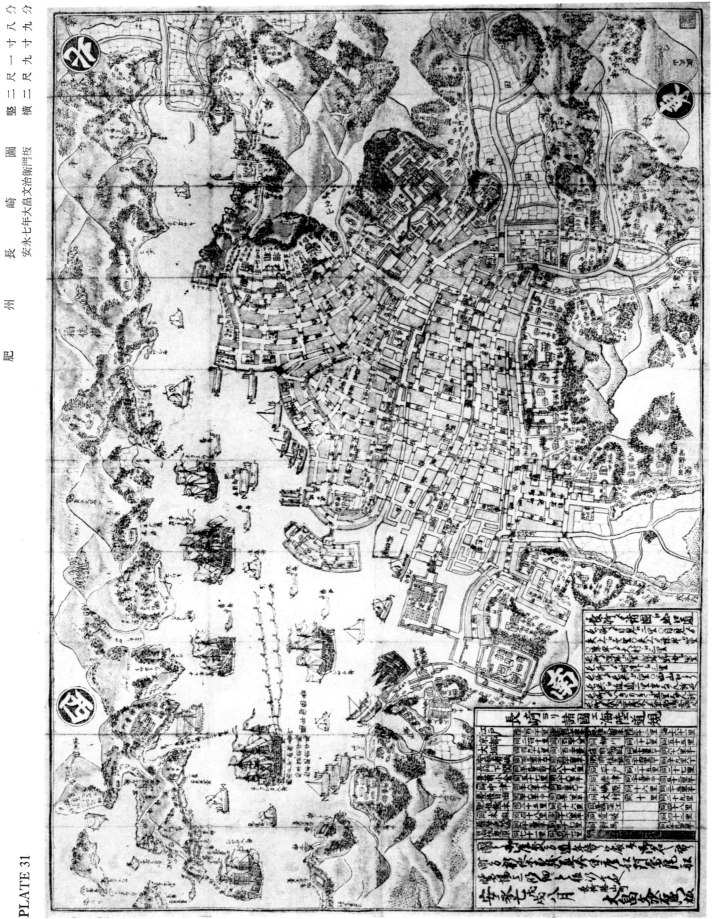

Hishu Nagasaki Dzu

Woodcut of Nagasaki Harbour, published by Obatake Bunjiemon, dated the 7th year of An-yei (1778).
Height 66.3 cm. Width 90.5 cm.

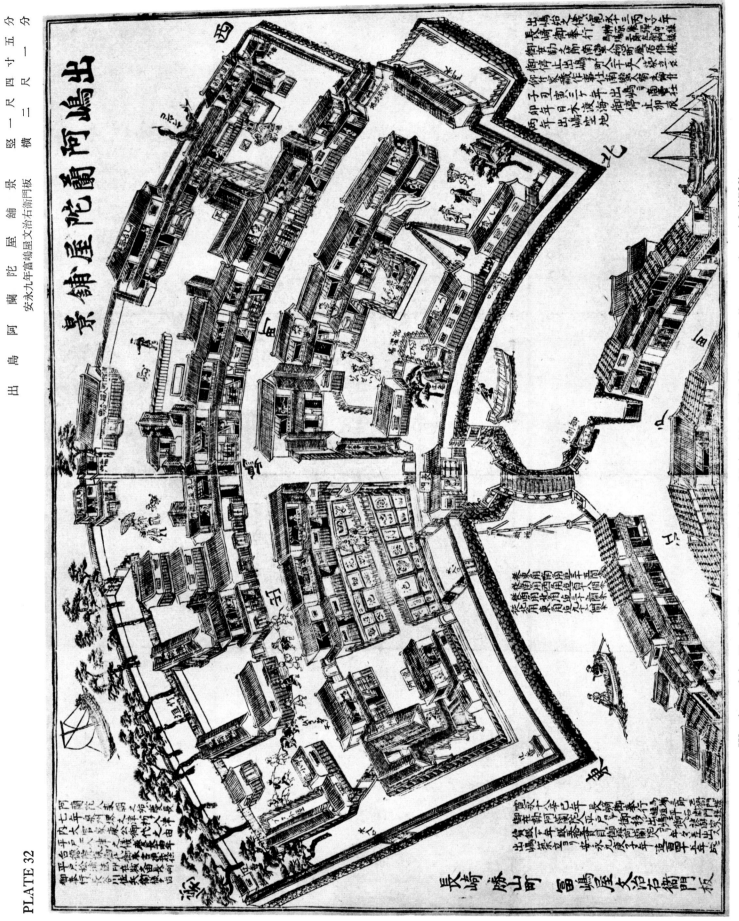

出島阿蘭陀屋舗景

安永九年富嶋屋文治右衛門板

PLATE 32

Woodcut of the Dutch Settlement at Deshima, Nagasaki, by Toshimaya Bunjiuemon, An-yei 9 (1780). Height 44 cm. Width 61 cm.

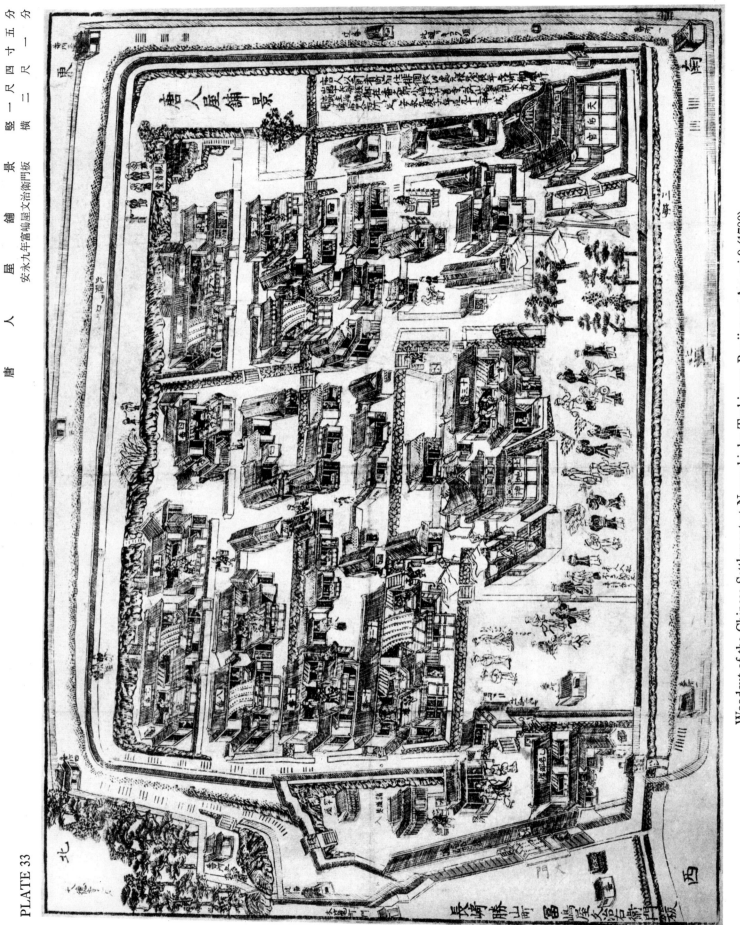

PLATE 33

唐 人 屋 舗 景

唐人屋舗景　安永九年富嶋屋文治衛門板

堅一尺四寸五分　横二尺一分

Woodcut of the Chinese Settlement at Nagasaki, by Toshimaya Bunjiemon An-yei 9 (1780). Height 44 cm. Width 61 cm.

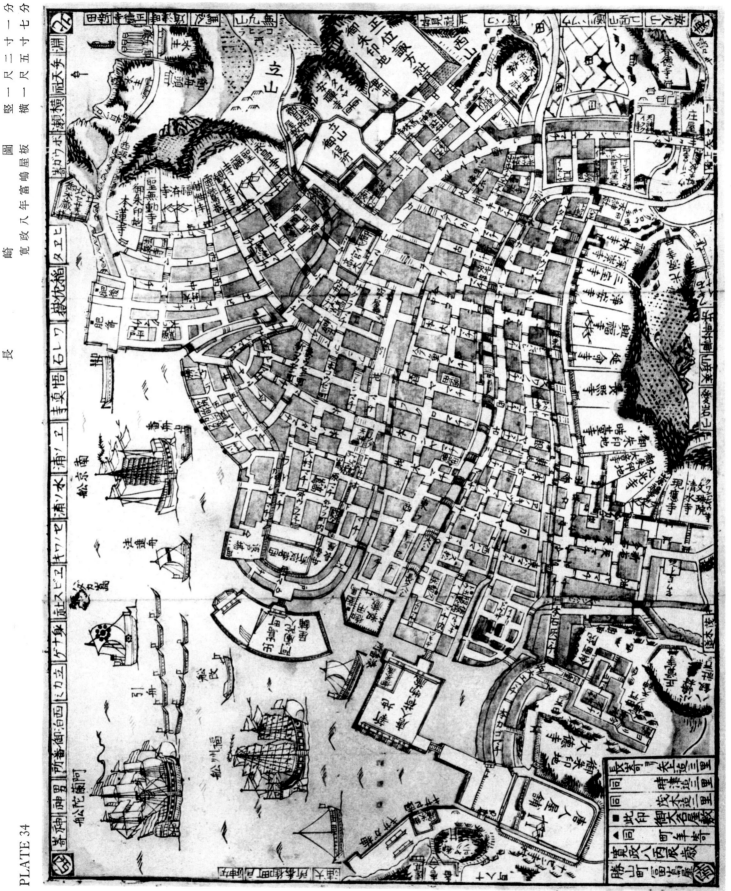

PLATE 34

Woodcut of Nagasaki Harbour, published by Toshimaya, and dated Kwansei 8 (1796).
Height 36.6 cm. Width 47.5 cm.

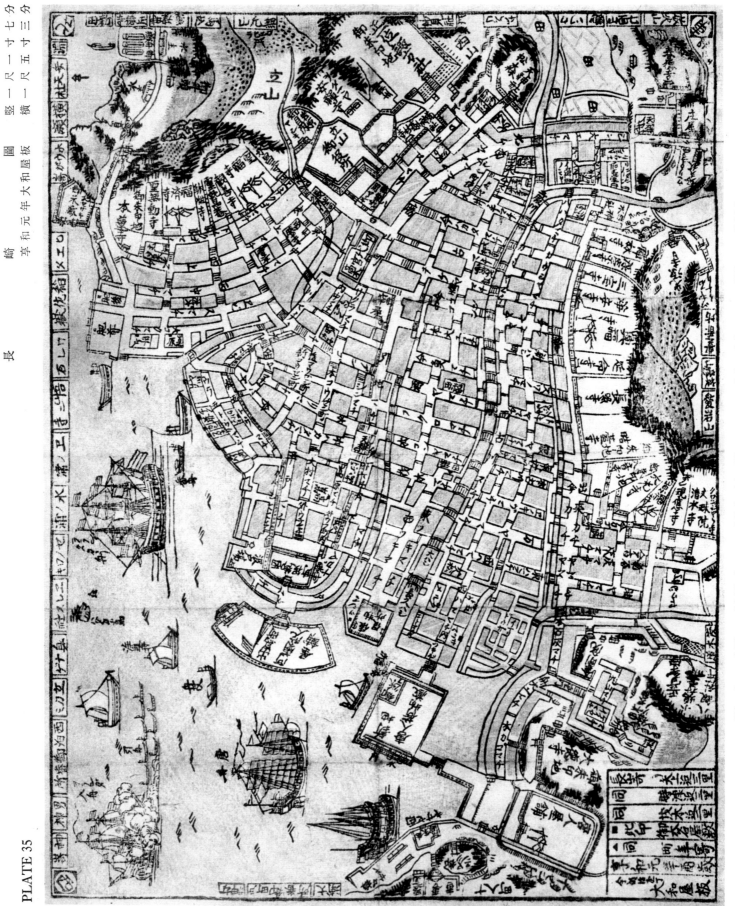

PLATE 35

Woodcut of Nagasaki Harbour, published by Yamatoya, and dated 1st year of Kyowa (1801).
Height 35.5 cm. Width 46.5 cm.

PLATE 36

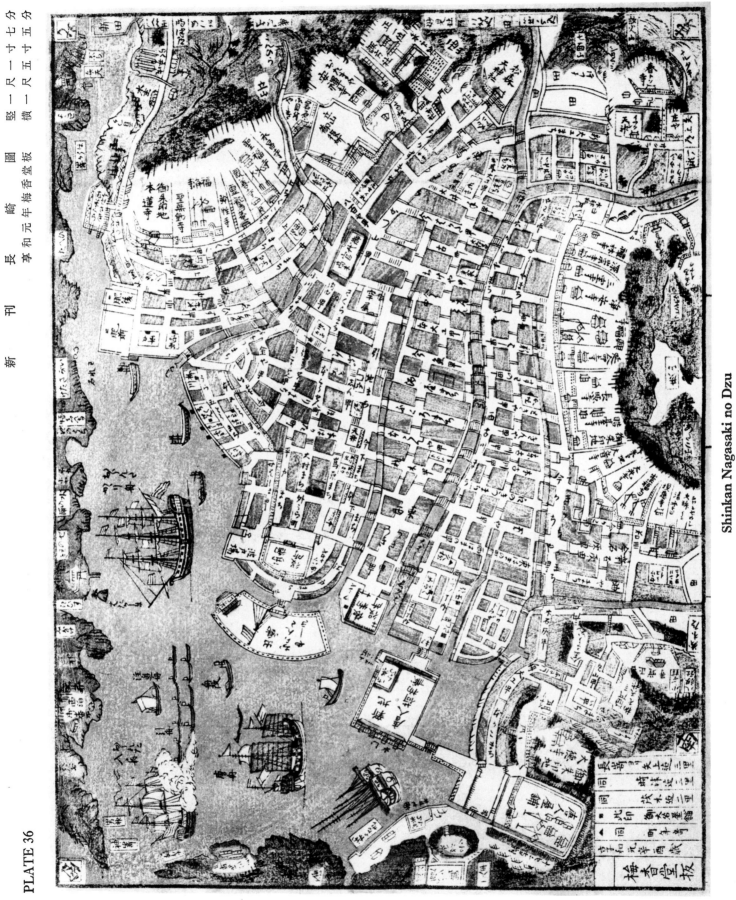

Shinkan Nagasaki no Dzu

Woodcut of Nagasaki Harbour, published by Baikodo, and dated 1st year of Kyowa (1801). Height 35.3 cm. Width 47 cm.

PLATE 37

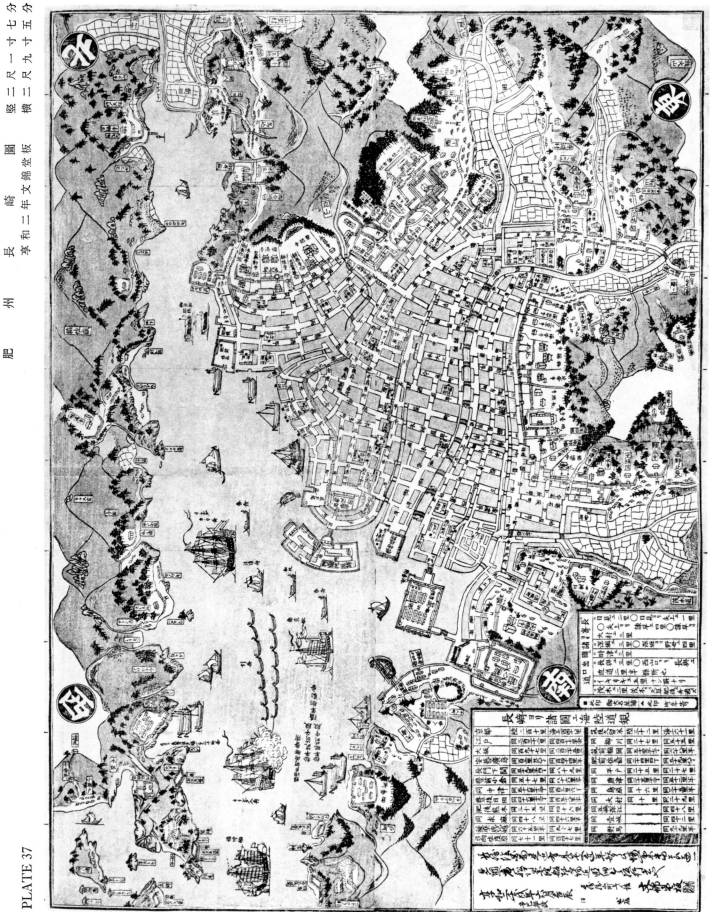

Hishu Nagasaki Dzu

Woodcut of Nagasaki Harbour, published by Bunkindo, and dated 2nd year of Kyowa (1802).

Height 65.7 cm. Width 89.5 cm.

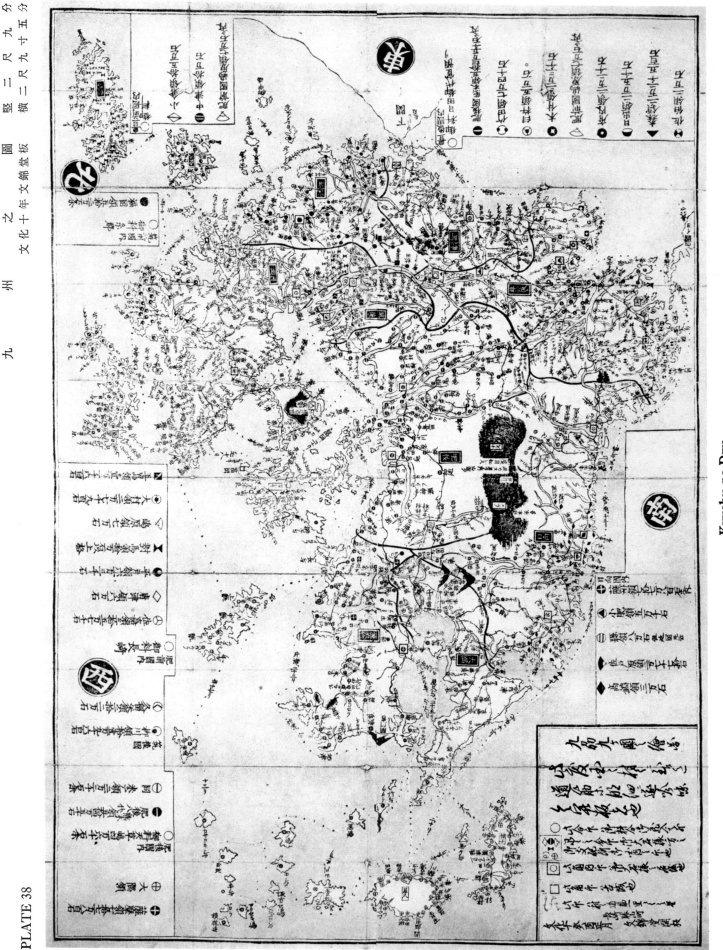

PLATE 38

Kyushu no Dzu

Map of Kyushu, published by Bunkindo, and dated 10th year of Bunkwa (1813).
Height 63.5 cm. Width 89.3 cm.

PLATE 39

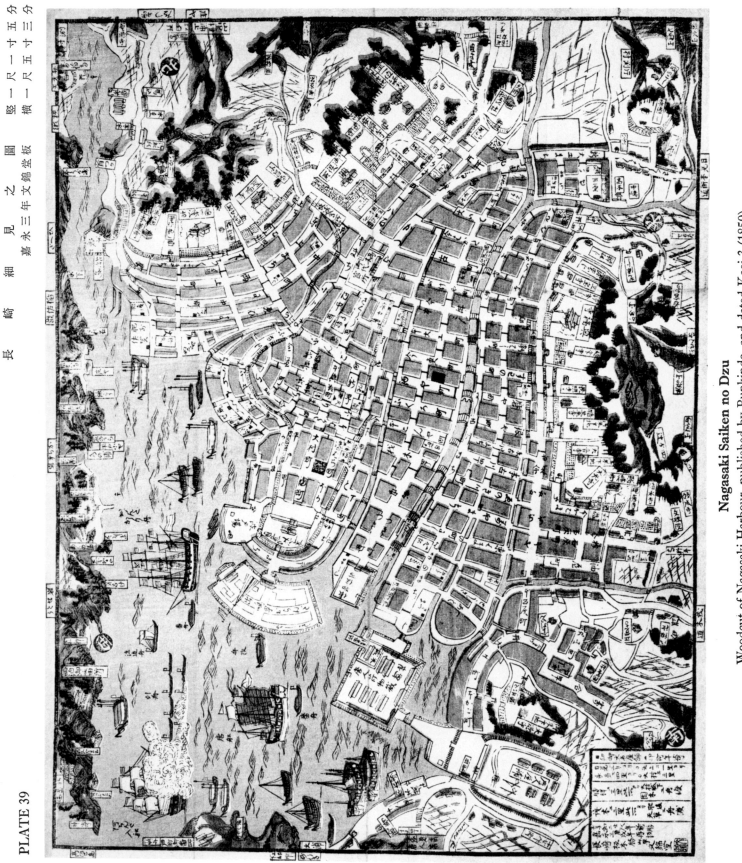

長崎細見見之圖　嘉永三年文錦堂板

堅一尺一寸五分
横一尺五寸三分

Nagasaki Saiken no Dzu

Woodcut of Nagasaki Harbour, published by Bunkindo, and dated Kaei 3 (1850).
Height 35 cm. Width 46.5 cm.

PLATE 40

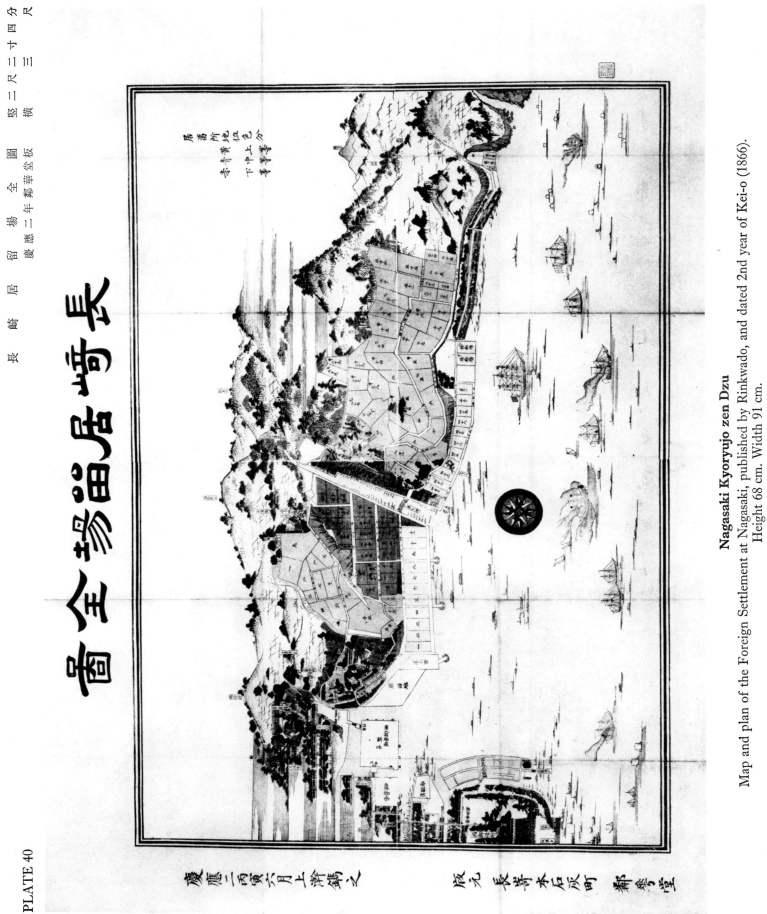

Nagasaki Kyoryujo zen Dzu

Map and plan of the Foreign Settlement at Nagasaki, published by Rinkwado, and dated 2nd year of Kei-o (1866).
Height 68 cm. Width 91 cm.

PLATE 41

Hizen Nagasaki no Dzu
Woodcut of the Port of Nagasaki, published by Kojudo.
Height 45.5 cm. Width 68 cm.

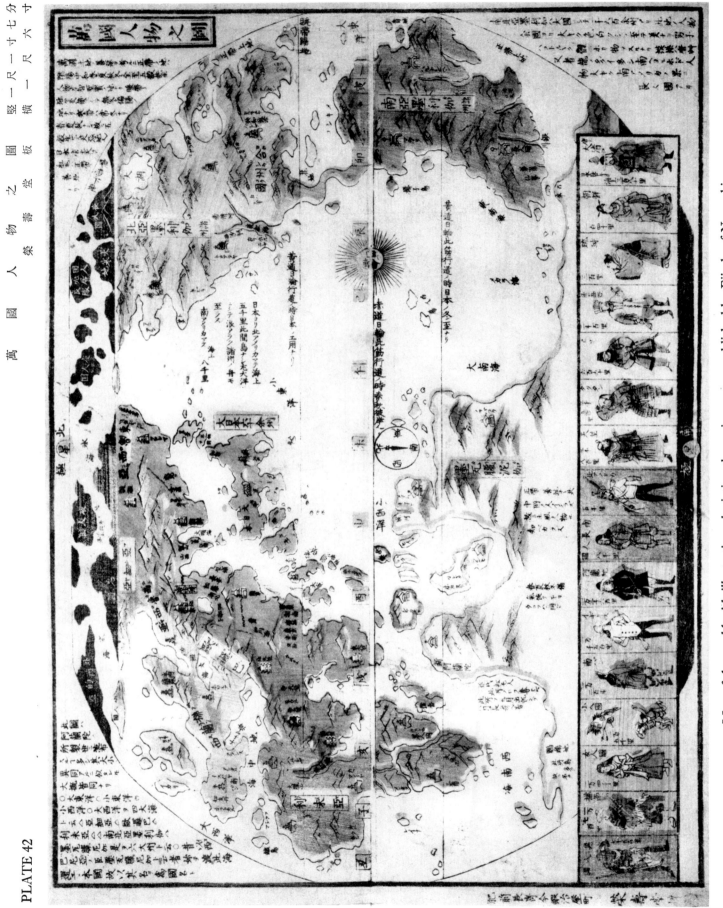

PLATE 42

Map of the world with illustrations depicting the various races, published by Eijudo of Nagasaki.
Height 35.7 cm. Width 48.5 cm.

PLATE 43

阿蘭陀女人之圖　竪一尺四寸六分
横　六　尺　一　分

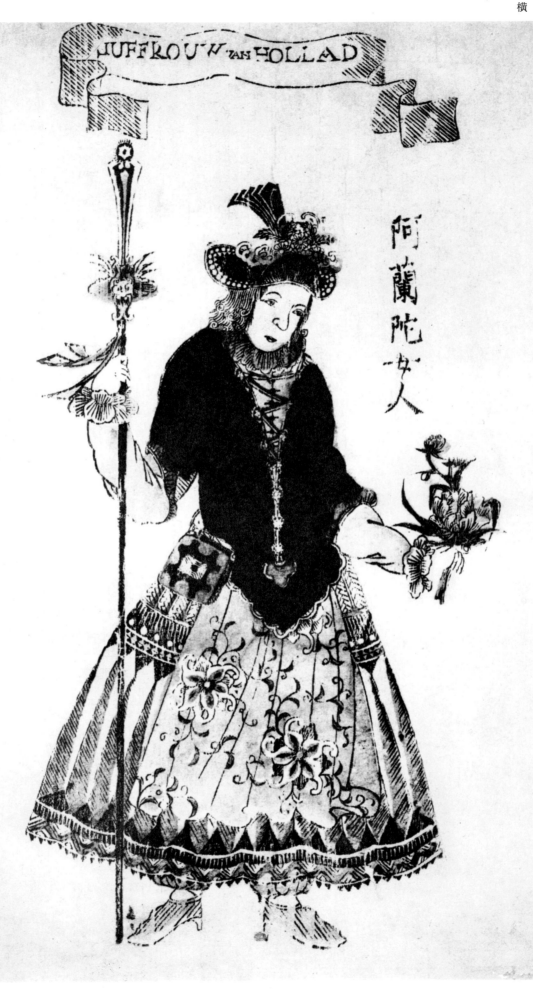

Picture of Juffrouw Van Hollad
From an early hand-coloured Nagasaki colour-print.
Height 44.2 cm. Width 32.2 cm.

PLATE 44

阿蘭陀人東入圖　堅一尺五寸
（かびたん）　横一尺六寸

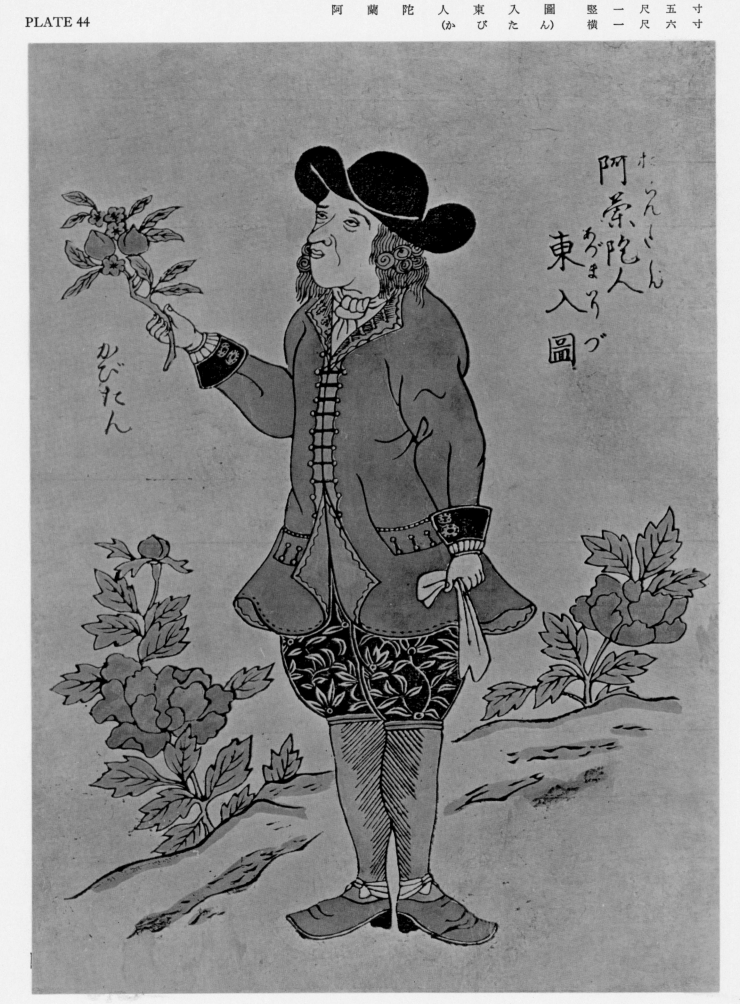

Picture of a Hollander *(Hollander Jin)*
From an early hand-coloured Nagasaki colour-print.
Height 45.5 cm. Width 32 cm.

PLATE 45

南 京 人 之 圖　堅一尺五寸七分
　　　　　　　横一尺九分

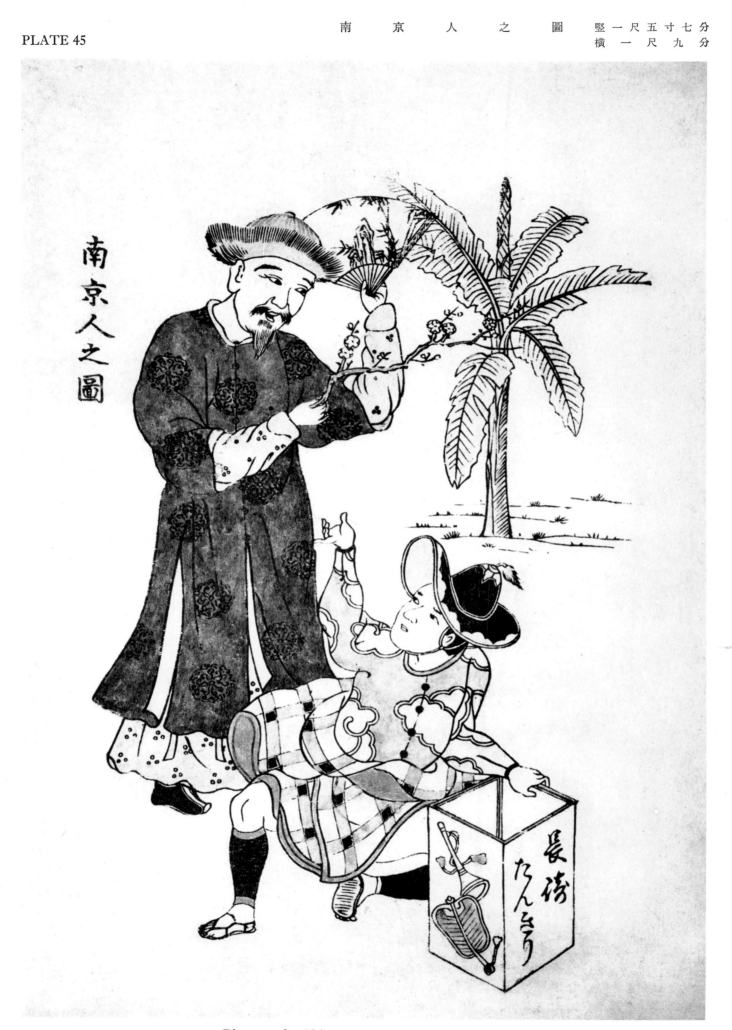

南
京
人
之
圖

Picture of a Chinese *(Nankin Jin no Dzu)*
From an early hand-coloured Nagasaki colour-print.
Height 47.5 cm. Width 33 cm.

PLATE 46

大　清　朝　人　圖　　竪一尺四寸七分
横　一　尺　八　分

Picture of a Chinese of the Manchu Dynasty *(Dai Shin Chō-jin no Dzu)*
From an early hand-coloured Nagasaki colour-print.
Height 44.7 cm. Width 32.7 cm.

横
一尺四寸九分

PLATE 49

唐 船 之 圖 竪 一尺 九 分
横 一尺 四 寸 三 分

Picture of a Chinese Ship (*To Sen no Dzu*)
From an early hand-coloured Nagasaki colour-print.
Height 33 cm. Width 43 cm.

PLATE 50

大清朝人之圖　　竪一尺四寸三分
　　　　　　　　横一尺三分

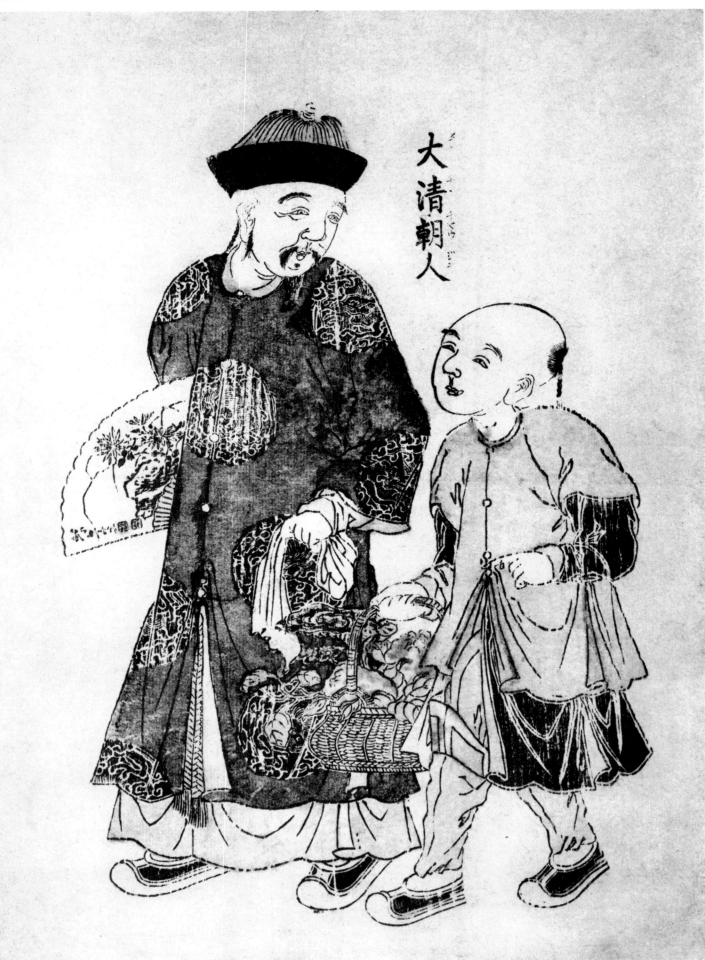

Picture of a Chinese of the Manchu Dynasty (*Tai Shin Cho Jin*)
From an early hand-coloured Nagasaki colour-print.
Height 43.5 cm. Width 31 cm.

PLATE 51

唐人圖，阿蘭陀人圖　　堅一尺四寸一分
　　　　　　　　　　横一尺四寸五分

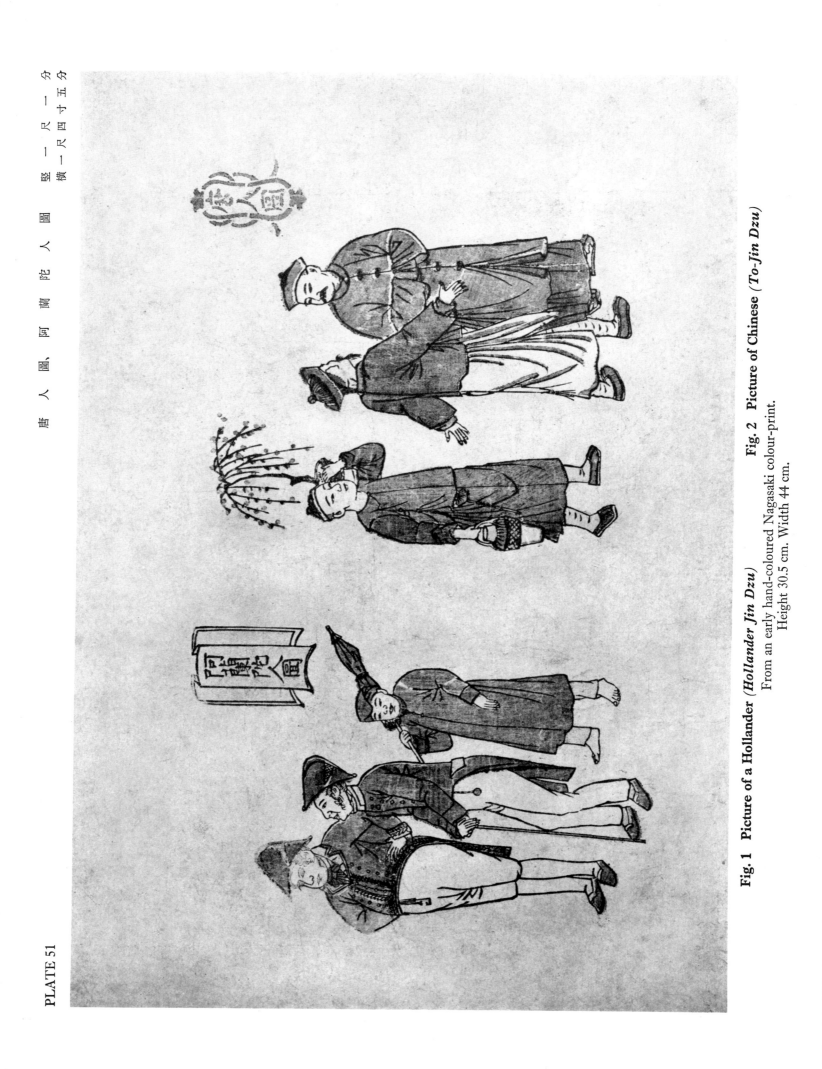

Fig. 1 Picture of a Hollander (*Hollander Jin Dzu*)　　**Fig. 2 Picture of Chinese** (*To-Jin Dzu*)

From an early hand-coloured Nagasaki colour-print.
Height 30.5 cm. Width 44 cm.

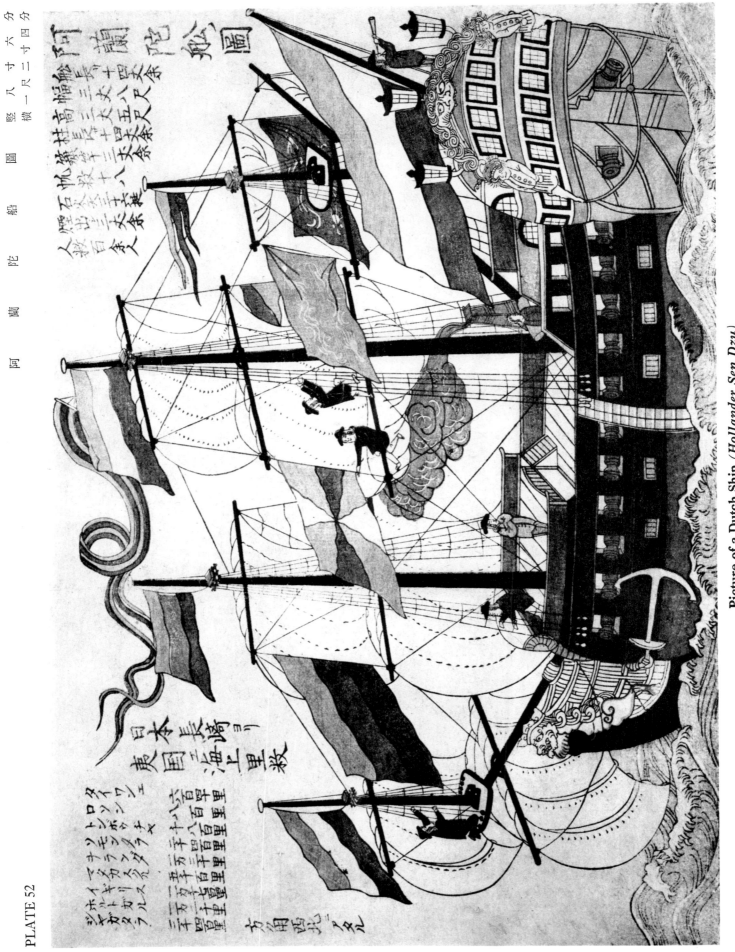

Picture of a Dutch Ship (*Hollander Sen Dzu*)
From an early hand-coloured Nagasaki colour-print.
Height 26 cm. Width 38 cm.

PLATE 52

PLATE 53

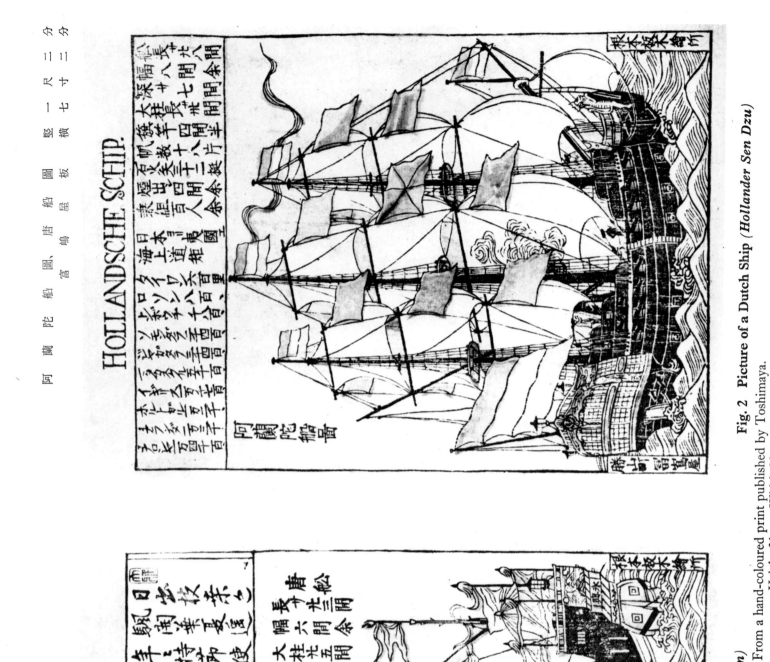

HOLLANDSCHE SCHIP.

Fig. 2 Picture of a Dutch Ship (*Hollander Sen Dzu*)
From a hand-coloured print published by Toshimaya.
Height 31 cm. Width 22 cm.

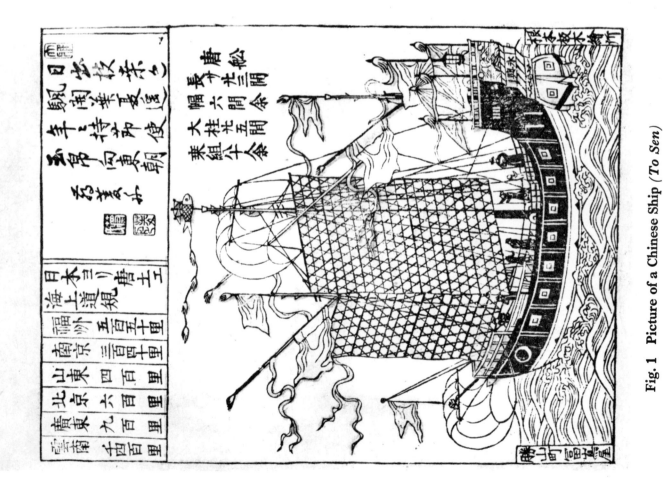

Fig. 1 Picture of a Chinese Ship (*To Sen*)

PLATE 54

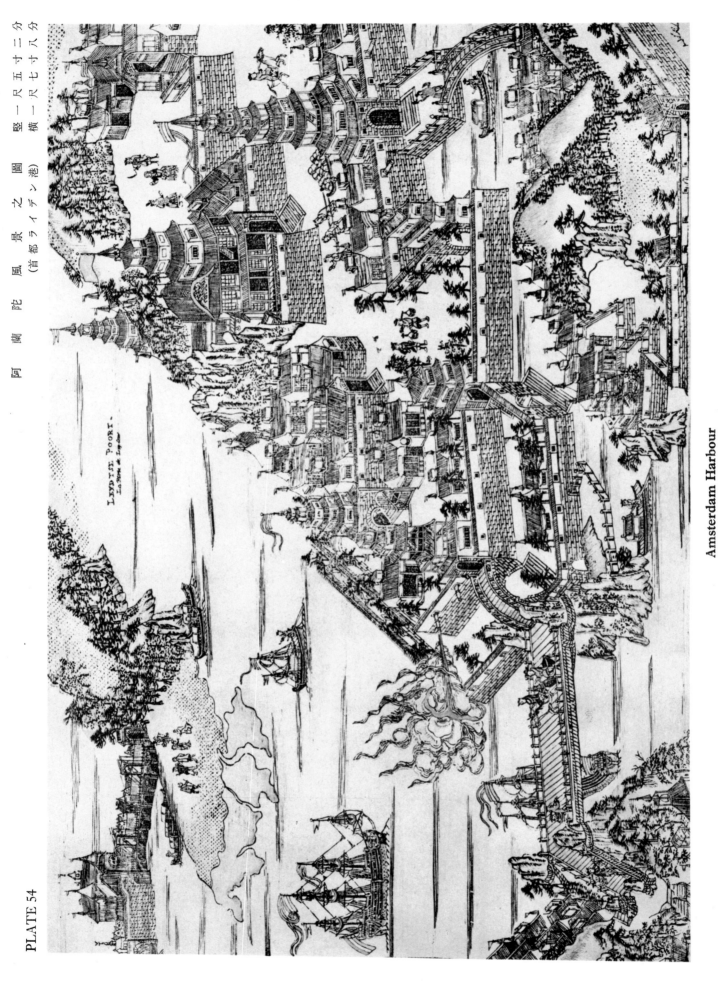

阿　蘭　陀　風　景　之　圖　　　竪一尺五寸二分

（首都ライデン港）　　横一尺七寸八分

LEYDZE POORT.
La Ville de Leydze.

Amsterdam Harbour

From an early Nagasaki colour-print. This is the *Leydtse poort*, and is the upper half of the print.
The lower half, which should show the *Muyder poort*, is missing.
Height 46 cm. Width 54 cm.

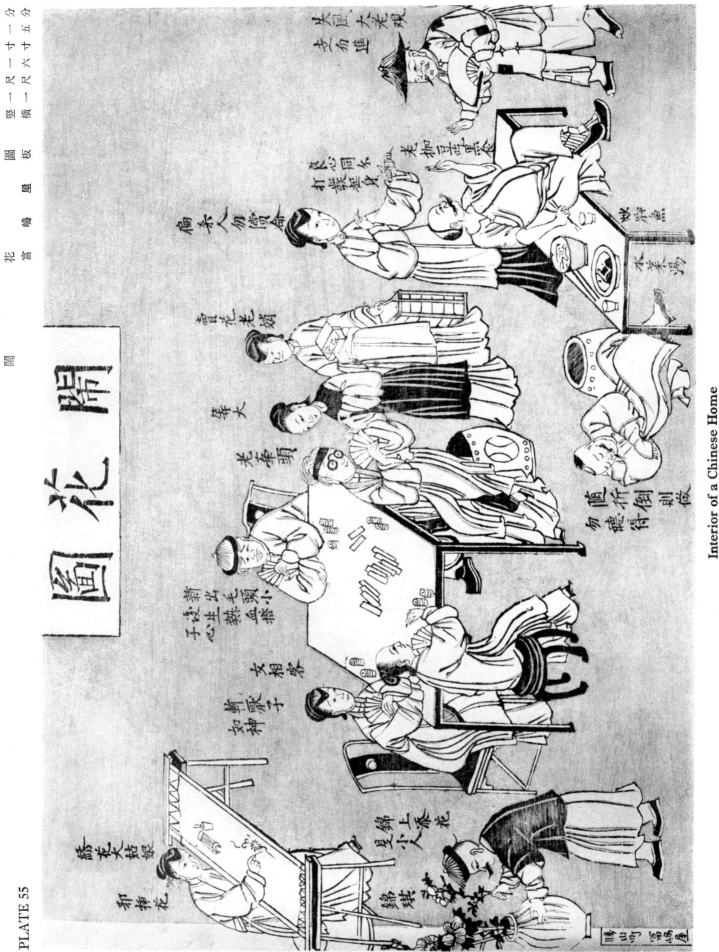

PLATE 55

Interior of a Chinese Home

From a colour-print in grey and black on a grey ground, published by Toshimaya.
Height 33.5 cm. Width 50 cm.

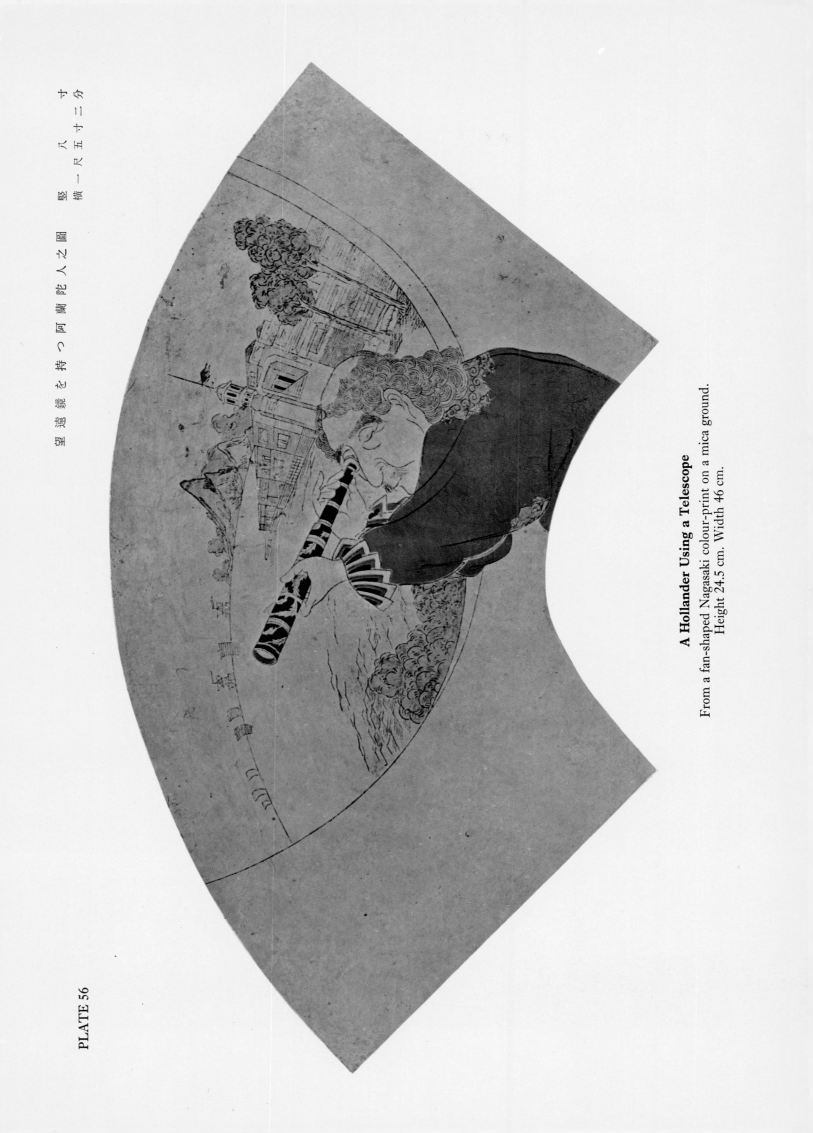

A Hollander Using a Telescope

From a fan-shaped Nagasaki colour-print on a mica ground.
Height 24.5 cm. Width 46 cm.

PLATE 56

PLATE 57

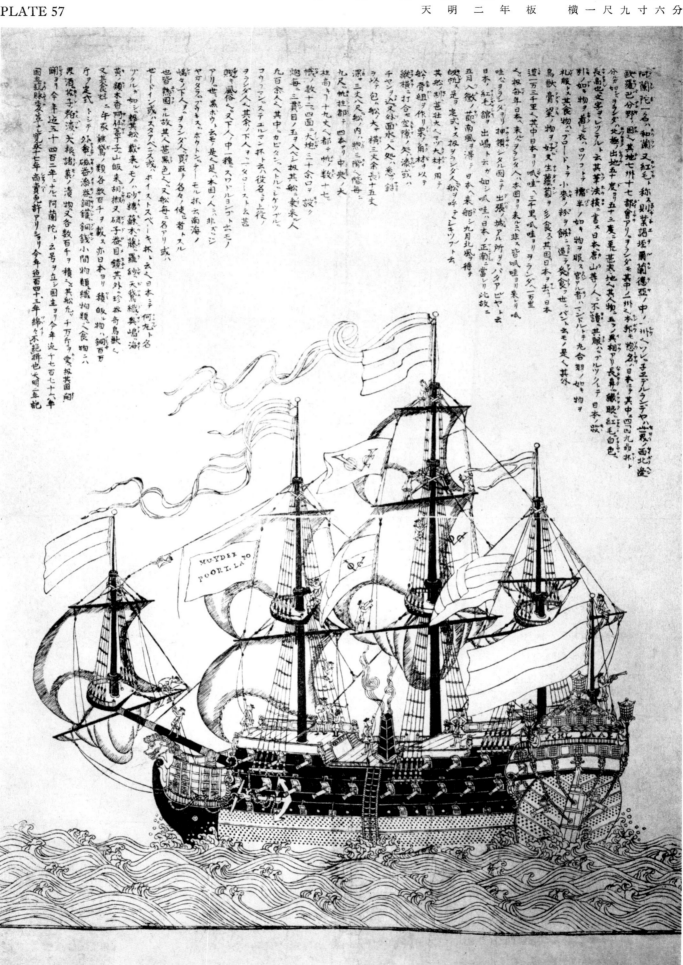

A Dutch East India Ship *(Tenmei period)*
From a black-and-white print by Rin Shihei.
Height 85 cm. Width 59.5 cm.

PLATE 58

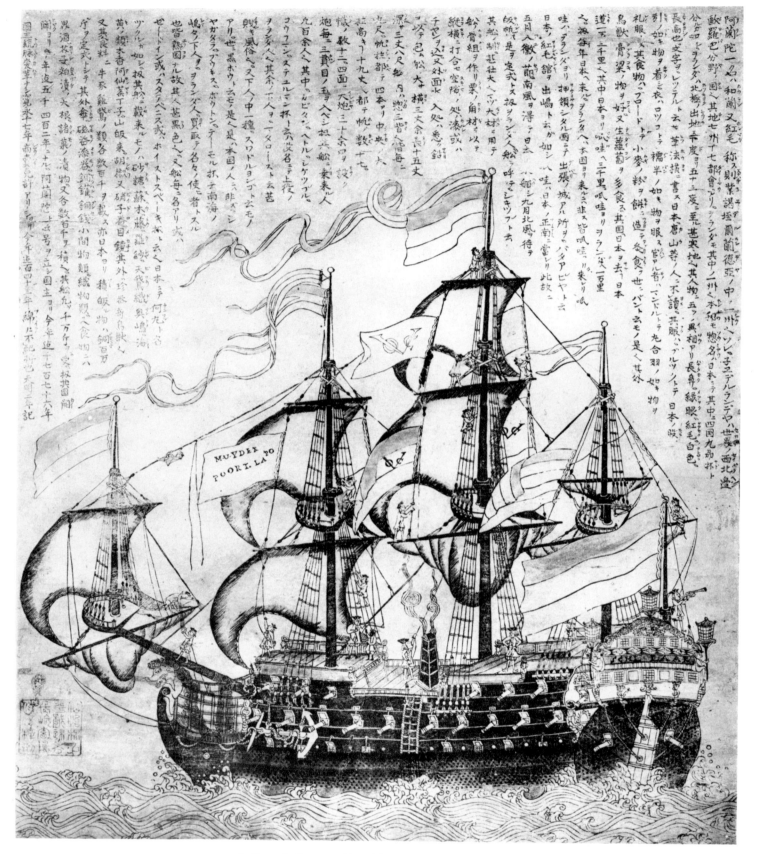

A Dutch East India Ship (*Tenmei period*)

From a hand-coloured print inscribed (Seal): Sendai Rin Shihei Kijutsusho Nagasaki Toshimaya Denkichi Shikoku, "Done for amusement by Rin Shihei of Sendai, and published by Toshimaya Denkichi of Nagasaki."

This print was published by Hayashi Shihei in order to obtain funds for the publication of the *Kaikoku Heidan*, a military work on coast defence. In his letter to Fujita Yūsuke, Rin Shihei writes as follows: "I have made a large print of a Dutch Ship, and I am sending you thirty copies of this print. I want three *momme* for a copy. It seems rather too dear, but it cannot be helped since they are published for soliciting contributions: I cannot ask people for money without giving them something in return."

Height 64 cm. Width 53.5 cm.

PLATE 59

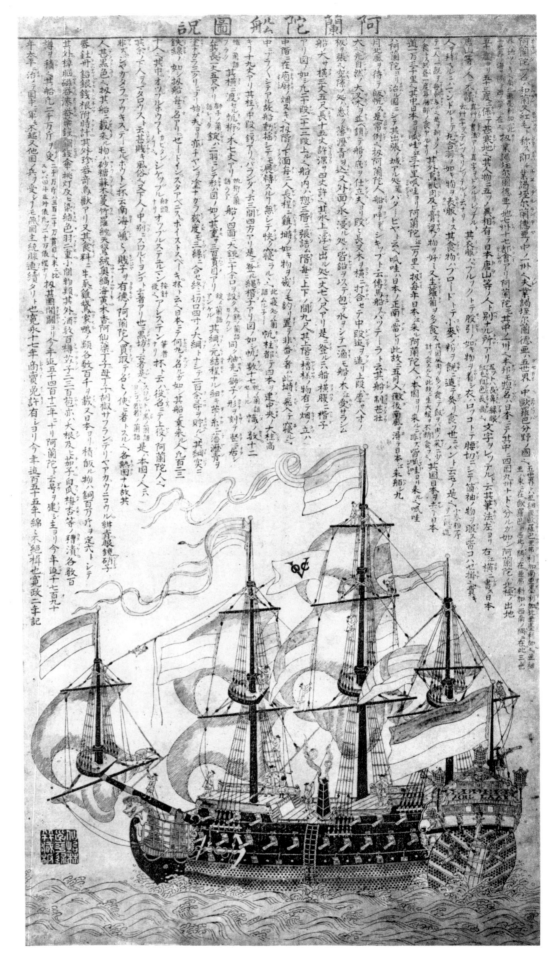

阿
蘭
陀
船
圖
説

寛
政
二
年
板

（林子平録併藏板）ノ印章有

竪
三
尺
三
寸

横
一
尺
七
寸
四
分

A Dutch East India Ship
(Kwansei period)

From a hand-coloured print inscribed (Seal): Sendai Rin Shihei Roku narabini zohan, "Done by Rin Shihei, Sendai, who owns the copyright."

Height 100 cm. Width 54 cm.

The difference between the Tenmei period print and the Kwansei 2 (1790) period may be noted as follows:

(1) The Tenmei edition is printed on four sheets of *hanshi* (paper) joined together, while the Kwansei edition is printed on one large sheet of *Tōshi* (Chinese paper).

(2) The Kwansei edition bears six large Chinese characters at the top of the print reading as follows: Oranda Sen Dzu-Setsu, "Picture and explanation of a Dutch Ship," while the Tenmei edition lacks these large Chinese characters. The lines of the waves are different in the two editions.

(3) The colouring of both editions is done by hand, but the colours used are not the same. For example, the tricolour flag flying from the main mast in the Tenmei edition shows blue, white and white, but in the Kwansei edition it is red, white, and pale blue. The colour of the East India Company's flag also differs in these two editions: in the Tenmei edition it is yellow, while the Kwansei edition uses a light shade of red. Again, the colouring of the figures of the crew differs in the two editions.

PLATE 60

阿 蘭 陀 人 宴 會 圖　堅 九 寸 三 分
　　　　　　　　横 一 尺 三 寸 五 分

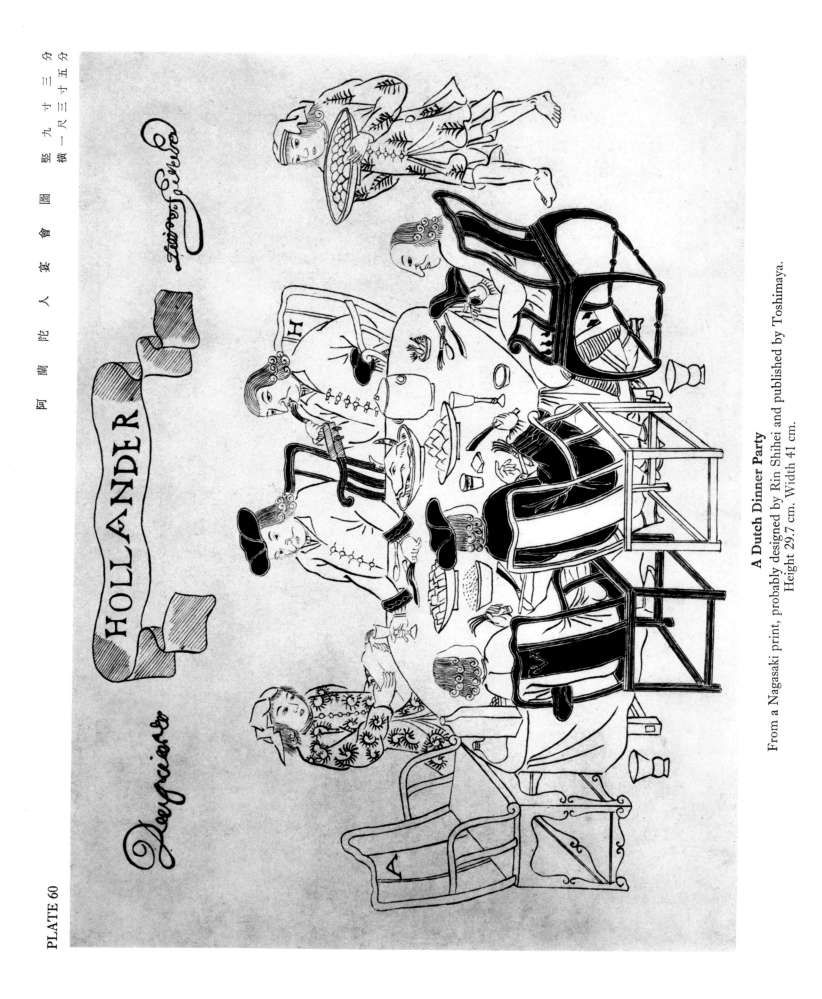

A Dutch Dinner Party

From a Nagasaki print, probably designed by Rin Shihei and published by Toshimaya.
Height 29.7 cm. Width 41 cm.

PLATE 61

阿　蘭　陀　船　之　圖　　竪一尺一寸四分
　　　　　　　　　　　　横一尺一分

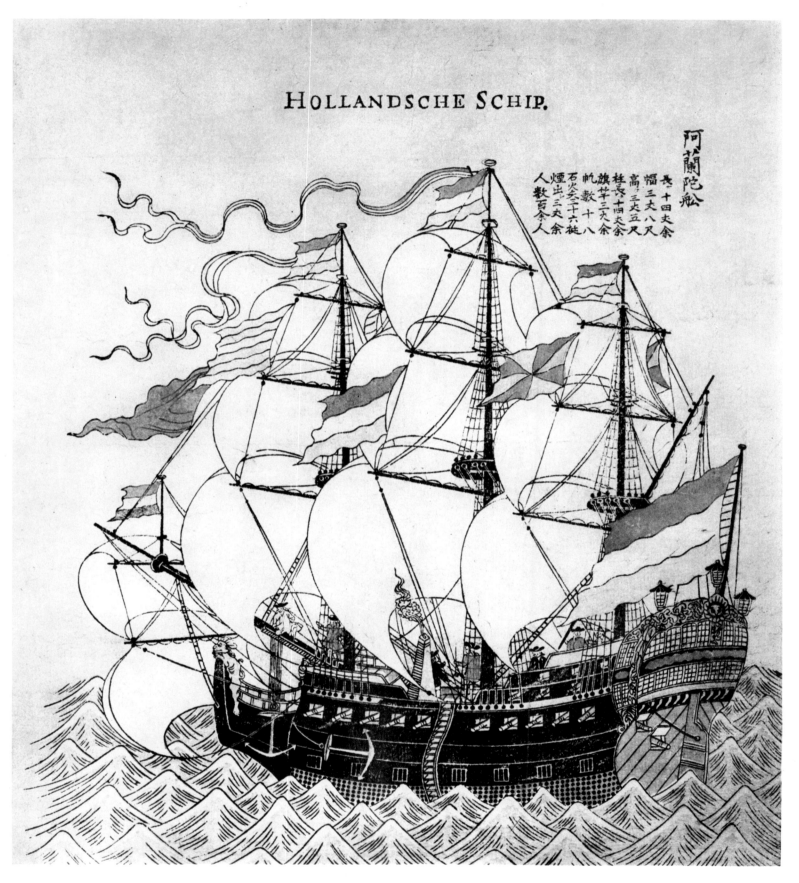

HOLLANDSCHE SCHIP.

A Dutch Ship *(Hollander Sen)*
From a Nagasaki colour-print. Printed on Chinese *toshi* paper.
Height 34.5 cm. Width 30.5 cm.

PLATE 62

唐　船　之　圖　　

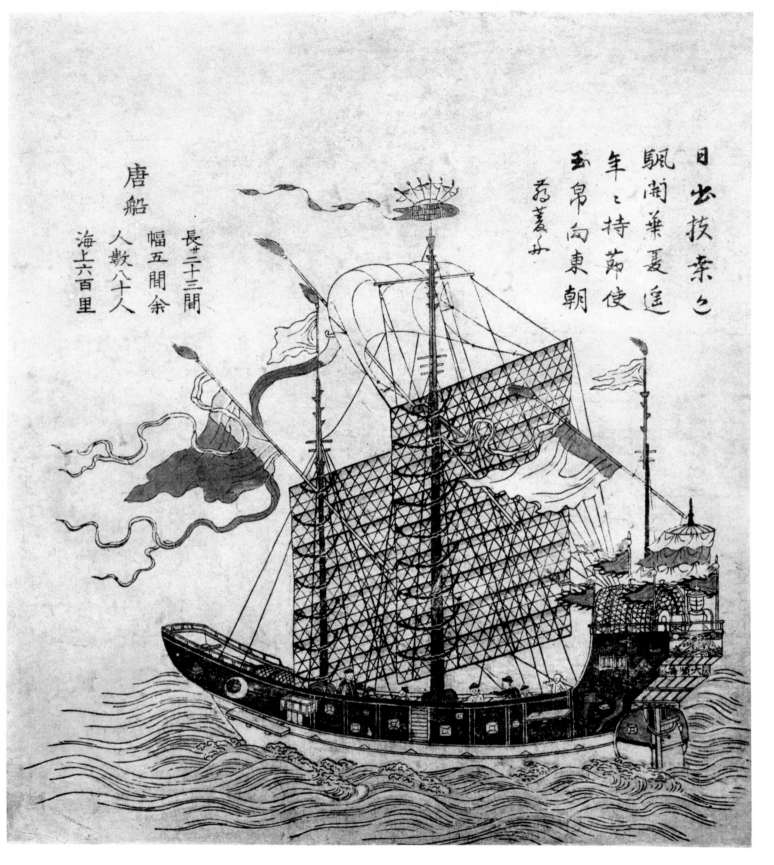

日出技奈之
駃鬪藥叓遙
年ゝ持節使
玉帛向東朝
蒞菱﨑

唐船
人數八十人
幅五間余
長廿三間
海上六百里

A Chinese Ship
From a Nagasaki colour-print, printed on Chinese *toshi* paper.
Height 34.5 cm. Width 30.5 cm.

PLATE 63

Fig. 2 A Dutch Ship (*Hollander Sen Dzu*)
From a Nagasaki colour-print, published by Bunkindo.
Height 30.5 cm. Width 22 cm.

Fig. 1 A Chinese Ship (*To Sen*)
From a Nagasaki colour-print, published by Bunkindo.
Height 30.5 cm. Width 22 cm.

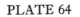

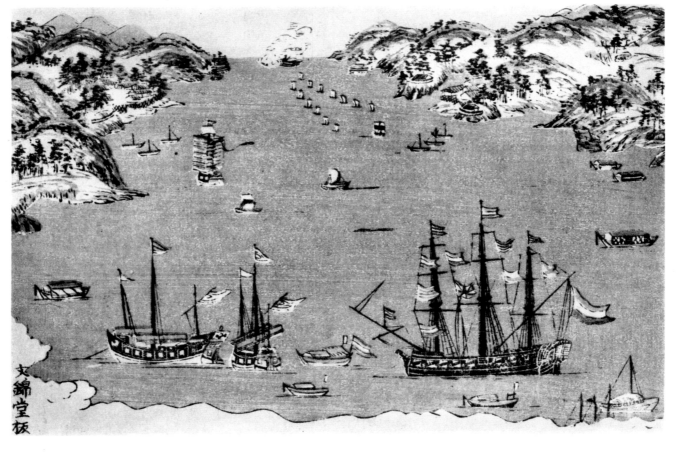

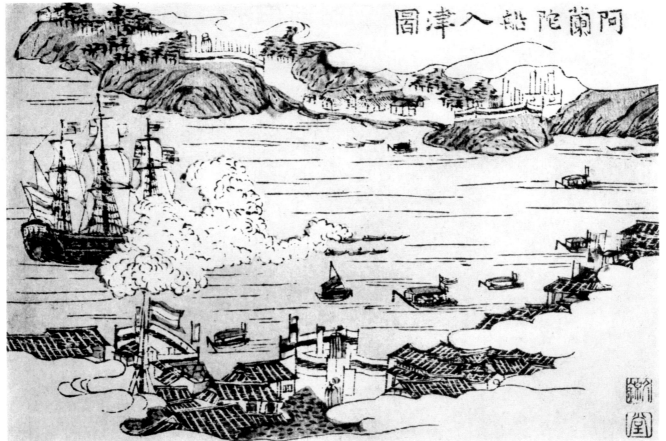

Two Views of Nagasaki Harbour
From a Nagasaki colour-print, published by Bunkindo.
Fig. 1.　Height 22 cm. Width 32 cm.
Fig. 2.　Height 20 cm. Width 26 cm.

PLATE 65

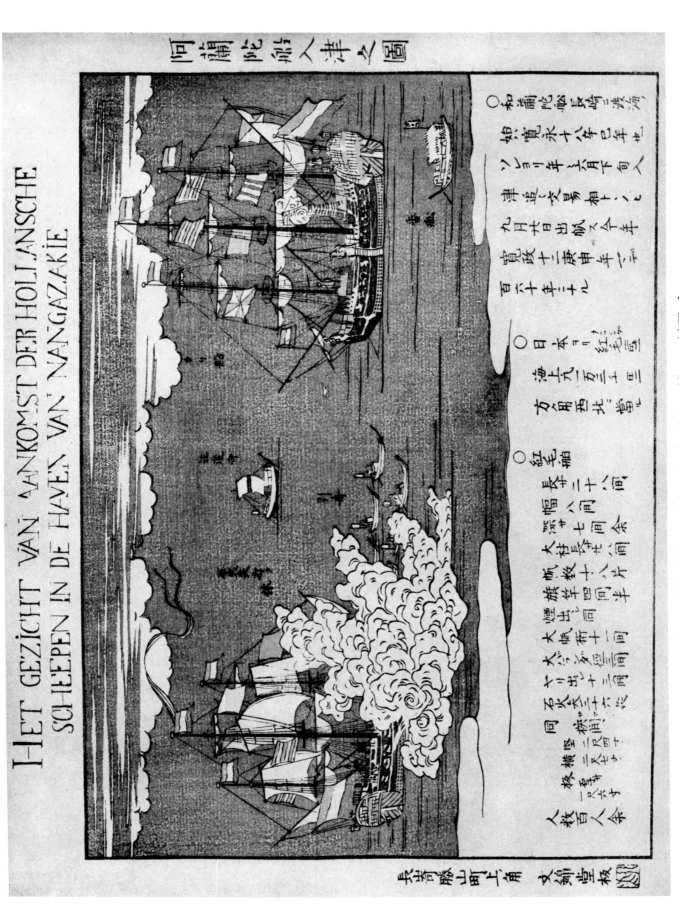

HET GEZICHT VAN AANKOMST DER HOLLANSCHE
SCHEEPEN IN DE HAVEN VAN NANGAZAKIE

A Dutch Ship Firing a Salute as she Enters Nagasaki Harbour

From a Nagasaki colour-print, published by Bunkindo.
Height 29.5 cm. Width 39 cm.

PLATE 66

朝 鮮 人 狩 山 之 圖 竪 九 寸
文 錦 堂 板 横 六 寸 九 分

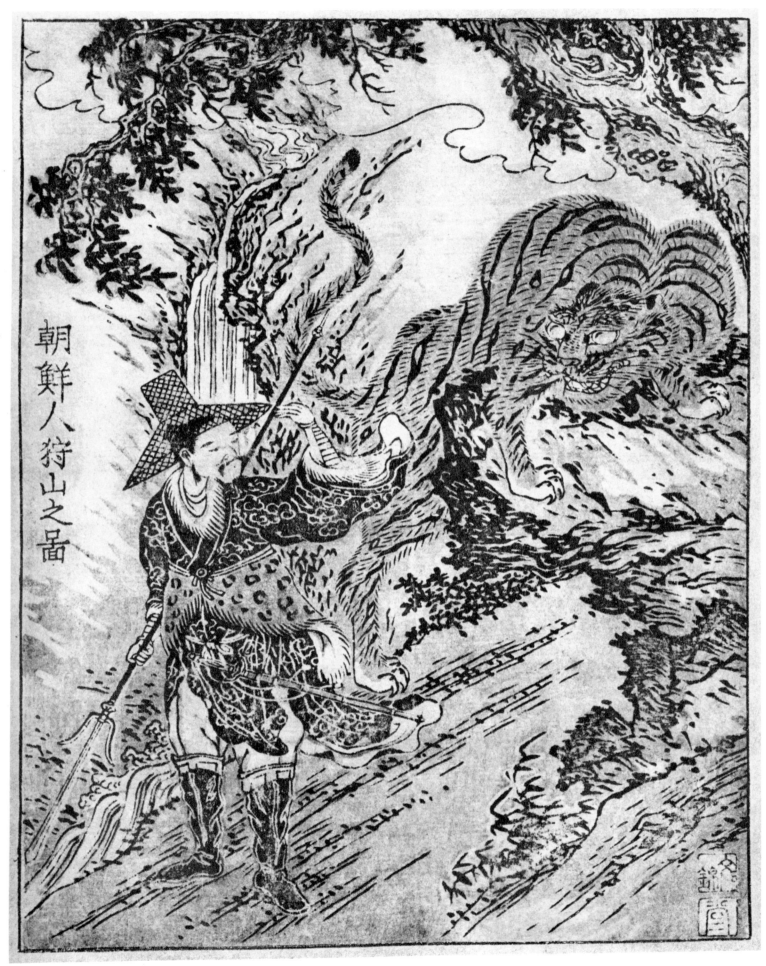

A Korean Hunter and a Tiger
From a Nagasaki colour-print, published by Bunkindo.
Height 27.5 cm. Width 21 cm.

PLATE 67

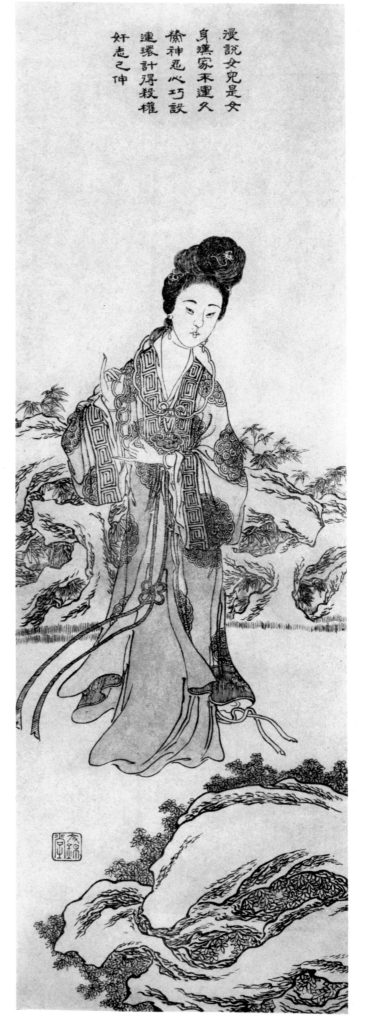

唐美
文人
横堅二錦
六尺堂
寸二一板
六寸圖
分

漫說女兒是父
身礙家不運久
像神忍心巧設
連環計得殺權
奸志己伸

The Celebrated Chinese Beauty, Yokihi
From a Nagasaki colour-print, published by Bunkindo.
Height 63.5 cm. Width 20 cm.

PLATE 68

清　人　合　奏　之　圖　竪　一　尺　五　分
文　錦　堂　板　橫　七　寸　三　分

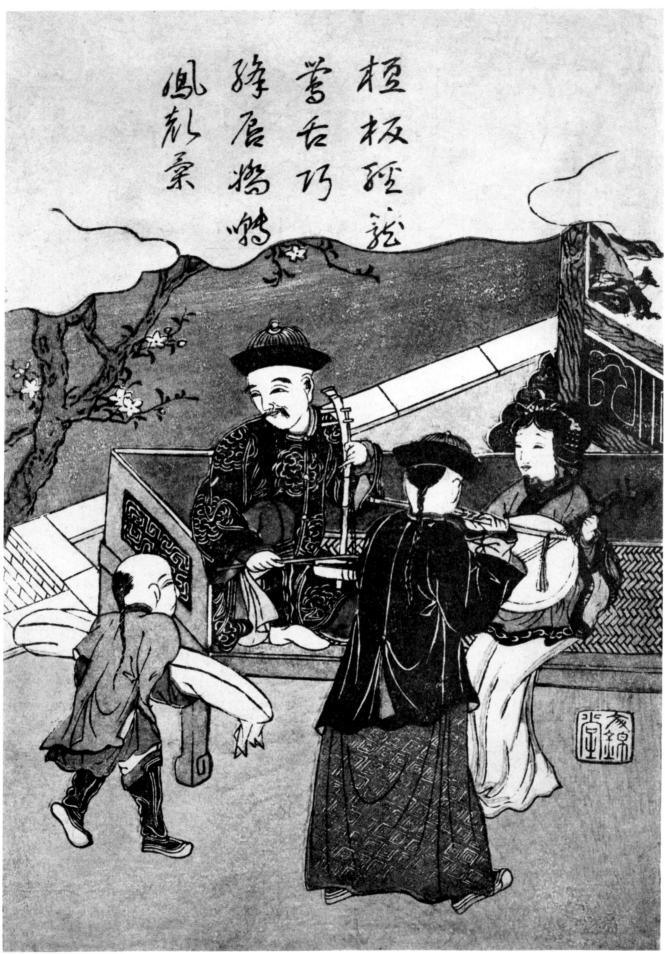

Chinese Musical Entertainment
From a Nagasaki colour-print, published by Bunkindo.
Height 32 cm. Width 22.2 cm.

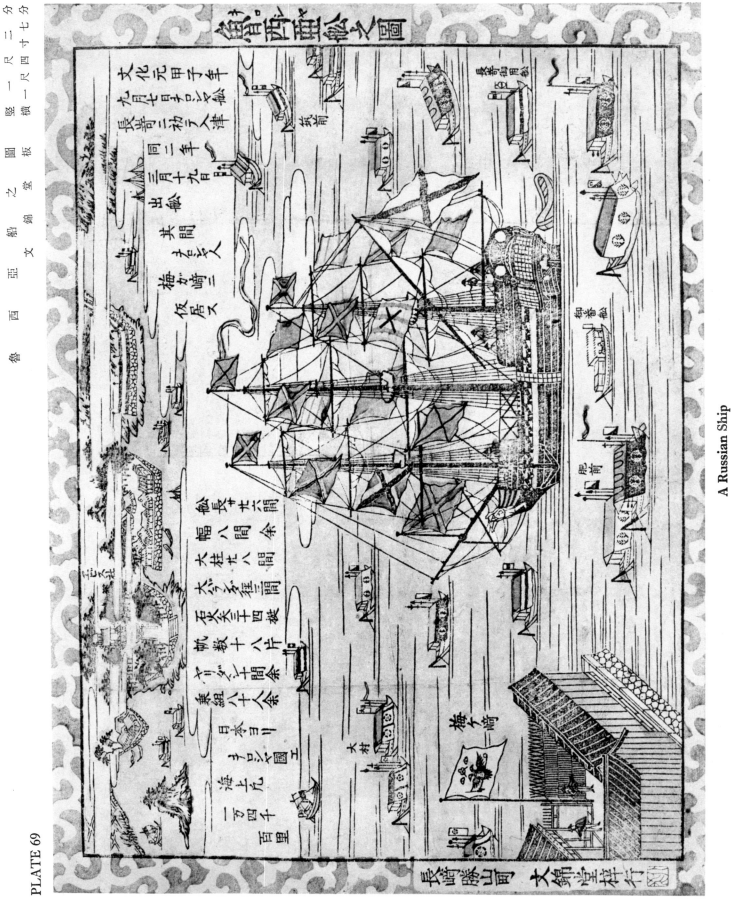

PLATE 69

A Russian Ship

From a Nagasaki colour-print, published by Bunkindo.
Height 31 cm. Width 45 cm.

PLATE 70

ヲロシヤ人之圖　堅九寸九分
文錦堂板　横七寸二分

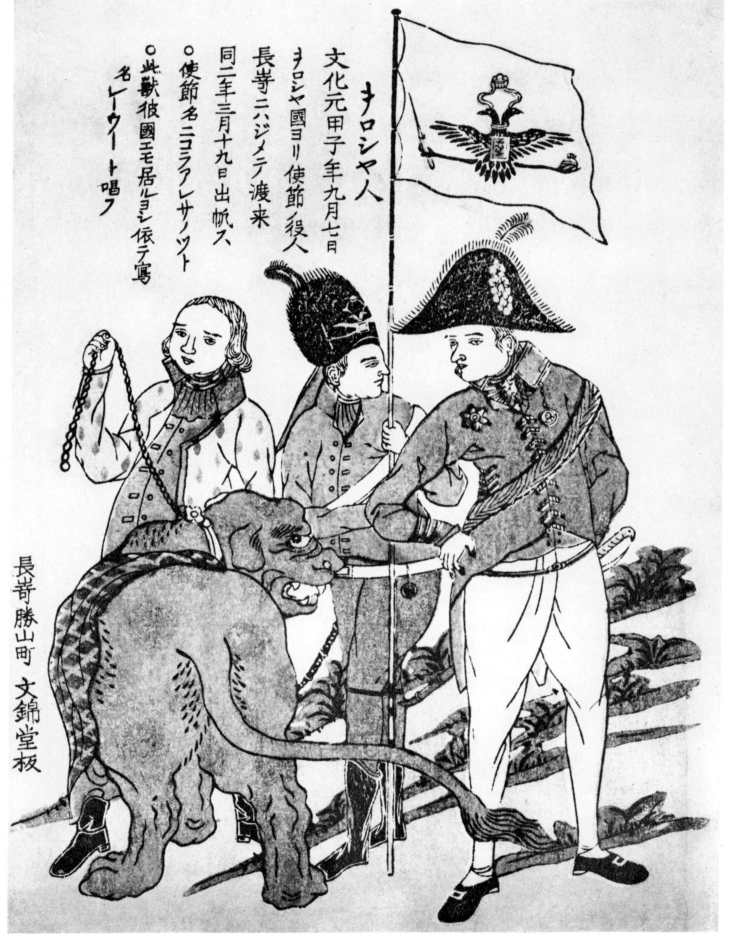

ヲロシヤ人

文化元甲子年九月七日
ヲロシヤ國ヨリ使節役人
長嵜ニハジメテ渡来
同二年三月十九日出帆ス
○使節名ニコラアレサノツト
○此獸彼國エモ居ルヨシ依テ寫
名レーウート唱フ

長嵜勝山町　文錦堂板

Rezanov and his Suite
From a Nagasaki colour-print, published by Bunkindo, relating to Rezanov's Embassy to Japan in Bunkwa 1 (1804).
Height 30 cm. Width 22 cm.

PLATE 71

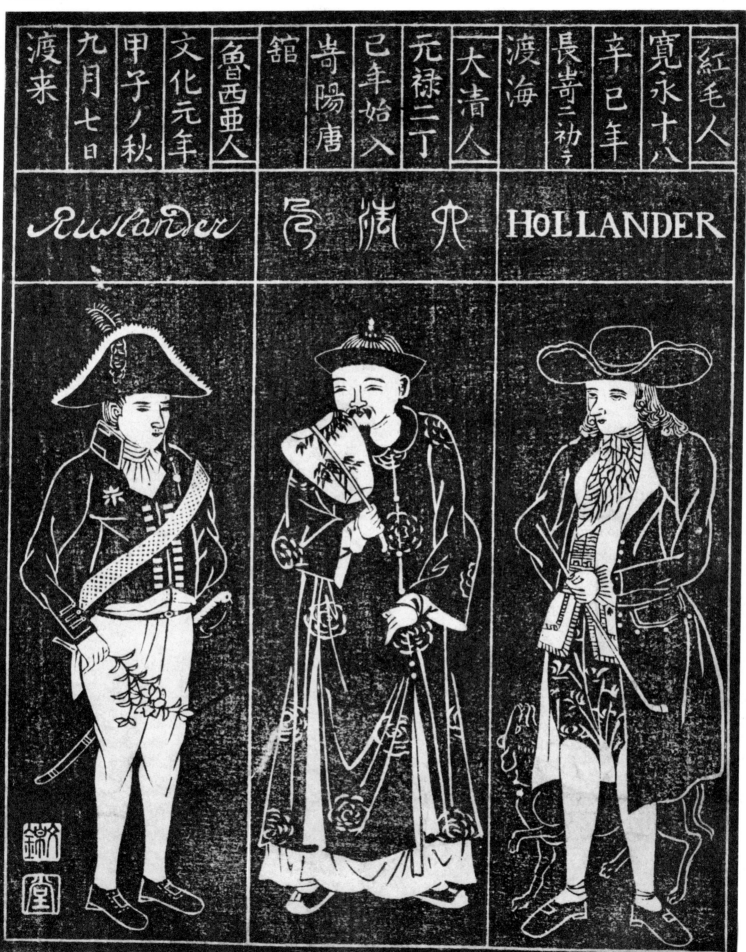

三　　國　　人　　之　　圖　竪八寸三分
文　　錦　　堂　　板　　横六寸五分

A Russian, a Chinese and a Hollander
From a black-and-white Nagasaki print, published by Bunkindo.
Height 26.5 cm. Width 19.7 cm.

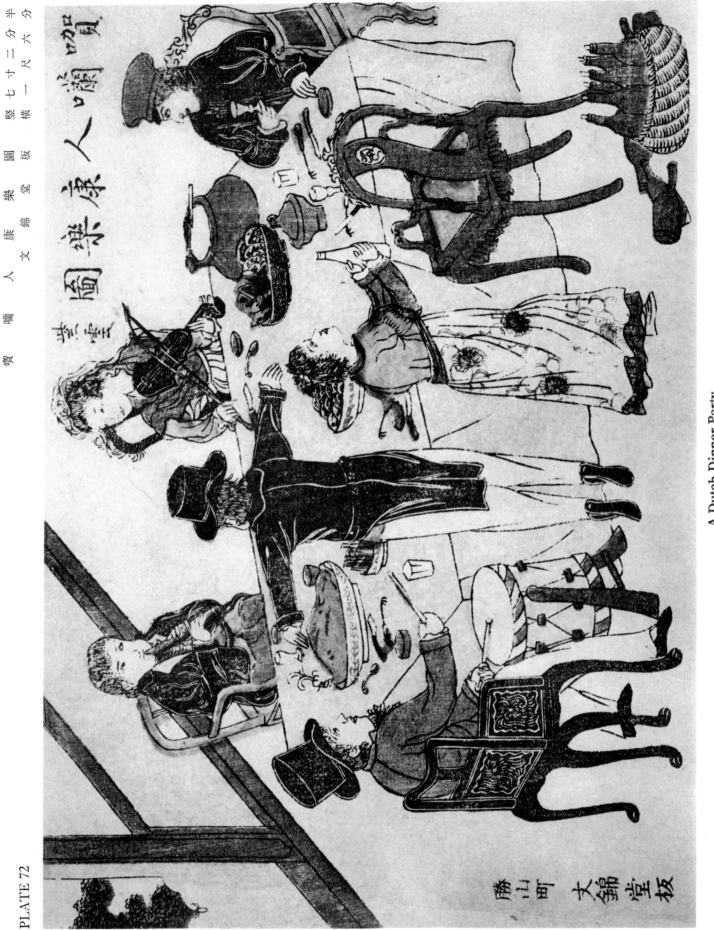

PLATE 72

A Dutch Dinner Party

From a Nagasaki colour-print, published by Bunkindo.
Height 22 cm. Width 33 cm.

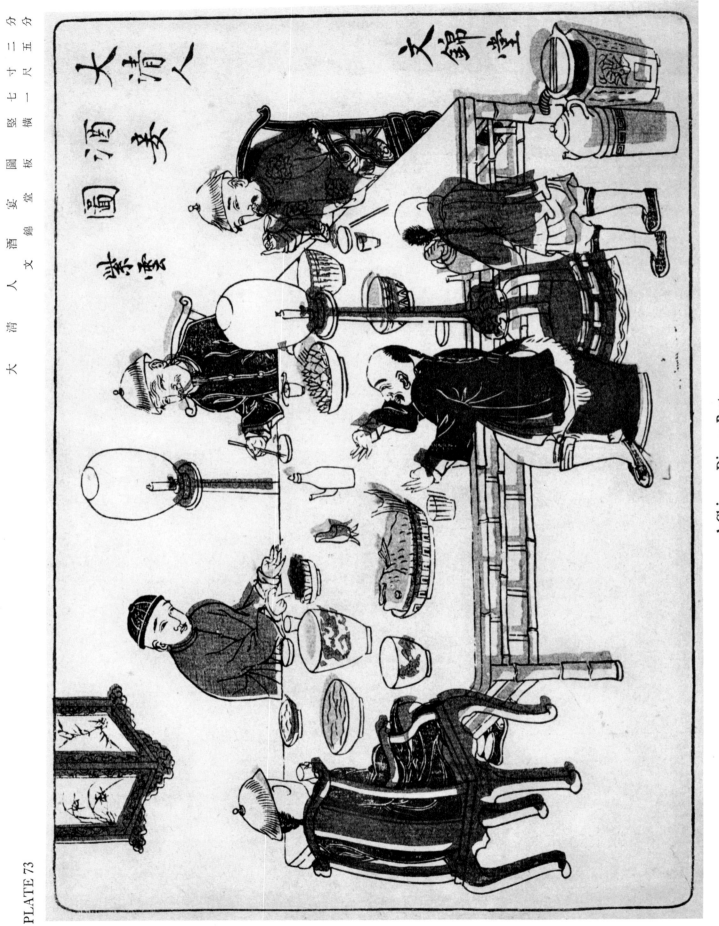

PLATE 73

A Chinese Dinner Party

From a Nagasaki colour-print, published by Bunkindo.
Height 22 cm. Width 32 cm.

PLATE 74

短冊と扇面、山水唐人物之圖　竪一尺二分
文錦堂板　横六寸九分

Chinese Figure-Subjects and Landscape in black and white, and grey
From a Nagasaki colour-print, published by Bunkindo.
Height 31 cm. Width 21 cm.

PLATE 75

漢英湖風景之圖 竪 一 尺 二 分
文 錦 堂 板 横 六 寸 九 分

漢英湖風景

文錦堂梓

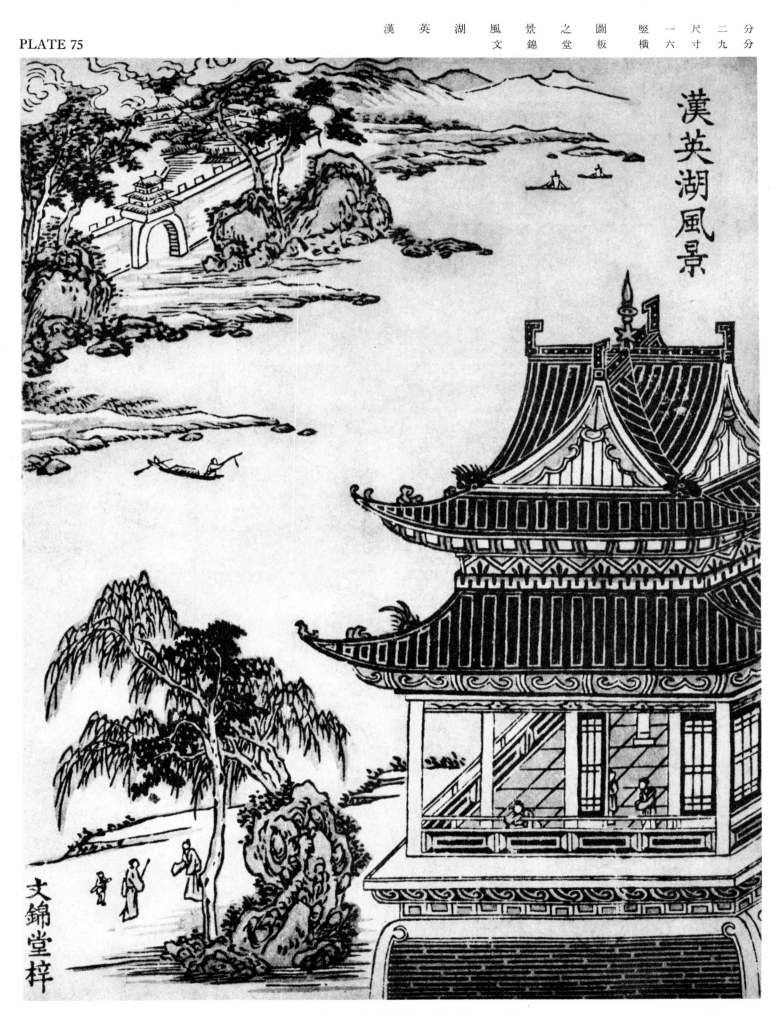

Chinese Landscape in black and white, and grey
From a Nagasaki colour-print, published by Bunkindo.
Height 31 cm. Width 21 cm.

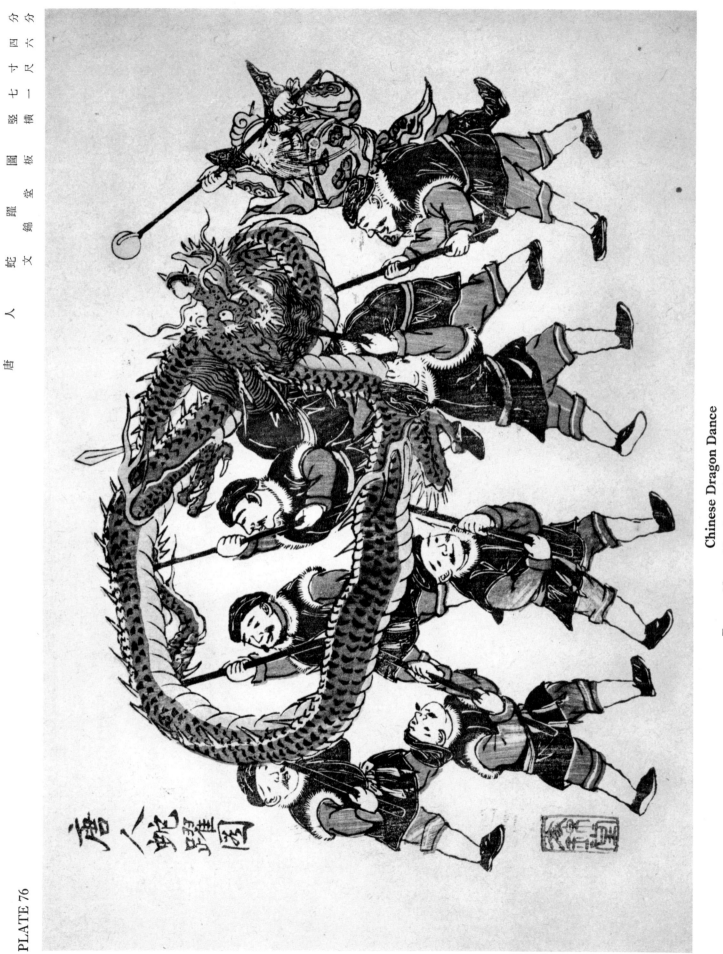

Chinese Dragon Dance

From a Nagasaki colour-print, published by Bunkindo.
Height 22.5 cm. Width 32 cm.

PLATE 76

PLATE 77

阿蘭陀人巡見之圖　錦堂板　竪横七三寸尺一六分分

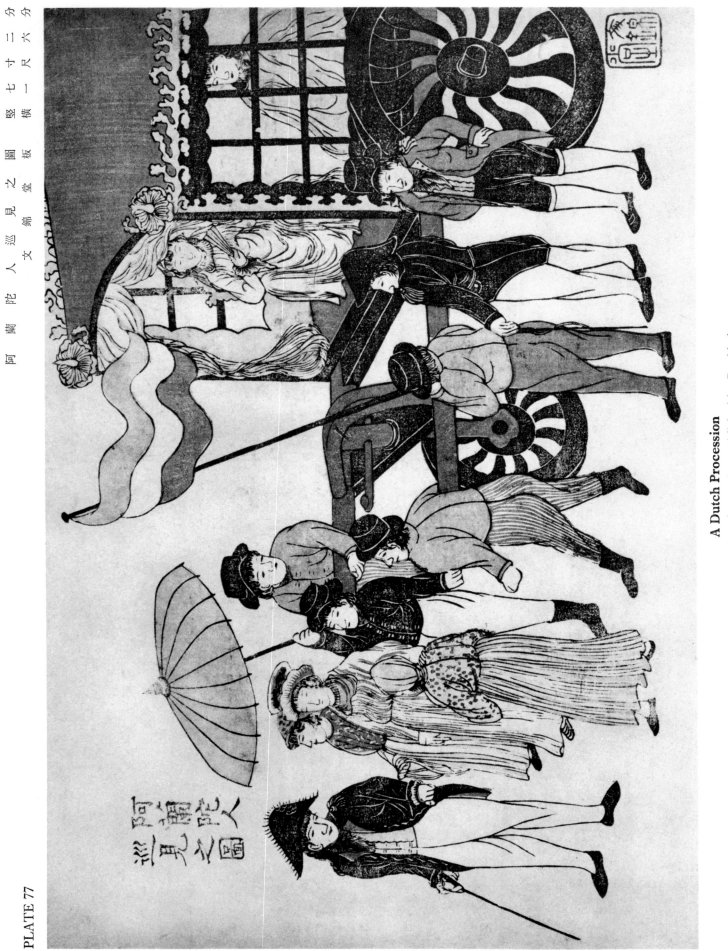

A Dutch Procession

From a Nagasaki colour-print, published by Bunkindo.
Height 22 cm. Width 32 cm.

PLATE 78

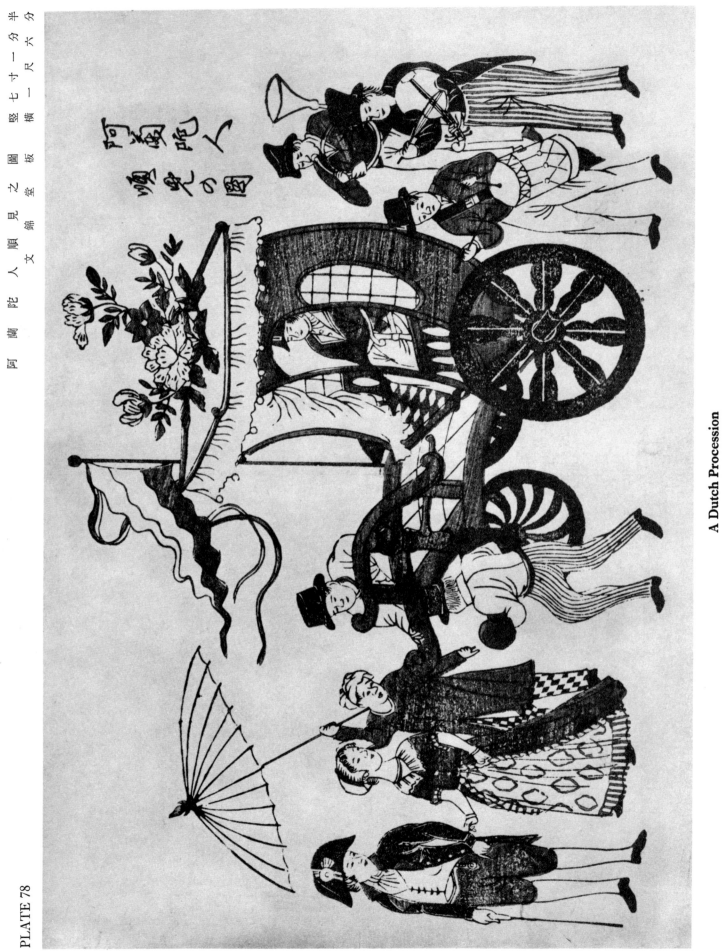

阿蘭陀人順見之圖　竪七寸一分半　横一尺六分

阿蘭陀人觀炎の圖

A Dutch Procession

From a Nagasaki colour-print, published by Bunkindo.
Height 21.7 cm. Width 32.2 cm.

PLATE 79

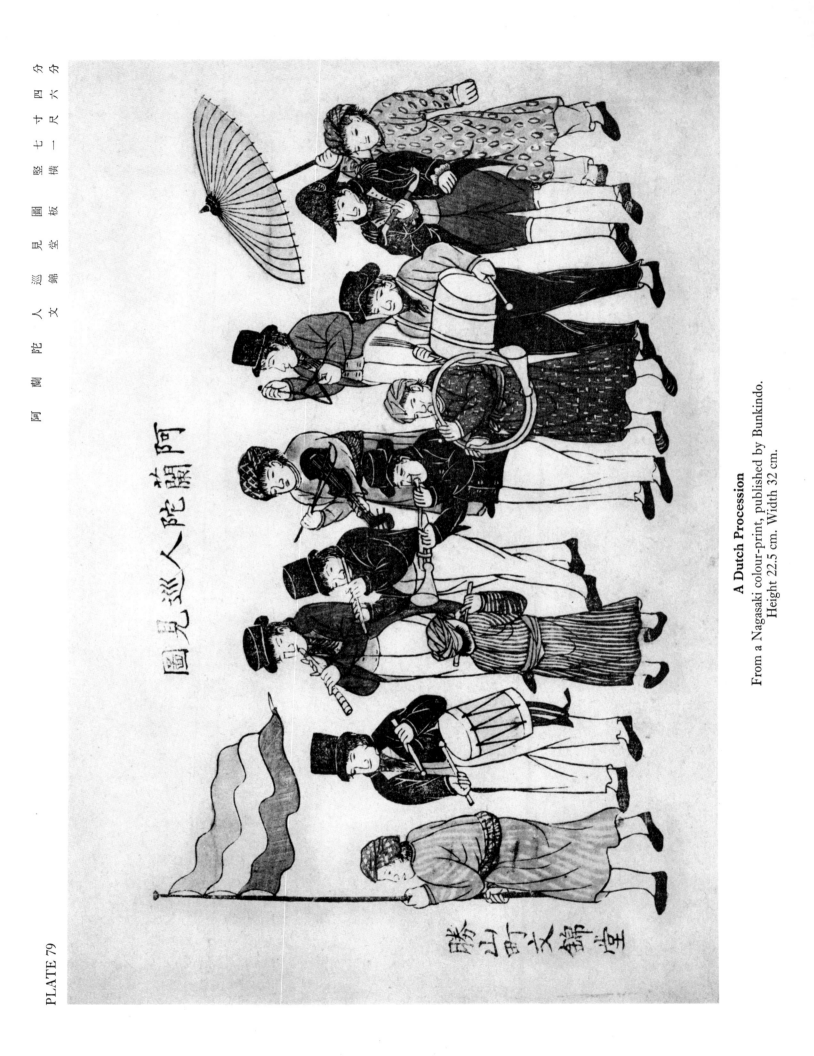

A Dutch Procession
From a Nagasaki colour-print, published by Bunkindo.
Height 22.5 cm. Width 32 cm.

PLATE 80

阿蘭陀婦人之圖 堅一尺二寸
大和屋板 横八寸三分

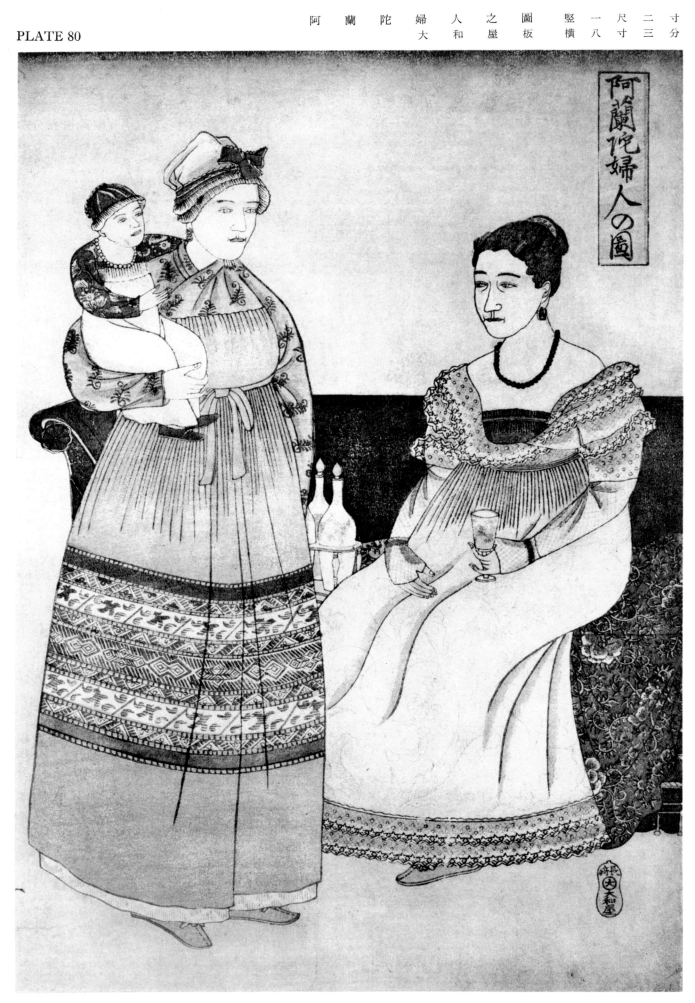

阿蘭陀婦人の圖

Mevrouw Cock Blomhoff with her Child and Nurse
From a colour-print designed by Kawara Keiga and published by Yamatoya.
Height 36.3 cm. Width 25 cm.

PLATE 81

唐 土 婦 人 納 涼 之 圖　竪 一 尺 二 寸 四 分
大 和 屋 板　橫 八 寸 六 分

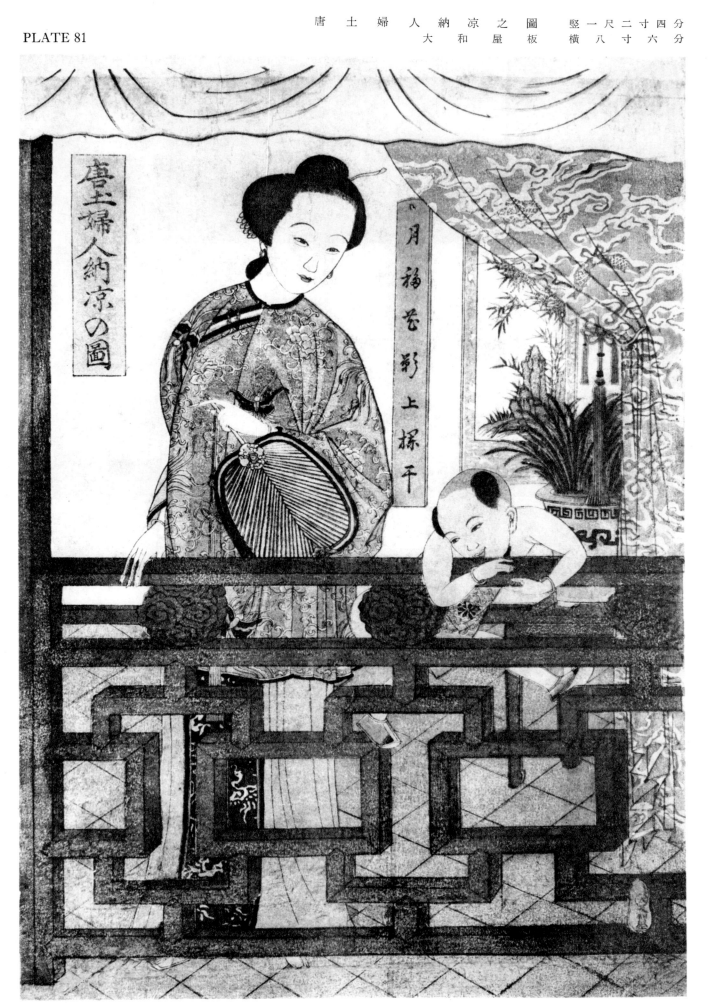

A Chinese Lady and her Child
From a colour-print published by Yamatoya.
Height 37.3 cm. Width 26 cm.

PLATE 82

唐　舘　部　屋　の　圖　　堅一尺一寸四分
大　和　屋　板　　横七寸九分

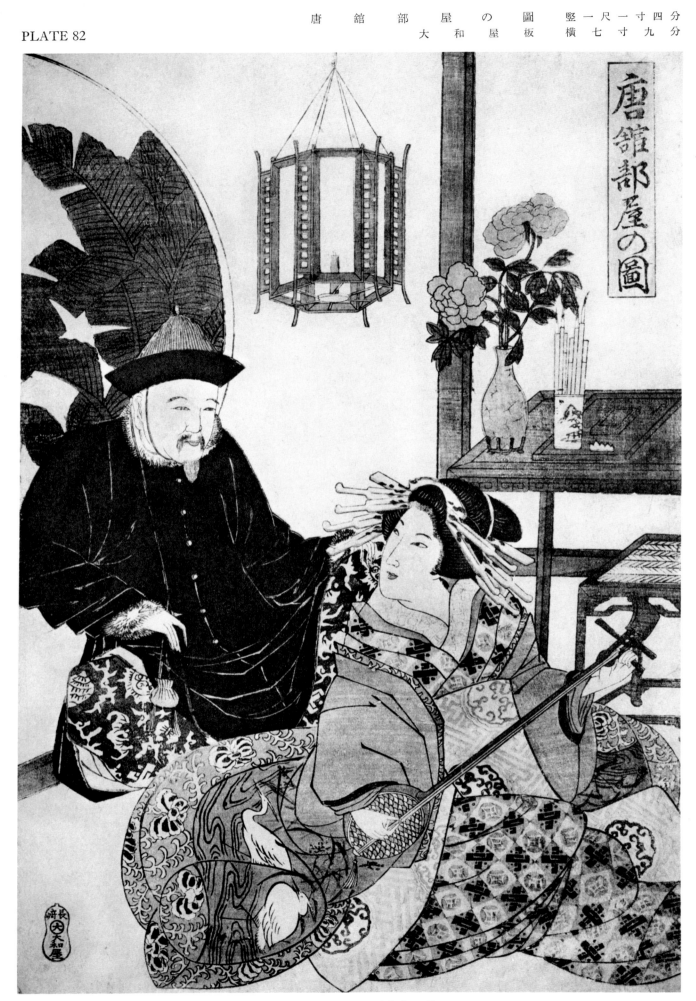

A Maruyama Beauty with her Patron
From a colour-print published by Yamatoya.
Height 34.7 cm. Width 24 cm.

PLATE 83

唐　館　書　房　之　圖　竪　一　尺　二　寸
大　和　屋　板　横　七　寸　九　分

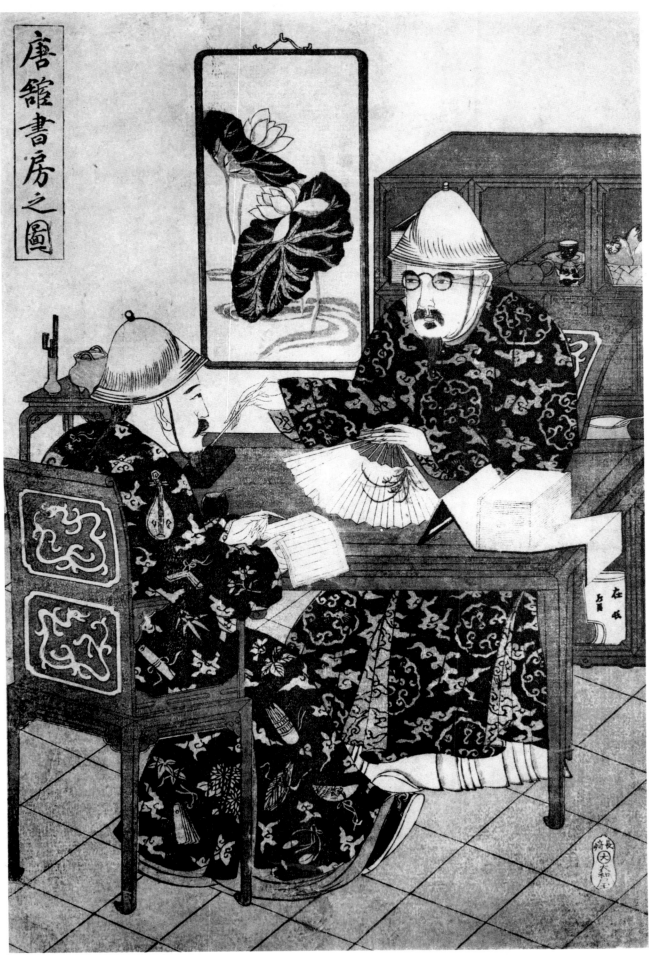

Two Chinese Figure-Subjects
From a colour-print published by Yamatoya.
Height 36.3 cm. Width 24 cm.

PLATE 84

長崎八景ノ內　立山秋月、笠頭夜雨之圖　竪　四　寸　六　分
大　和　屋　板　横　六　寸　五　分

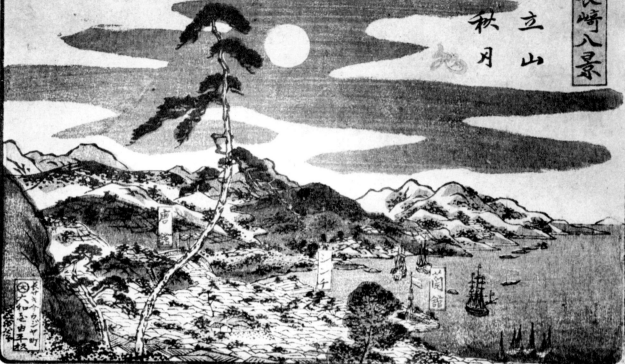

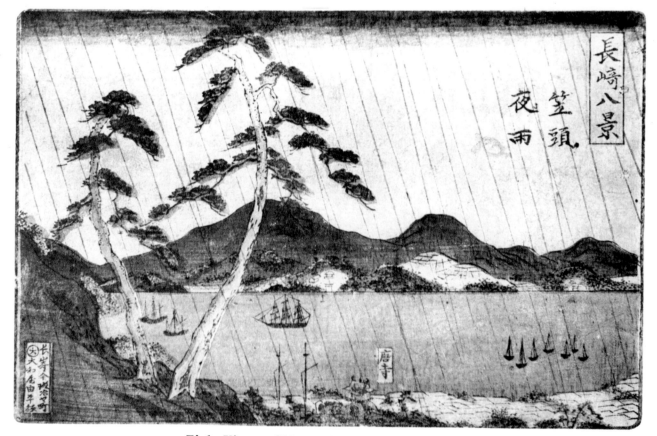

Eight Views of Nagasaki (Nagasaki Hakkei)

From eight colour-prints designed by Isono Bunsai and published by Yamatoya, signed by the artist and inscribed:

(1)　Autumn moon at Tateyama.
(2)　Boats sailing home to Kanzaki.
(3)　Bright sky and cool breeze at Ichinose.
(4)　The glow of evening at Inasa.

(5)　Night rain at Kasagashira.
(6)　The evening bell at Anzen (temple).
(7)　Wild geese alighting at Ōura.
(8)　Lingering snow on Atago.

Height 14 cm. Width 19.8 cm.

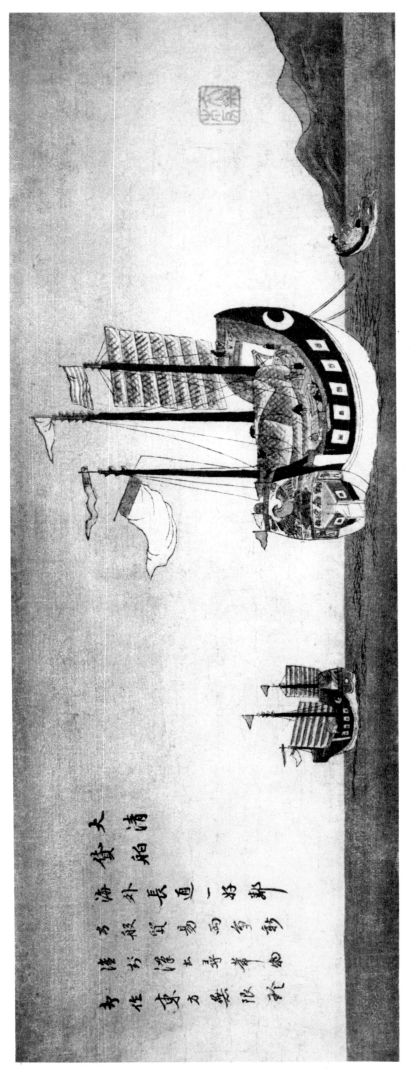

大清　貨舶　大和屋之圖板　縦五寸三分　横一尺四寸九分

大清　貨舶

大海多在清外長崎通一好和
往來多紛貿易不至奇寄客和
方藝取謬船

PLATE 85

A Chinese Ship

From a colour-print designed by Isono Bunsai and published by Yamatoya.
Height 16 cm. Width 45.2 cm.

PLATE 86

阿 蘭 陀 船 入 津 之 圖　　竪 一 尺 二 寸 四 分
大 和 屋 板　　横 八 寸 三 分

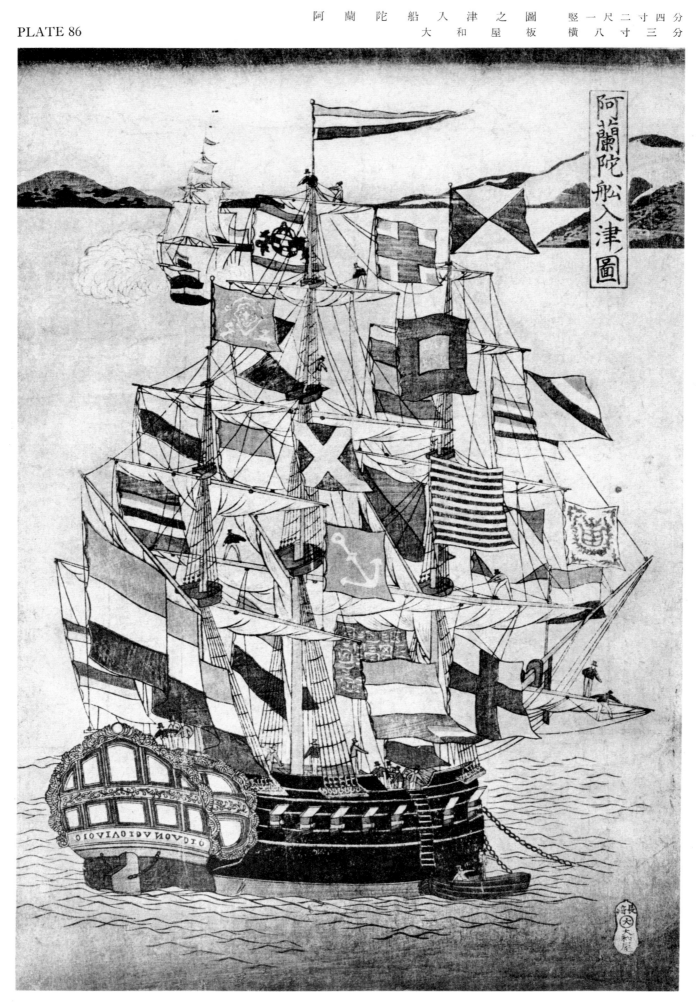

阿蘭陀船入津圖

A Dutch Ship
From a colour-print published by Yamatoya.
Height 37.5 cm. Width 25 cm.

PLATE 87

唐　船　入　津　の　圖　　竪一尺二寸四分
大　和　屋　板　　横　八　寸　三　分

唐船
入津の圖

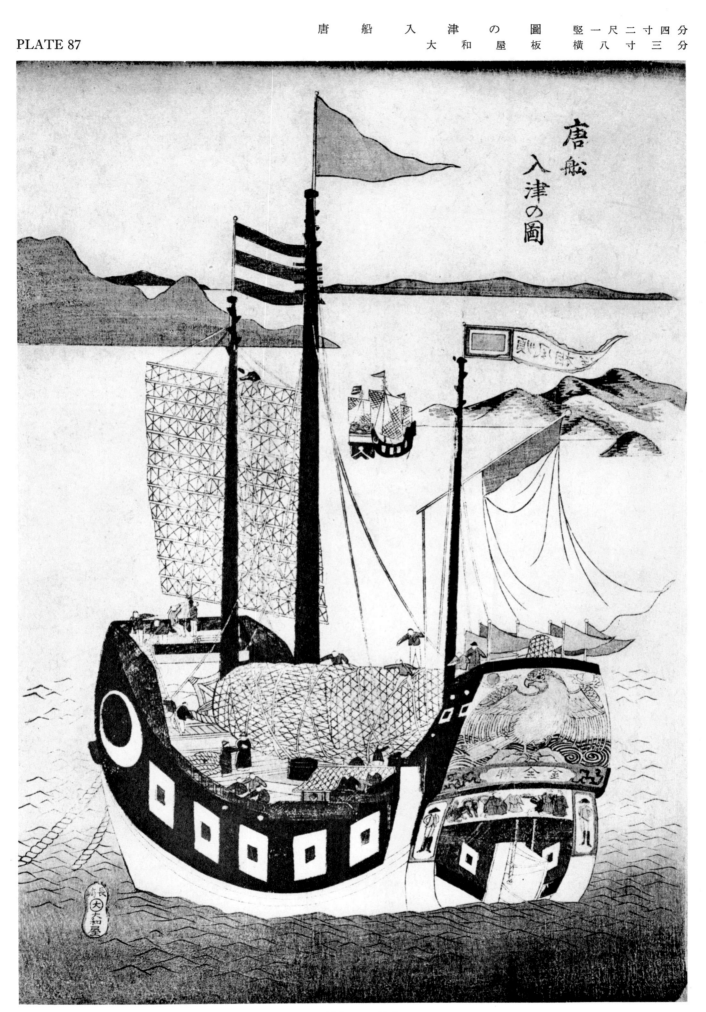

A Chinese Ship
From a colour-print published by Yamatoya.
Height 37.5 cm. Width 25 cm.

PLATE 88

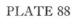

長崎唐寺唐人參詣圖　堅一尺五分
大和屋板　横七寸二分

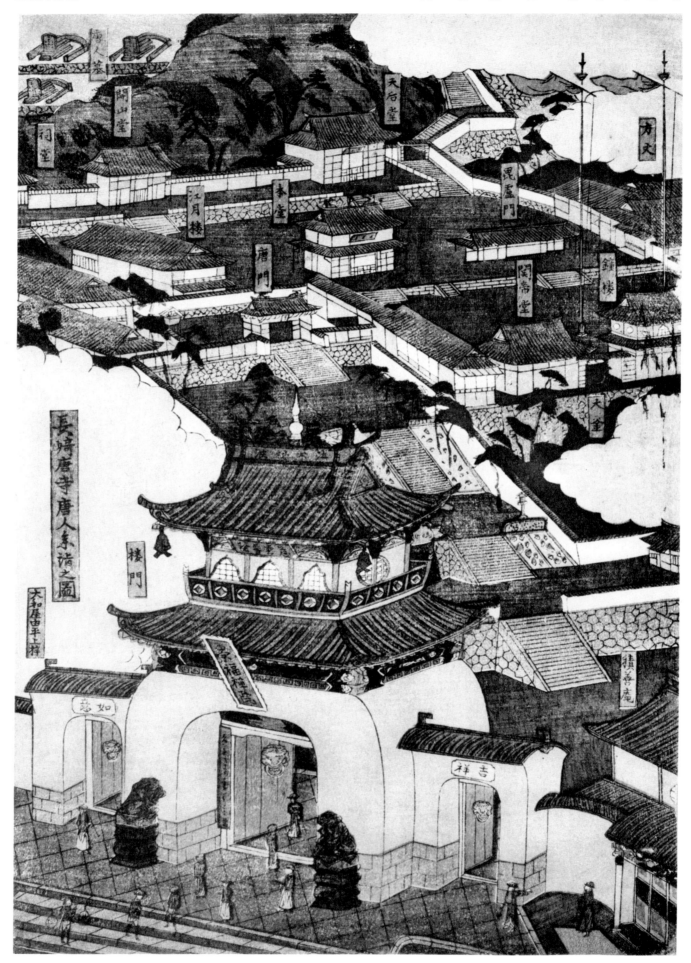

Sō Fuku Zenin (A Chinese Temple in Nagasaki)
From a colour-print published by Yamatoya.
Height 32 cm. Width 22 cm.

PLATE 89

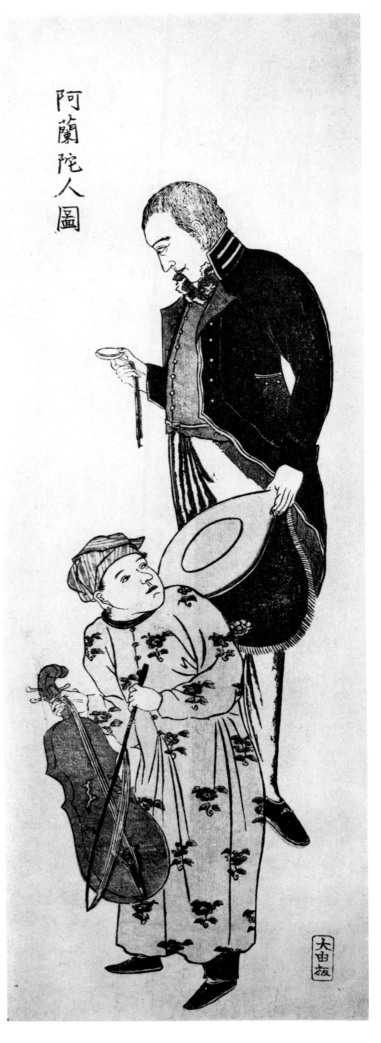

阿蘭陀人圖

阿
蘭
横　竪　大　陀
四　一　和　人
寸　尺　屋　圖
九　四　板
分　寸
　　六
　　分

A Hollander with his Attendant Carrying a Violin
From a colour-print published by Yamatoya.
Height 44.2 cm. Width 15 cm.

PLATE 90

魯 西 亞 整 儀 寫 眞 鑑
大 和 屋 板

竪板 竪 一 尺 三 寸
横 八 寸 二 分
横板 竪 八 寸 二 分
横 一 尺 三 寸

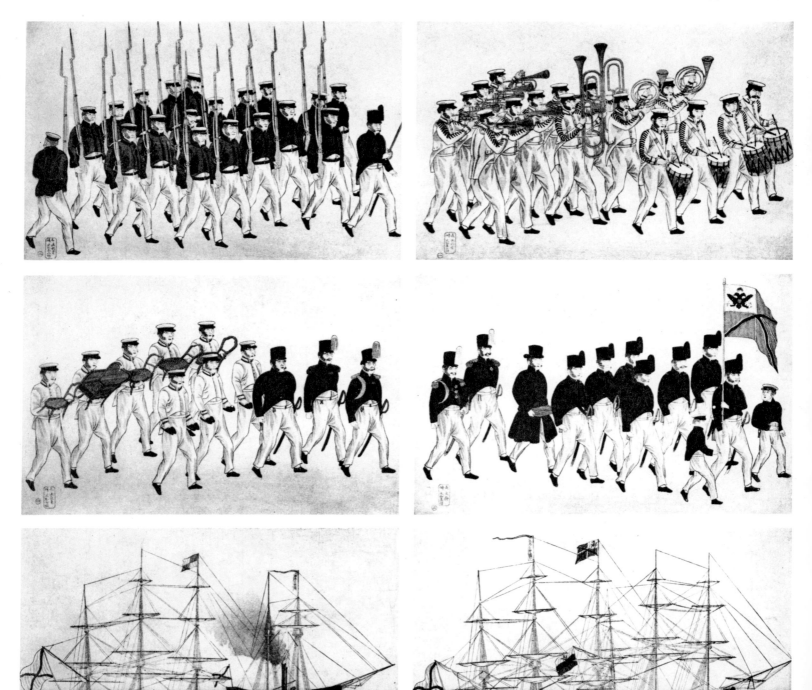

Admiral Putiatine and his Staff
The seven prints portrayed are designed by Kawara Keiga and published by Yamatoya.
Height 39.5 cm. Width 26.3 cm.
Height 26.3 cm. Width 39.5 cm.

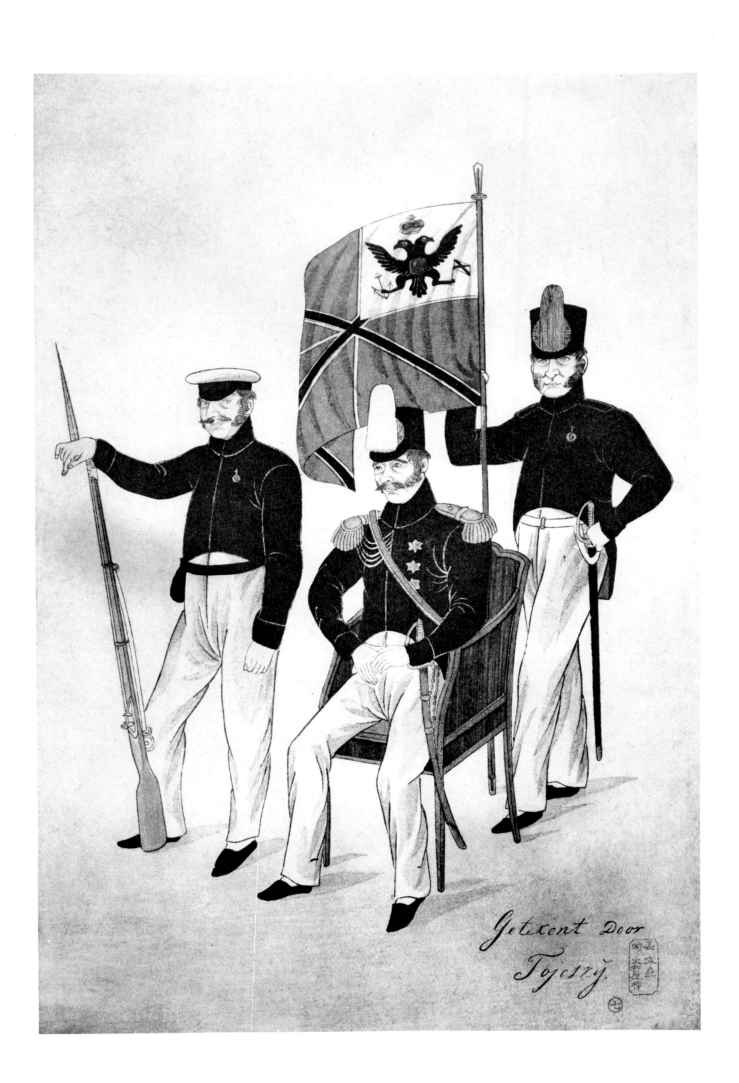

Getekent Door
Tojosny.

PLATE 91

ヲロシヤ國の使節之圖
大和屋板
竪一尺五寸
横五寸四分

A Russian Admiral
From a colour-print published by Yamatoya.
Height 45.4 cm. Width 16.5 cm.

PLATE 92

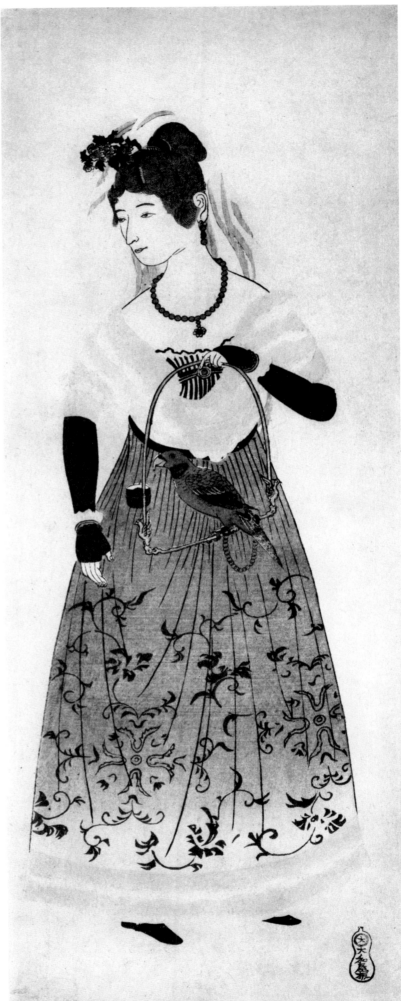

鸚鵡と阿蘭陀美人之圖
大和屋板
竪一尺四寸七分
横五寸三分

A Dutch Lady with a Bird
From a colour-print published by Yamatoya.
Height 44.5 cm. Width 16 cm.

PLATE 93

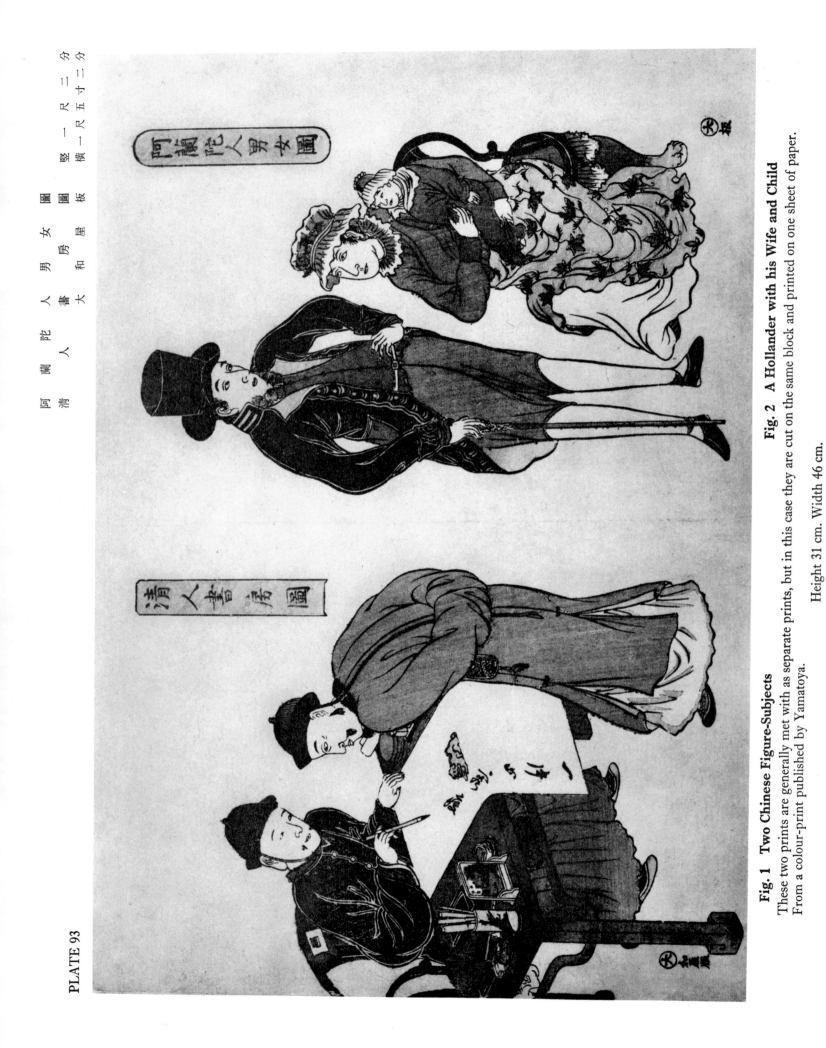

阿蘭陀人男女圖　竪　一尺三寸三分
清人書房圖　　　　横　一尺五寸三分

阿蘭陀人男女圖
清人書房圖

Fig. 1　Two Chinese Figure-Subjects

These two prints are generally met with as separate prints, but in this case they are cut on the same block and printed on one sheet of paper.

From a colour-print published by Yamatoya.

Fig. 2　A Hollander with his Wife and Child

Height 31 cm. Width 46 cm.

PLATE 94

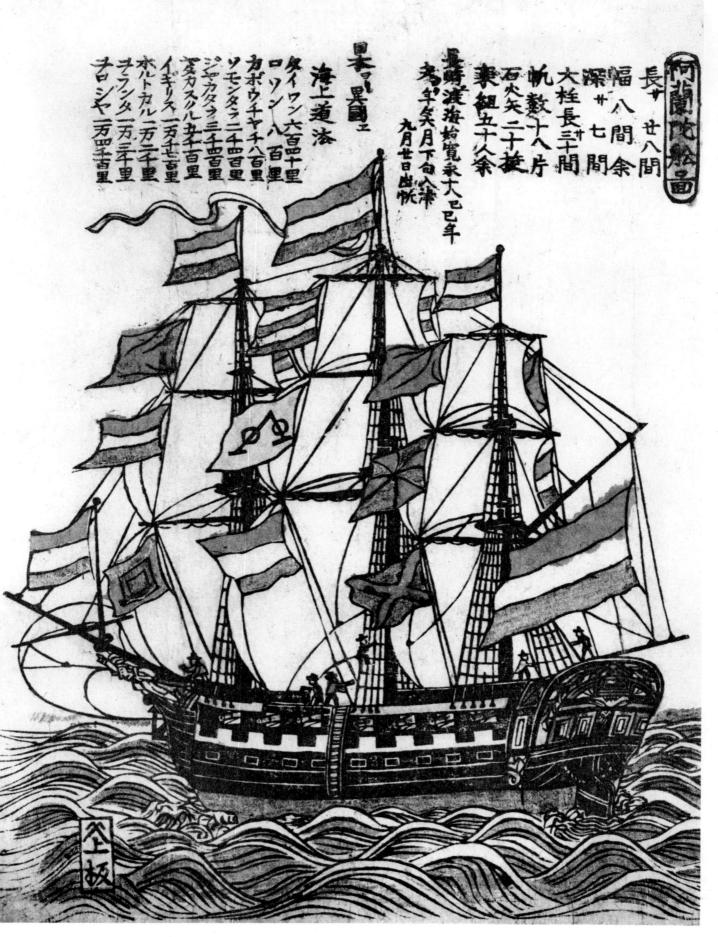

A Dutch Ship
From a colour-print published by Yamagami.
Height 31 cm. Width 22.3 cm.

PLATE 95

阿 蘭 陀 本 國 船 圖 堅 横 一尺四寸七分 一尺七分

阿 蘭 陀 本 國 深 牛 屋 板

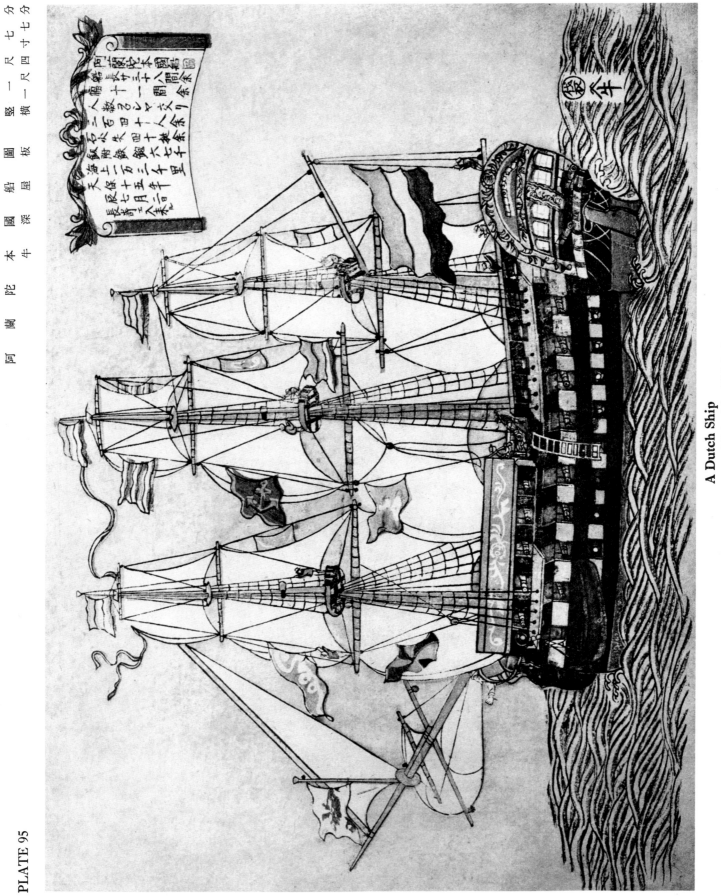

A Dutch Ship

From a colour-print published by Ushibukaya.
Height 32.5 cm. Width 44.5 cm.

PLATE 96

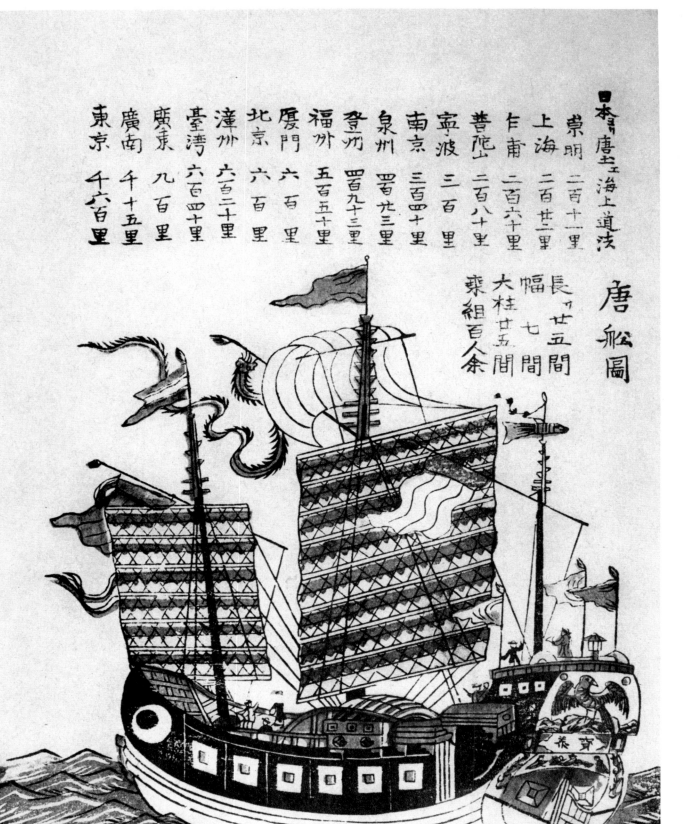

唐　　　船　　　圖　竪一尺三分
益　永　板　横七寸二分

日本ヨリ唐土ヘ海上道法　唐船圖

長ッ廿五間
幅七間
大柱廿五間
乗組百人余

崇明　二百十一里
上海　二百卅三里
寧甫　二百六十里
普陀山　二百八十里
寧波　三百里
南京　三百四十里
泉州　晋九百三里
登州　晋九百三里
福州　五百五十里
厦門　六百里
北京　六百里
漳州　六百二十里
臺湾　六百四十里
廣東　九百里
廣南　千十五里
東京　千六百里

A Chinese Ship
From a colour-print published by Masunaga.
Height 31.3 cm. Width 21.8 cm.

PLATE 97

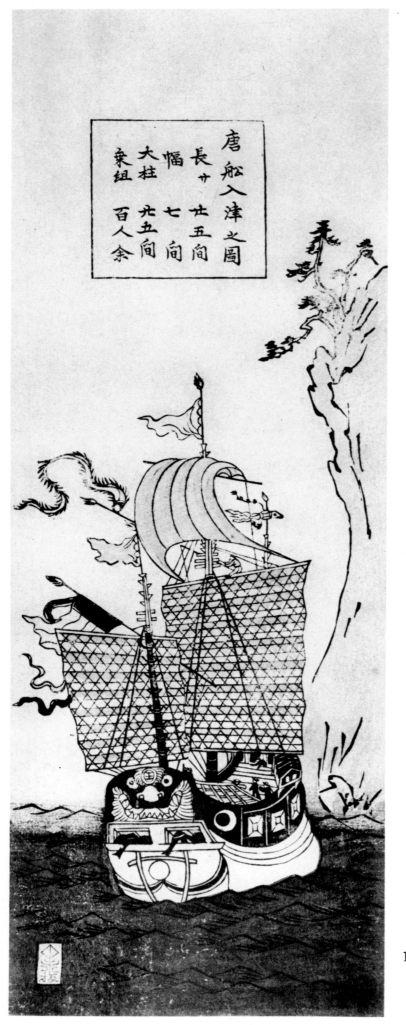

A Chinese Ship
From a colour-print published by Masunaga.
Height 45.8 cm. Width 15.8 cm.

唐船入津之圖
盆永板
竪一尺四寸八分
横五寸三分

PLATE 98

唐人卓子盆圖　竪一尺七寸五分　横七尺四分

唐人卓子盆之圖　板屋板

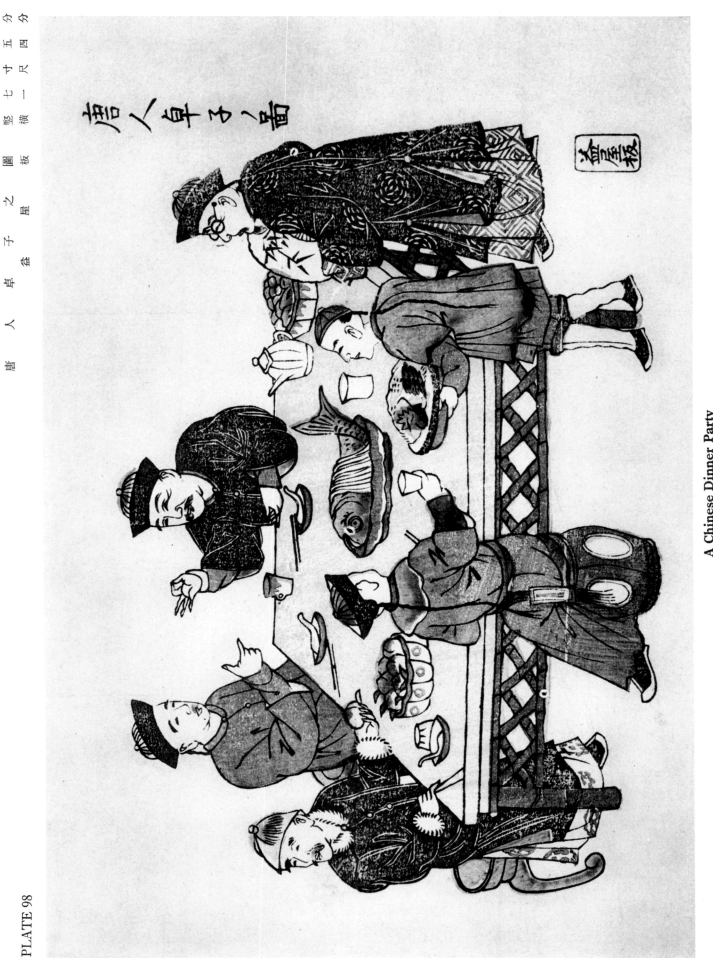

唐人卓子之圖　板屋鑑

A Chinese Dinner Party

From a colour-print published by Masuya.

Height 22.7 cm. Width 31.7 cm.

PLATE 99

蠻舶圖繪之內
蘭船之圖、唐船長崎へ入津之圖　　竪　四　寸　一　分
紫　雲　堂　板　　横　五　寸　八　分

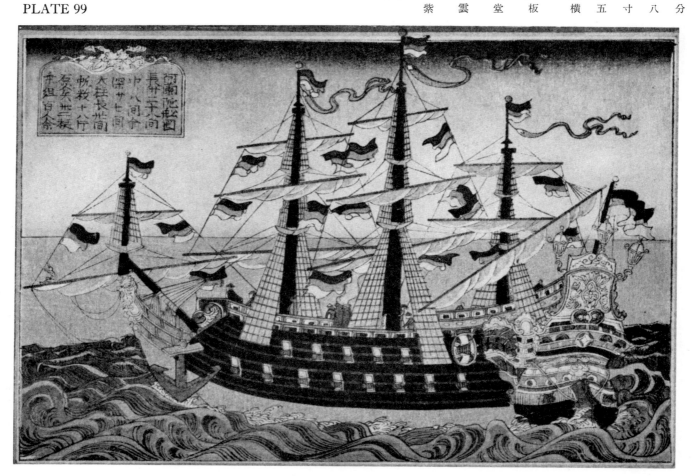

Fig. 1　A Dutch Ship

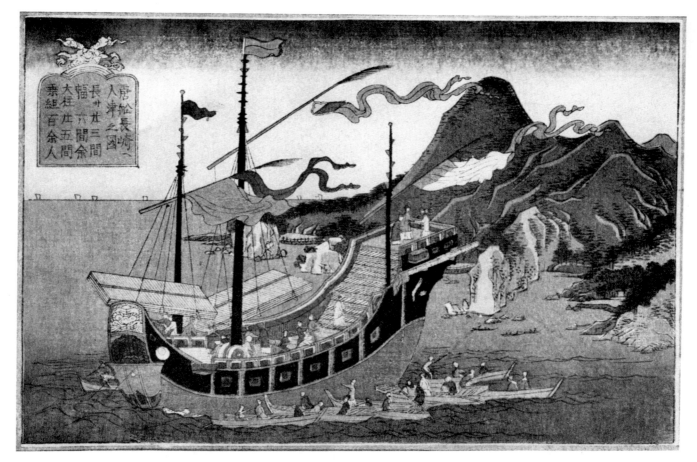

Fig. 2　A Chinese Ship
From a colour-print album published by Shiundo.
Height 12 cm. Width 17.6 cm.

PLATE 100

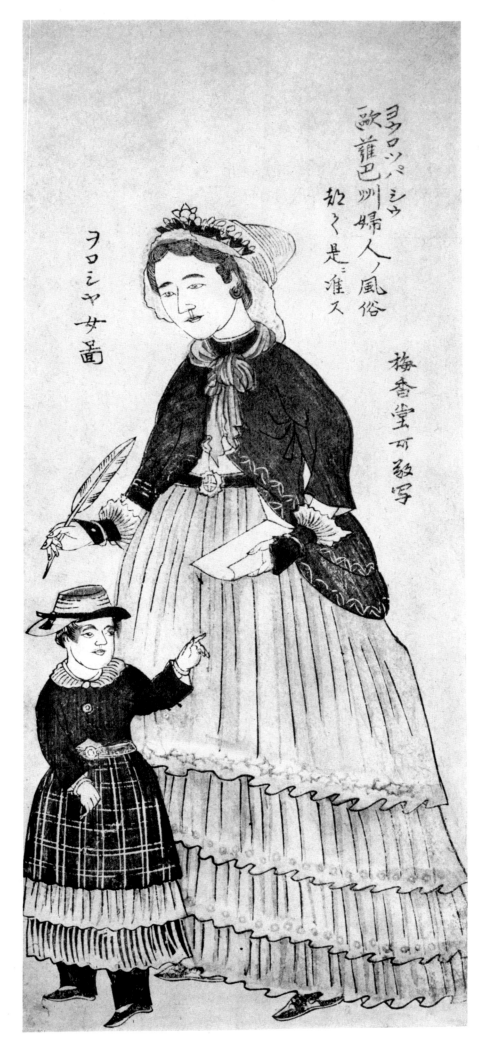

ヨーロッパシュ
欧羅巴州婦人ノ風俗
如ク是ニ准ス

ヲロシャ女圖

梅香堂可敬写

ヲ
ロ
シ
横 竪 ヤ
一 梅 女
一 尺 香
五 二 堂 圖
寸 板
寸 一
分

A Dutch Lady and her Child
From a colour-print published by Baikodo.
Height 36.5 cm. Width 15 cm.

PLATE 101

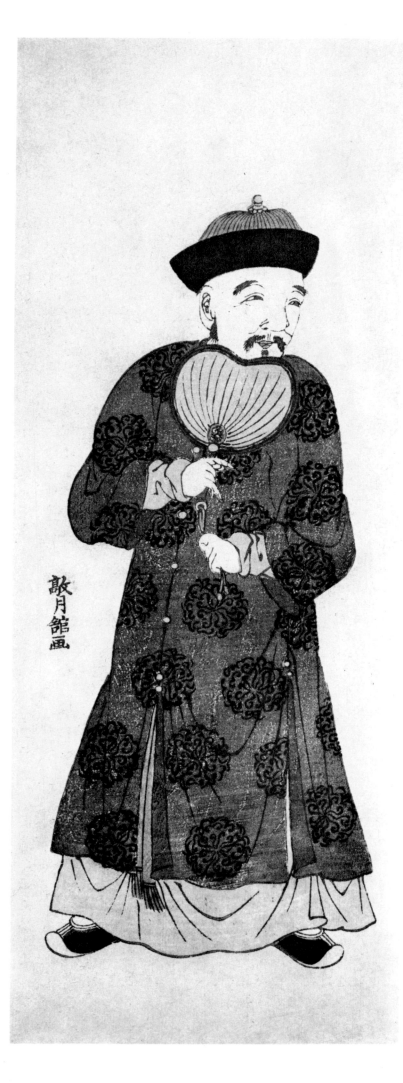

唐

人

敲

之

月

橫　豎　　　　圖

一　　館

五　尺　月

寸　四　　分

三　寸

　　九

分　分　館

A Chinese

From a colour-print designed by Kogetsukwan.
Height 45 cm. Width 16.2 cm.

PLATE 102

異 國 軍 人 之 圖　　堅 一 尺 二 寸 三 分
　　　　　　　　　　　横　八　寸　六　分

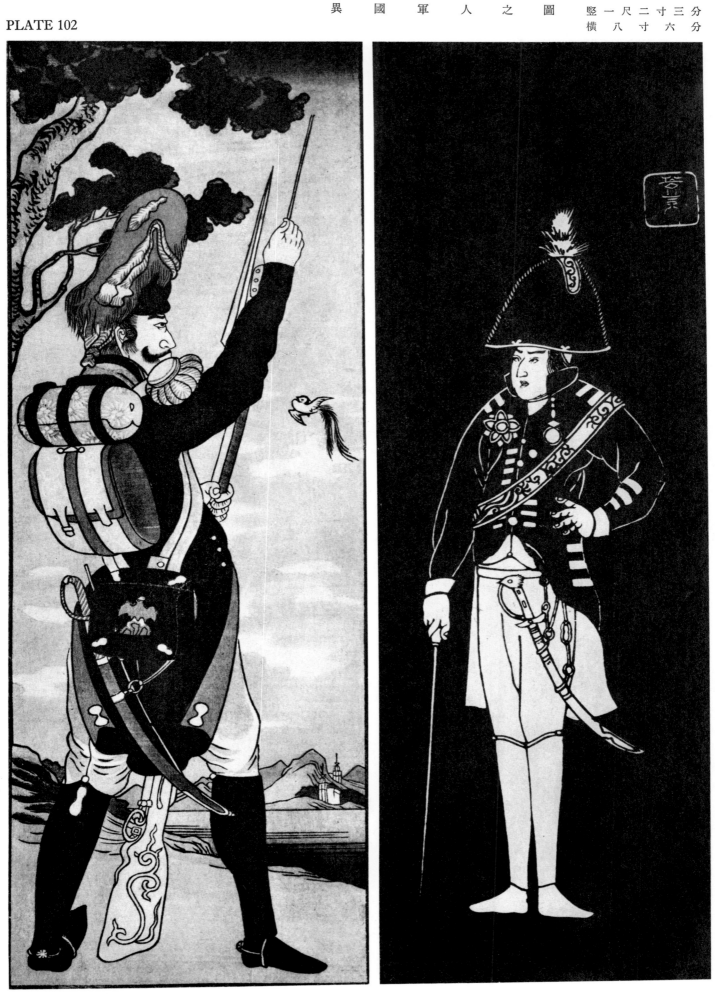

Fig. 1　A Russian Soldier　　　　　**Fig. 2　A Russian Admiral**

From a colour-print designed by Tani Ho.
Height 37. 2 cm. Width 26 cm.

PLATE 103

諏訪神社祭禮行列之圖　板屋笹

竪一尺一寸九分
横一尺六寸一分

Suwa Shrine Festival (*Suwa Jinsha*)
From a colour-print published by Sasaya.
Height 36 cm. Width 48.7 cm.

PLATE 104

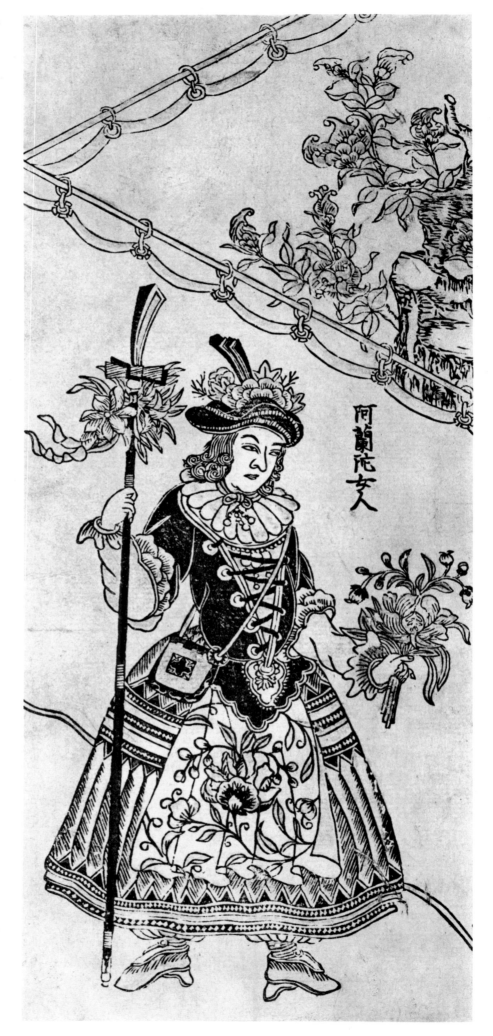

阿蘭陀女人之圖
竪 一尺一寸五分
横 五寸五分

Portrait of Juffrouw Van Hollad
From an early hand-coloured Nagasaki colour-print.
Height 35 cm. Width 15 cm.

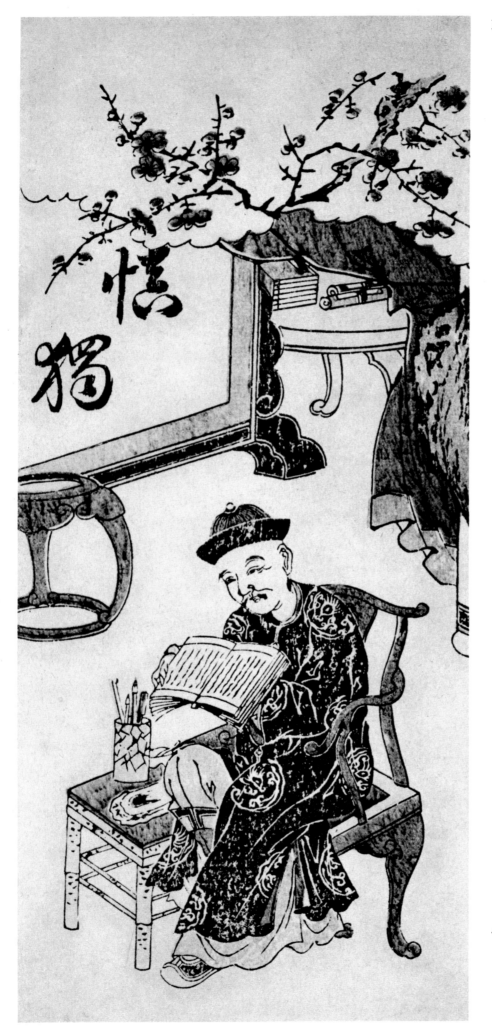

PLATE 105

唐
人
讀
書
之
圖

豎
一
尺
一
寸
四
分

橫
五
寸
一
分

**A Chinese of the Ming Dynasty
in his Study**

From a Nagasaki colour-print.
Height 36 cm. Width 15.5 cm.

PLATE 106

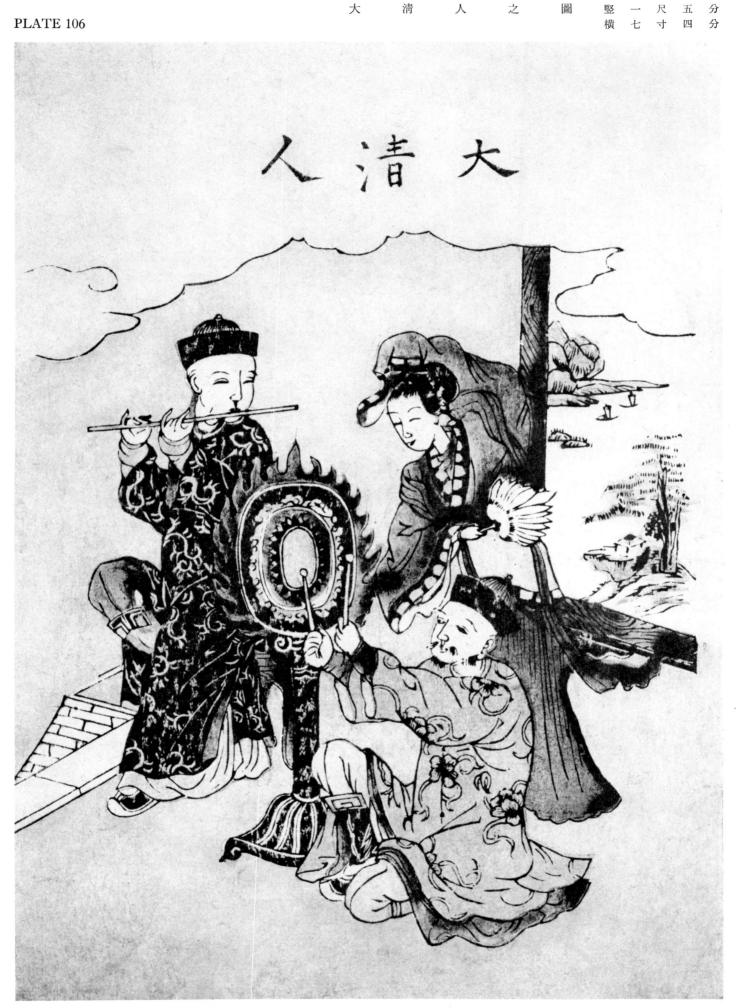

A Chinese Musical Entertainment with Drum and Flute
From a Nagasaki colour-print.
Height 31.6 cm. Width 22.5 cm.

PLATE 107

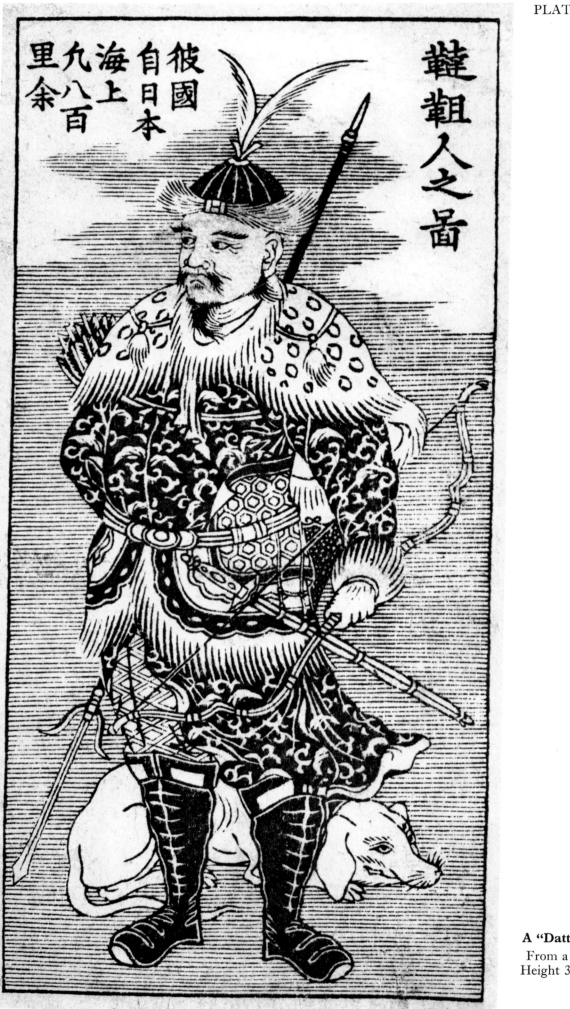

韃靼人之圖

彼國自日本海上九百八十里余

韃靼人之圖

堅一尺七分

横四寸

A "Dattan Jin" with his Dog
From a Nagasaki colour-print.
Height 30.4 cm. Width 14.2 cm.

PLATE 108

ヲランダ人外科療治之圖　竪一尺三分
　　　　　　　　　　　横七寸四分

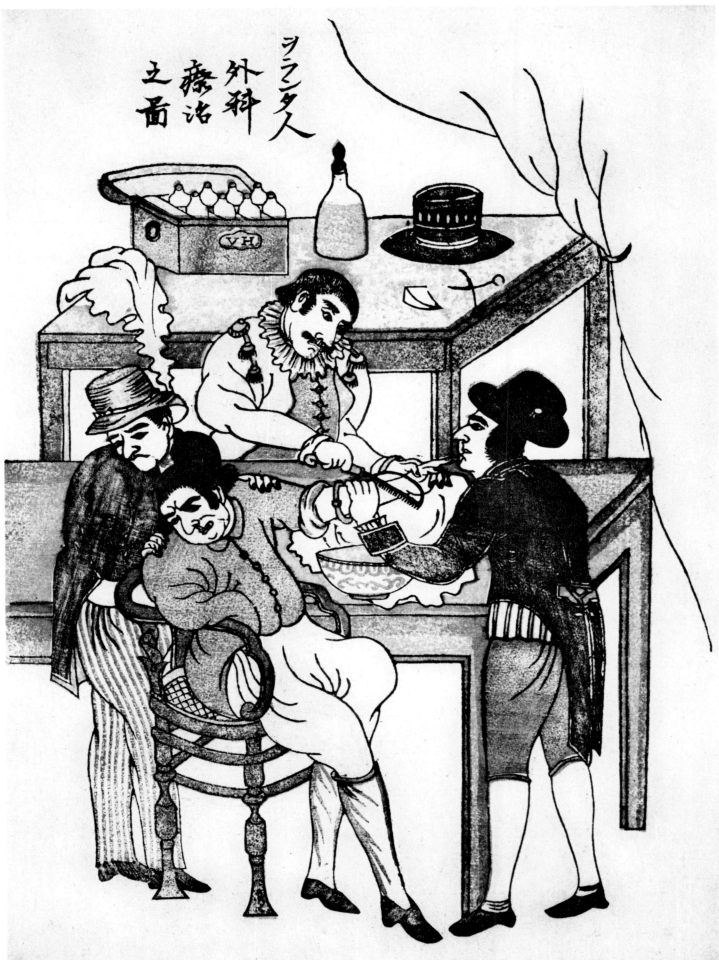

A Dutch Doctor Performing a Surgical Operation
From a Nagasaki colour-print.
Height 31.3 cm. Width 22.5 cm.

PLATE 109

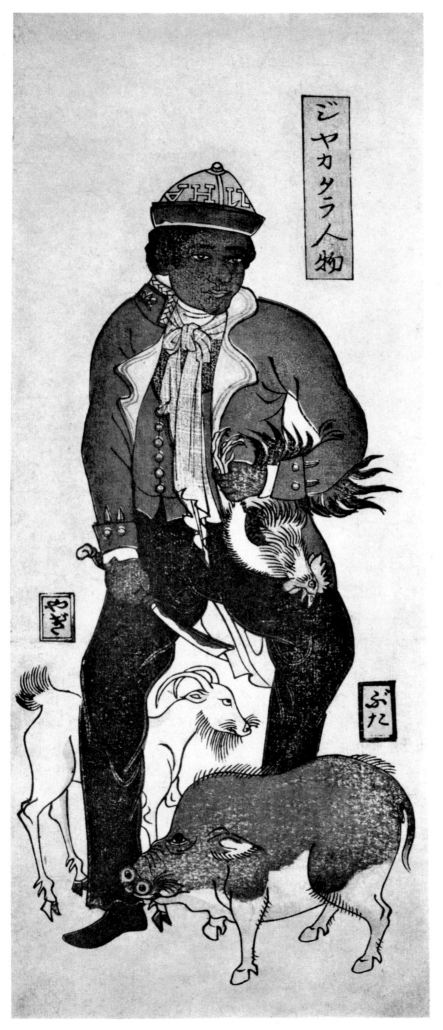

ジャガタラ人物

やぎ

ぶた

ジャガタラ人物之圖
竪一尺三寸九分
横五寸四分

A Batavian Cook
From a Nagasaki colour-print.
Height 42.2 cm. Width 16.5 cm.

PLATE 110

露 西 亞 船 之 圖　竪一尺四寸七分
　　　　　　　　　　横一尺二分

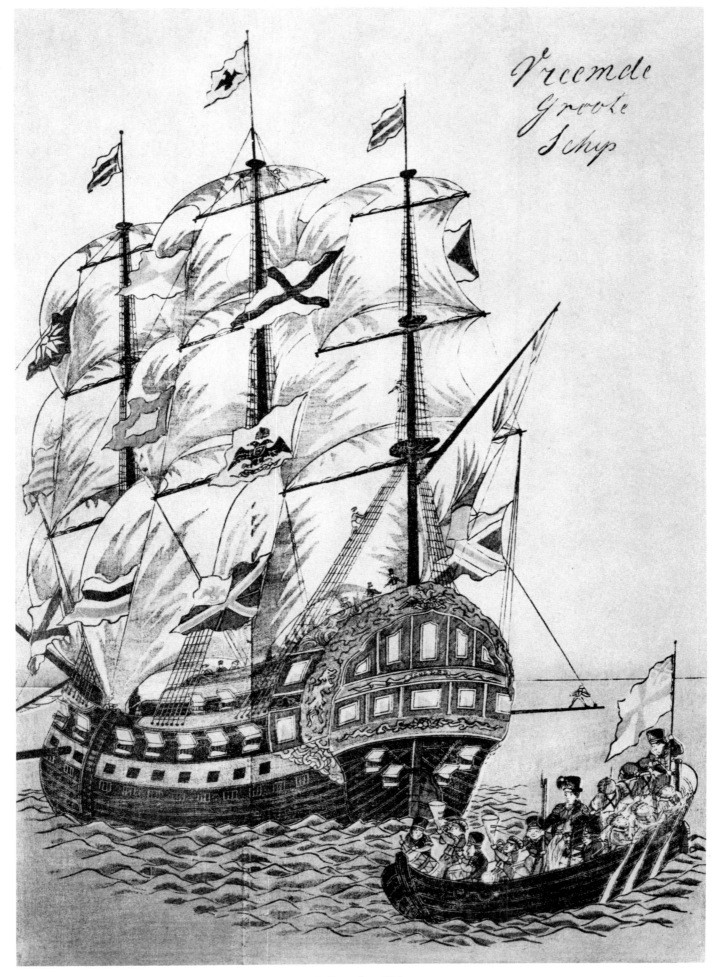

Vreemde
Groote
Schip

A Russian Ship
From a Nagasaki colour-print.
Height 44.6 cm. Width 31 cm.

PLATE 111

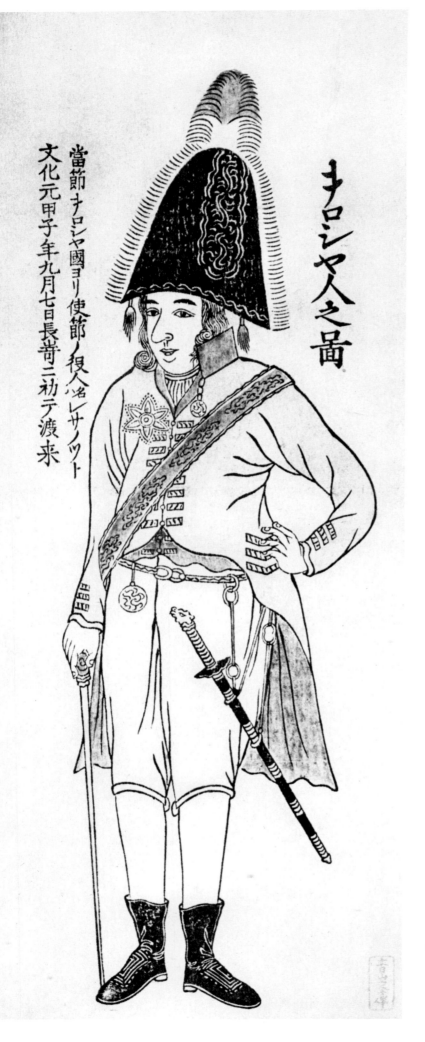

ヲロシヤ人之圖

當節ヲロシヤ國ヨリ使節ノ役人名ハレサノット

文化元甲子年九月七日長崎ニ初テ渡来

キロシヤ人之圖

ヲロシヤ人之圖

堅一尺四寸六分

横五寸九分

The Russian Admiral, Rezanov
From a Nagasaki colour-print.
Height 45.4 cm. Width 18 cm.

PLATE 112

ヲロシヤ人之圖 竪一尺三分
横七寸二分

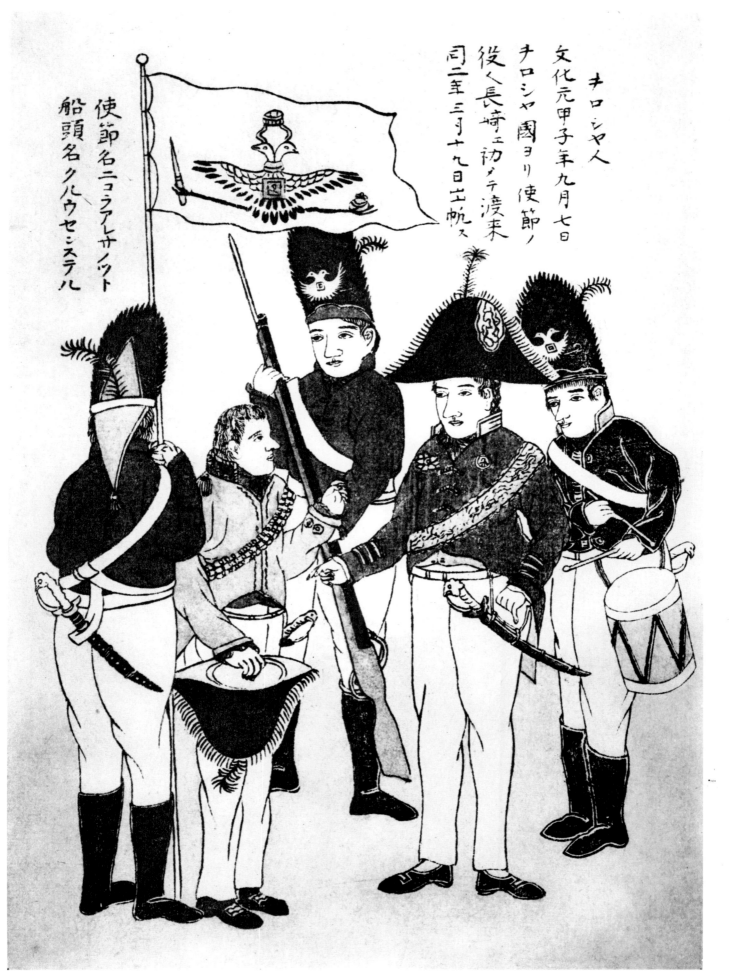

使節名ニコラアレサンツト
船頭名クルウセンステル

チロシヤ人
文化元甲子年九月七日
チロシヤ國ヨリ使節ノ
役人長崎ヱ初メテ渡来
同二年三月十九日出帆ス

Rezanov and his Flag Captain, Krusenstern
From a Nagasaki colour-print.
Height 31.2 cm. Width 21.8 cm.

PLATE 113

バッテイラより見送りの圖　　堅　一尺七分
　　　　　　　　　　　　　横　一尺四寸六分

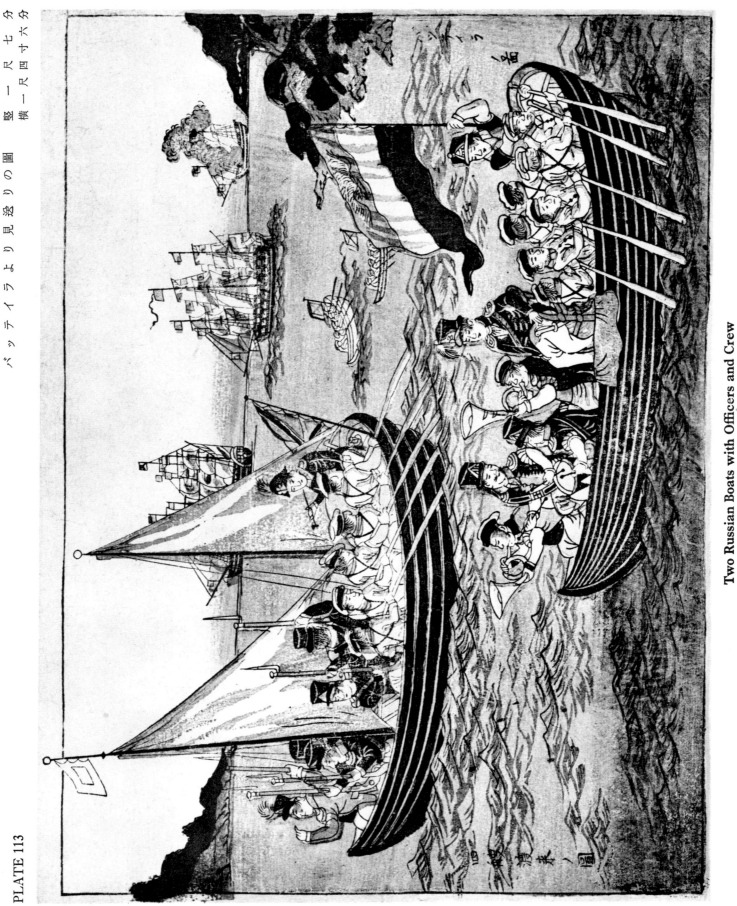

Two Russian Boats with Officers and Crew
From a Nagasaki colour-print.
Height 32.3 cm. Width 44.2 cm.

PLATE 114

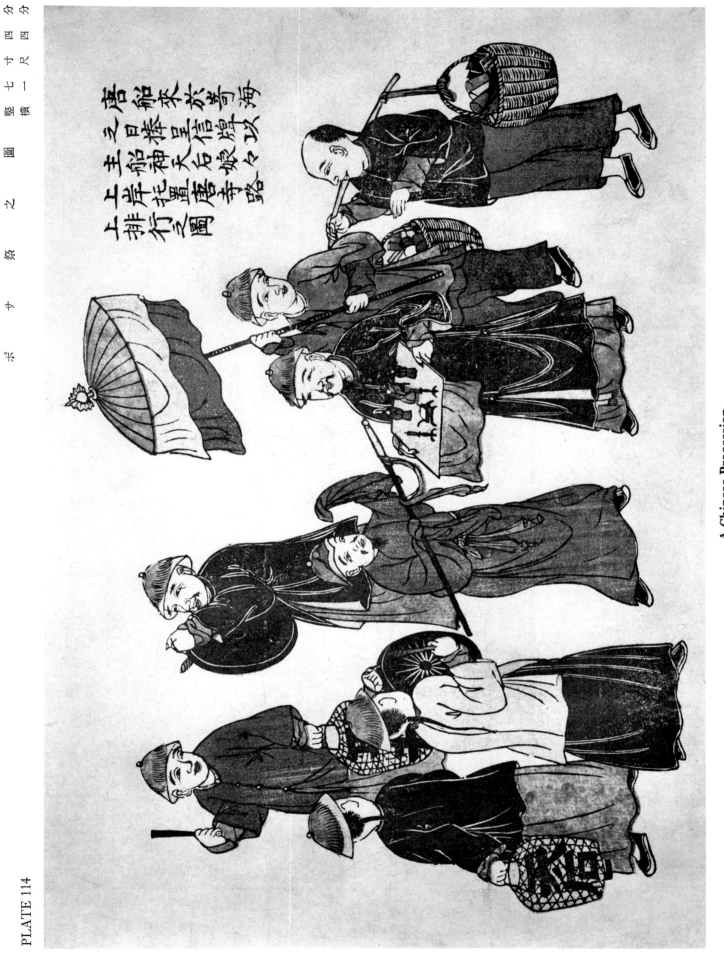

唐船來於寄崎海
之圖唐船呈信牌
主神廟唐寺路々
上岸托置唐寺
排行之圖
日棒天后娘々

ボサ祭之圖　堅一尺四寸七分　横四寸四分

A Chinese Procession
From a Nagasaki colour-print.
Height 22.5 cm. Width 31.4 cm.

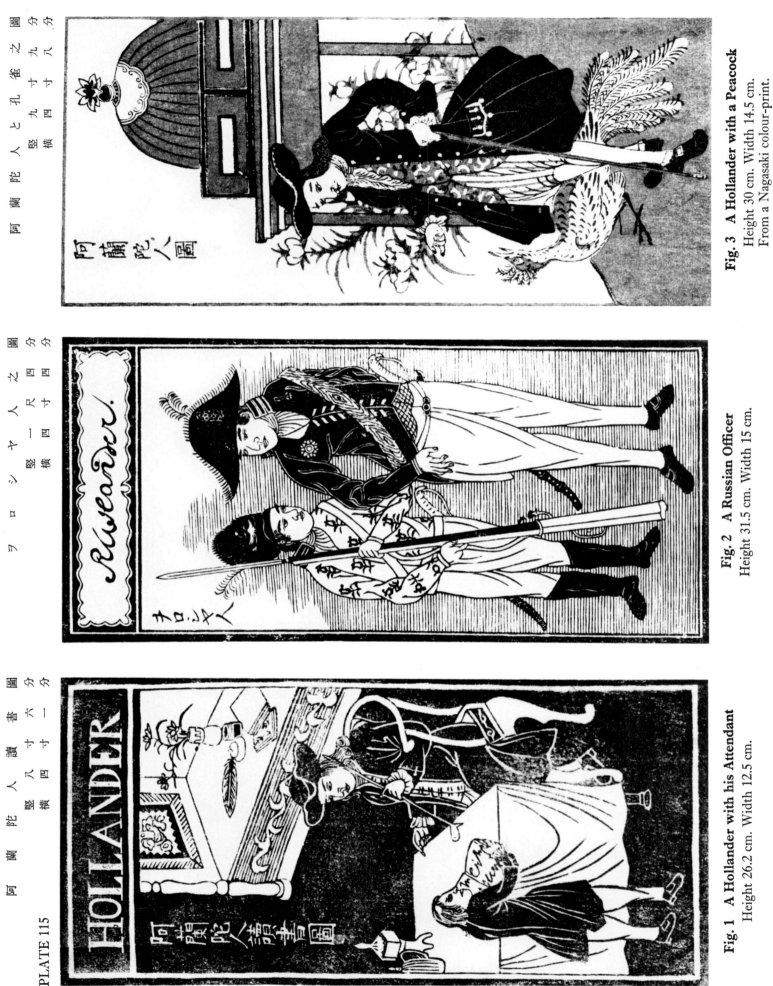

阿蘭陀人讀書圖
竪六寸一分
横四寸四分

ラ ュ シ ヤ 人 之 圖
竪一尺四寸
横四寸四分

阿蘭陀人と孔雀之圖
竪九寸八分
横四寸九分

PLATE 115

Fig. 1 A Hollander with his Attendant
Height 26.2 cm. Width 12.5 cm.

Fig. 2 A Russian Officer
Height 31.5 cm. Width 15 cm.

Fig. 3 A Hollander with a Peacock
Height 30 cm. Width 14.5 cm.
From a Nagasaki colour-print.

PLATE 116

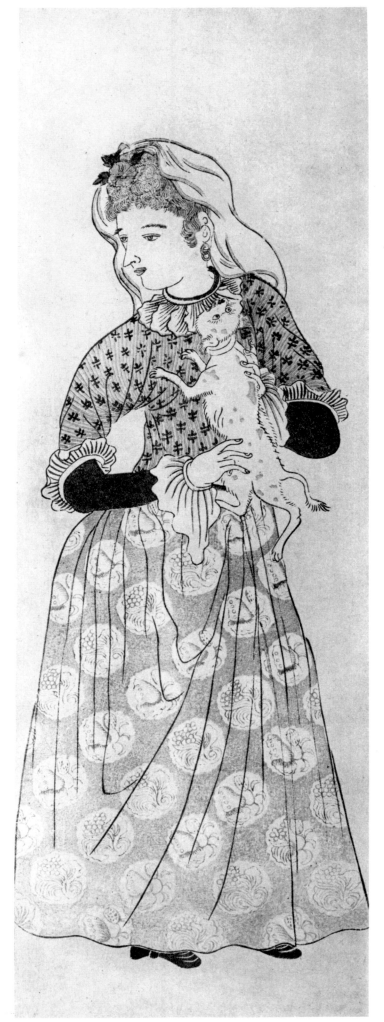

阿蘭陀美人と狆之圖

竪一尺四寸八分

横四寸六分

A Dutch Lady with her Dog
From a Nagasaki colour-print.
Height 44.8 cm. Width 14 cm.

PLATE 117

阿 蘭 陀 人 之 圖
竪 一 尺 四 寸 八 分
横 五 寸 三 分

ヲロシヤ國の使節之圖
竪 一 尺 五 寸 二 分
横 五 寸 三 分

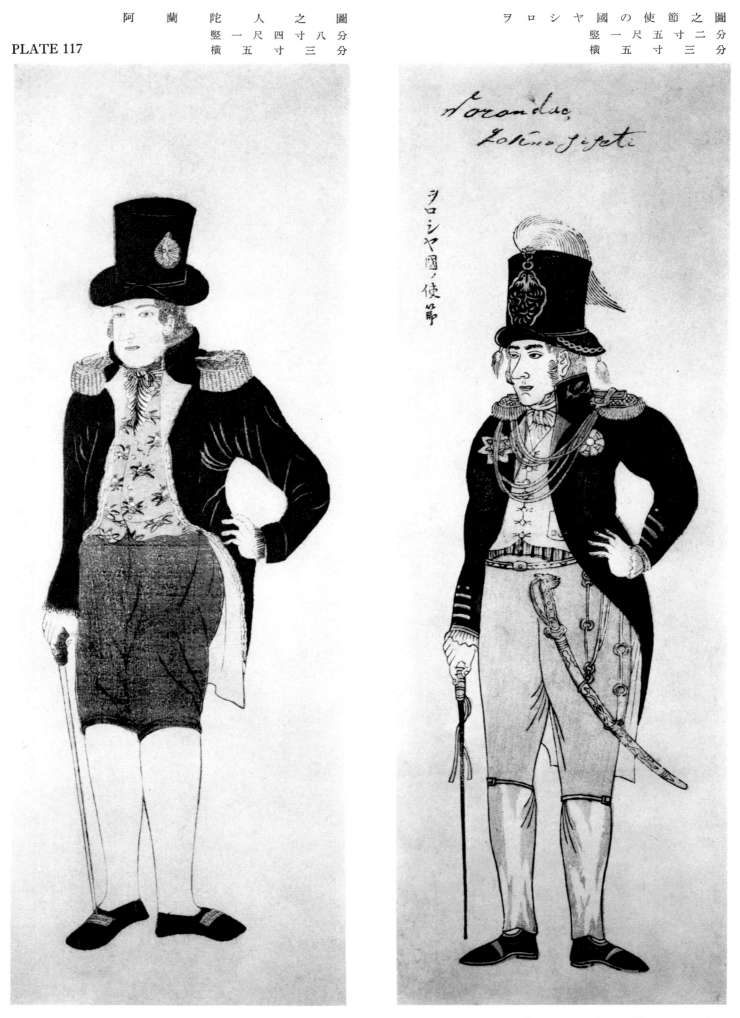

Fig. 1 Portrait of a Foreigner
Height 45 cm. Width 16 cm.

Fig. 2 Portrait of a Russian Officer
Height 46 cm. Width 16 cm.

From a Nagasaki colour-print.

PLATE 118

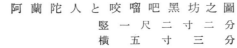

阿蘭陀人と咬𠺕吧黒坊之圖
竪一尺二寸二分
横　五　寸　三　分

望遠鏡を持つ阿蘭陀人之圖
竪一尺四寸七分
横　四　寸　三　分

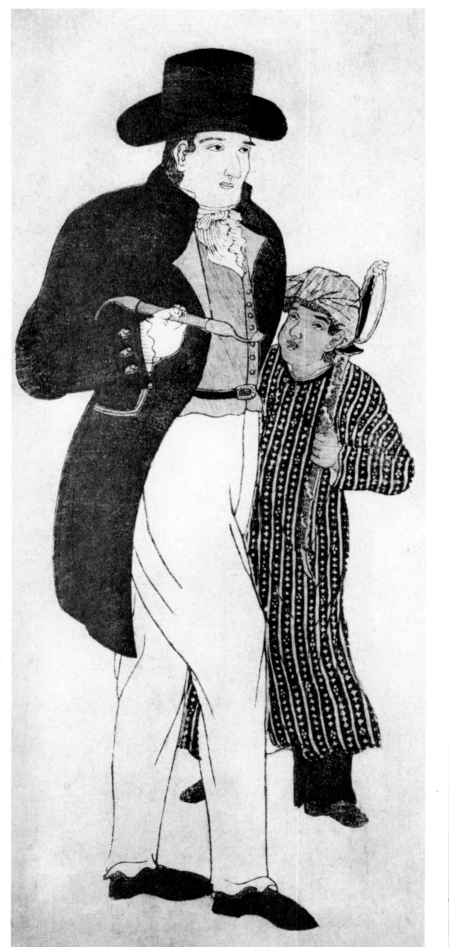

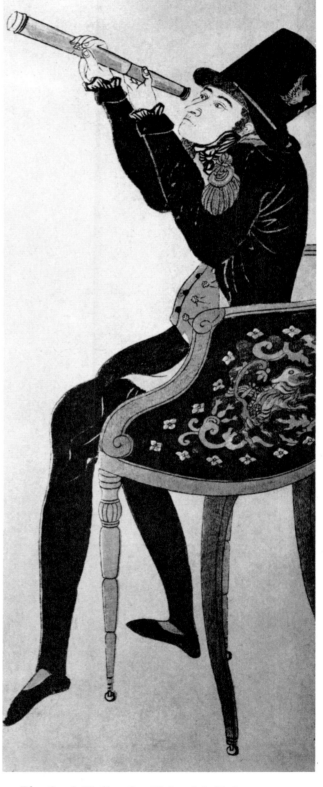

Fig. 1 A Hollander with his Javanese Attendant
Height 36.8 cm. Width 16 cm.
From a Nagasaki colour-print.

Fig. 2 A Hollander Using his Telescope
Height 44.5 cm. Width 13 cm.

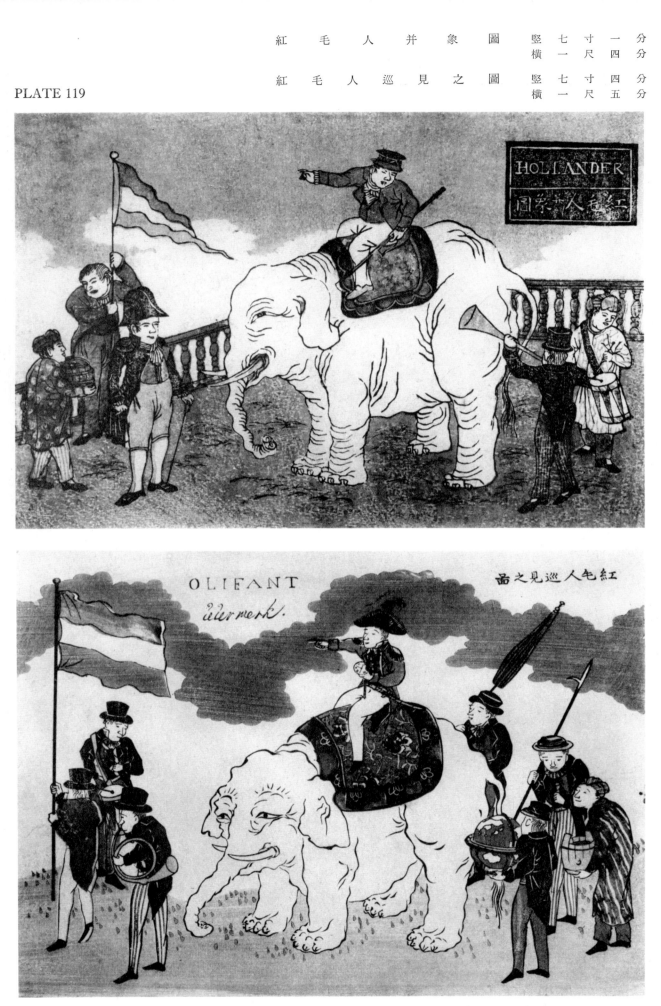

Figs. 1 and 2　A Dutch Procession with a Hollander Seated on an Elephant
From a Nagasaki colour-print.
Fig. 1　Height 21.5 cm. Width 31.5 cm.
Fig. 2　Height 22.5 cm. Width 32 cm.

PLATE 120

大清朝人圖
竪一尺四寸六分
横五寸三分

紅毛人遠見之圖
竪一尺三寸三分
横五寸一分

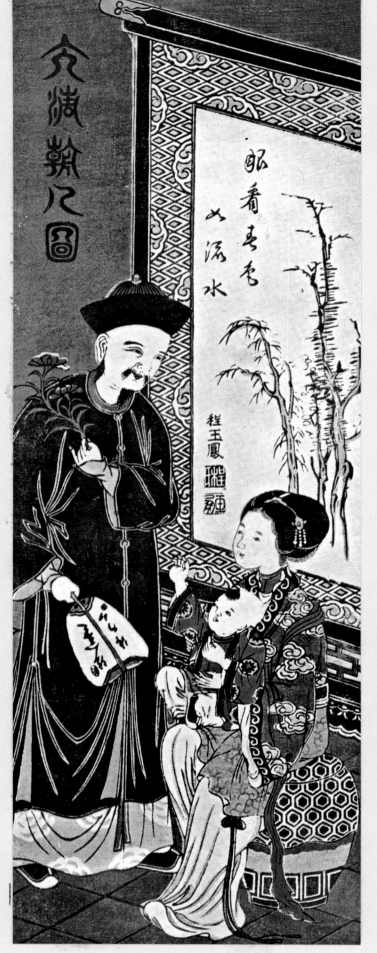

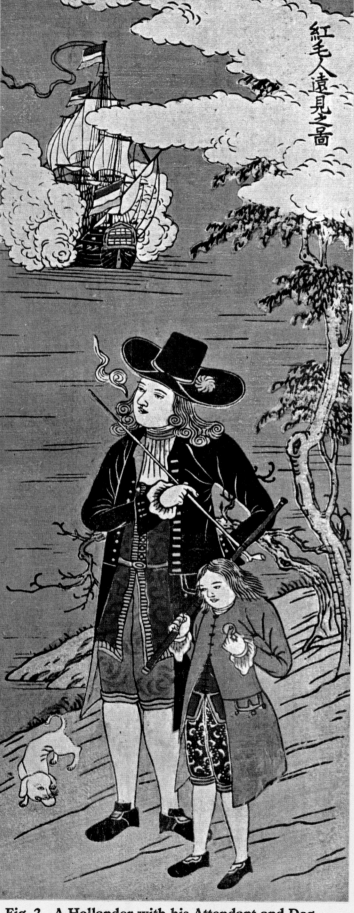

Fig. 1 A Chinese Family
Height 44.3 cm. Width 16 cm.

Fig. 2 A Hollander with his Attendant and Dog
Height 40.3 cm. Width 15.5 cm.

From a Nagasaki colour-print.

PLATE 121

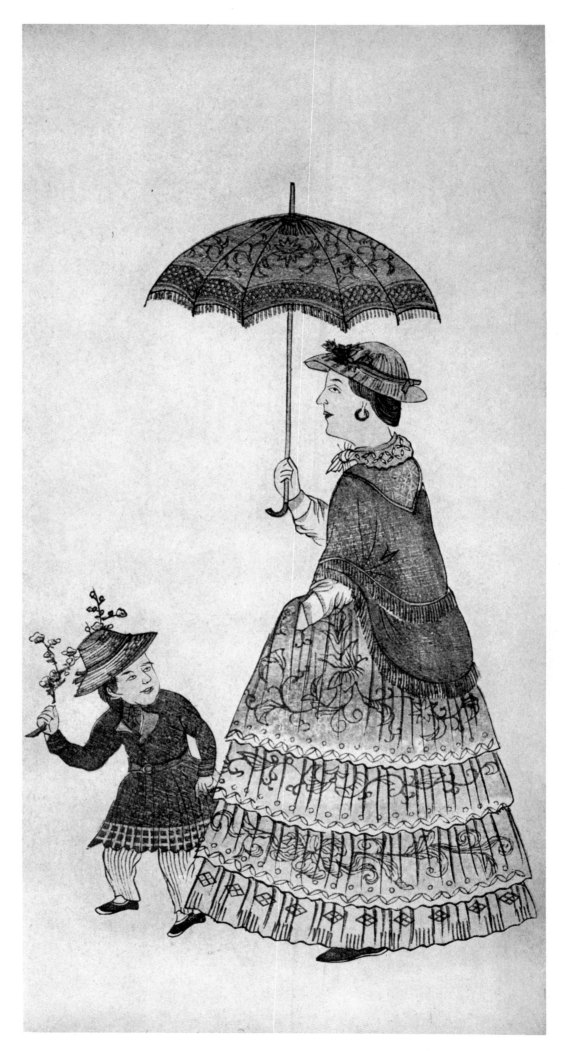

阿蘭陀美人と小人之圖
竪一尺四寸八分
横七寸五分

A Dutch Lady with her Child
From a Nagasaki colour-print.
Height 44.8 cm. Width 22.5 cm.

PLATE 122

唐　船　之　圖　　堅一尺五寸三分
唐　子　遊　之　圖　　横一尺二分

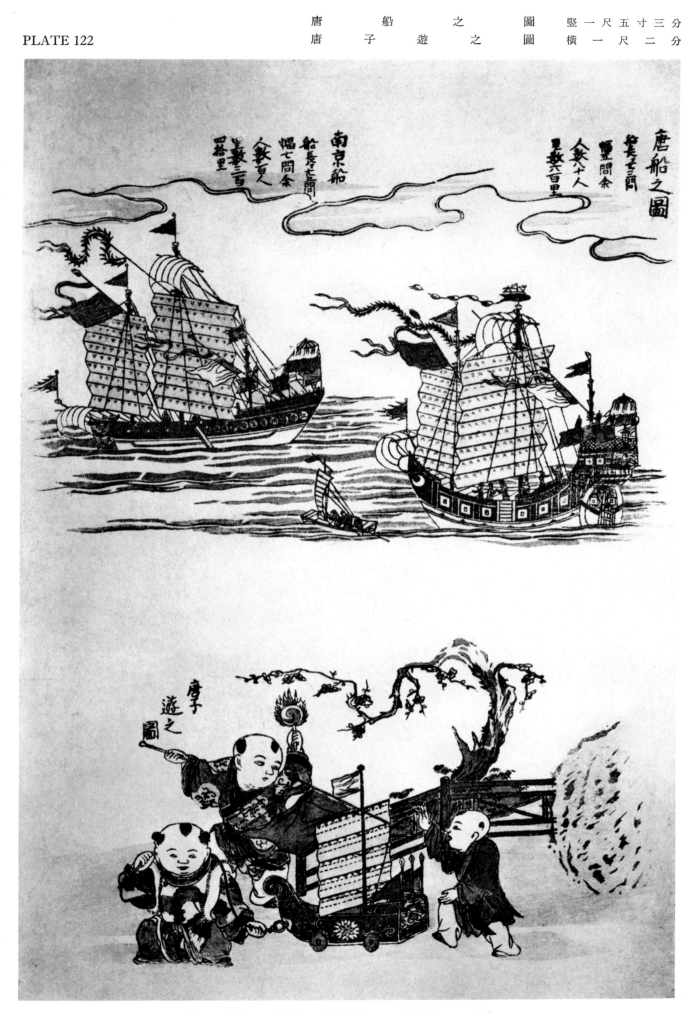

Two Chinese Ships with Chinese Children at Play
From a Nagasaki colour-print.
Height 46.5 cm. Width 31 cm.

PLATE 123

長崎津江唐人舶上之圖　竪　五　寸　八　分
横　五　寸　六　分

A Chinese Procession, Nagasaki
From a Nagasaki colour-print.
Height 17.5 cm. Width 16.8 cm.

PLATE 124

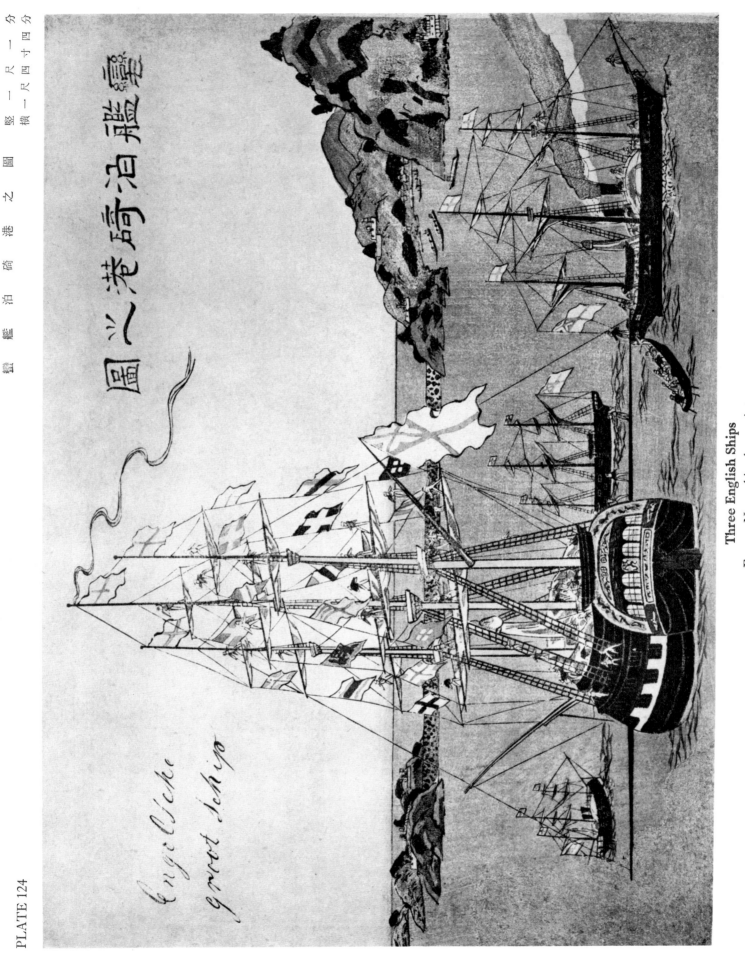

engelsche
groot schip

圖之泊碇港碕長ニ艦軍蘭諳

蘭諳泊碇港碕長之圖　堅一尺一分
　　　　　　　　　横一尺四寸四分

Three English Ships
From a Nagasaki colour-print.
Height 30.6 cm. Width 43.6 cm.

PLATE 125

蒸汽船蘭名ストンボート之圖　竪七寸三分
　　　　　　　　　　　　横一尺七分

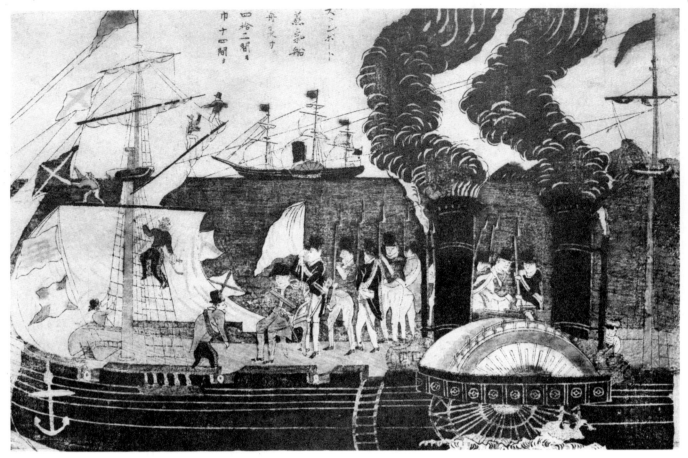

Fig. 1　A Two-Funnel Paddle Steamer
From a Nagasaki Colour-print
Height 22.2 cm. Width 32.5 cm.

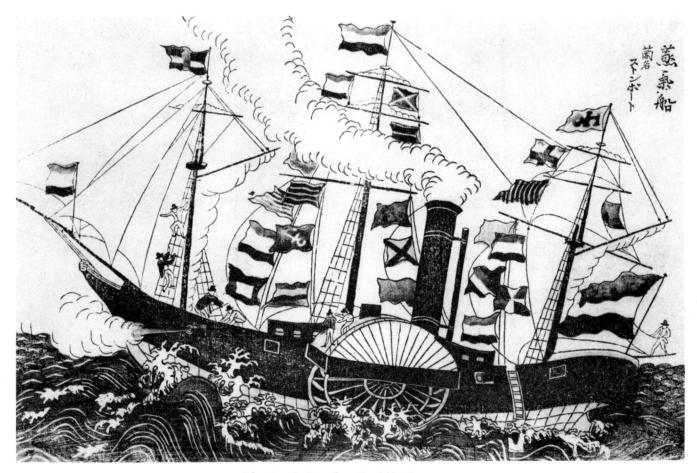

Fig. 2　A Foreign Paddle Steamer
From a Nagasaki colour-print.
Height 22 cm. Width 32.3 cm.

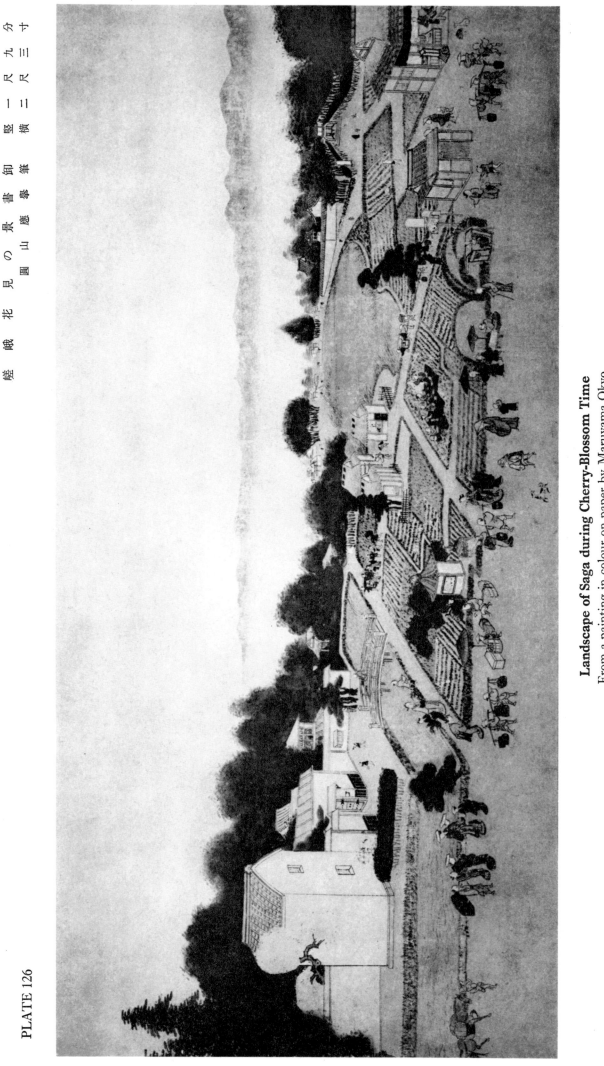

PLATE 126

嵯峨花見の景 圓山應擧筆書畫

竪 二尺一寸九分
橫 二尺三寸三

Landscape of Saga during Cherry-Blossom Time
From a painting in colour on paper by Maruyama Okyo.
Height 33 cm. Width 70 cm.

GREYSCALE

BIN TRAVELER FORM

Cut By _Williams_____ Qty__11____Date_____

Scanned By_____ Qty_____Date_____

Scanned Batch IDs

_____ _____ _____

Notes / Exception

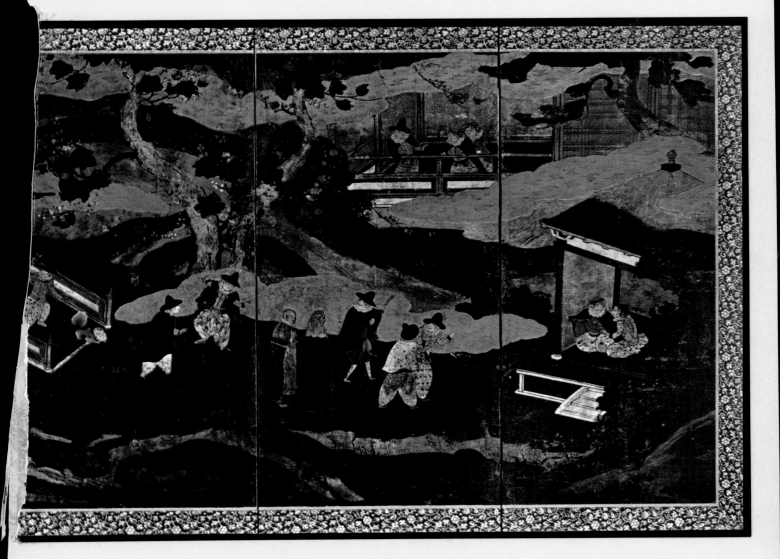

PLATE 127

南蠻屏風　天正頃　高　三　尺
堺南蠻寺庭園ノ景　巾　九　尺

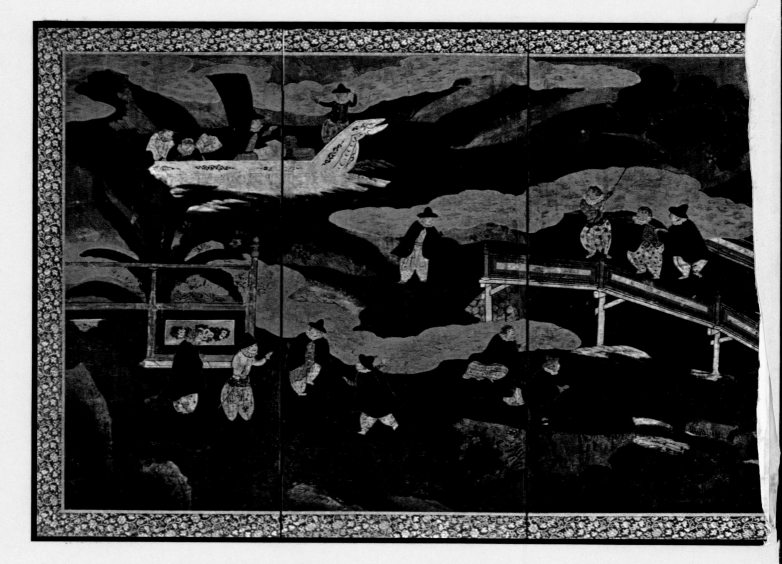

The Portuguese Church, Sakai, with a landscape garden showing Chinese influence.
From a six-fold screen in colour and gold.
Tensho period (1573–1585).
Height 100 cm. Width 273 cm.

PLATE 128

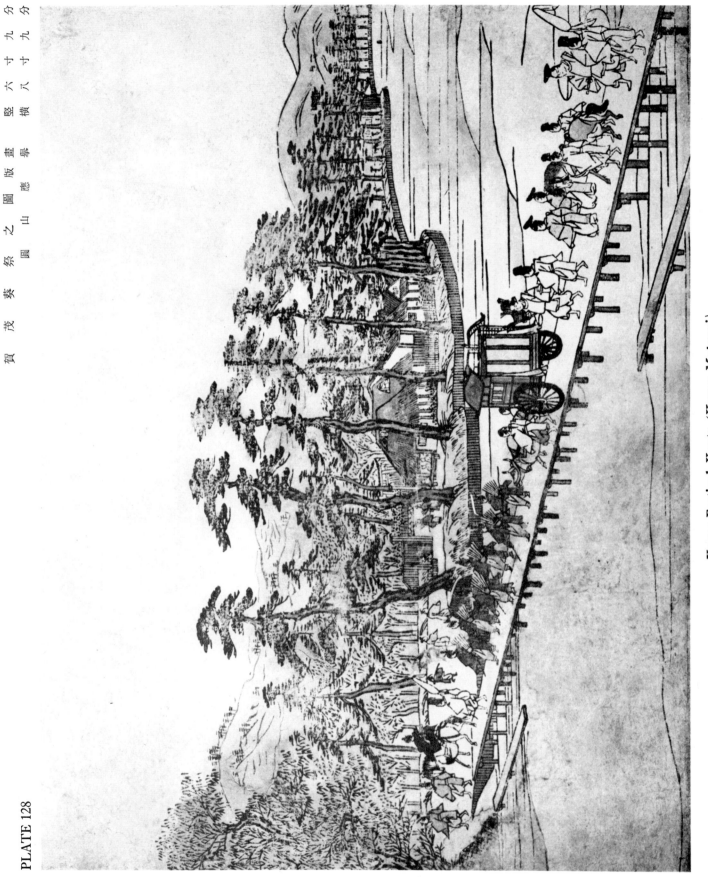

賀茂祭之圖　應舉畫　豎六寸九分　横八寸九分

Kamo Festival, Kyoto (*Kamo Matsuri*)
From a colour-print after Maruyama Okyo.
Height 21 cm. Width 27 cm.

PLATE 129

支 那 風 景 山 圓 應 畫 版 景 堅 横 六 九 寸 尺 三 分 一 二 分

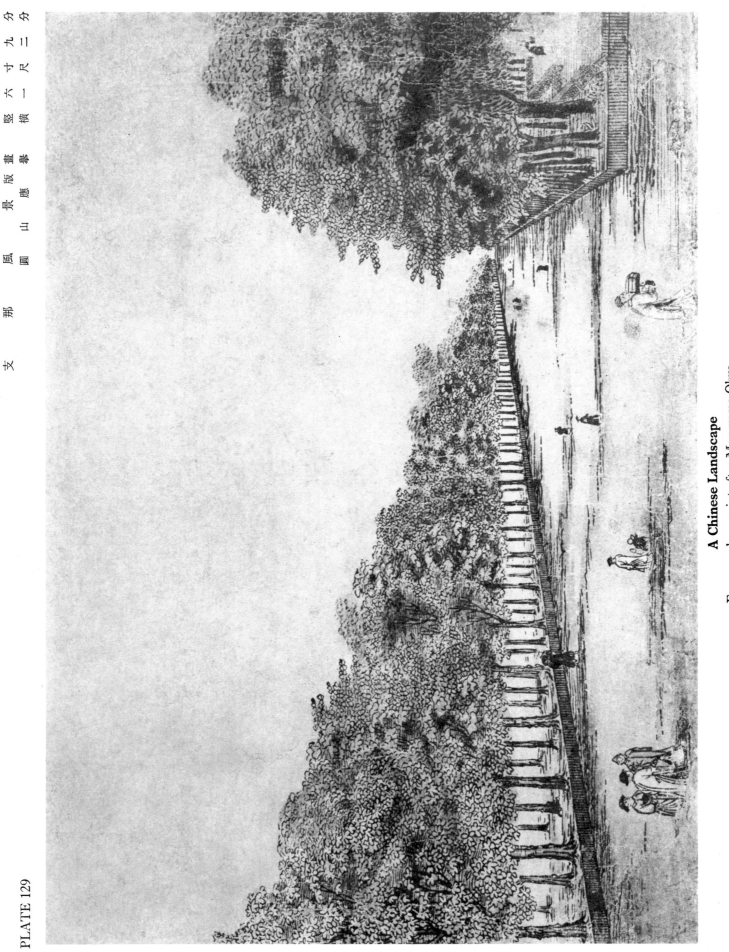

A Chinese Landscape
From a colour-print after Maruyama Okyo.
Height 21 cm. Width 31 cm.

PLATE 130

阿蘭陀ゴブラン織見送りの圖　版畫　　竪一尺二寸九分
松　尾　秀　山　　横　八　寸

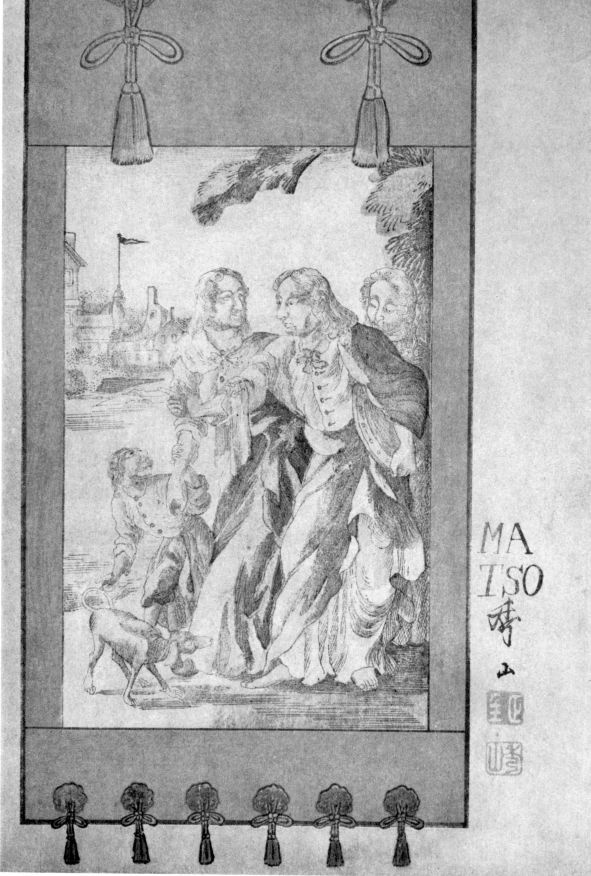

Dutch Figure-Subjects

From a colour-print after Matsuo Shuzan. This print is a copy of a Dutch Tapestry now in the posses-
sion of Kyoto city and used as a decoration for the festival car.

Height 39 cm. Width 24.5 cm.

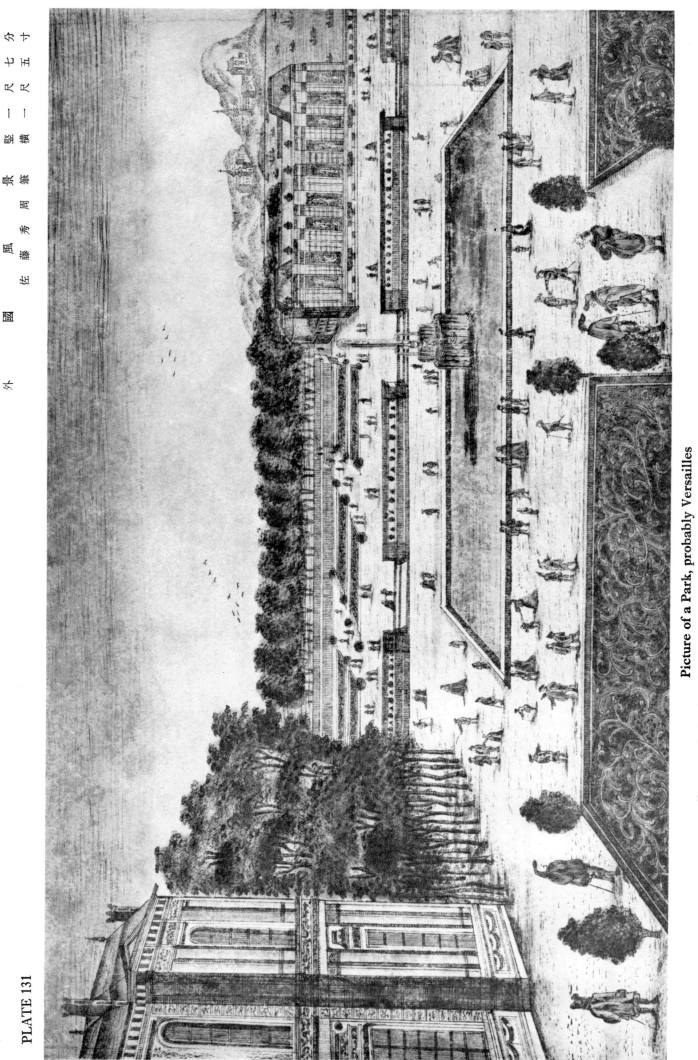

PLATE 131

外 國 鳳 佐 藤 秀 周 景 筆 竪 一 尺 七 分 横 一 尺 五 寸

Picture of a Park, probably Versailles

From a painting in colour by Sato Hidechika. Signed by the artist and dated Tenmei 7 (1787).
Height 32.5 cm. Width 45.5 cm.

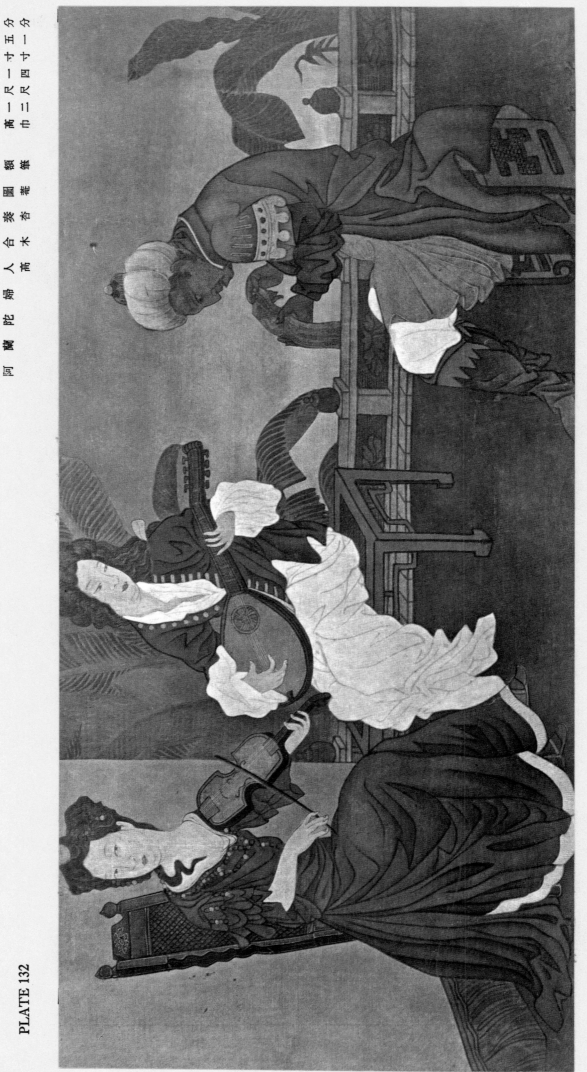

PLATE 132

阿 蘭 陀 婦 人 合 奏 圖 額 高 一 尺 一 寸 五 分
筆 杏 木 毫 巾 三 尺 四 寸 一 分

A Musical Entertainment with Mandolin and Violin
From a painting in colour on silk. Unknown Artist.
Height 35 cm. Width 73 cm.

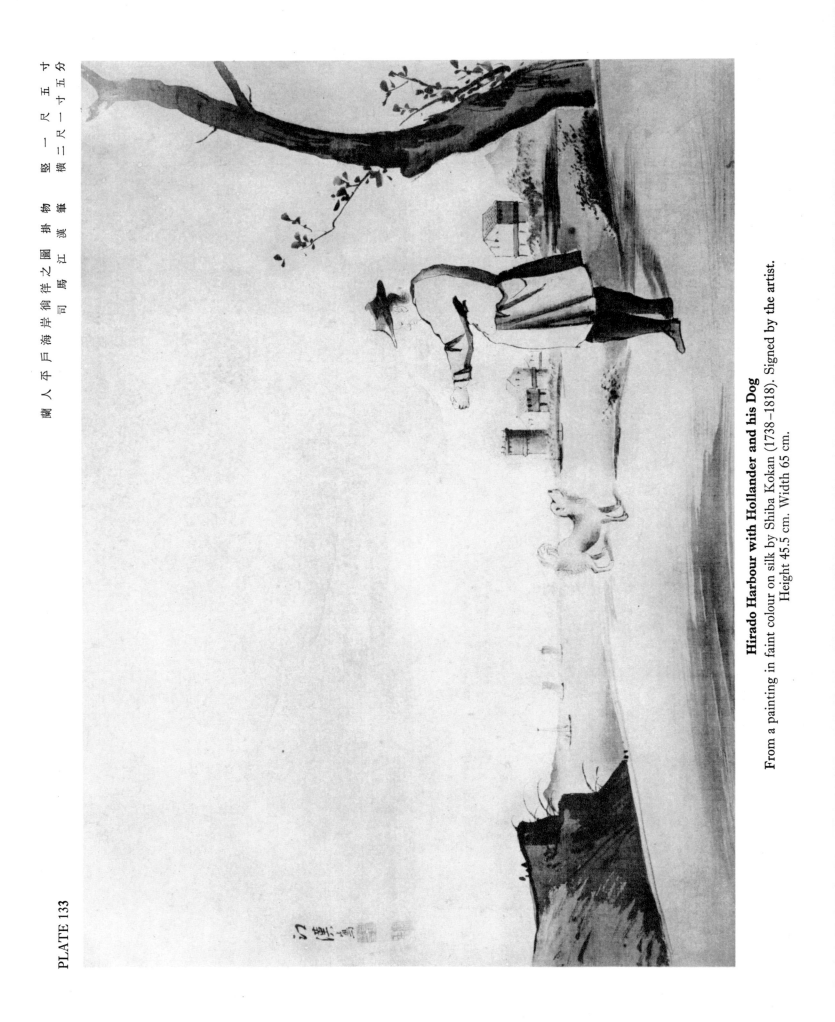

PLATE 133

蘭人平戸海岸偸伴之圖　司馬江漢筆　掛物　竪一尺五寸　横二尺一寸五分

Hirado Harbour with Hollander and his Dog

From a painting in faint colour on silk by Shiba Kokan (1738–1818). Signed by the artist.
Height 45.5 cm. Width 65 cm.

PLATE 134

阿　蘭　陀　船　之　圖　掛　物　　竪一尺八寸九分
　　司　馬　江　漢　筆　　橫一尺七寸五分

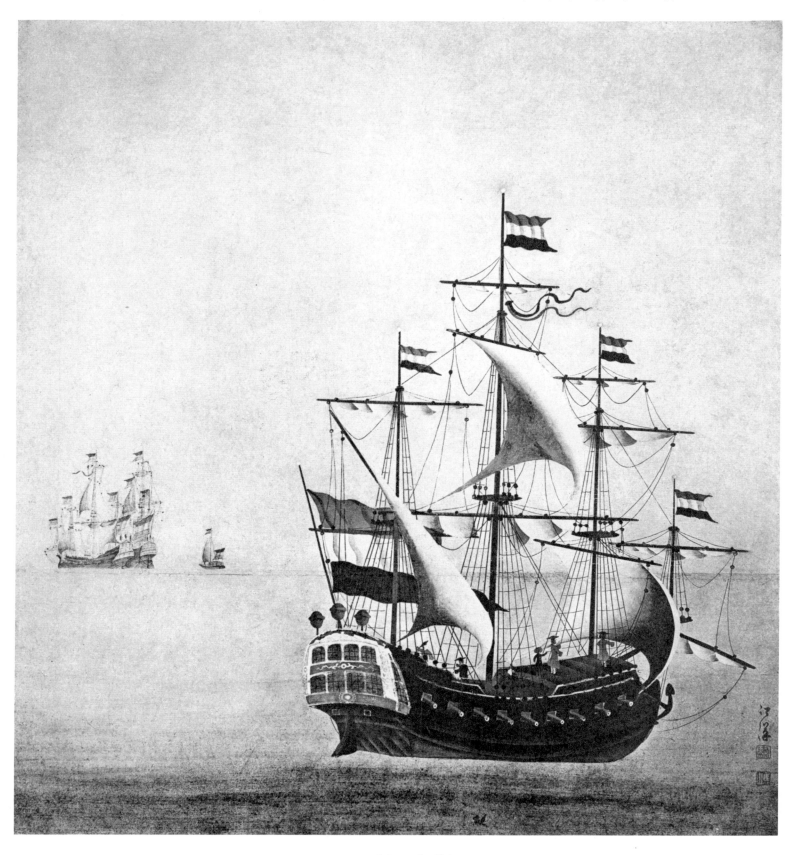

A Dutch Ship
From a painting in colour on paper by Shiba Kokan. Signed by the artist.
Height 57 cm. Width 53 cm.

PLATE 135

異　人　像　二　覩　繪　竪　八　寸
傳　司　馬　江　漢　筆　横　一　尺　五　分

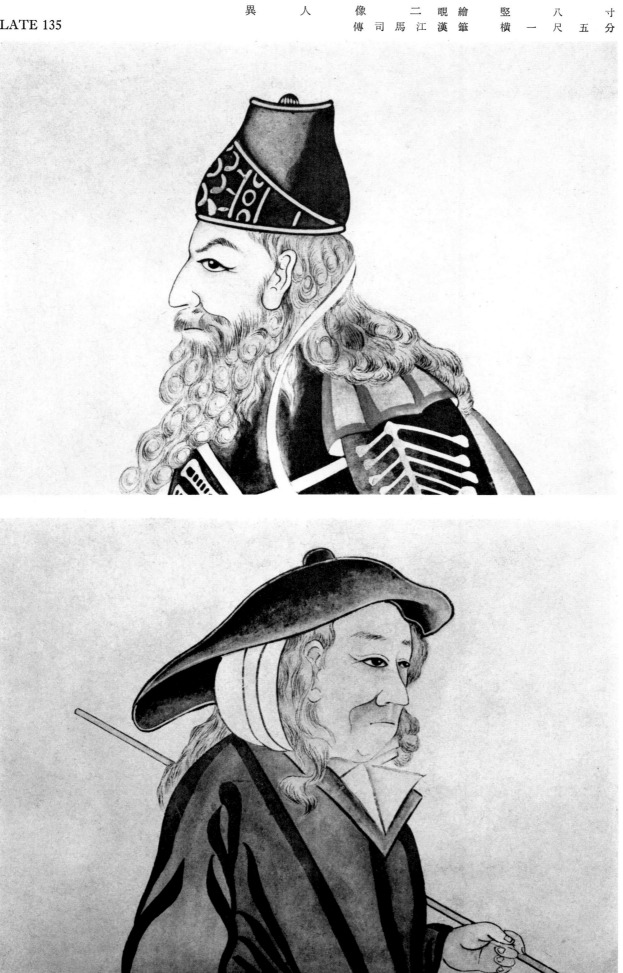

Two Foreign Figure-Subjects
From a painting in colour on paper, attributed to Shiba Kokan.
Height 24 cm. Width 31.5 cm.

PLATE 136

眞　　人　　像　油繪額　　高一尺二寸五分

大久保一丘筆元箱付　　巾　一　尺　五　分

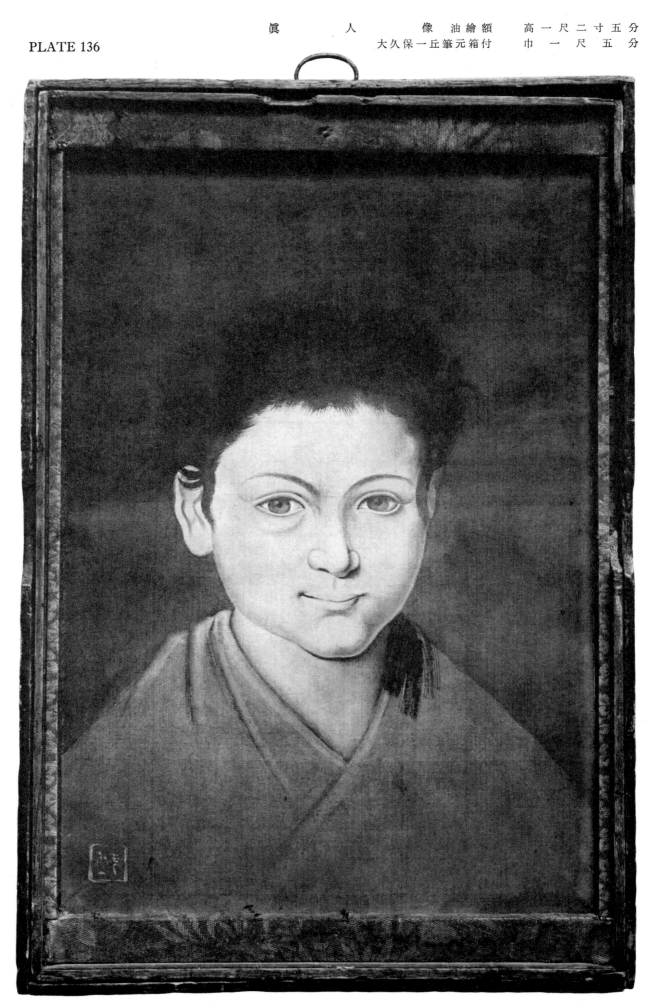

Oil Painting of Christ
By Okubo Ikkyū, a pupil of Kokan. Seal of the artist.
Height 48 cm. Width 32 cm.

PLATE 137

月 ケ 浦 夜 景 繪 物 長三尺九寸七分
亞 歐 堂 田 善 筆 竪 七 寸 四 寸

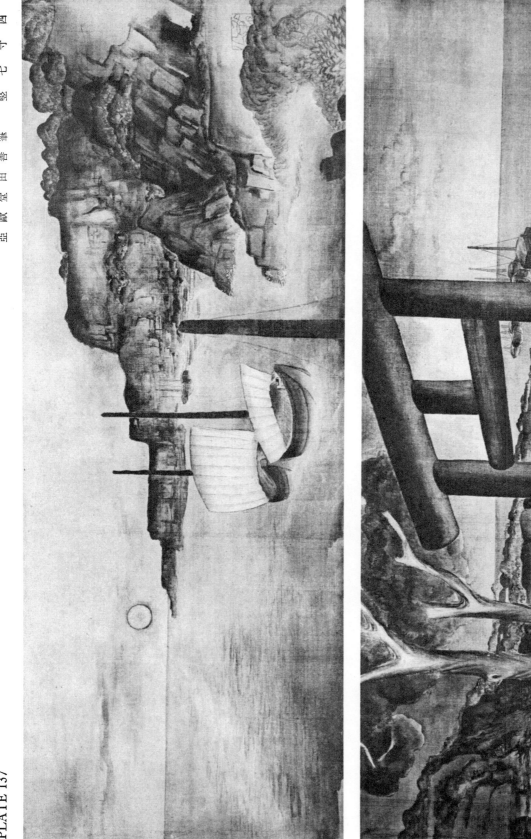

Tsukigaura by Moonlight

From a scroll painting in colour on silk by Aodo Denzen. Seal of the artist.
Length 120.5 cm. Height 22.5 cm.

PLATE 138

ヒツポクラテス肖像掛物　竪一尺九寸一分
石川大浪筆　横一尺六寸

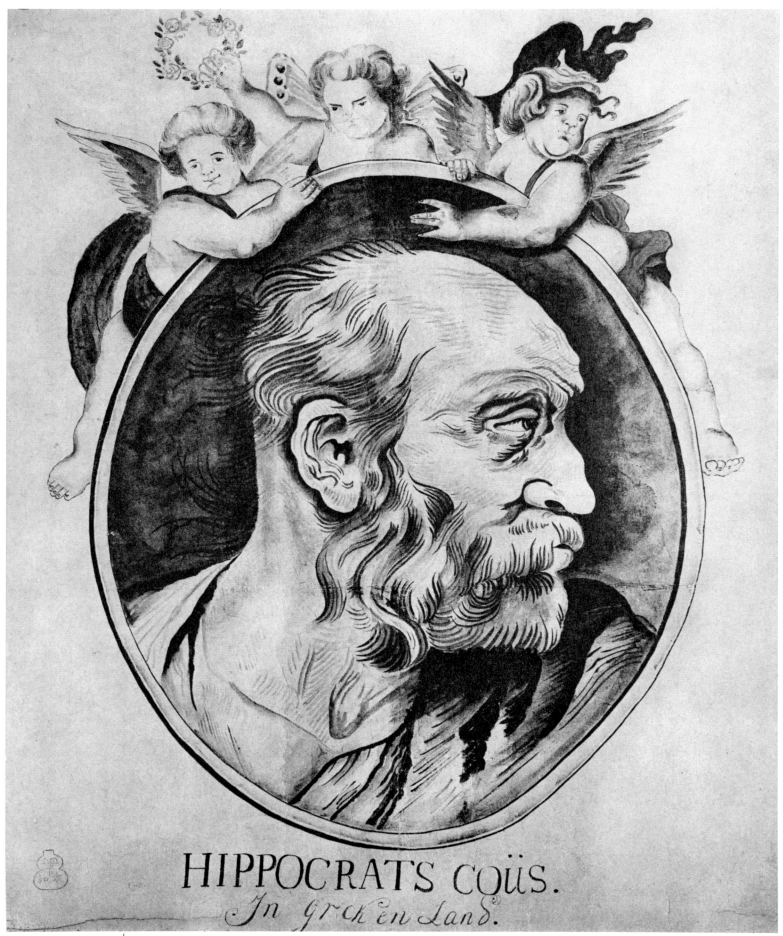

HIPPOCRATS coüs.
In Grœken Land.

Portrait of Hippocrates

From a painting in ink and faint colour on paper by Ishikawa Tairo. Tairo studied the European style of painting in Nagasaki. He died during the Bunsei era (1818–1829).

Height 58 cm. Width 48 cm.

PLATE 139

暫寄高舶泊﨑津怜
兄立山雲雨新鳥眼
初蕚情國色　　桜
是故吾表

雲
亭
高
豪

阿蘭陀人と丸山遊女の圖　掛物
石川大浪筆
竪三尺二寸
横九尺九分

A Maruyama Beauty and a Hollander
From a painting in ink and faint colour on paper by
Ishikawa Tairo.
Height 97 cm. Width 30 cm.
(Kuroda Collection)

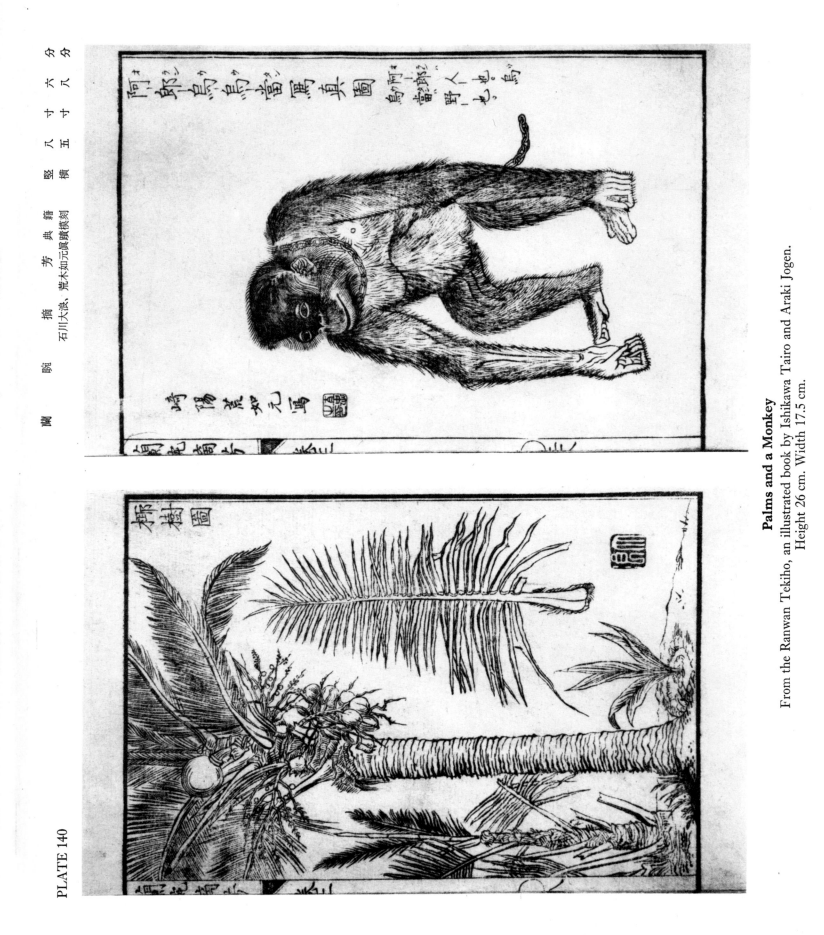

PLATE 140

Palms and a Monkey

From the Ranwan Tekiho, an illustrated book by Ishikawa Tairo and Araki Jogen.
Height 26 cm. Width 17.5 cm.

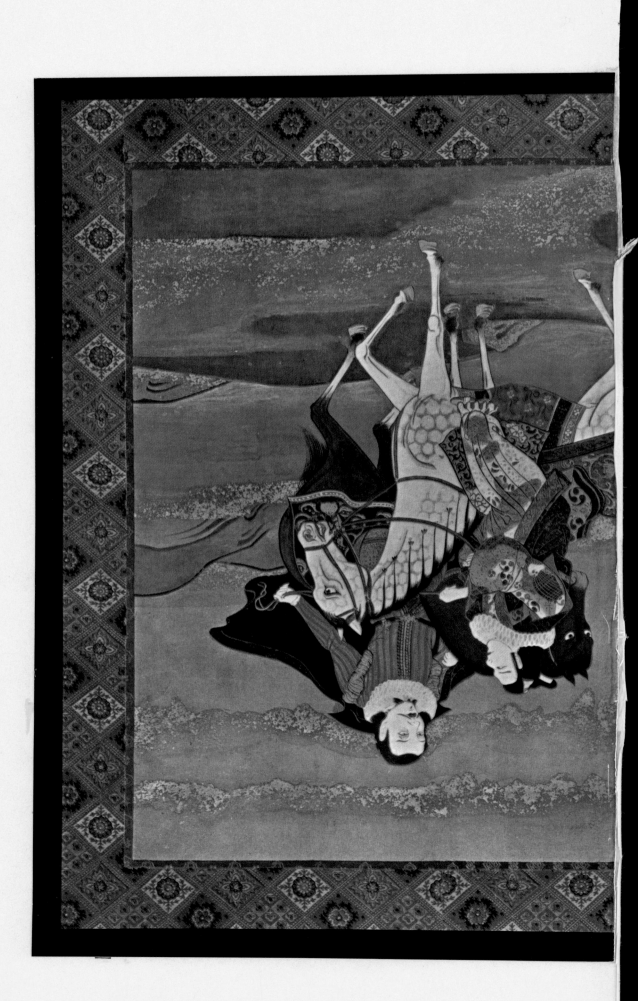

PLATE 141

異、邦、騎馬武士之圖　二枚折
高二尺二寸八分
巾二尺九寸七分

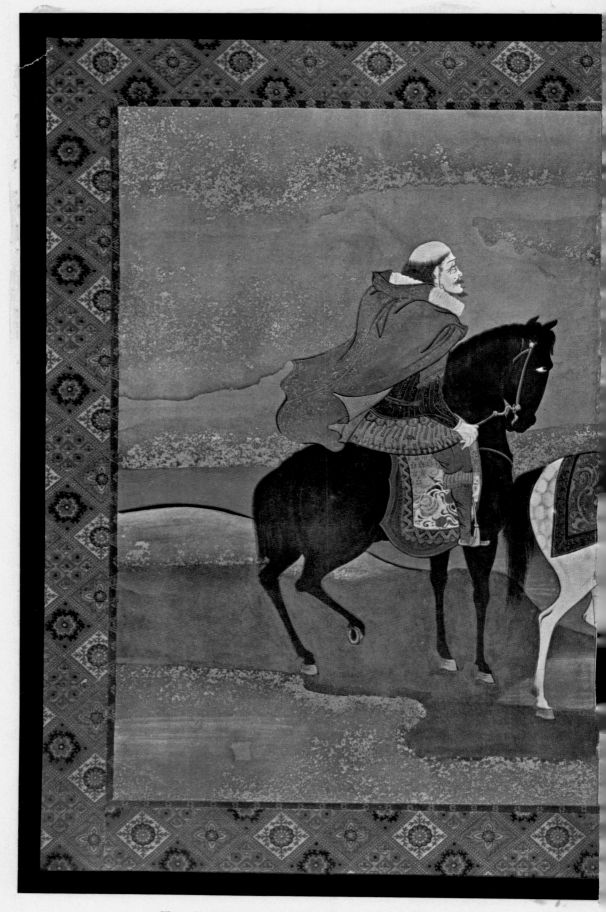

Two Foreigners and a Japanese on Horseback

From a two-fold screen in colours on gold ground. The Japanese is supposed
to represent Hazekura Rokuemon, Envoy to Rome, who went on a Mission to
the Pope. Unknown Artist.

Height 69 cm. Width 90 cm.

PLATE 142

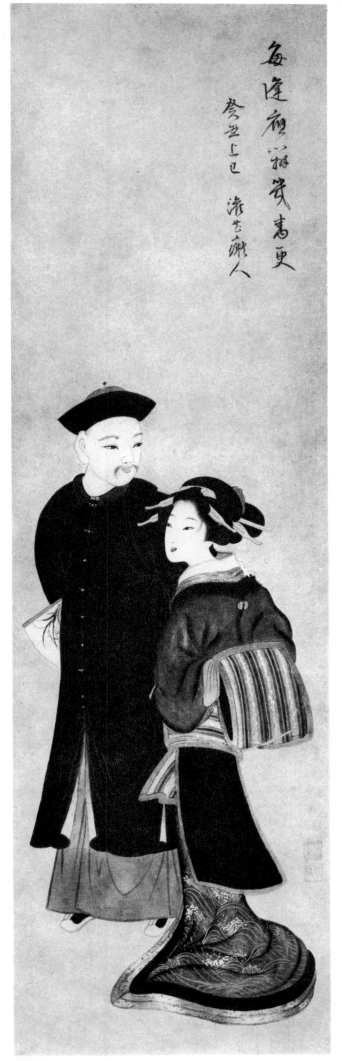

丸山遊女と唐人之圖 掛物

渡邊如山筆

堅三尺三寸一分

横九寸二分

A Maruyama Beauty and a Chinese

From a painting in colour by Watanabe Nyozan with seal of the artist (Kwatei).

The following is a free translation of the somewhat cryptic inscription by Kankwa Chijin, seen in the upper part of the picture:

Amid pleasure-seekers, her partner changes every night.

Height 100.5 cm. Width 28 cm.

PLATE 143

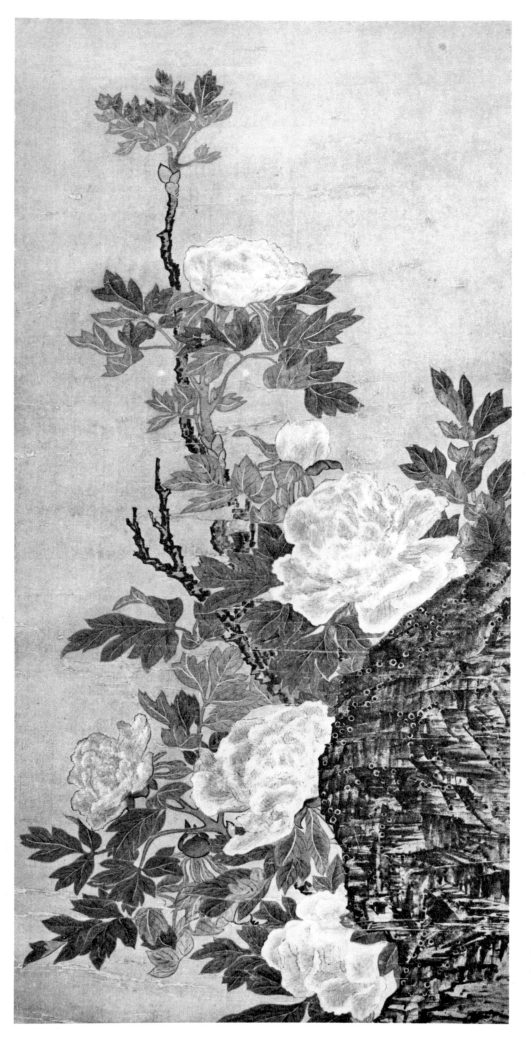

巌
に
牡
丹
之
圖
掛
物

小
田
野
直
武
筆

竪
二
尺
四
寸
二
分

横
一
尺
一
寸
五
分

Peony Blooms and Rock

From a painting in colour on silk by
Odano Naotake, a samurai painter of
Akita.

Height 73.5 cm. Width 35 cm.

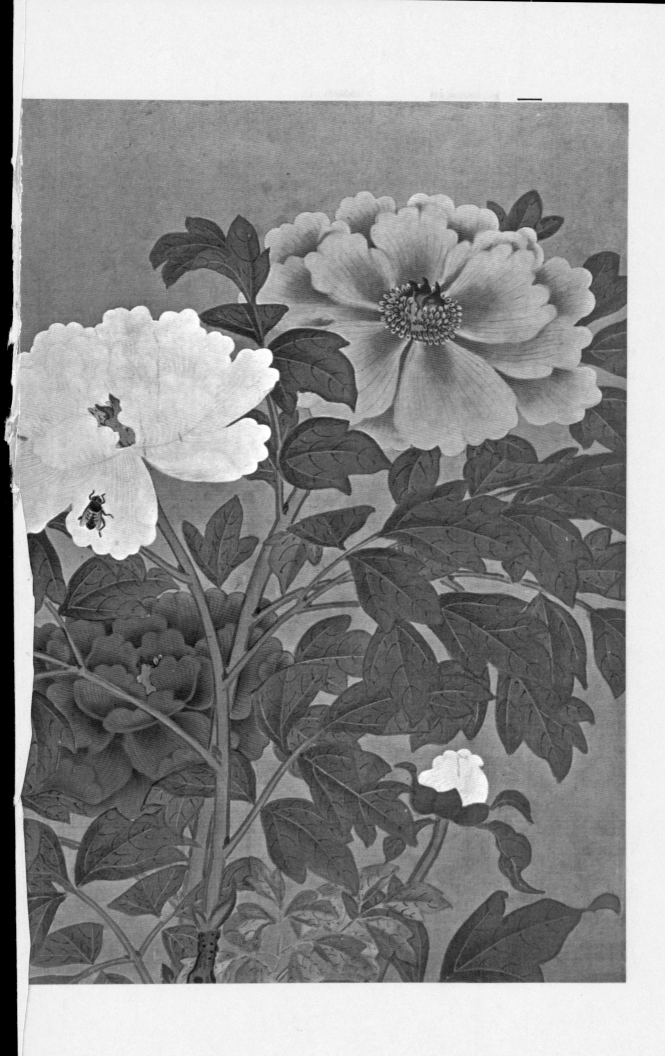

PLATE 144

蝶
に
牡
丹
の
圖
書
卸

佐
竹
曙
山
筆

堅
一
尺
五
分

横
一
尺
四
寸
三
分

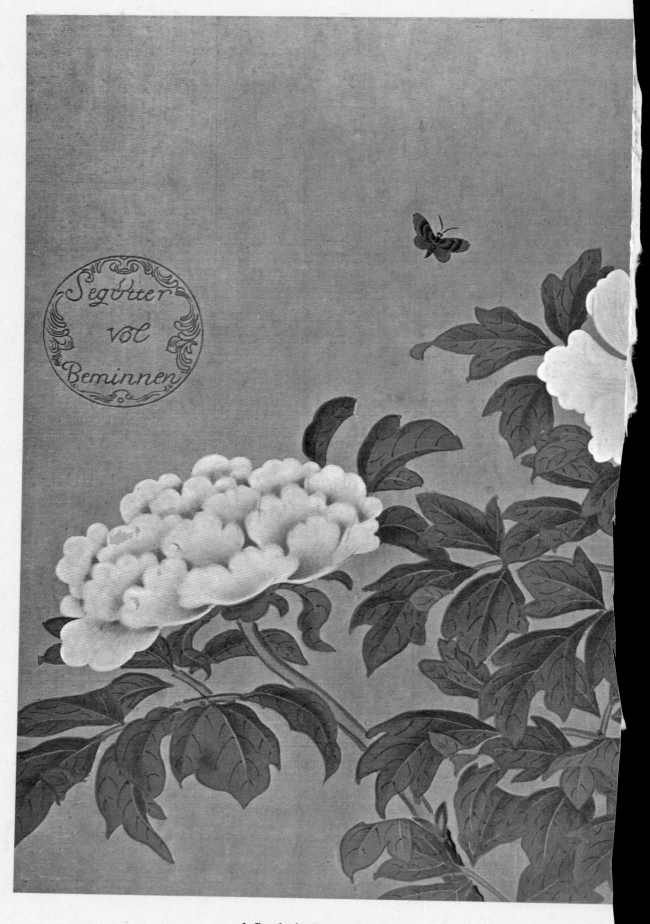

A Study in Peony Blooms

From a painting in colour on paper by Satake Shozan, a samurai painter of Akita. Among the seals used by Satake Shozan were three on which Dutch letters were engraved and of which he was especially fond. The seal shown on the print is the second of these seals.

Height 32 cm. Width 43.5 cm.

PLATE 145

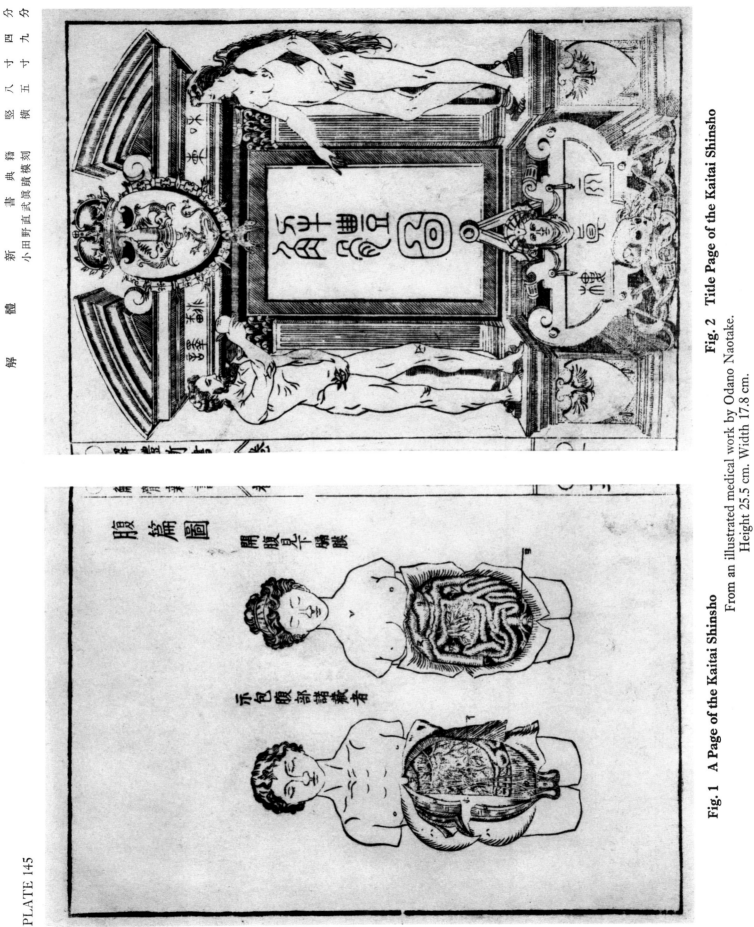

解　體　新　書　典　籍　書　堅　横
　　　　　　　小田野直武武員摸刻　八　五
　　　　　　　　　　　員讀摸刻　寸　寸
　　　　　　　　　　　　　　　　四　九
　　　　　　　　　　　　　　　　分　分

Fig. 1 A Page of the Kaitai Shinsho

Fig. 2 Title Page of the Kaitai Shinsho

From an illustrated medical work by Odano Naotake.
Height 25.5 cm. Width 17.8 cm.

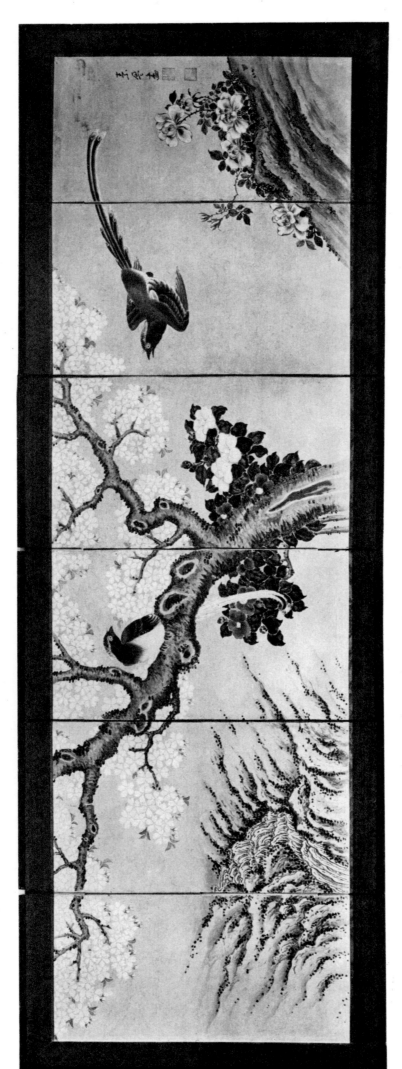

Mountain Landscape with Pheasants, Cherry Blossoms and a Waterfall
From a six-fold screen in colour by Satake Yoshimi, a samurai painter of Akita.
Height 46 cm. Width 182 cm.

PLATE 147

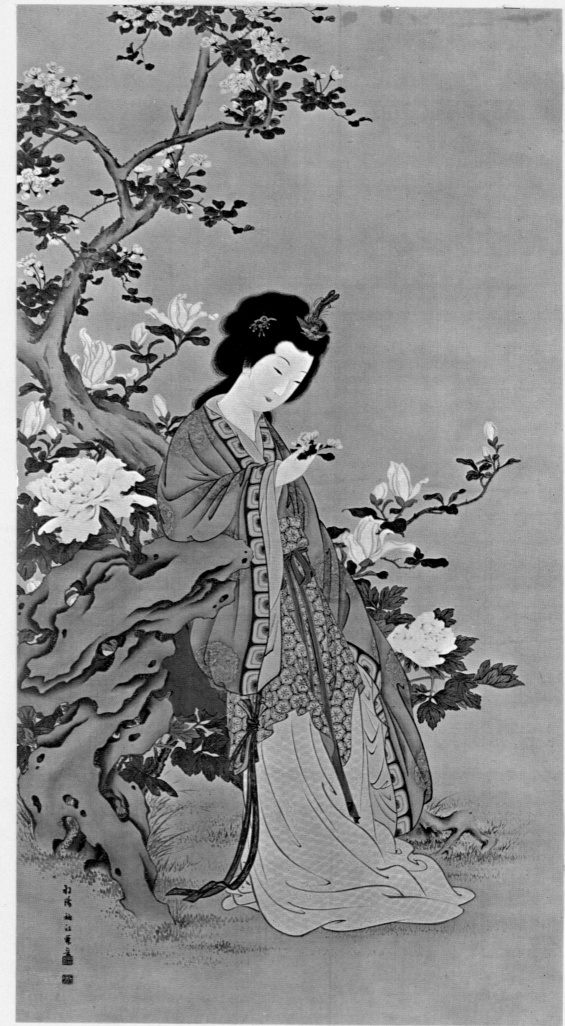

楊貴妃之圖　掛物
關袖江筆
竪四尺三寸二分
横二尺二寸八分

The Celebrated Chinese Beauty, Yokihi, for whom the Emperor left his Throne

From a painting in colour on silk by Seki Shuko, a painter of the Akita school of European painting. He was born during the Enkyō era (1744–1747) and died during the Bunkwa era (1804–1817).
Height 131 cm. Width 69 cm.

隱元和尚肖像掛物
傳喜多元規筆
竪三尺九寸三分
横九寸四分

鐵心和尚遊山之圖掛物
傳喜多元規筆
竪三尺五寸九分
横一尺二寸七分

Fig. 1 A Portrait of Tesshin Osho

From a painting in colour on paper attributed to Kita Genki.
Height 109 cm. Width 28.5 cm.
(Shofukuji Collection)

Fig. 2 A Portrait of the Chinese Priest, Ingen Zenshi

From a painting in colour on paper attributed to Kita Genki.
In 1661, Ingen founded the monastery of Obaku San, near Uji,
and a fief of five hundred *koku* of rice was granted his temple.
Height 119 cm. Width 28.5 cm.

PLATE 148

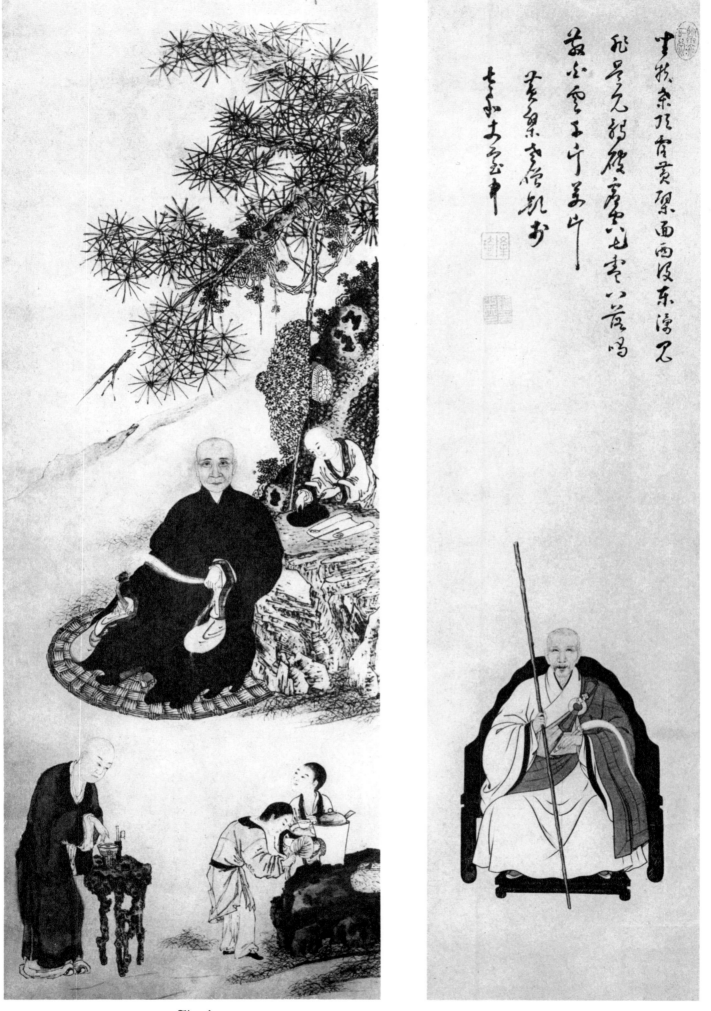

Fig. 1

Fig. 2

Fig. 1 Chrysanthemum Blooms

From a painting in colour on paper by Watanabe Shuseki, a celebrated painter of the Itsunen school.

Height 134 cm. Width 30 cm.

Fig. 2 Daruma

From a painting in colour on silk by Itsunen, a Chinese priest who came over to Japan in 1644 as the Abbot of the Kofukuji, a temple in Nagasaki. Signed by the artist and inscribed: "Piously drawn by priest Itsunen, after burning incense, on a lucky day in the seventh month of the fourth year of the Kwanbun era (1664)." Itsunen died in Nagasaki in the eighth year of the Kwanbun era (1668) at the age of sixty-seven.

Height 90 cm. Width 34 cm.

PLATE 149

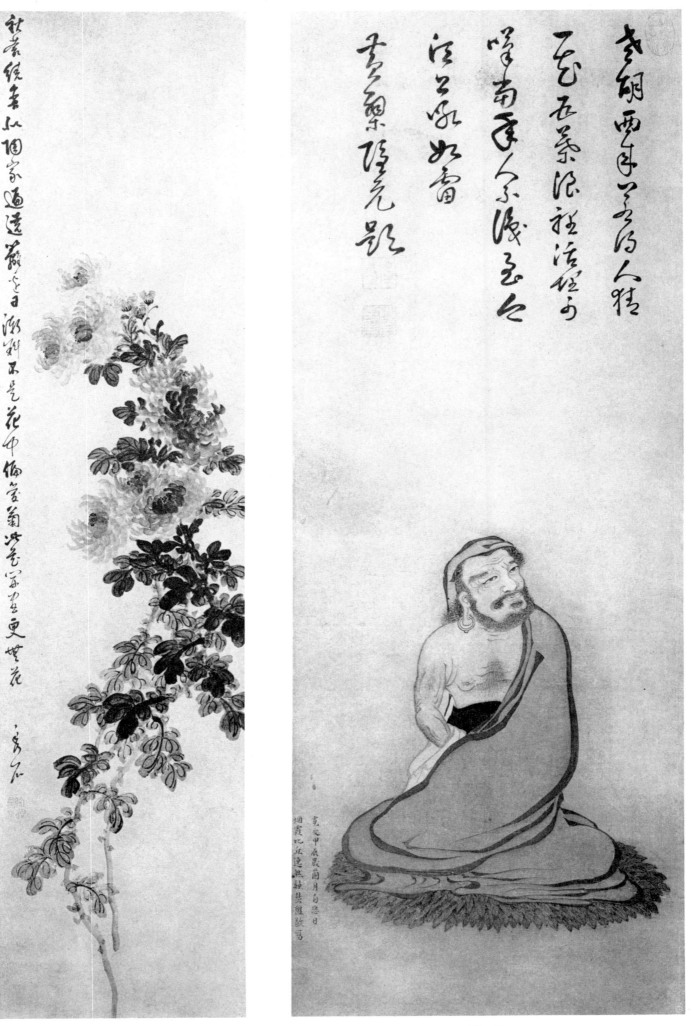

Fig. 1 Fig. 2

渡海達摩之圖掛物
河村若芝筆
竪三尺五寸四分
横一尺三寸五分

鐘馗之圖掛物
河村若元筆
竪二尺五寸
横九寸六分

Fig. 1　Shoki, the Devil Queller
From a painting in colour on paper by Kawamura Jakugen, who learned painting from his father, Kawamura Jakushi.
Height 75.5 cm. Width 28 cm.

Fig. 2　Daruma Crosses the Waves
(Tokai Daruma)
From a painting in colour on silk by Kawamura Jakushi, a famous painter of the Itsunen school.
Height 106 cm. Width 40.5 cm.

PLATE 150

一龕斜髭髮俱左脂眼眼甚之

齜牙刊齒劍鋒禿獨斬狂魔尤

地間貧許多不平事

甲屋莽角

嶹江道人華左自題

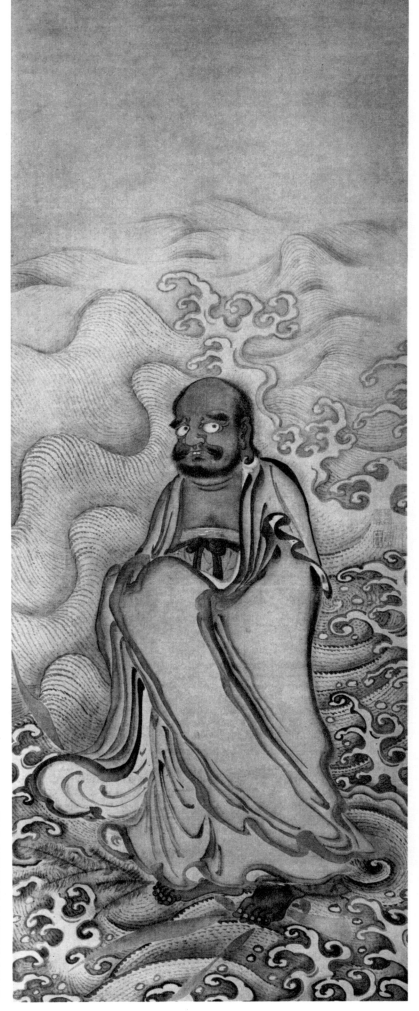

Fig. 1

Fig. 2

PLATE 151

異 國 人 之 圖 書 卸　豎 一 尺 三 寸 五 分
　　　　　　　　　　　　横 九 寸 八 分

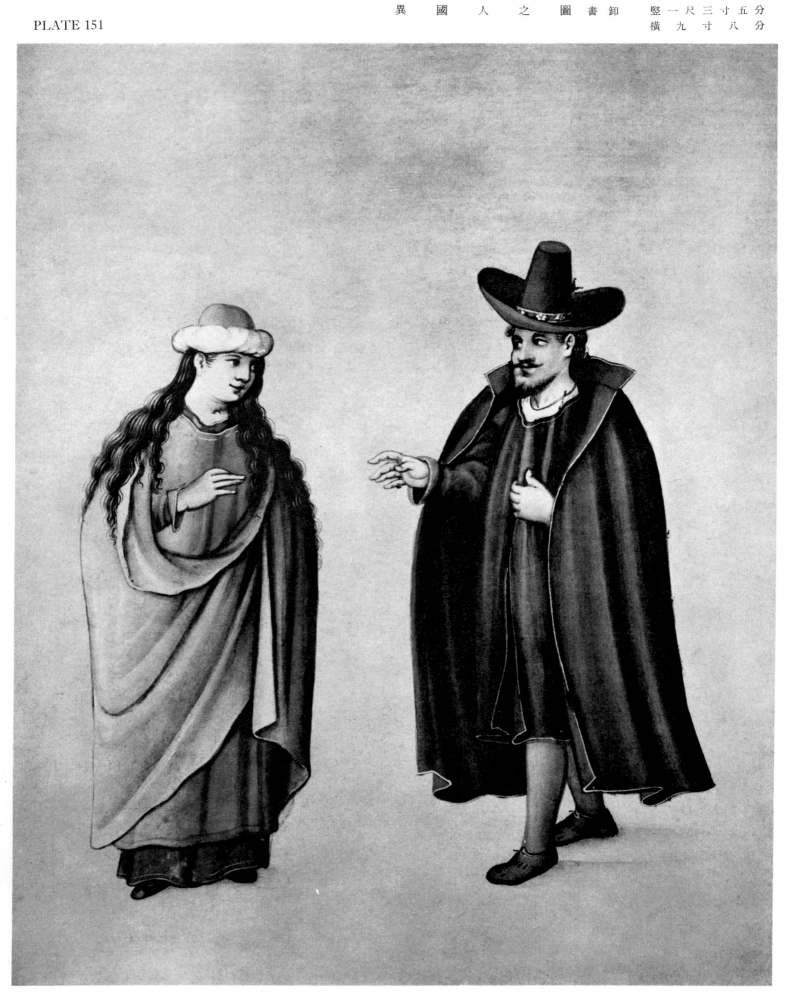

A Foreign Couple
From a painting in colour on paper.
Height 41 cm. Width 30 cm.

PLATE 152

欧　洲　風　景　額　　高一尺五寸三分
石崎元徳筆　　巾二尺六寸四分

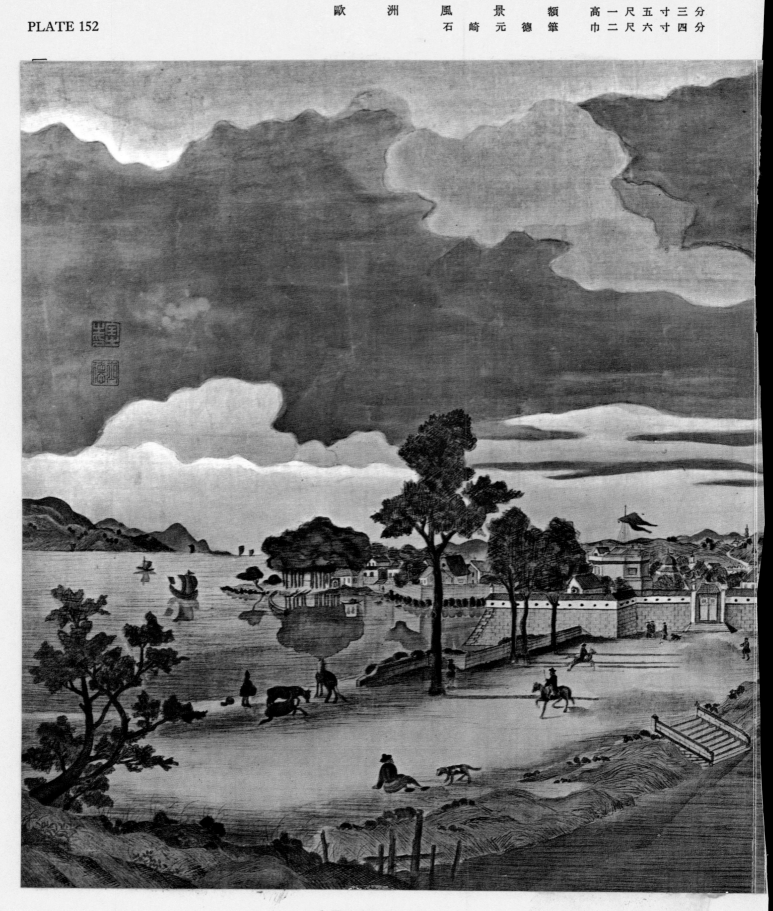

A Foreign Landscape

From a painting in colour on silk by Ishizaki Gentoku. Ishizaki Gentoku lived in Nagasaki and became one of the most famous painters of the early Nagasaki School. He studied painting under Ohara Keizan and specialized in landscape painting. In the first year of the Gembun era (1736) he was appointed superintendent of Official Painters. He died in the tenth month, seventh year of the Meiwa era (1770).

Height 46.5 cm. Width 79.7 cm.

阿蘭陀船之圖掛物

荒木元慶筆

竪三尺五寸六分

横一尺八寸八分

A Dutch Ship

From a painting in colour on paper by Araki Genkei. The following is a free translation of the inscription seen in the upper part of the picture:

Human intelligence and the skilful adaptation of means to ends have discovered a way whereby, by the power of man, the waters may be crossed and the seas navigated, as is evidenced by the man of rare intelligence who built the first vessel and whose intellect did not become dulled in the making of it. It is also evidenced every day by those whom shipping enriches.

Height 108 cm. Width 57 cm.

PLATE 153

Door wijs beleijt en verstant
is 'er door s'menschen vant
Een middel uijt geronden
Om Zee en Wateren te doorkruijssen en te doorgronden
Gelijk het is gebleeken door het versuck
van die geen die onder het maken van het eerste vaartuijg
niet en is versuijt
Gelijk men nog dagelijks Siet Blijken
aan die geene die haar door vaartuijg te maken frijken

PLATE 154

阿蘭陀（萬國人物圖ノ内）典籍章元崎石 筆

堅八寸六分 橫三寸九分

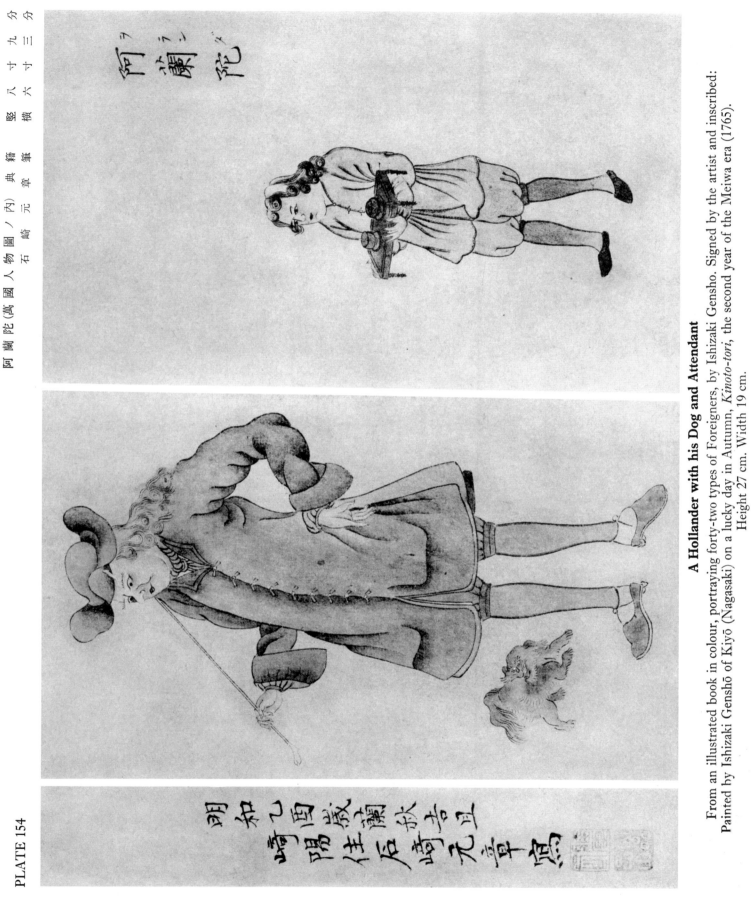

阿ヲ 蘭ラ 陀ダ

明和乙酉歳蘭舘吉且
崎陽住石崎元章寫

A Hollander with his Dog and Attendant

From an illustrated book in colour, portraying forty-two types of Foreigners, by Ishizaki Gensho. Signed by the artist and inscribed:
Painted by Ishizaki Genshō of Kiyō (Nagasaki) on a lucky day in Autumn, *Kinoto-tori*, the second year of the Meiwa era (1765).
Height 27 cm. Width 19 cm.

PLATE 155

山 水 人 物 之 圖 掛 物　　竪 三 尺 八 寸 五 分
石 崎 融 思 筆　　横 三 尺 四 寸

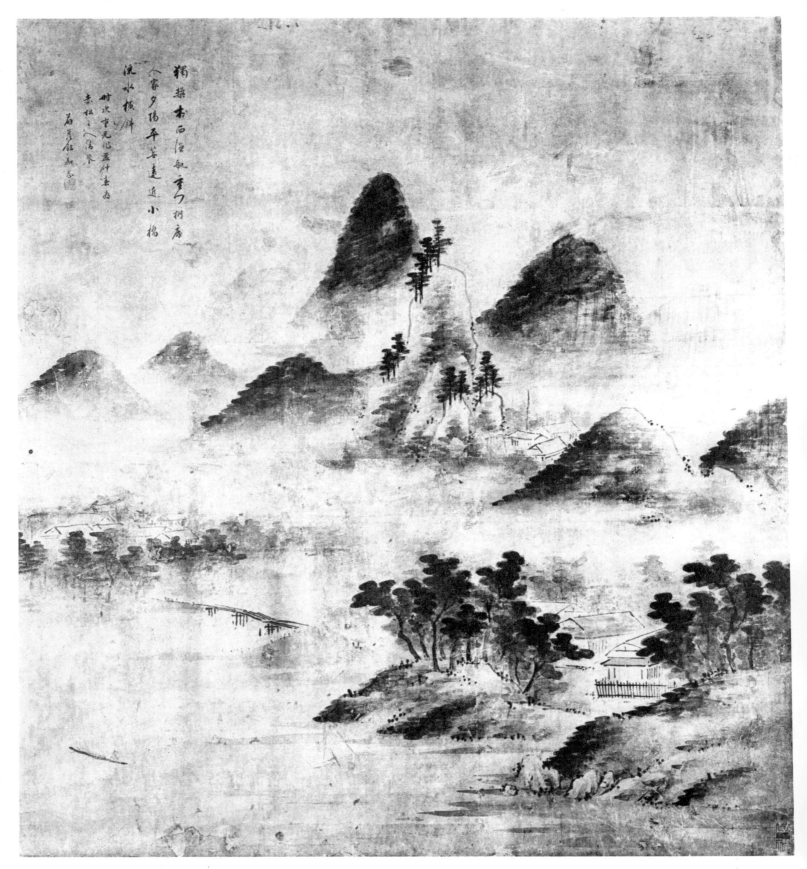

A Mountain Landscape
From a painting in ink on paper, after the Chinese style, by Ishizaki Yushi.
Height 116.5 cm. Width 103 cm.

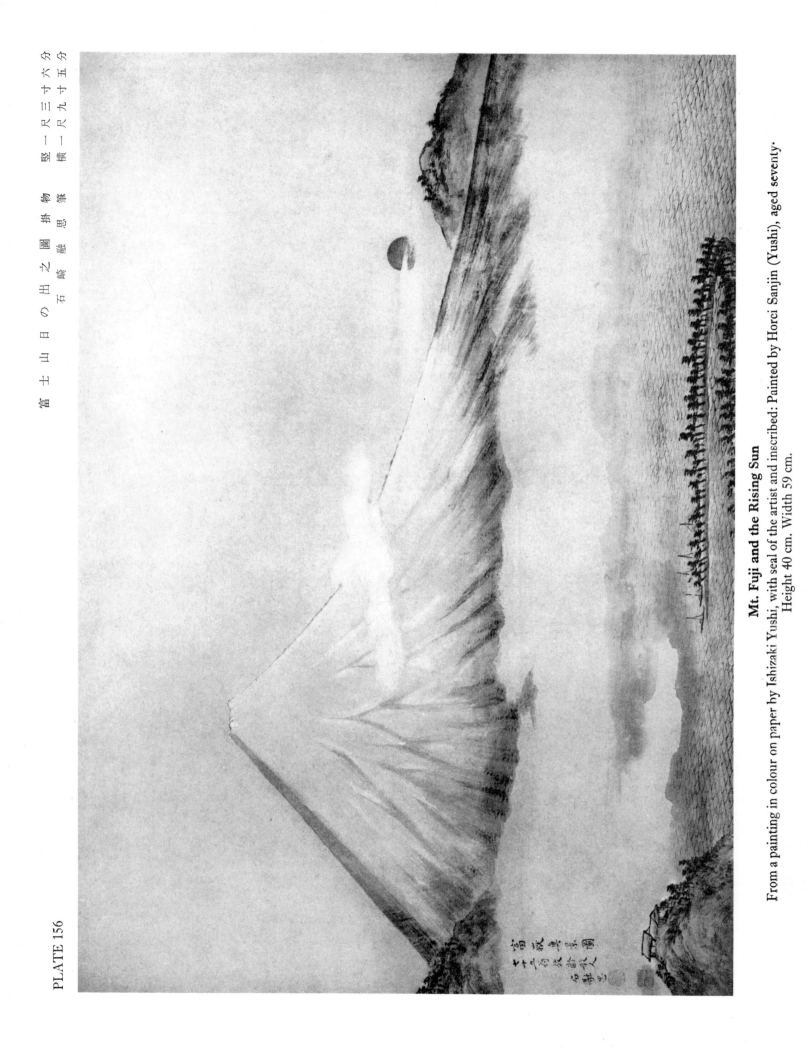

PLATE 156

富士山日の出之圖　掛物　　竪一尺三寸六分
　　石崎融思筆　　　横一尺九寸五分

Mt. Fuji and the Rising Sun

From a painting in colour on paper by Ishizaki Yushi, with seal of the artist and inscribed: Painted by Horei Sanjin (Yushi), aged seventy.
Height 40 cm. Width 59 cm.

PLATE 157

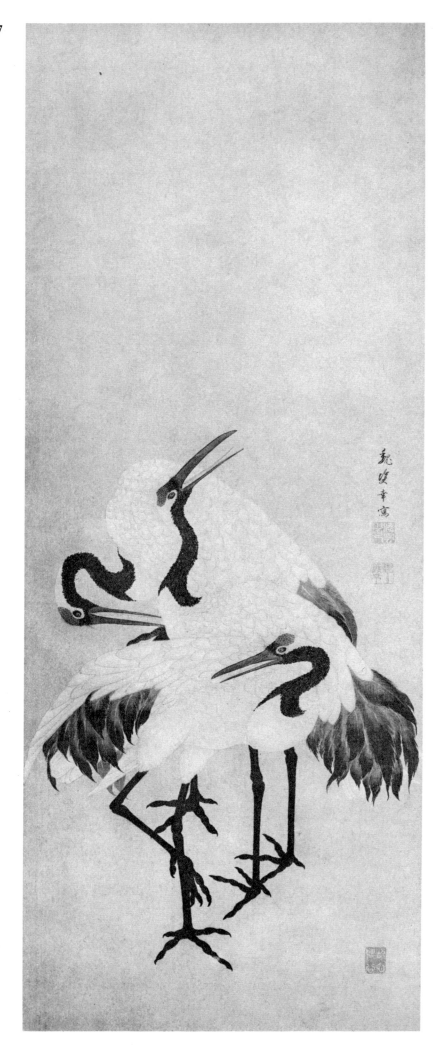

三羽鶴之圖掛物
魏雙幸筆
竪三尺三寸七分
横一尺三寸

Three Storks

From a painting in colour on silk by
Gisoko. Gisoko worked during the Mei-
wa and Kyowa eras (1764–1801).
Height 102 cm. Width 39.5 cm.

PLATE 158

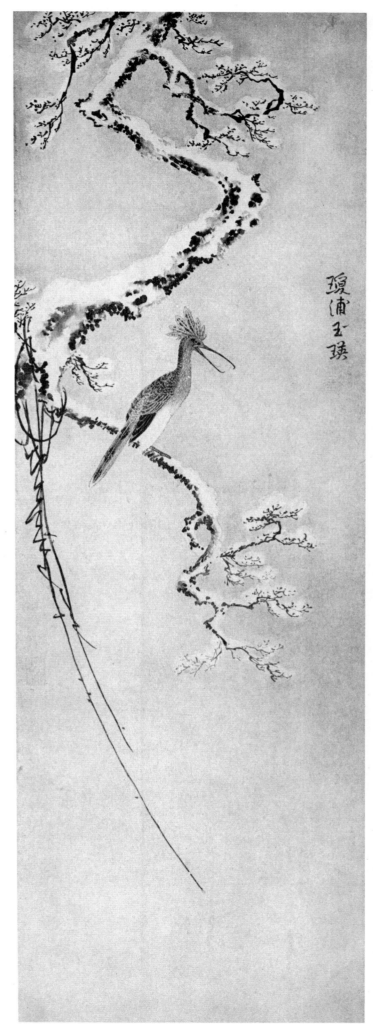

雪
中
の
鳥
之
圖
掛
物

石
崎
融
濟
筆

堅
三
尺
二
寸
二
分

横
一
尺
四
寸

Bird on Bough in Winter

From a painting in colour on silk by Ishizaki Yusai, son
of Ishizaki Yushi.

Height 97.5 cm. Width 31.5 cm.

<div align="right">

出嶋阿蘭陀屋舗之圖卷物

荒木如元筆

長一丈六尺六寸七分

竪一尺一寸五分

</div>

The Dutch Factory

From a scroll painting in colour on paper by Araki Jogen.

The plan of Deshima bears inscriptions some of which seem sufficiently interesting for a free translation to be given. Translations of measurements of ground areas, length of roof ridges, etc., are omitted, though it may be mentioned that these measurements are given with that meticulous degree of exactness which is still a Japanese characteristic.

The Seisatsu, or notice-board, shown in the print, gives public warning that any one breaking the law, or even planning to do so, must be instantly denounced. Also the bribing of an official is expressly forbidden, and an informer of a case of bribery is promised a reward double the amount of the bribe given or offered. An official must neither accept bribes nor connive at the acceptance of bribes by a colleague. Any one either accepting bribes or failing to report cases of bribery known to him will be severely punished.

One part of the map has a list of rules and regulations, referring to the area indicated, that are exceedingly interesting and somewhat illuminating. It is first of all expressly stated that only courtesans may enter the prescribed area. It is then added that while neither Buddhist priests nor "Yamabushi" may enter, high priests from Koyasan may do so. Presumably, high priests were considered able to resist temptations that might prove too strong for their subordinates. Beggars and persons soliciting subscriptions are alike warned off. It is also stated that no one may go farther out to sea than the harbour beacons and that no one may pass under the entrance bridge. Dutch residents are forbidden to go out of Deshima without having first given notice of their intention to do so.

On the top of each beacon is the notice: "No boat is allowed to pass this beacon." The prohibition refers, of course, to boats approaching from the sea.

Details are also given as to construction work and repairs for which (1) the Government, (2) the citizens of Nagasaki and (3) the Dutch residents are to be severally responsible.

<div align="center">

Height 35 cm. Length 505 cm.

</div>

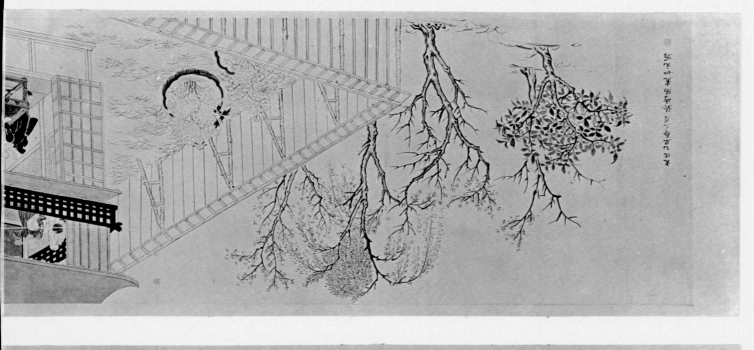

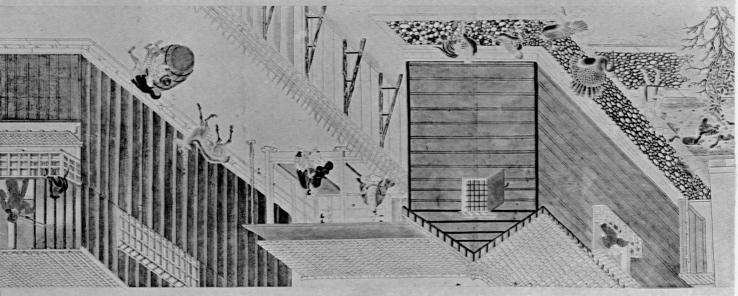

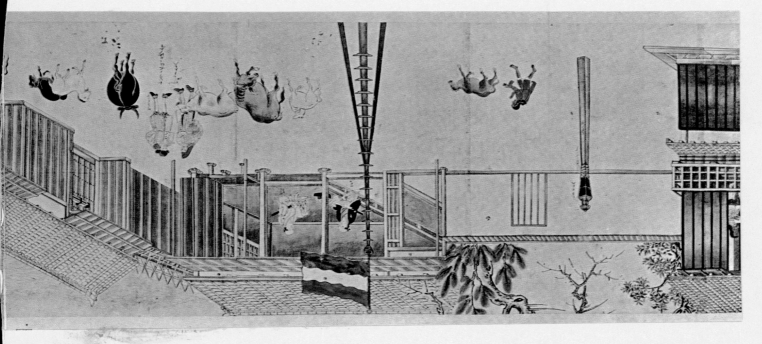

PLATE 159

PLATE 160

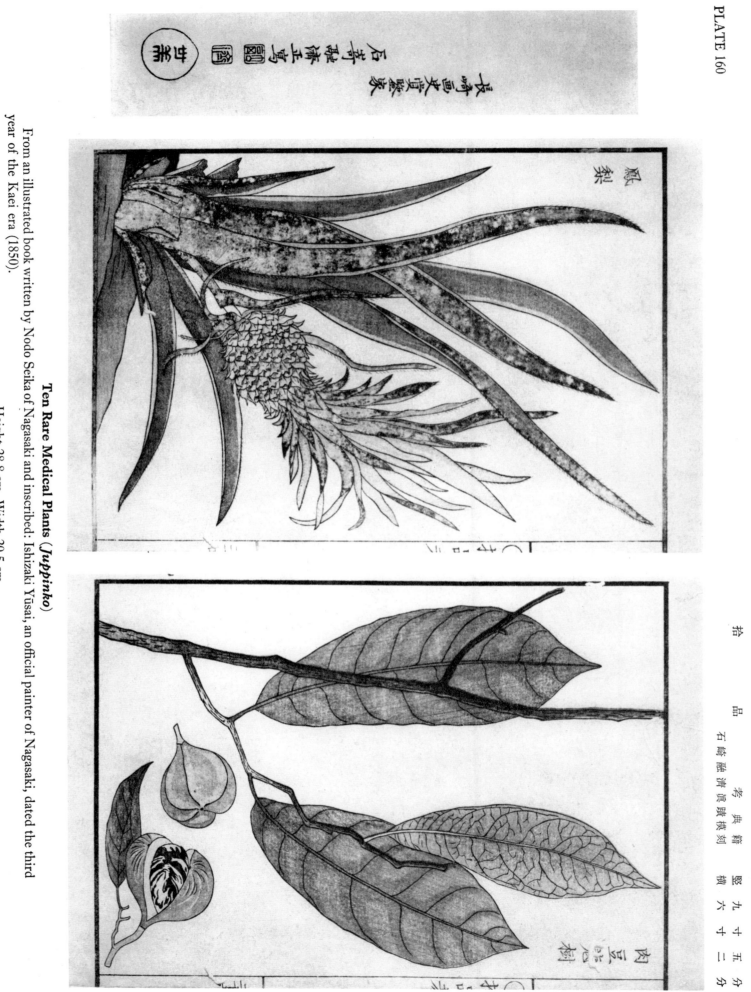

Ten Rare Medical Plants (*Juppinko***)**

From an illustrated book written by Nodo Seika of Nagasaki and inscribed: Ishizaki Yūsai, an official painter of Nagasaki, dated the third year of the Kaei era (1850).

Height 28.8 cm. Width 20.5 cm.

PLATE 161

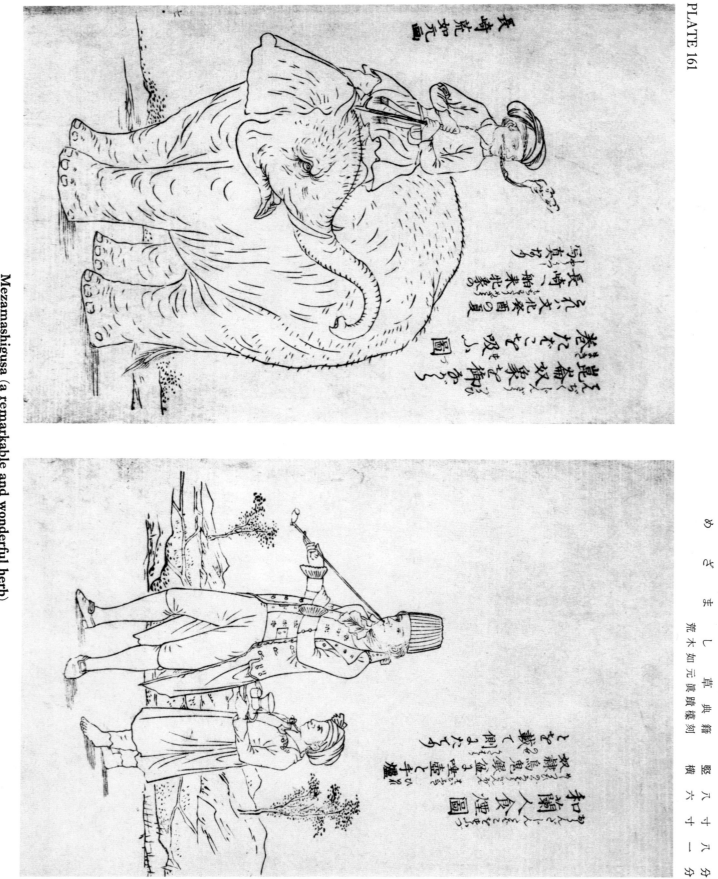

めざまし草　典籍　竪　八寸六分

荒木如元真蹟摸刻　横　六寸一分

Mezamashigusa (a remarkable and wonderful herb)

From an illustrated book on tobacco and smoking utensils by Araki Jogen.

Height 26.5 cm. Width 18.5 cm.

PLATE 162

天 明 名 家 書 畫 帖 竪 九 寸
董 九 如、金 陵 横 五 寸 三 分

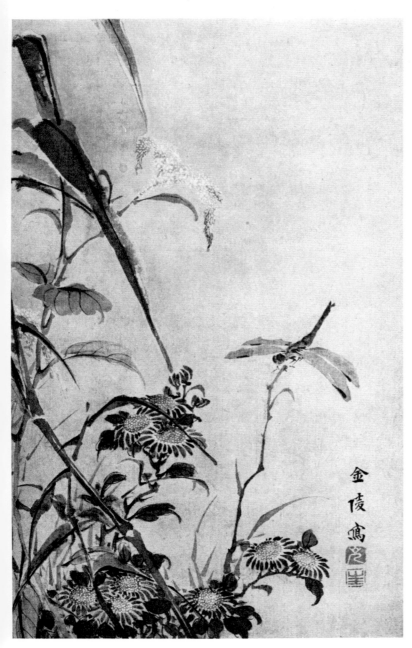

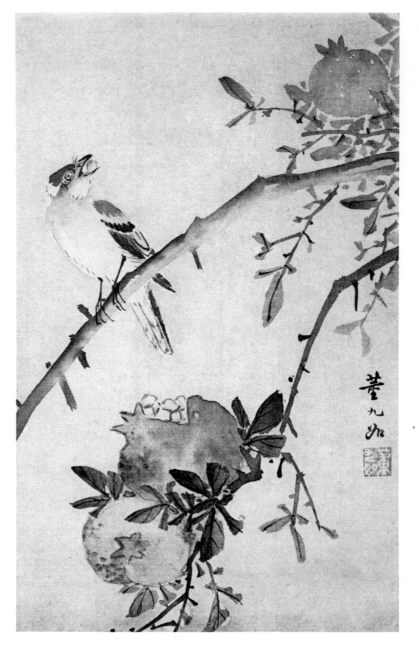

Fig. 1 "Dragonfly and Flowers"
From a painting in colour on silk by Kinryo.
Height 27 cm. Width 16 cm.

Fig. 2 Bird and Pomegranates
From a painting in colour on silk by Tō-Kyūjo, from the
Tenmei Meika Shogua-Jo: an album painting on silk contain-
ing ten paintings and ten specimens of calligraphy by famous
Nagasaki artists of the Tenmei period (1781–1788). The
painters represented are: Suzuku Fuyo, Kitayama Kangen,
Kaneko Kinryō, Watanabe Gentai, Kaburagi Baikei, Fushi-
kami Kyokkō, Aoki Shunmei, Masuyama Sessai, Tokon, and
Tō-Kyūjo.

Height 27 cm. Width 16 cm.

PLATE 163

De Afbeelding
van de
Hollander met
Een Bloem in
De Hand.

J. Gonnooke

阿　蘭　陀　人　之　圖　掛　物
松　井　慶　仲　筆
吉　雄　權　之　助　贊
竪　二　尺　三　寸　四　分
橫　六　寸　六　分

A Picture of a Hollander

From a painting in colour on silk by Matsui Keichu. Keichu was the son of Matsui Genchu. He was born in the fifth year of the An-yei era (1776). The date of his death is not known. The inscription on the top is by the well-known interpreter, Yoshio Gonnosuke, and reads, in translation, "The figure of a Hollander with a flower in his hand." He was a contemporary of Cock Blomhoff and Doeff. He died in 1831, aged forty-seven.

Height 71 cm. Width 20 cm.

萬　國　人　物　圖　卷　物
城　義　鄰　筆
長　二　丈　七　尺　四　寸
竪　九　寸　四　分

Fig. 1　A Picture of a Dutch and a Chinese Ship

Fig. 2　A Picture of a Chinese Family of the Shin and Ming Dynasties

Fig. 3　A Picture of a Spanish and a Dutch Couple

From a scroll painting in colour on paper by Jo Girin with seals of the artist.

Height 28.5 cm. Length 830 cm.

PLATE 164

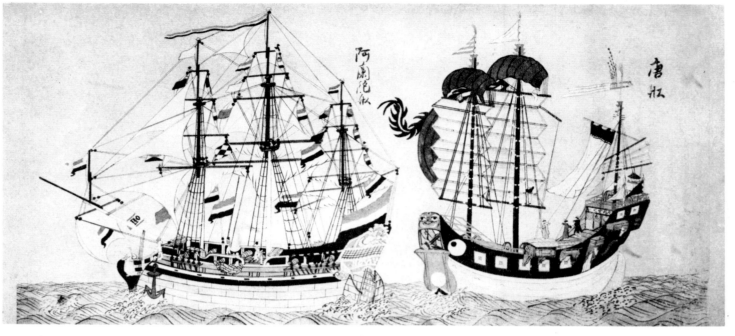

阿蘭陀船

唐船

Fig. 1

大清人

大明人

Fig. 2

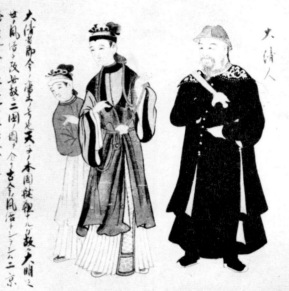

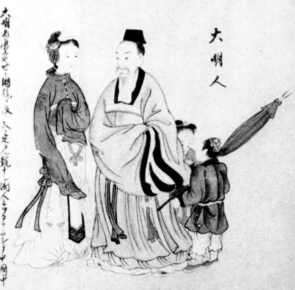

頂西把尼亜人

阿蘭陀人

Fig. 3

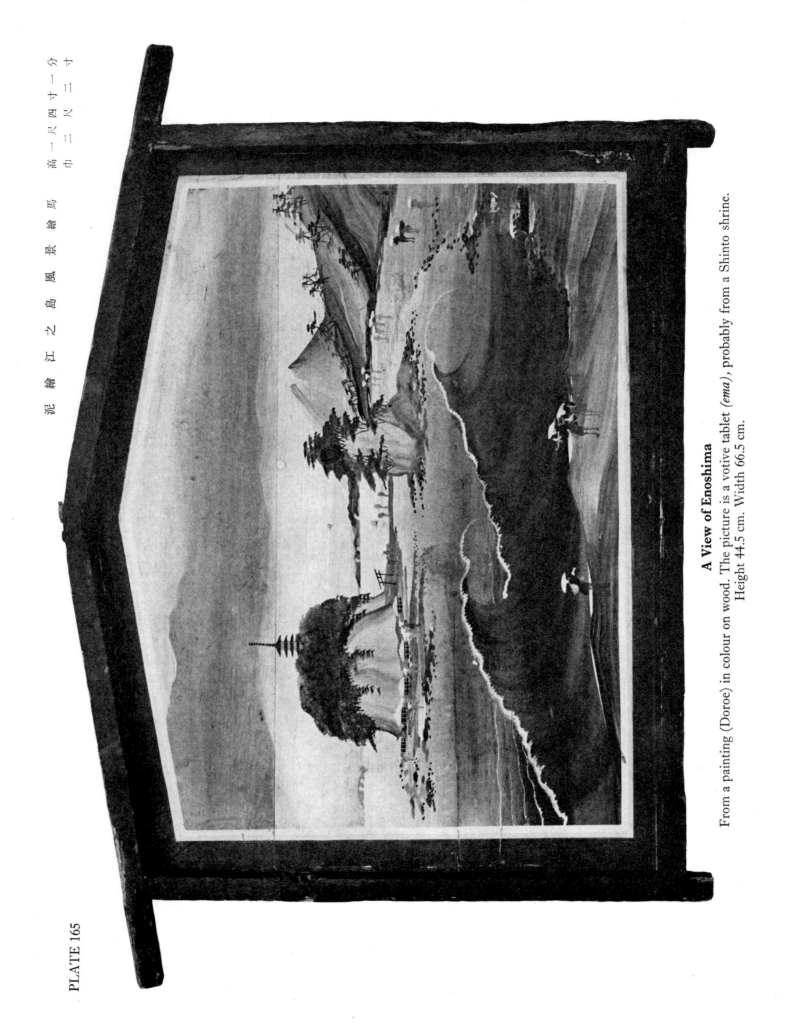

PLATE 165

泥繪江之島風景繪馬　高一尺四寸一分
巾三尺二寸

A View of Enoshima

From a painting (Doroe) in colour on wood. The picture is a votive tablet *(ema)*, probably from a Shinto shrine.
Height 44.5 cm. Width 66.5 cm.

PLATE 167

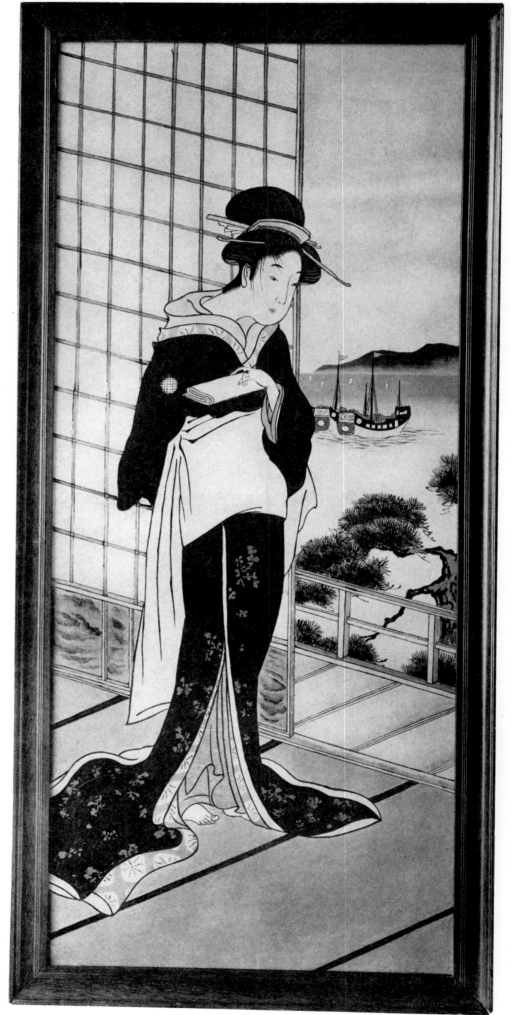

丸山遊女硝子繪

高二尺五寸

巾一尺一寸九分

A Maruyama Beauty

From an oil painting in colour on glass.
Height 76 cm. Width 36 cm.

PLATE 168

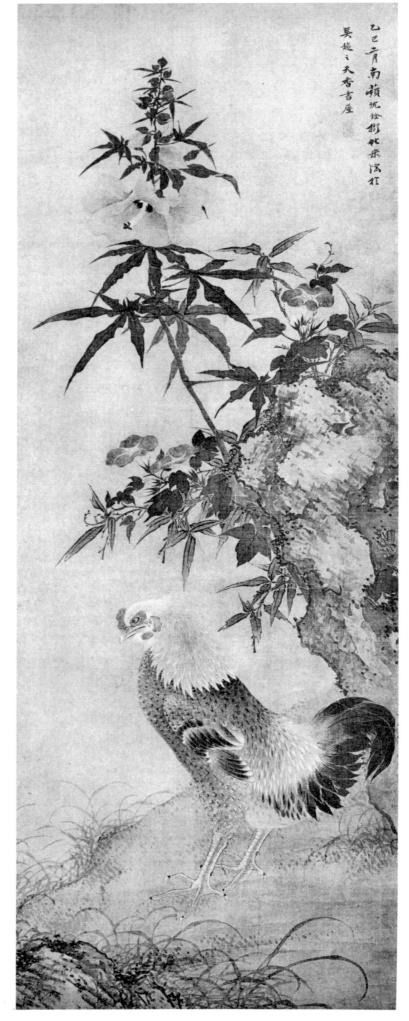

朝顔と鶏之圖掛物
沈南蘋筆
竪三尺三寸
横一尺二寸

Cock and Morning-glory

From a painting in colour on silk by Chin Nampin. Chin Nampin was a celebrated Chinese painter who came over to Nagasaki in the 16th year of the Kyoho era (1731). He established studios in Nagasaki, Kyoto, and Yedo and had many pupils all over Japan.

Height 100 cm. Width 36.5 cm.

PLATE 169

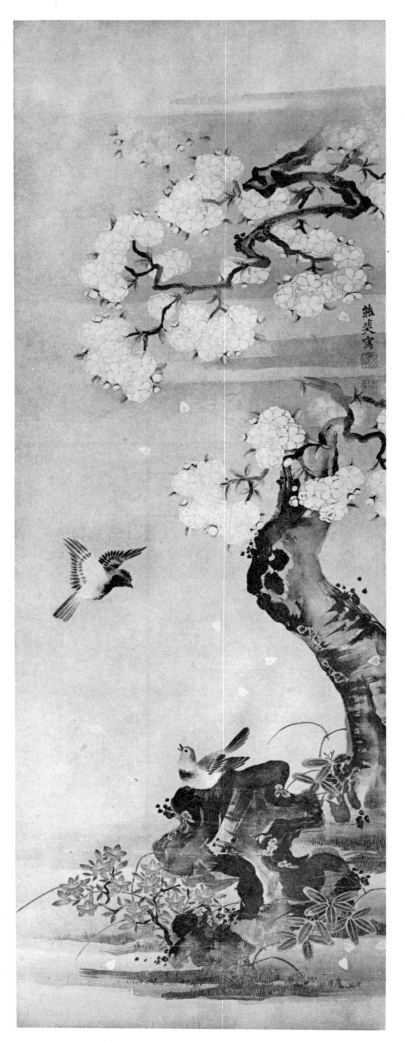

櫻
に
鳥
之
圖
掛
物

熊
代
熊
斐
筆

竪
三
尺
五
寸
五
分

横
一
尺
二
寸
七
分

Bird and Cherry Blossoms

From a painting in colour on silk by Kumashiro Yuhi. Kumashiro Yuhi was born in Nagasaki in the second year of the Shotoku era (1712). He began to study painting under Chin Nampin when nineteen years old. Later he became one of the most famous painters of the Chin Nampin school. The date of his death is not known.

Height 107.5 cm. Width 38.5 cm.

PLATE 170

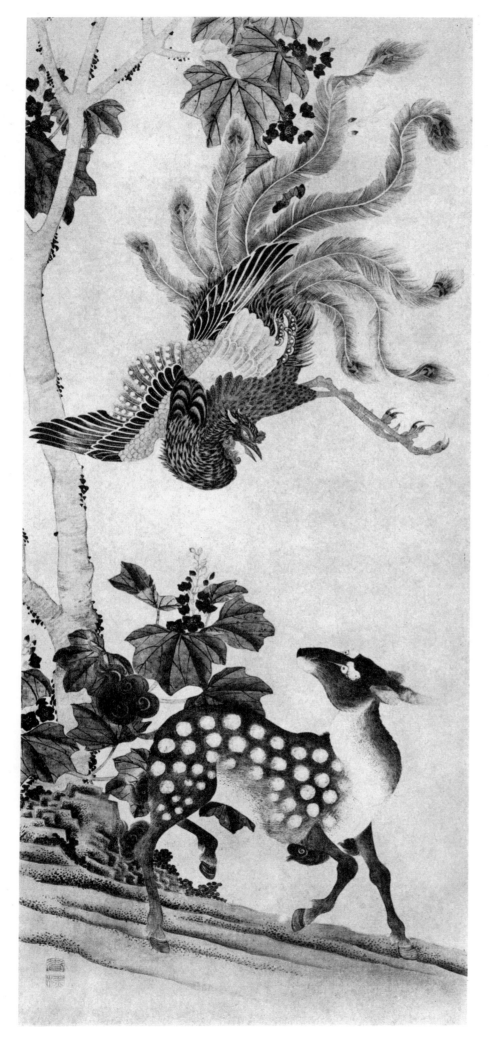

麒麟と鳳凰之圖掛物
熊代斐文筆
竪三尺八寸八分
横一尺六寸三分

Kirin and Hō-Bird

From a painting in colour on paper by Kumashiro Hibun. Kumashiro Hibun was the son of Kumashiro Yuhi. He learned painting from his father and adhered strictly to the same style.

Height 117.5 cm. Width 51 cm.

三幅對掛物
中楊貴妃　右白牡丹　左鳥に牡丹
黑川亀玉筆
竪二尺七寸四分
横一尺一寸四分

A Chinese Beauty Viewing Peony Blooms ▶

From a painting in colour on silk by Kurokawa Kigyoku. Kurokawa Kigyoku was one of the most famous painters of the Chin Nampin school. The following sentence is taken from his biography: "Indeed he was no common person; he was a genius, and his heart was like that of Buddha." This eulogy will convey to Western minds some idea of the spirituality which cultured Japanese desire and find in the works of the best of their painters. He died in the sixth year of the Hōreki era (1756), aged twenty-five.

Height 83 cm. Width 34.5 cm.

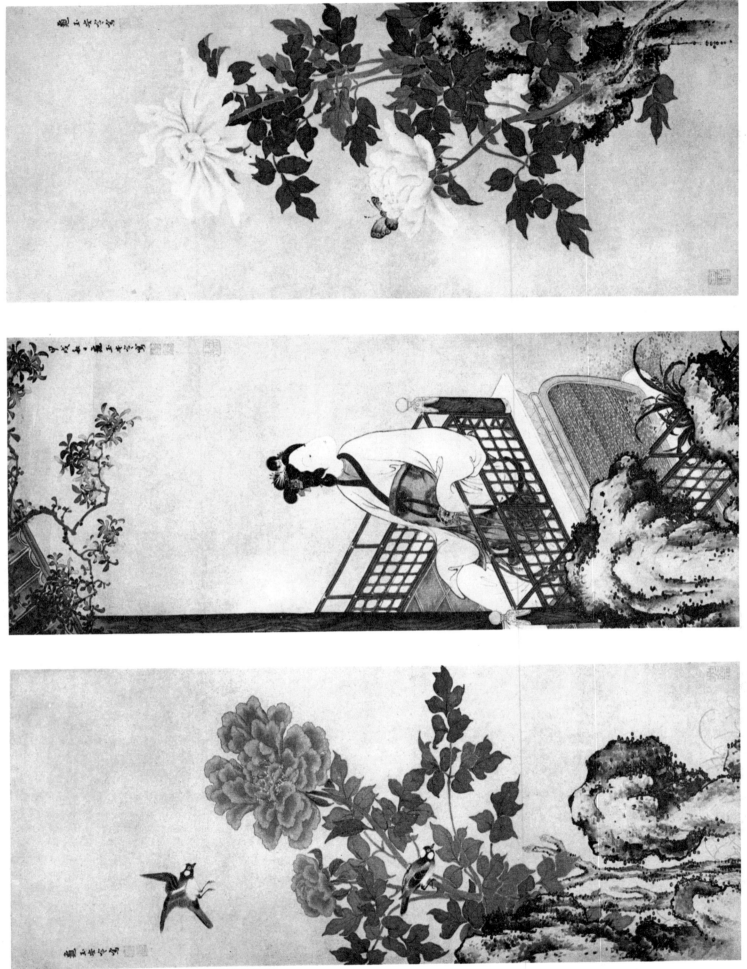

PLATE 171

PLATE 174

牧童之方西圖掛物竪一尺四寸四分

童圖掛物筆圖橫三尺六寸分

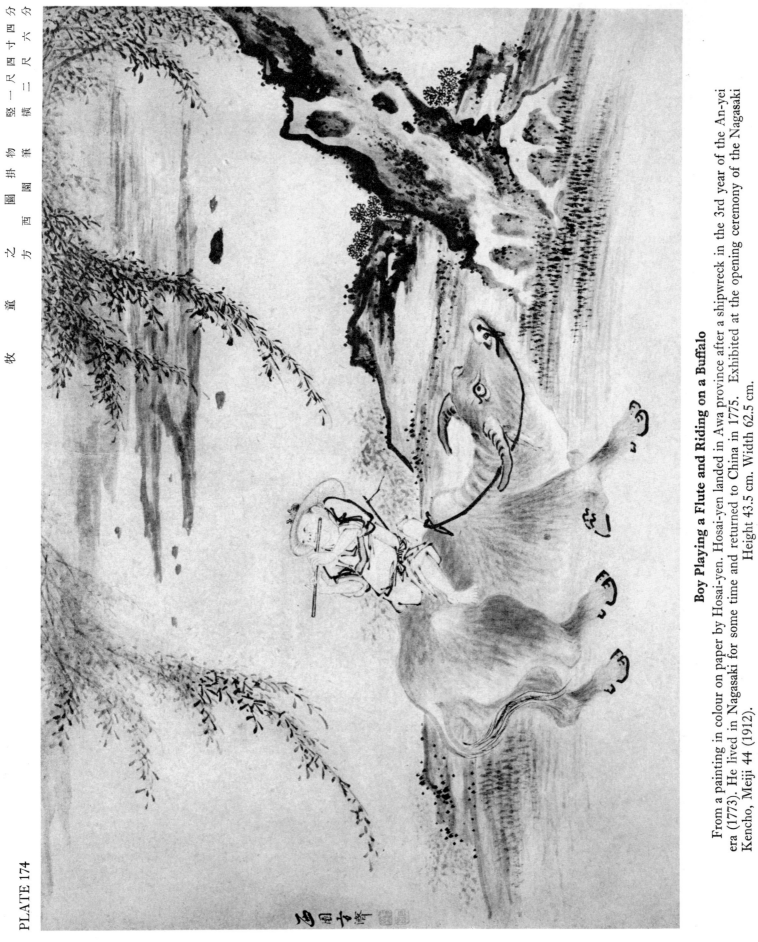

Boy Playing a Flute and Riding on a Buffalo

From a painting in colour on paper by Hosai-yen. Hosai-yen landed in Awa province after a shipwreck in the 3rd year of the An-yei era (1773). He lived in Nagasaki for some time and returned to China in 1775. Exhibited at the opening ceremony of the Nagasaki Kencho, Meiji 44 (1912).
Height 43.5 cm. Width 62.5 cm.

PLATE 175

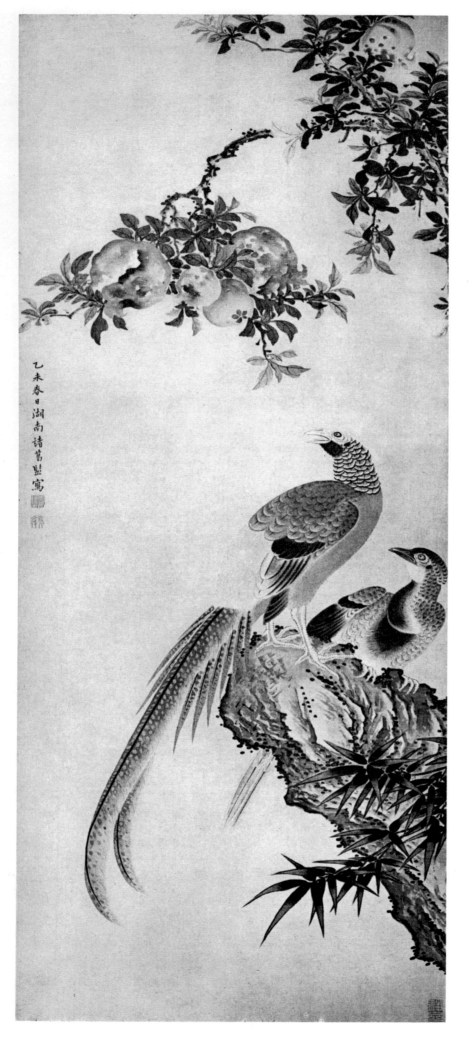

雉子に石榴之圖　掛物
諸　葛　藍　筆
竪三尺一寸五分
横一尺三寸一分

Pheasants and Pomegranates

From a painting in colour on silk by Shokatsu Kwan, who was a famous painter of the Nagasaki school and had many pupils. Signed by the artist and inscribed: Painted in the spring of the fourth year of the An-yei era (1775).

Height 95.5 cm. Width 40 cm.

花　鳥　之　圖　掛物
森　蘭　齋　筆
竪　五尺一寸五分
横　三　尺

Pheasant, Bird and Flowers　▶

From a painting in colour on silk by Mori Ransai. Mori Ransai was a celebrated painter of the Nagasaki school. He died in 1801.

Height 156 cm. Width 91 cm.

PLATE 176

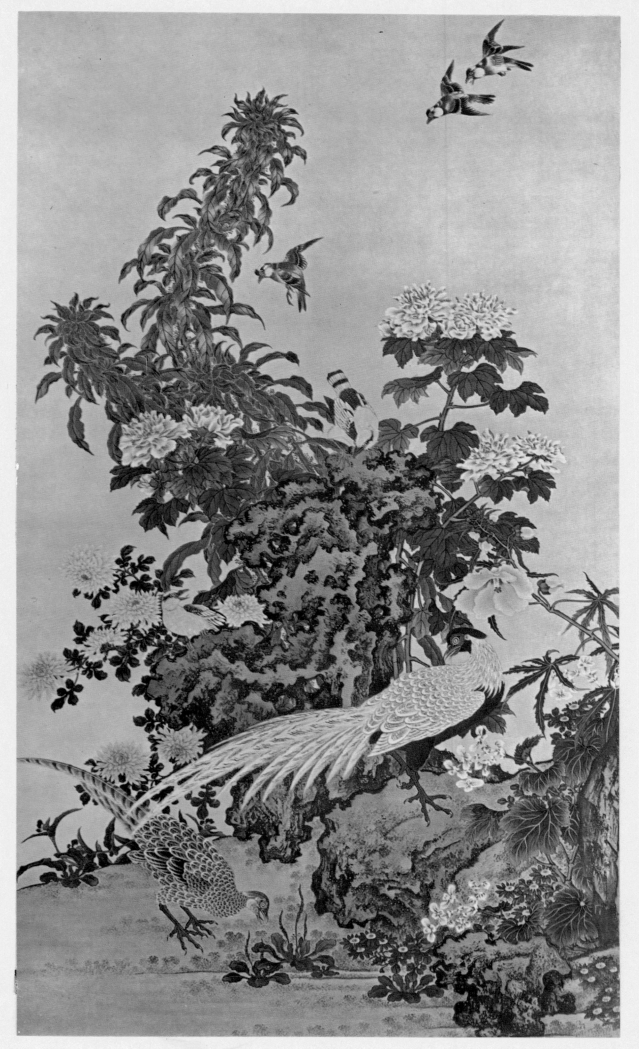

PLATE 178

阿蘭陀人と象之圖　双幅
孟涵九と從者之圖　　　竪二尺六寸四分
波　了　筆　横一尺三寸五分

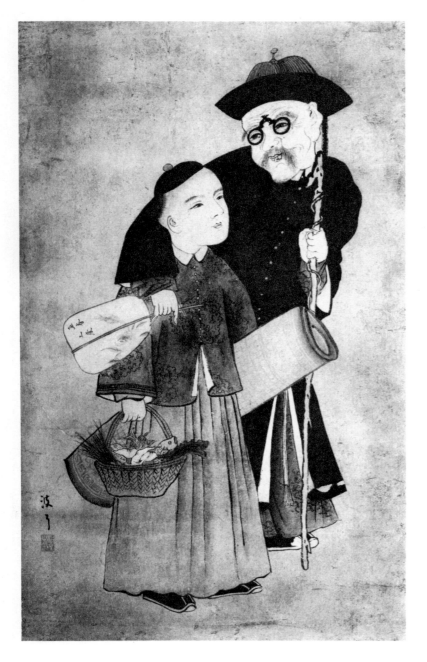

Fig. 1　The Chinese Philosopher, Mōkan-Kyu, with his Attendant

From a painting in colour on paper by Haryo. Mōkan-Kyu came to Nagasaki in the Bunkwa era (1804–1818). Height 80 cm. Width 41 cm.

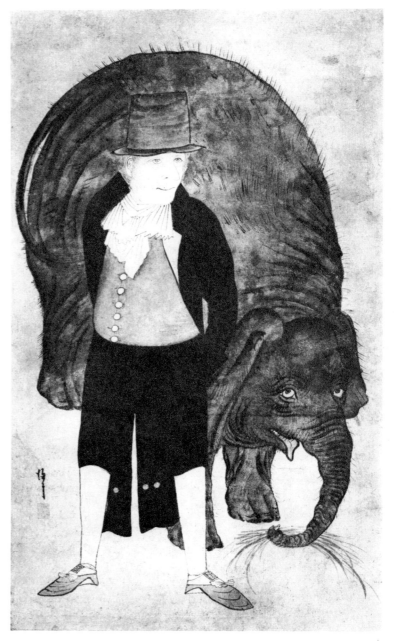

Fig. 2　A Hollander with an Elephant

From a painting in colour on paper by Haryo. Height 80 cm. Width 41 cm.

PLATE 179

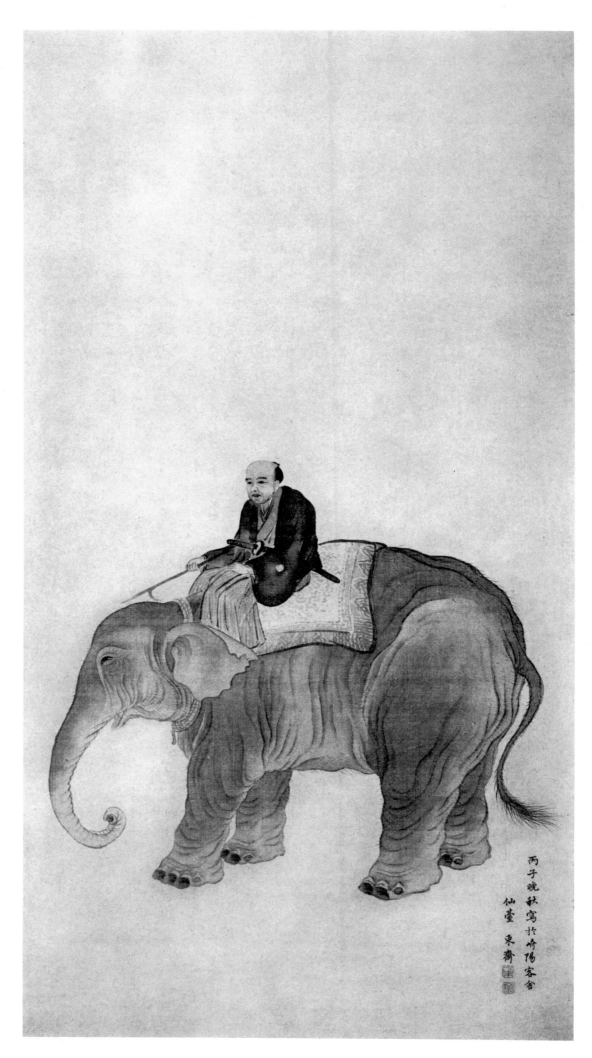

支倉六右衛門肖像掛物
菅井梅關筆
堅三尺八寸
横一尺五寸五分

Hazekura Rokuemon Riding on an Elephant

From a painting in colour on silk by Sugai Baikwan. Sugai Baikwan was a native of Sendai. He visited Nagasaki and entered Kō-Kahō's studio, staying there for more than ten years. This work portrays Hazekura Rokuemon's visit to Luzon and is inscribed: Painted by Tosai (Baikwan) of Sendai at an inn in Nagasaki in the late autumn of the thirteenth year of the Bunkwa era (1816). Height 115 cm. Width 47 cm.

PLATE 180

ナポレオン戰爭之圖　掛物　　堅一尺五寸一分
安　田　雷　州　筆　　横一尺九寸九分

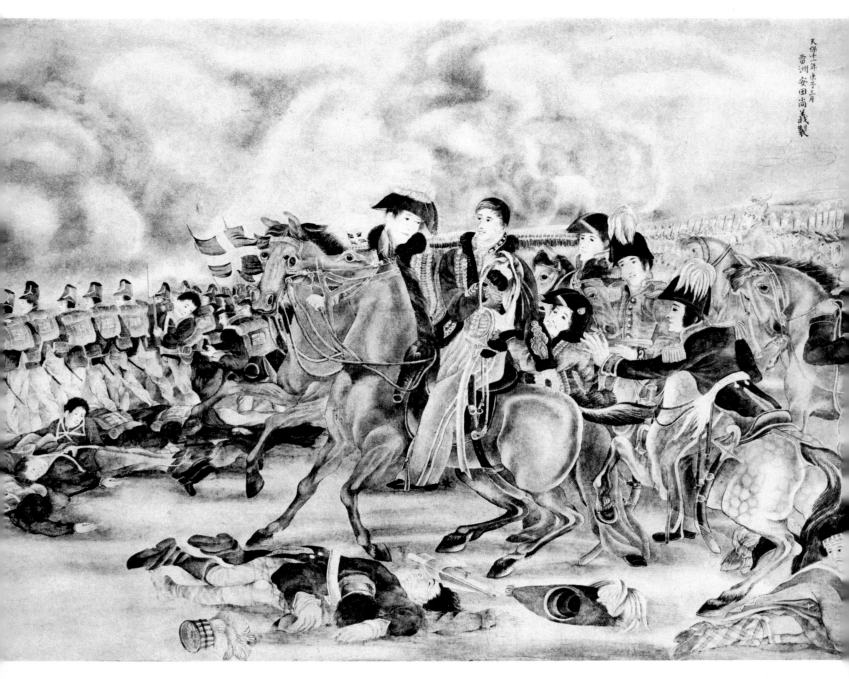

Scene from the Napoleonic Wars

From a painting in colour on paper by Yasuda Raishu. Raishu was a pupil of Hokusai and also studied painting of the European school. Signed by the artist and inscribed: Raishū Yasuda Naoyoshi, Kwao, in the third month and eleventh year of the Tempo era (1840).

Height 46 cm. Width 60 cm.

PLATE 181

森林に韃靼人之圖掛物　竪一尺七分
横一尺一寸五分

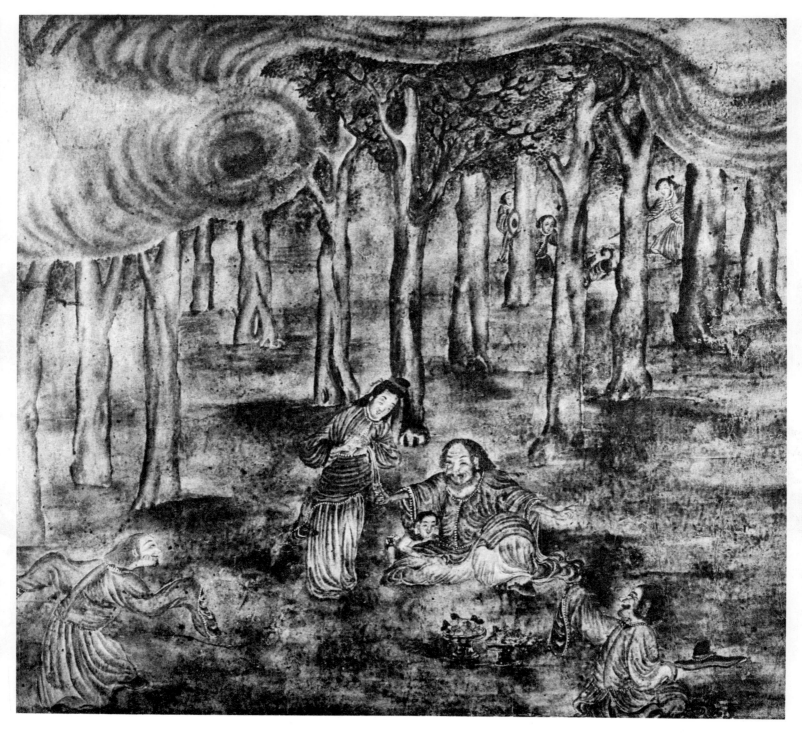

A "Dattan-Jin" and Family
From a painting in oil on silk. Unknown Artist.
Height 32.5 cm. Width 35 cm.

PLATE 182

耶　　　蘇　　　像　高一尺二分
金　鍍　金　板　巾八寸七分

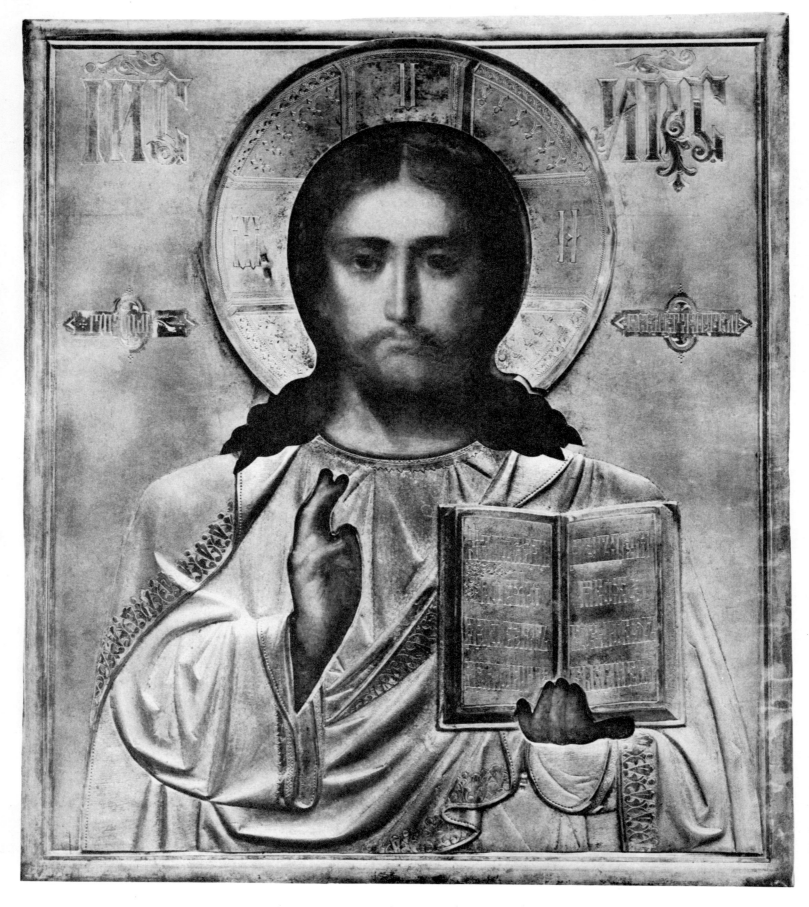

Oil Painting of Christ
Probably copied from a Russian icon and painted in oil in Nagasaki. A similar icon is in the Tokyo Museum Collection.
The picture is placed in a plain Kiri-wood case with folding doors.
Height 31 cm. Width 26.7 cm.

PLATE 183

基督と悪魔之圖　掛物

露山筆

竪三尺七寸三分
横一尺三寸七分

The Temptation of Christ

From a painting in colour on paper by Rozan. This picture portrays the scene in St. Matthew's gospel, Chapter IV, Verses 8–10: "Again, the devil taketh him up into an exceeding high mountain, and sheweth him all the kingdoms of the world, and the glory of them; and saith unto him, All these things will I give thee, if thou wilt fall down and worship me. Then saith Jesus unto him, Get thee hence, Satan: for it is written, Thou shalt worship the Lord thy God, and him only shalt thou serve." Signed by the artist and inscribed: Painted by Rozan while deeply impressed in the mid-spring. Kinoe-Dragon year.

Height 113.5 cm. Width 41.5 cm.

PLATE 184

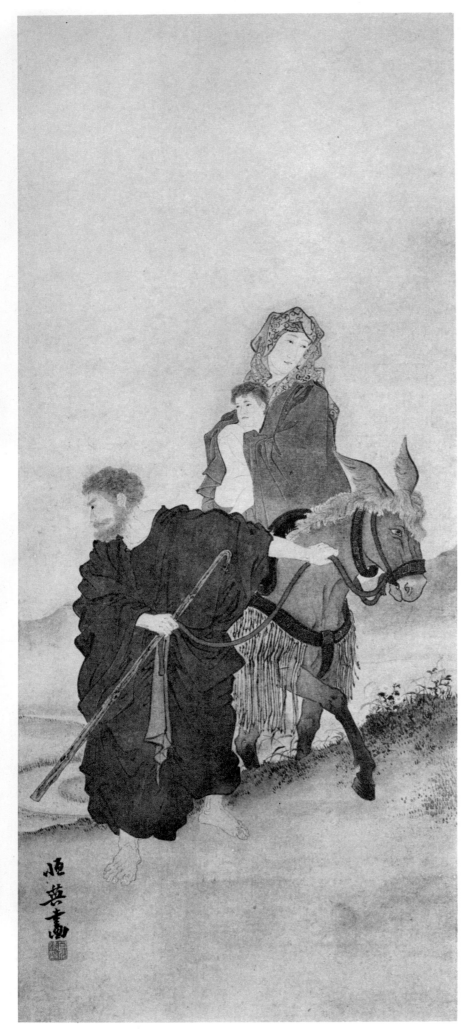

キリスト、マリア逃避之圖　掛物

恒英筆

竪三尺二寸七分

横一尺一寸九分

Mary's Flight into Egypt with the Infant Christ

From a painting in colour on silk by Tsunehide. This picture represents the scene in St. Matthew's Gospel, Chapter 2, Verses 13–14: "And when they were departed, behold, the angel of the Lord appeareth to Joseph in a dream, saying, Arise, and take the young child and his mother, and flee into Egypt, and be thou there until I bring thee word: for Herod will seek the young child to destroy him. When he arose, he took the young child and his mother by night, and departed into Egypt." Signed by the artist.

Height 99 cm. Width 36 cm.

西國之繪圖卷物

長二丈二尺九寸三分

竪一尺九寸五分

PLATE 186

南蠻船之圖　額　高一尺二分
巾一尺三寸二分

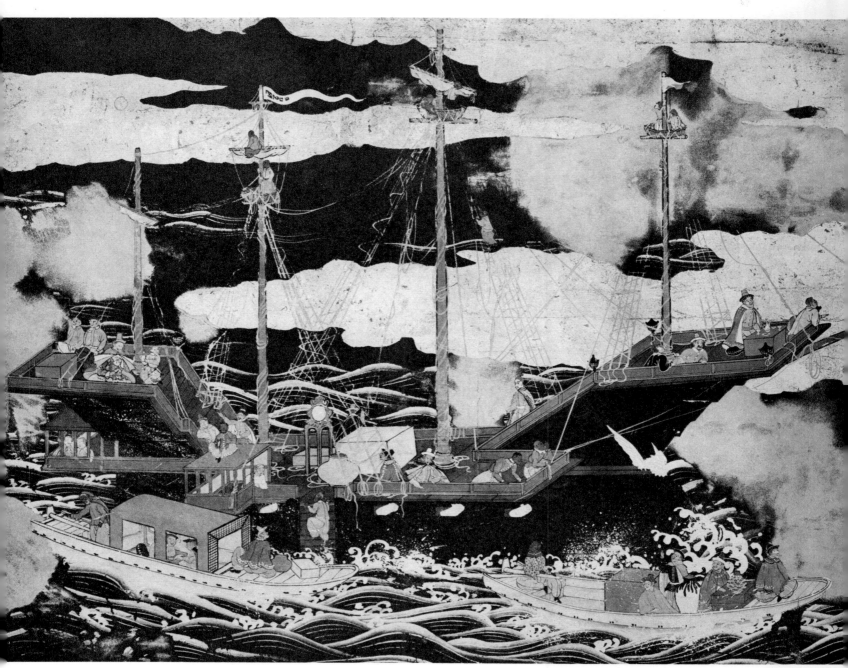

A Portuguese Ship
From a painting in colour on gold ground. Unknown Artist.
Height 31 cm. Width 40 cm.

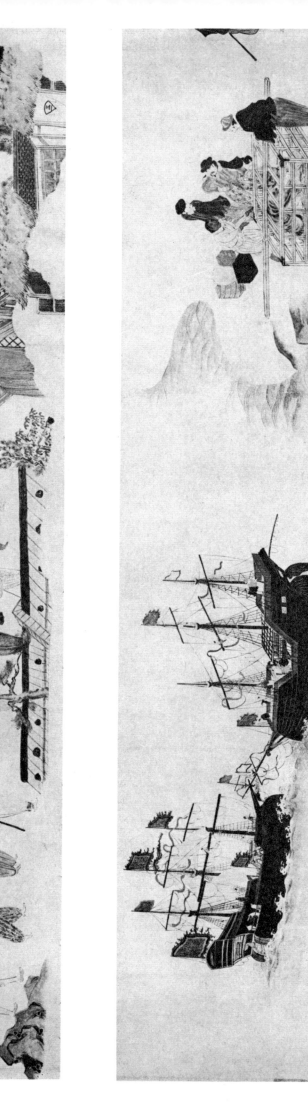

南蠻船と南蠻人之圖　巻物　長　八尺七寸
竪　一尺八寸

PLATE 187

Portuguese Ship and Figure-Subjects
From a scroll painting in colour on paper. Unknown Artist.
Length 285 cm. Height 32.5 cm.

PLATE 188

南蠻人之圖掛物　竪二尺三寸
　　　　　　　　　横七寸一分

南蠻人と犬之圖掛物　竪一尺九寸八分
　　　　　　　　　　横六寸六分

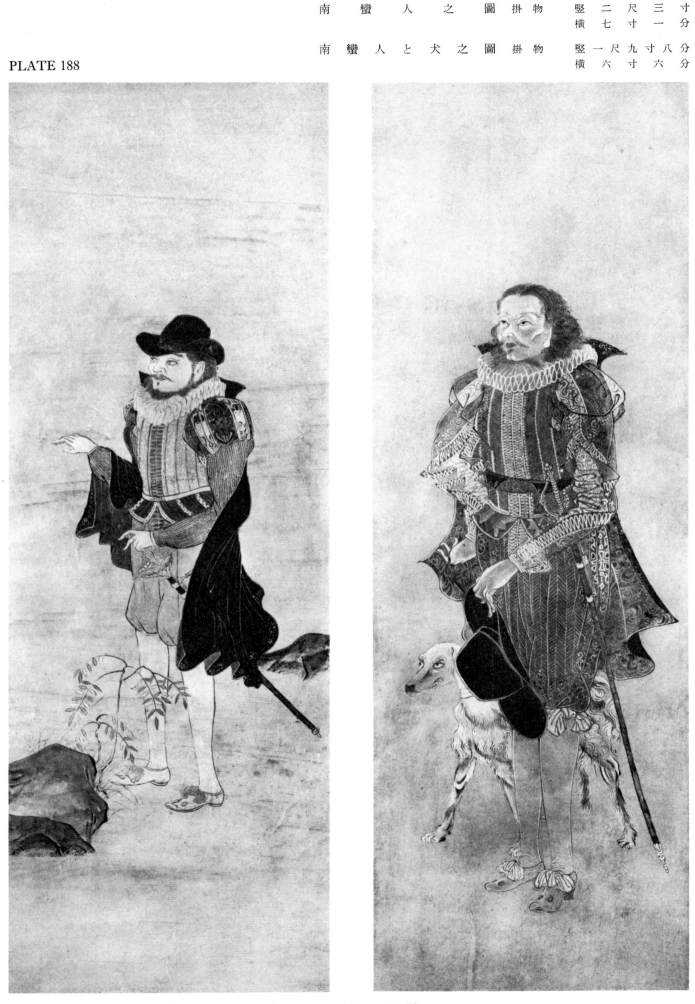

Two Portuguese Figure-Subjects

Fig. 1　From a painting in colour on bamboo.
Height 69.3 cm. Width 23 cm.

Fig. 2　From a painting in colour on paper.
Height 60 cm. Width 20 cm.

飛行船と靈鷲山之圖　双幅

竪三尺一寸
横九寸一分

Fig. 1　Picture of *Ryōjusen* or *Ghrdhrakuta*

From a painting in colour on black ground. This picture appears in the second volume of the *Oranda Kibun* and is signed by Shiba Kokan. The description may be translated as follows: The mountain portrayed is in Ceylon, rising up in the centre of the island. It is commonly known as Adam's Peak, which is the same as *Ryōjusen* or *Ghrdhrakuta*.

Height 94 cm. Width 27.5 cm.

Fig. 2　Picture of Hikōsen
(Flying Ship)

This picture, signed by Shiba Kokan, is also found in the first volume of the *Oranda Kibun*, in which it is called *ryukutosurōpu*, meaning air-ship. The original drawing of this picture was owned by Kuchiki Ryūkyō, the Lord of Fukuchiyama, Tamba, and is inscribed: "Copied from a *bangwa* (Dutch picture) recently engraved." The paintings are elaborately mounted on rich brocade with three-leaf Aoi crests. The inside lacquer-box for the Kakemono also shows the Tokugawa crest in gold lacquer on a black lacquer ground. The outside case is of Kiri wood.

Height 94 cm. Width 27.5 cm.

(Marquis Tokugawa Collection)

PLATE 189

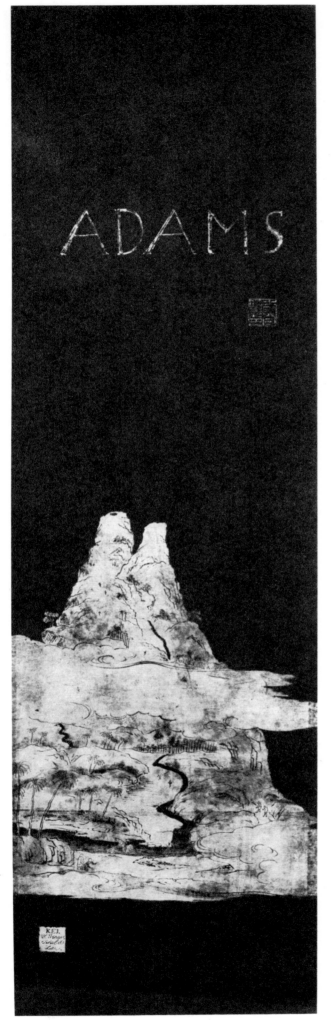

Fig. 1

Fig. 2

PLATE 190

阿蘭陀港と農夫之圖 掛物　竪 一尺二寸九分
　　　　　　　　　横 一尺七寸七分

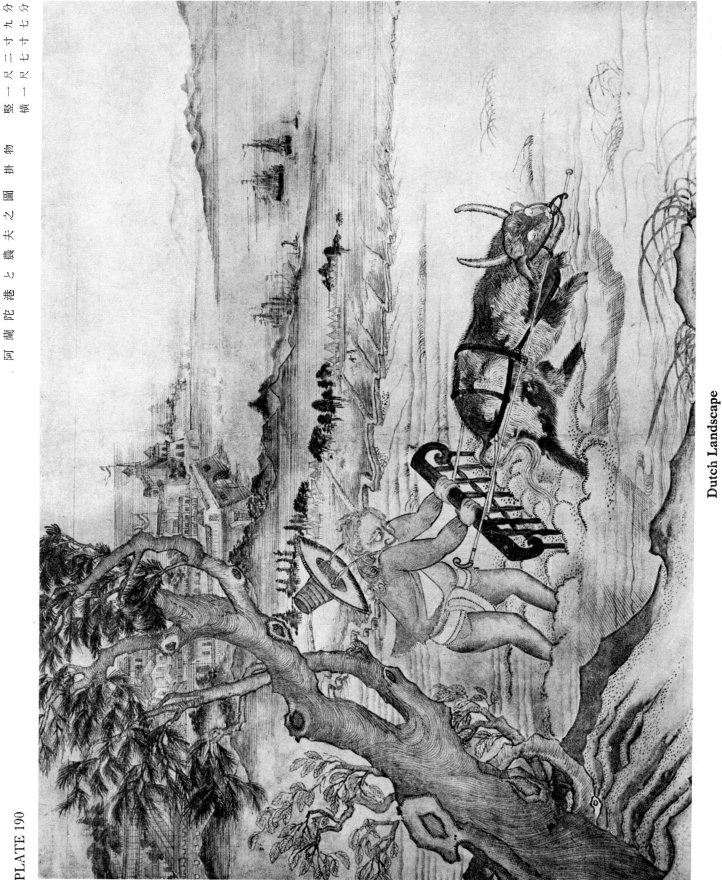

Dutch Landscape

From a painting in colour on paper. Unknown Artist. This is an imaginary picture of a Dutch landscape with a highly amusing Dutch farmer at his plough.

Height 39 cm. Width 53.5 cm.

PLATE 191

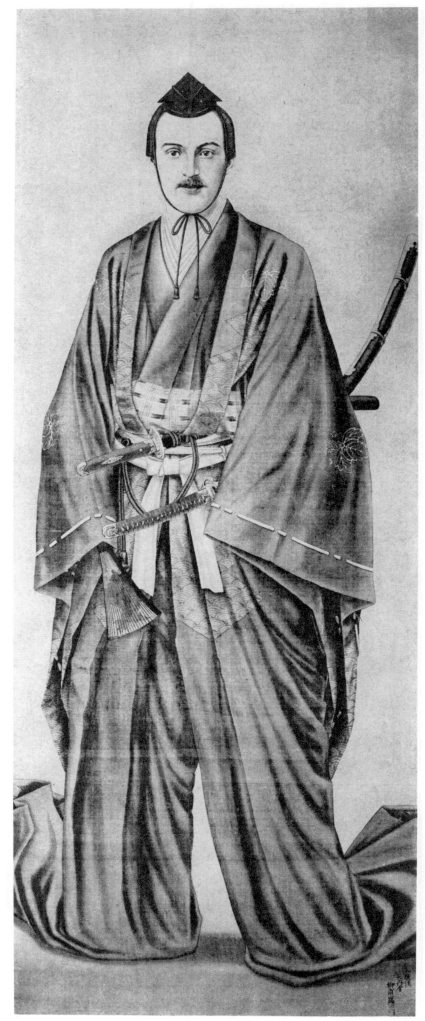

異人殿中裝束姿之圖　掛物

傳サー、アーネスト、サトウ氏肖像

柳　甫　筆

竪　四　尺　四　寸　五　分

横　一　尺　七　寸　三　分

**Picture of a Foreigner in the Costume
of a Daimyo**

From a painting in colour on silk by Ryuho. The
picture is supposed to be a portrait of Sir Ernest
Satow.

Height 134.5 cm. Width 52.5 cm.

PLATE 192

阿 蘭 陀 人 行 列 之 圖 額　高 九 寸 七 分
　　　　　　　　　　　巾 四 尺 四 寸 二 分

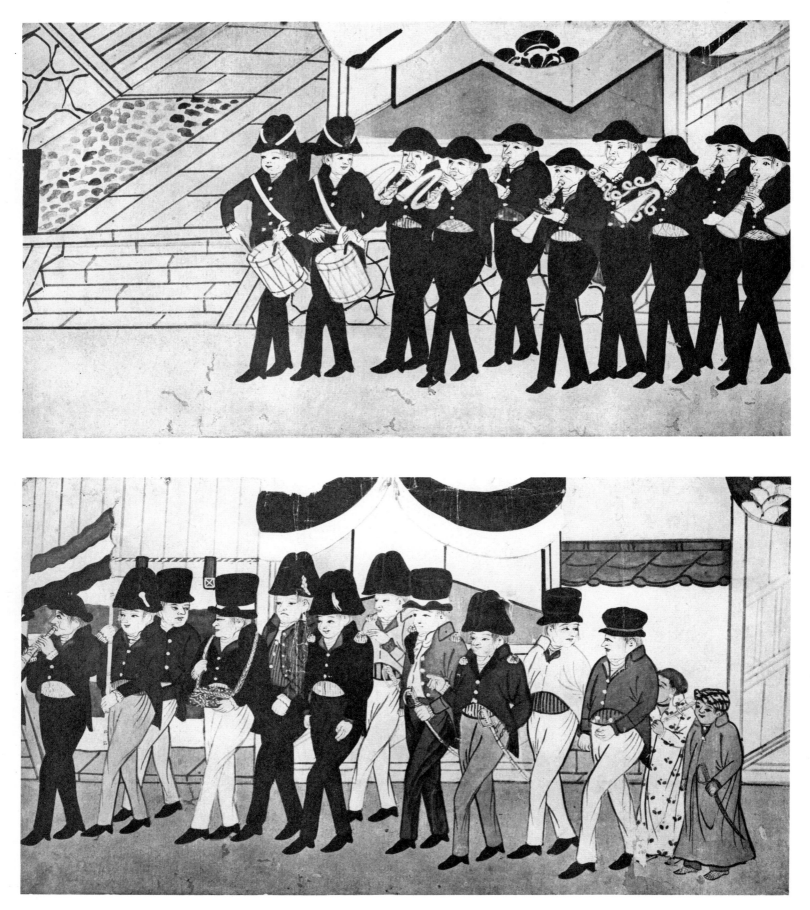

A Dutch Procession

From a painting in colour on paper. Unknown Artist.
Height 29.5 cm. Width 134 cm.

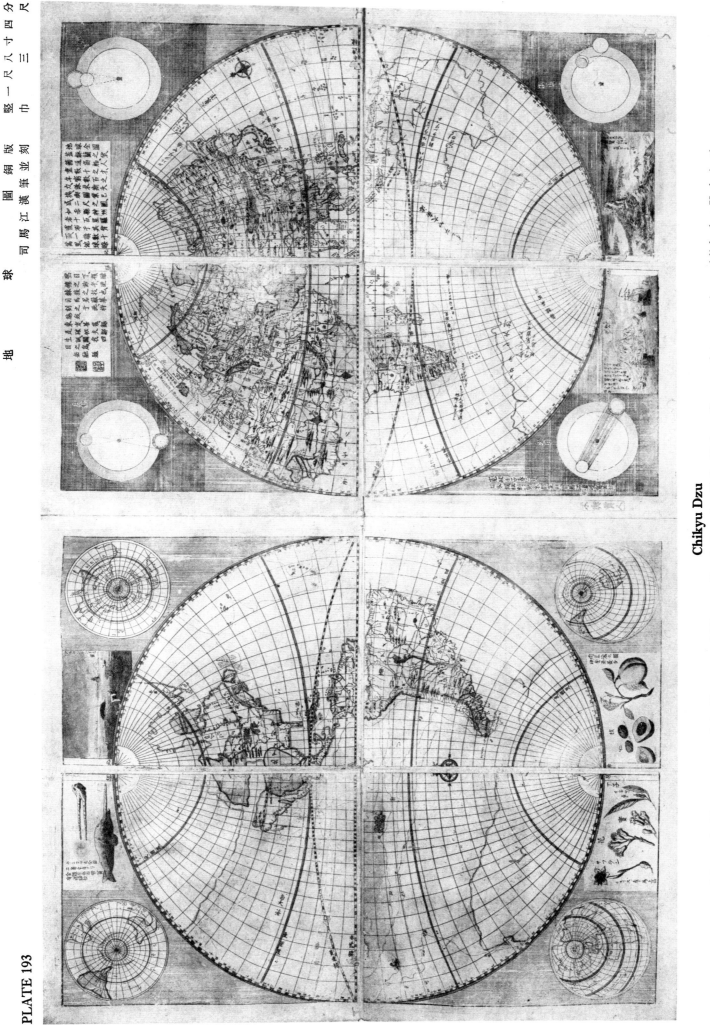

PLATE 193

地　球　圖

司馬江漢筆並刻

銅版　竪一尺八寸四分

巾一尺三寸

Chikyu Dzu

A large double-page map of the Eastern and Western Hemisphere by Shiba Kokan. Copper-plate engraving published at Yedo in the 4th year of the Kwansei era (1792).

Height 55.8 cm. Width 90.8 cm.

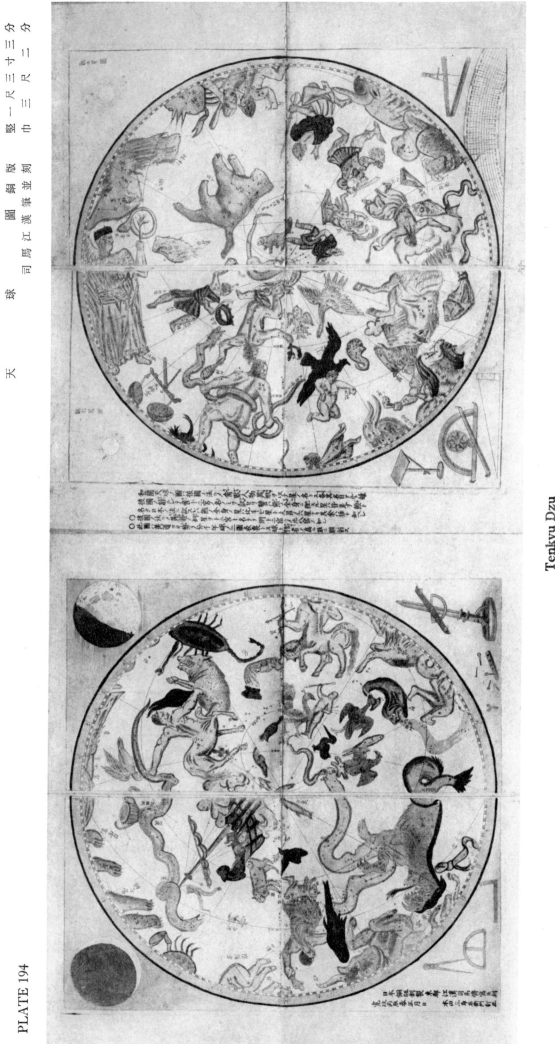

PLATE 194

天　球　司馬江漢筆並銅版圖　堅一尺三寸三分　巾三尺三分

Tenkyu Dzu

A large double-page, coloured, copper-plate engraving published by Shiba Kokan at Yedo in the 8th year of the Kwansei era (1796).
Height 40.5 cm. Width 91.5 cm.

PLATE 195

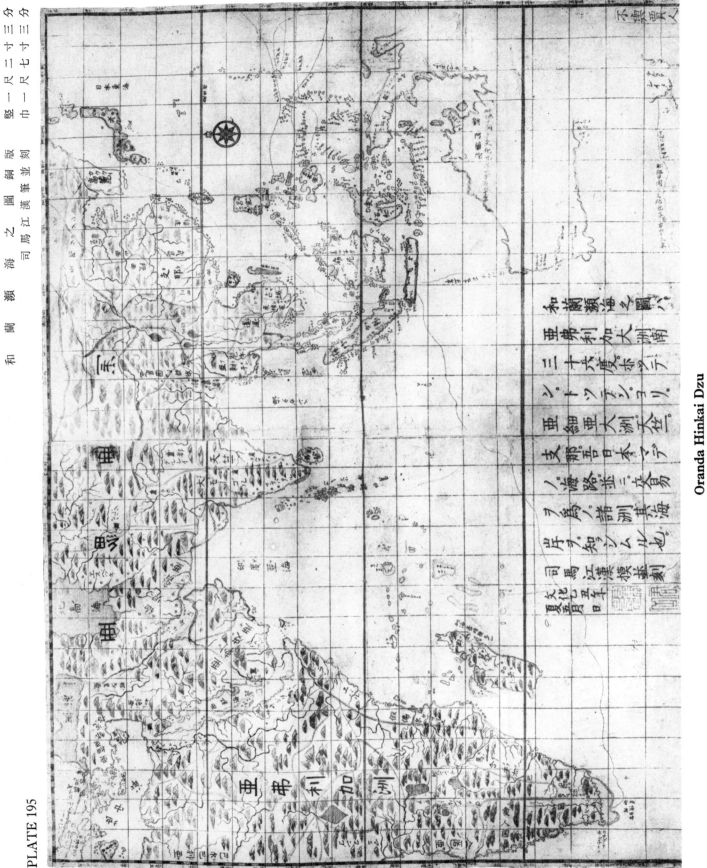

Oranda Hinkai Dzu

A chart of the navigation route to Holland. Signed by the artist and inscribed: Painted and engraved by Shiba Kokan, summer, Kinoto-ox year of the Bunkwa era (1805).

Height 37.5 cm. Width 52.5 cm.

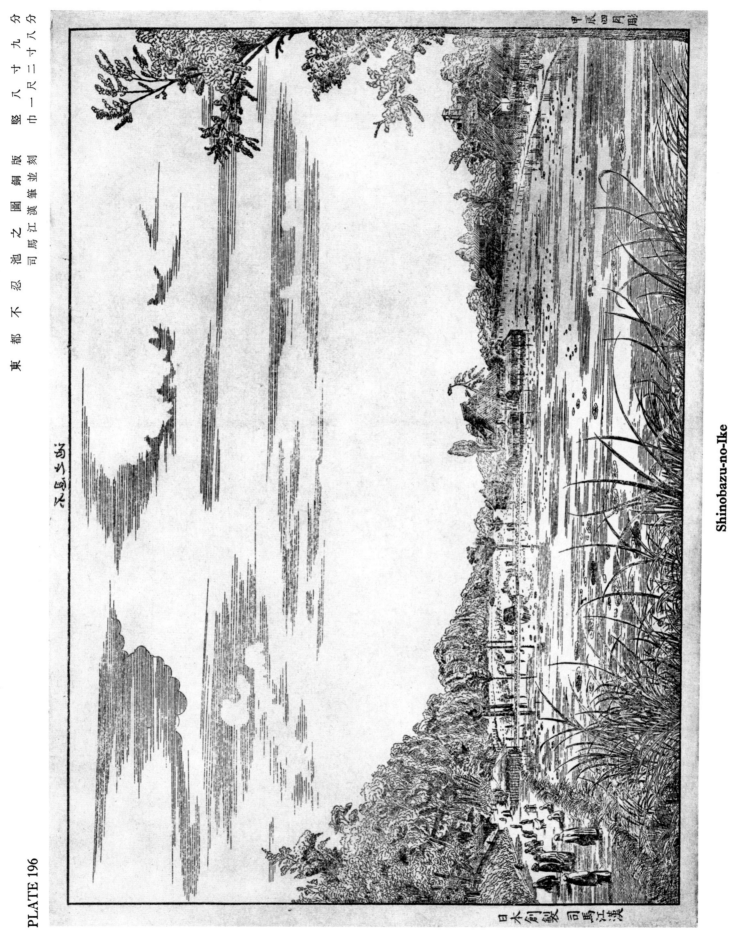

東都不忍池之圖銅版並筆漢江馬司　堅八寸九分　巾一尺二寸八分

PLATE 196

Shinobazu-no-Ike

Shinobazu Pond; copper-plate engraving by Shiba Kokan.
Height 27 cm. Width 39 cm.

PLATE 197

金龍山淺草寺之圖　銅版並刻　堅　一　尺　九　分
亞歐堂田善筆並刻　　　巾　二　尺　一　寸

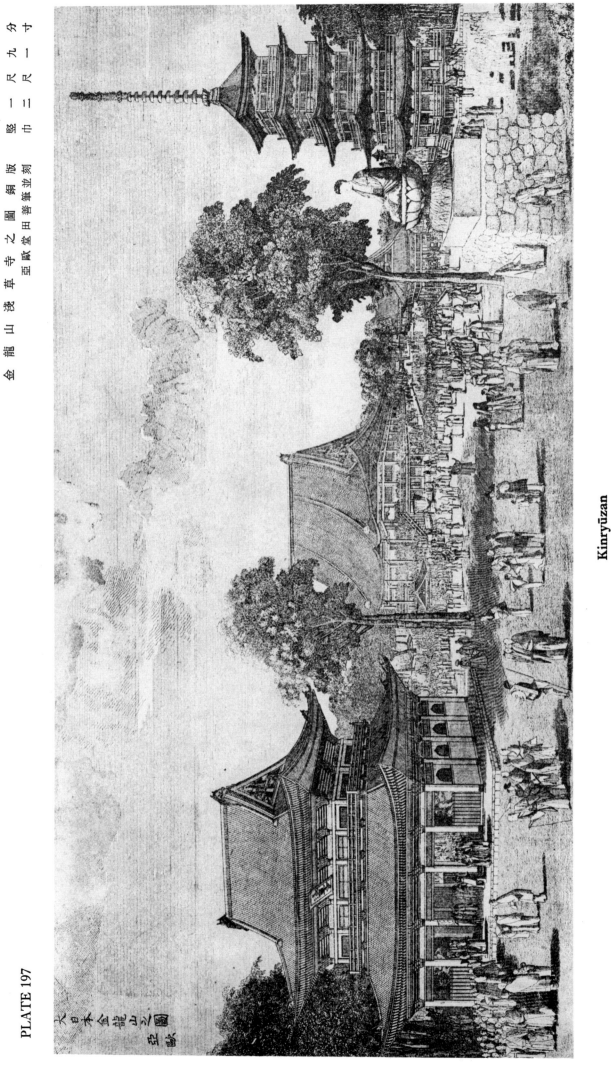

大日本金龍山之圖
亞歐

Kinryūzan

Kinryūzan Temple; copper-plate engraving by Ado Denzen.
Height 33 cm. Width 63.5 cm.

PLATE 198

異國人契煙之圖銅版　竪七寸七分
田騏筆並刻　巾六寸三分

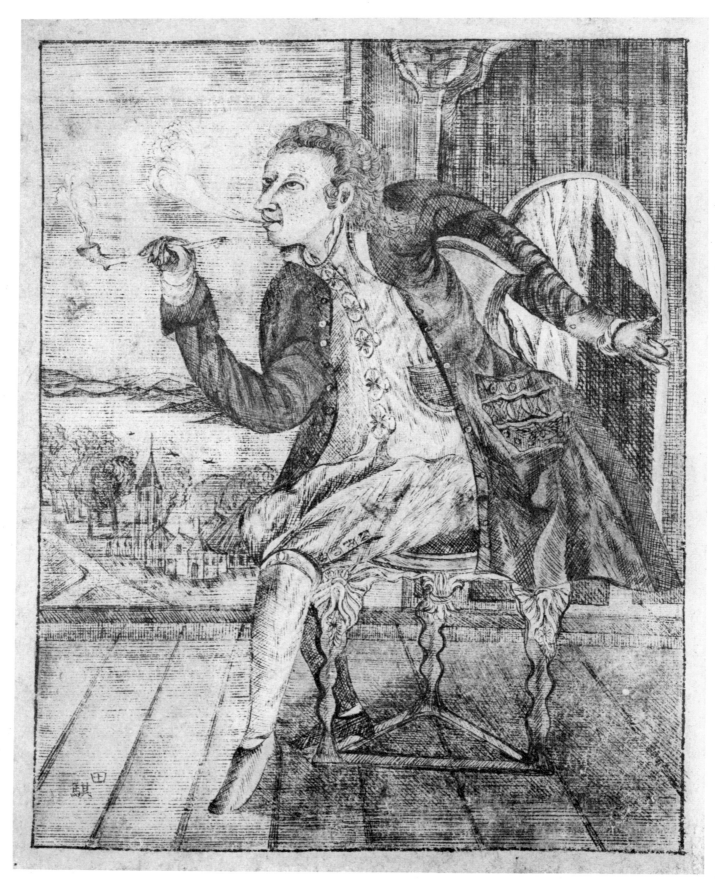

Hollander smoking a Pipe; copper-plate engraving by Yasuda Denki.
Height 23.5 cm. Width 19 cm.

PLATE 199

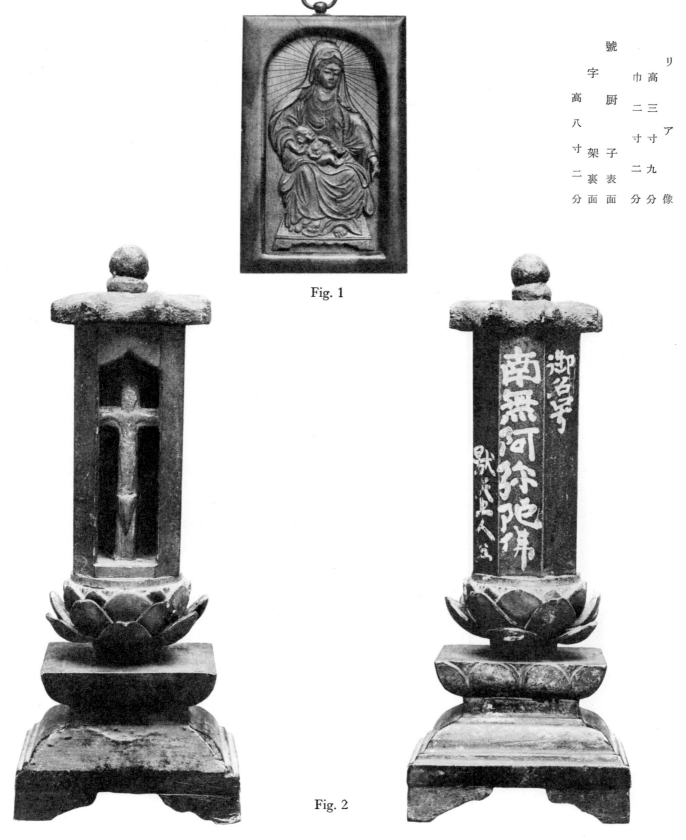

マ 名 十

リ 號

ア 字

像 九 二 高 厨 高

分 分 寸 三 子 八

二 架 寸

巾 裏 二

寸 表 分

Fig. 1

Fig. 2

Fig. 1　An Image of the Virgin and Child where the Virgin is represented as the Japanese Goddess of Mercy *(Kwannon)* in order to escape detection by persecuting officials. *Circa* 1750.
Height 12 cm. Width 6.5 cm.

Fig. 2　Old Black Lacquer Shrine decorated with gold lacquer and inscribed in red lacquer: Namu Amida Butsu on one side with a Crucifix on the other side. Probably made for a Buddhist priest converted to Christianity. *Circa* 1680.
Height 25 cm. Width 9.5 cm.

銅聖觀音像表面

十字架裏面　高徳三川中三分期

銅マリア像鬼子母神を祀る　高徳三川中七分期

銅マリア像鬼子母神を祀る　高徳三川初一分期

銅マリア像揚柳觀音を祀る　高徳五川末一分期

**"Marias," or Images of the Virgin and
Child Made to Resemble Buddhist Images**

Fig. 1 Bronze Sho Kwannon on one side and a Crucifix on the
other side. *Circa* 1730.
Height 10 cm.

Fig. 2 Bronze Yoryu Kwannon. *Circa* 1760.
Height 17 cm.

Fig. 3 Bronze Kishibojin. *Circa* 1660.
Height 9.5 cm.

Fig. 4 Bronze Kishibojin. *Circa* 1730.
Height 11.3 cm.

PLATE 200

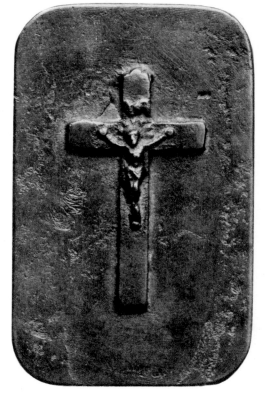

Fig. 1

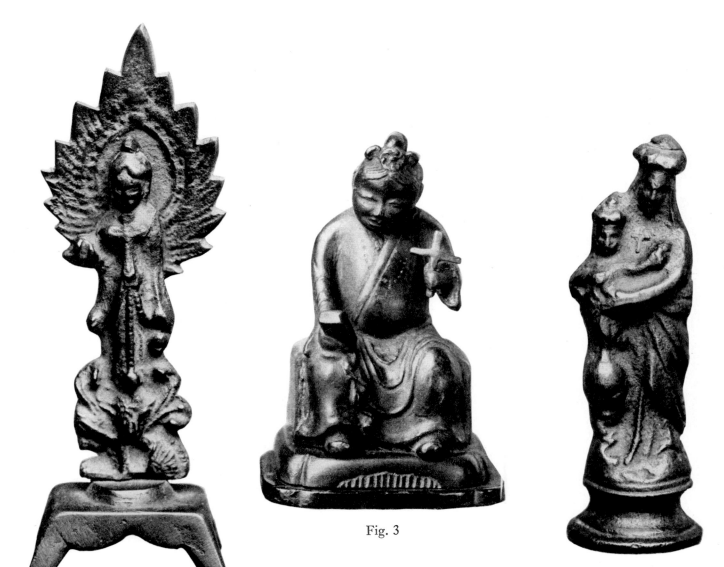

Fig. 2

Fig. 3

Fig. 4

PLATE 201

一　十　字　架　模　樣　洋　燈　　高一尺六寸八分
二　硝　子　銀　菊　花　入　根　付　磁　石　附　　直徑一寸五分

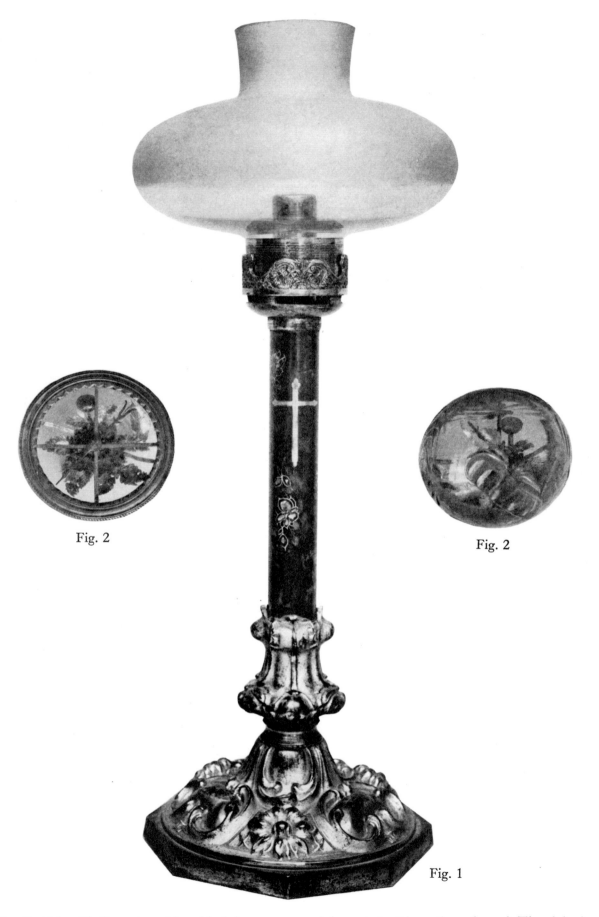

Fig. 2

Fig. 2

Fig. 1

Fig. 1　Candlestick with Cross in gold on black lacquer ground decorated with mother-of-pearl. The globe is of Naga-
saki glass and the stand is gold gilt.

Height 51 cm. Width 20 cm.

Fig. 2　Nagasaki glass Compass. Two views: front and back.

Diameter 4.5 cm.

PLATE 202

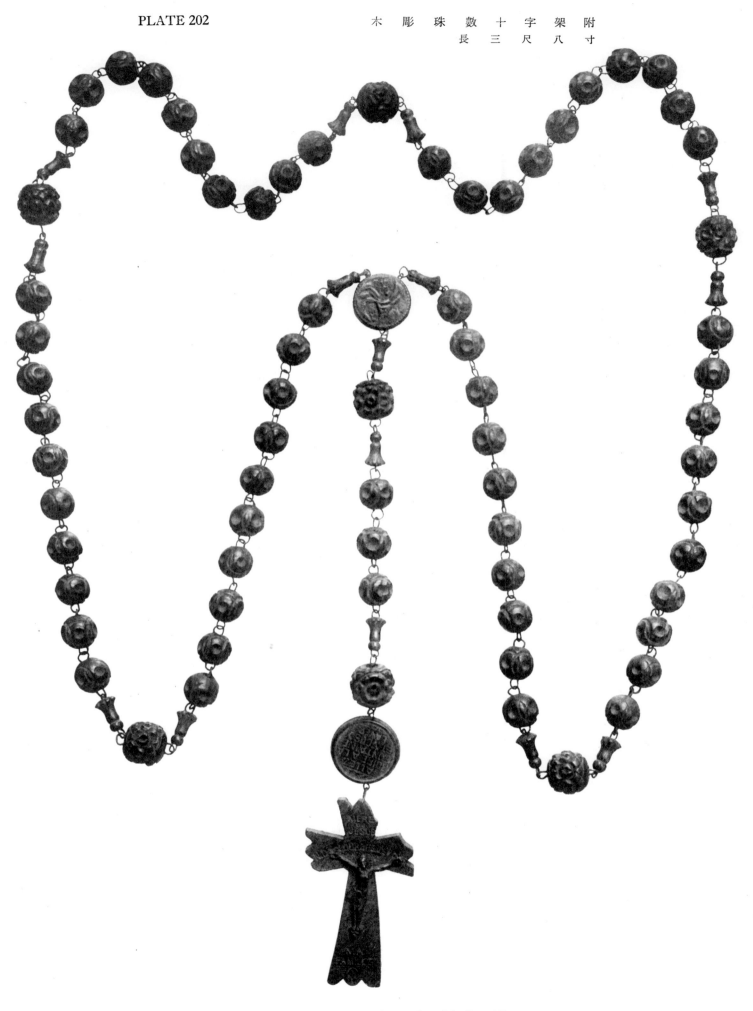

Rosary of Carved Open-Work Beads with Crucifix
Length 115 cm.

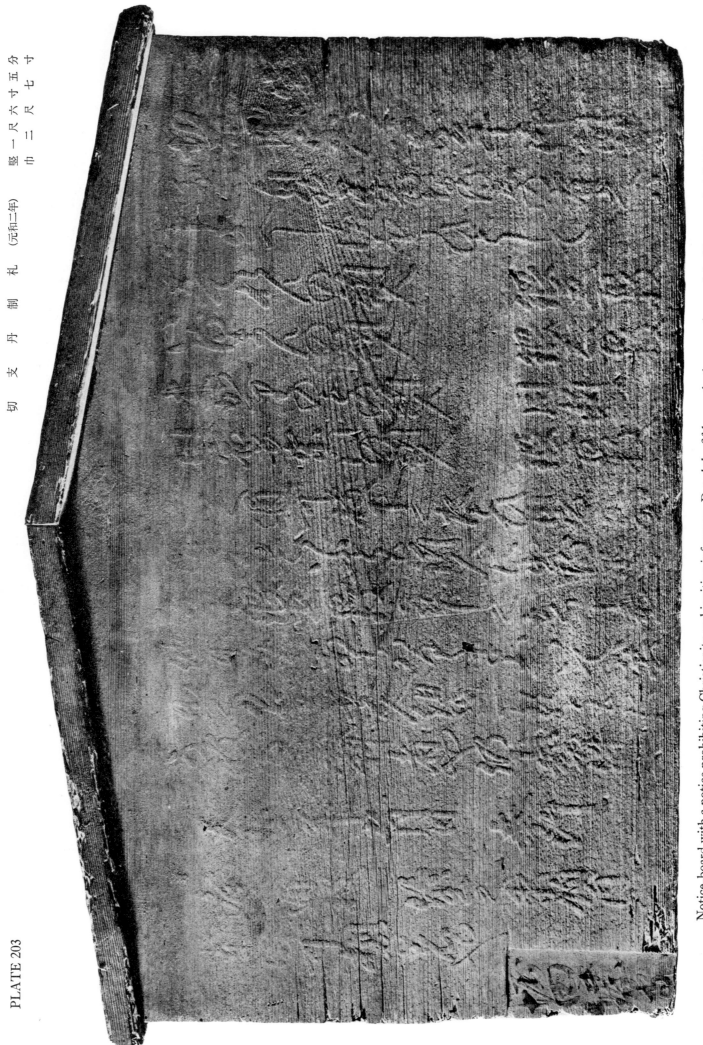

PLATE 203

切 支 丹 制 札 （元和二年） 竪 一尺六寸五分
巾 三 尺 七 寸

Notice-board with a notice prohibiting Christianity and inviting informers. Dated the fifth month, the second year of the Tenna period (1682). Height 50 cm. Width 82 cm.

PLATE 204

一　木　彫　踏　繪　高　一　尺　二　分
　　　　　　　　　　　巾　六　寸　六　分

二　板　形　踏　繪　竪　八　寸　一　分
　　　　　　　　　　　巾　六　寸　三　分

Fig. 1 The Ceremony of Jefumi, or Figure-treading, consisted in trampling upon the Cross, an image of Christ, the Virgin Mary or some other saint. The ceremony was observed in Nagasaki from the beginning of the 17th century down to the middle of the 19th century. This was supposed to be a convincing proof that the inhabitants of Nagasaki forever renounced the Catholic religion. The instrument shown in Fig. 1 was used only in Nagasaki Hospitals when the patient was too ill to get up and trample upon the Cross. The inscription is as follows : Hizen Matsudaira Han Nagasaki Bugiōsho (the office of the Governor of Nagasaki).
Height 31 cm. Width 20 cm.

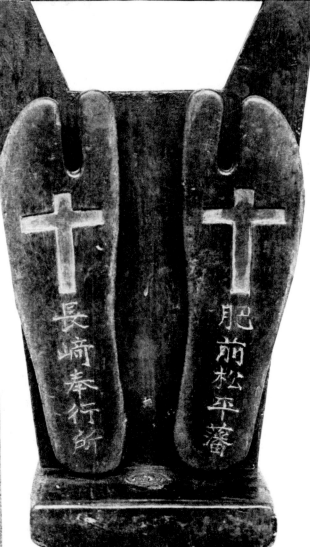

Fig. 2 Copper Figure in the Ceremony of Figure-treading fixed in a plank. Figure of Christ with the Crown of Thorns on his head. Height 24.5 cm. Width 19 cm.

PLATE 207

ウンスン歌留多　竪二寸四分
巾一寸七分

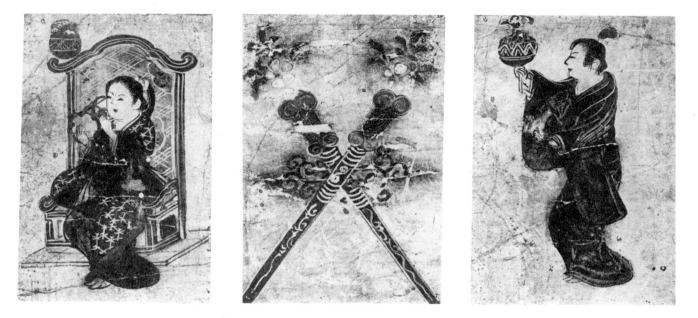

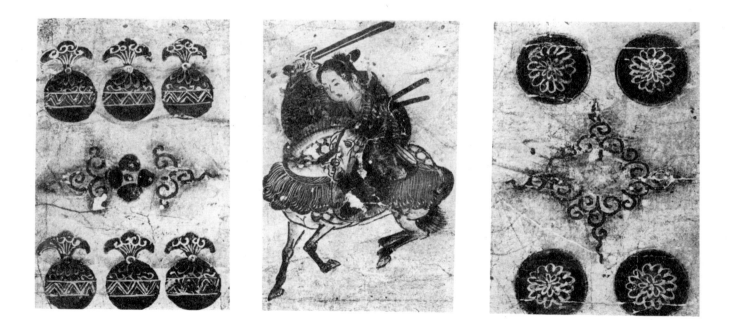

Six Specimens of Unsun Karuta (Earliest playing-cards)

Unsun Karuta were introduced in Japan during the Tembun era (1540), when a Portuguese Ship came into a port in Kyushu for trading. The pictures of the Pope and other religious subjects, which appeared on the cards, were changed in Japan into pictures of Daruma, Hotei and other Japanese subjects. Since all forms of gambling were prohibited by the Shogunate in the second year of the Keicho era (1597), Unsun Karuta subsequently almost disappeared in Japan.
Height 7.5 cm. Width 5 cm.

PLATE 208

沈金彫阿蘭陀船繪入煙草盆　　銀　煙　草　添
　　　　　　　　　　　　　　高　九　寸　三　分
　　　　　　　　　　　　　　巾　七　寸　五　分

後　長崎港之繪

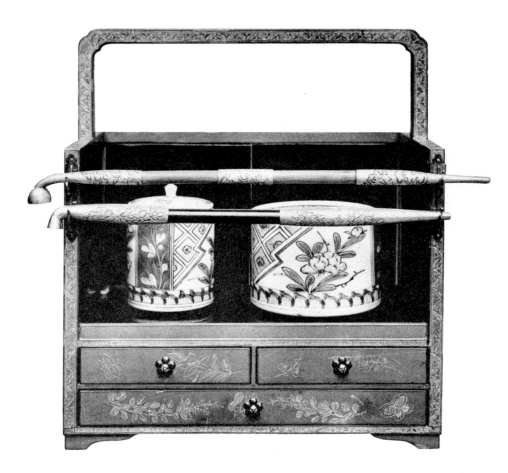

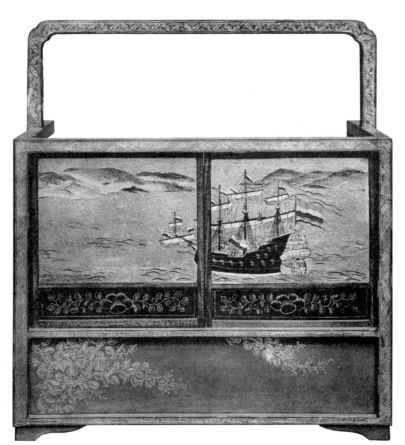

Fig. 1 Smoking Set in Red Lacquer decorated with *Chinkinbori* gold lacquer decoration, with coloured *Imari* charcoal retainer and receptacle for ashes, together with two silver pipes.

Fig. 2 Shows the back view of the Smoking Set with Nagasaki Harbour and a Dutch Ship in colours on gold ground. Silver ornaments.
Height 28 cm. Width 24 cm.

PLATE 209

銅　船　彫　香　合
竪　三　寸

象牙黑地阿蘭陀船模樣香合
直　徑　二　寸　二　分

丸形キュピー蒔繪香合
直　徑　三　寸　三　分

平目青貝入阿蘭陀船蒔繪香合
長　二　寸　八　分
巾　一　寸　五　分

Fig. 1　Copper Box for seal vermilion, decorated with a Dutch Ship in silver.
Height 9 cm. Width 6 cm.

Fig. 2　Incense case in red lacquer decorated with a Cupid in gold lacquer.
Diameter 10 cm.

Fig. 3　Ivory Box decorated with a Portuguese Ship in colours on dark green ground.
Diameter 6.5 cm.

Fig. 4　Black Lacquer Box with Nashiji decoration and a Foreign Ship with sails in Mother-of-Pearl.
Height 8.5 cm. Width 10.5 cm

PLATE 210

木地阿蘭陀人蒔繪酒器
高 六 寸 五 分

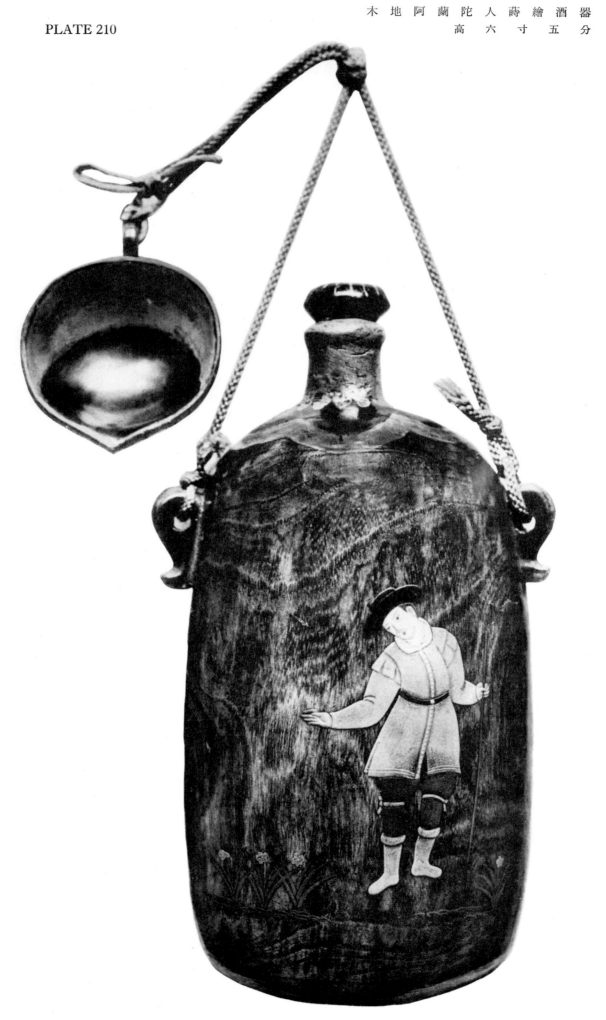

Red Lacquer Saké Bottle with Saké Cup decorated with a picture of a Hollander in colours.
Height 19.5 cm.

PLATE 211

木地丸形硝子繪入覘眼鏡　高八寸九分
直徑六寸九分

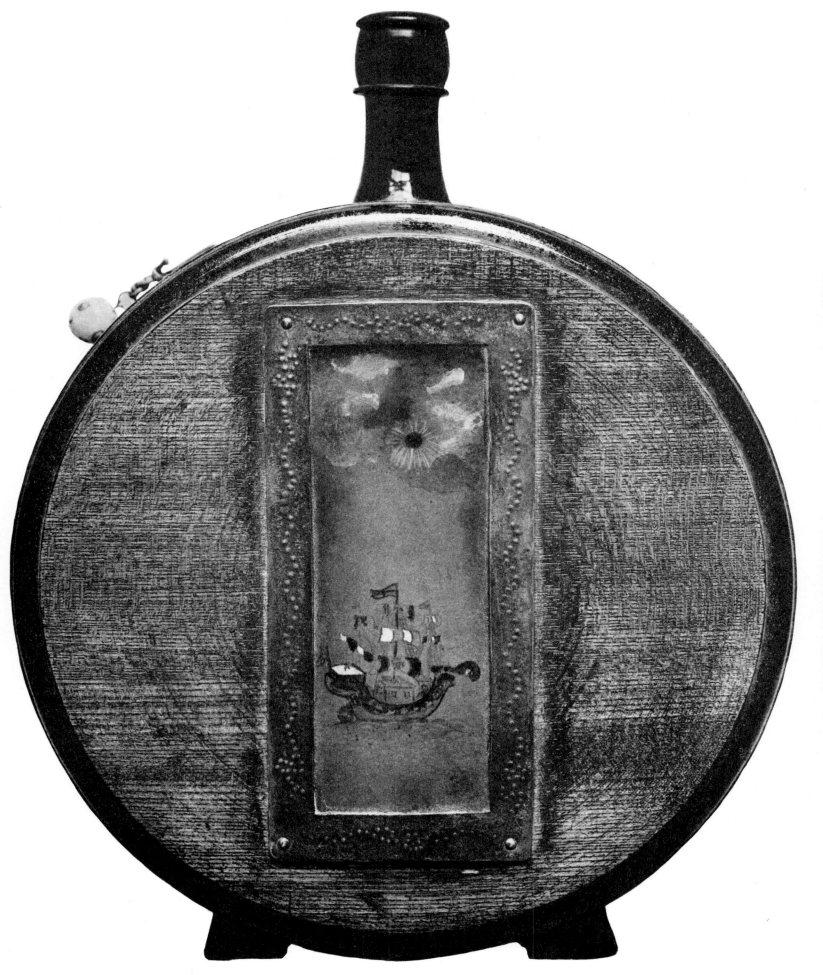

Red Lacquer Nozoki-Megane in form of a Saké Bottle with a Nagasaki glass panel with a Chinese Ship in colours and a Rising Sun outside and a Crucifixion Scene inside.
Height 27 cm. Diameter 21 cm.

硝子入櫛甲鼈
　　上　高　二寸三分三分
　　　　巾　二四寸六三分
　　中　高　一寸三二分
　　　　巾　三寸一五分
　　下　高　一寸四寸
　　　　巾

PLATE 212

硝子笄
島津齋彬公作
黑地紋付箱
長一尺四寸九分

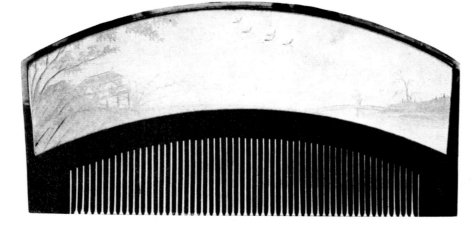

Fig. 1　Tortoise-shell Comb with a Nagasaki glass panel decorated with Landscape designs.
　　　　Height 7 cm. Width 14 cm.

Fig. 2　Tortoise-shell Comb with a Nagasaki glass panel decorated with a picture of a Dutch Ship.
　　　　Height 4 cm. Width 10.5 cm.

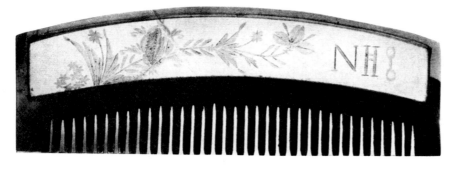

Fig. 3　Tortoise-shell Comb with a Nagasaki glass panel decorated with flowers and marked N H.
　　　　Height 4.5 cm. Width 12 cm.

Fig. 4　Two tortoise-shell Hair Ornaments in black lacquer case. Marquis Shimazu's Collection.
　　　　Length 45 cm.

PLATE 213

硝　子　切　子　香　入
銀磁石、干満潮表付
高　二　寸　八　分

硝　子　大　筆
長一尺三寸二分

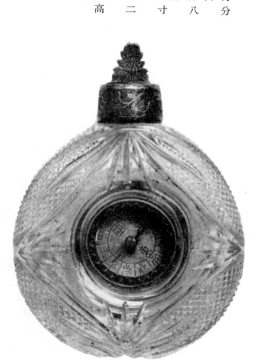

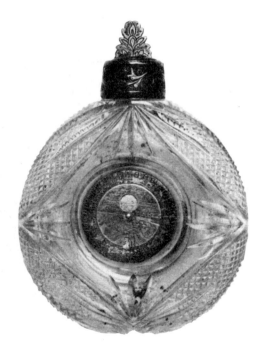

Fig. 1　Nagasaki cut-glass Bottle with
compass on one side and phases
of the moon on the other side.
Height 8.5 cm.

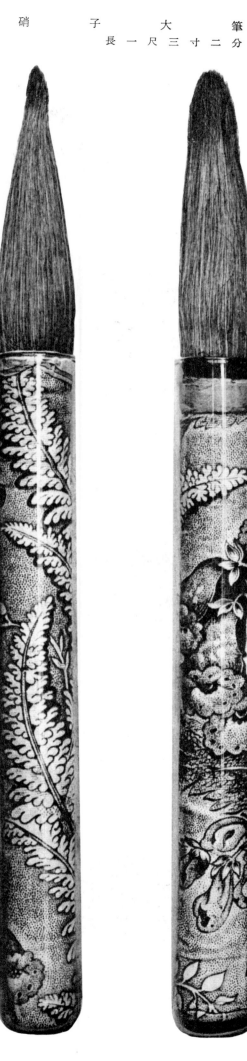

Fig. 2　A pair of Writing Brushes with
Nagasaki glass handles.
Height 40 cm.

PLATE 213

硝 子 切 子 香 入
銀 磁 石、干 滿 潮 表 付
高 二 寸 八 分

硝　子　大　筆
長 一 尺 三 寸 二 分

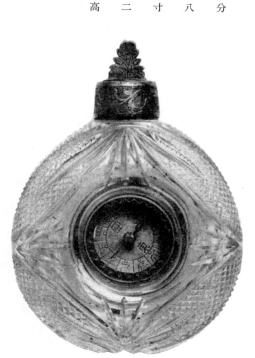

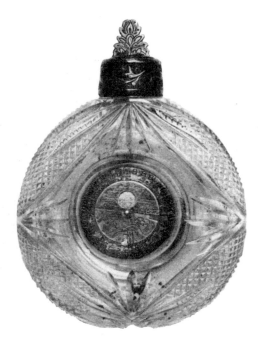

Fig. 1　Nagasaki cut-glass Bottle with
compass on one side and phases
of the moon on the other side.
Height 8.5 cm.

Fig. 2　A pair of Writing Brushes with
Nagasaki glass handles.
Height 40 cm.

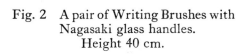

PLATE 214

黒塗吸物椀山水硝子繪入　十個　　高　二寸六分
硝子繪直徑二寸

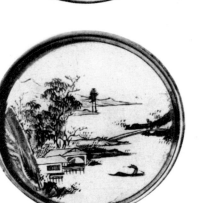
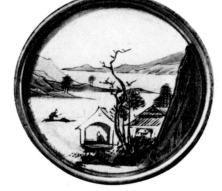

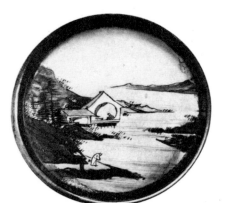

A Set of Ten Black-Lacquer Soup Bowls with cover decorated with Ten Views of Nagasaki on a round glass panel.
Height 8 cm.

PLATE 215

朱塗厨子辨財天像
林法橋作　高一尺四寸七分

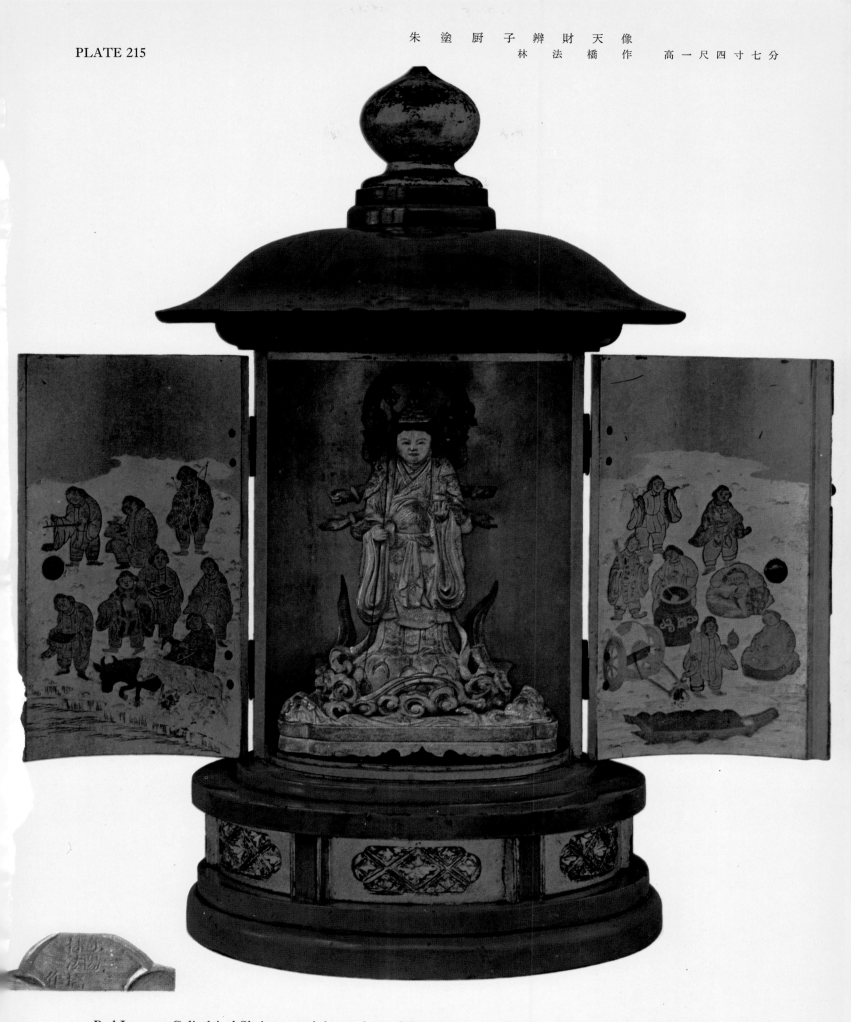

Red Lacquer Cylindrical Shrine containing an icon of *Benzai-ten* carved in wood. As Goddess of Water she is standing on Waves. On the inside of the two doors her sixteen boy attendants are painted in various colours on a gold ground. Signed: 'Kiyō (Nagasaki) Hayashi Hokkyo' (Inscription also reproduced). Hayashi was a Nagasaki sculptor who worked from about 1661 to 1688 and died sometime in the Shotoku era (1711–1715).
Height 44.5 cm.

PLATE 216

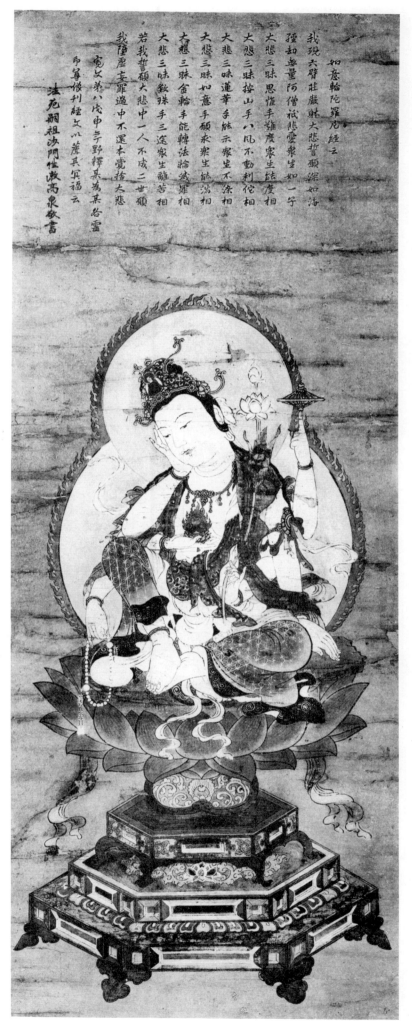

如意輪觀世音音像掛物

黃檗高泉筆

竪三尺一寸二分

巾一尺一寸六分

An image of *Nyoirin-Kwannon* painted by Kōsen Shōton Osho. The inscription on the top reads in part as follows: *"Nyoirin-Kwannon,* as described in the *Sūtra Nyoirin Darani* has six arms. Her power of granting people's desires is wide and deep like the ocean. The virtue of this *Sūtra* is boundless, and her followers will be loved and protected by the deity as if they were her own children. If one deeply follows this deity with true faith, there will be no desires unattainable. Therefore every one must devote himself to her. In the eighth year of the Kwanbun era (1668) this holy image of *Nyoirin-Kwannon* was painted. Piously written by Kōsen Shōton, a monk of the Obaku Sect."

Kōsen Shōton Osho came over to Nagasaki from China in the first year of the Kwanbun era (1661) and stayed at Kodaiji in Nagasaki until the tenth year of the Kwanbun era (1670). He died on the sixteenth day of the tenth month in the eighth year of the Genroku era (1695). He was skilled in painting Buddhist Icons.

Height 94.5 cm. Width 35.3 cm

PLATE 217

七寶燒阿蘭陀人繪茶碗　高三寸二分
沈金彫硝子繪入筆立　高五寸八分
巾六寸四分

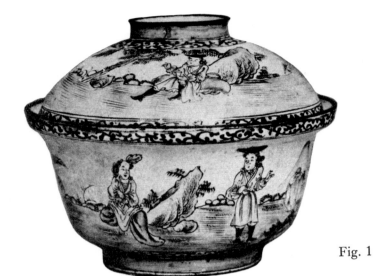

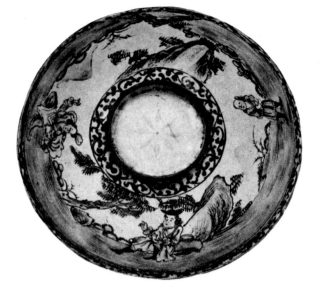

Fig. 1

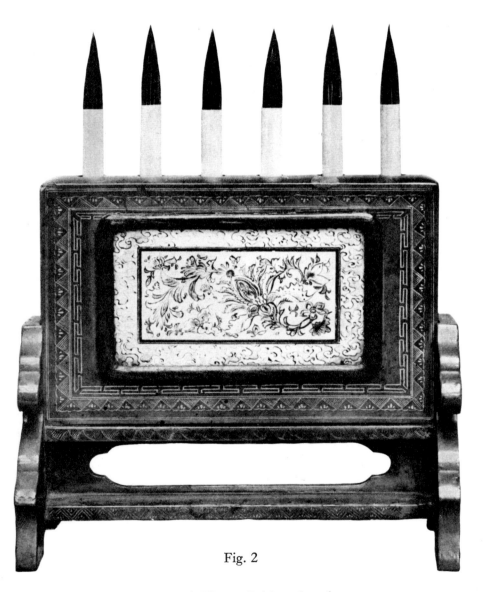

Fig. 2

Fig. 1　Enamel Cake Bowl decorated with Dutch Figure-Subjects in colours.
Height 9.5 cm.

Fig. 2　Writing-Brush Stand in red lacquer with *Chinkinbori* decoration and a panel of Nagasaki glass decorated with scrollwork and flower designs in colours.
Height 17.5 cm. Width 19.5 cm.

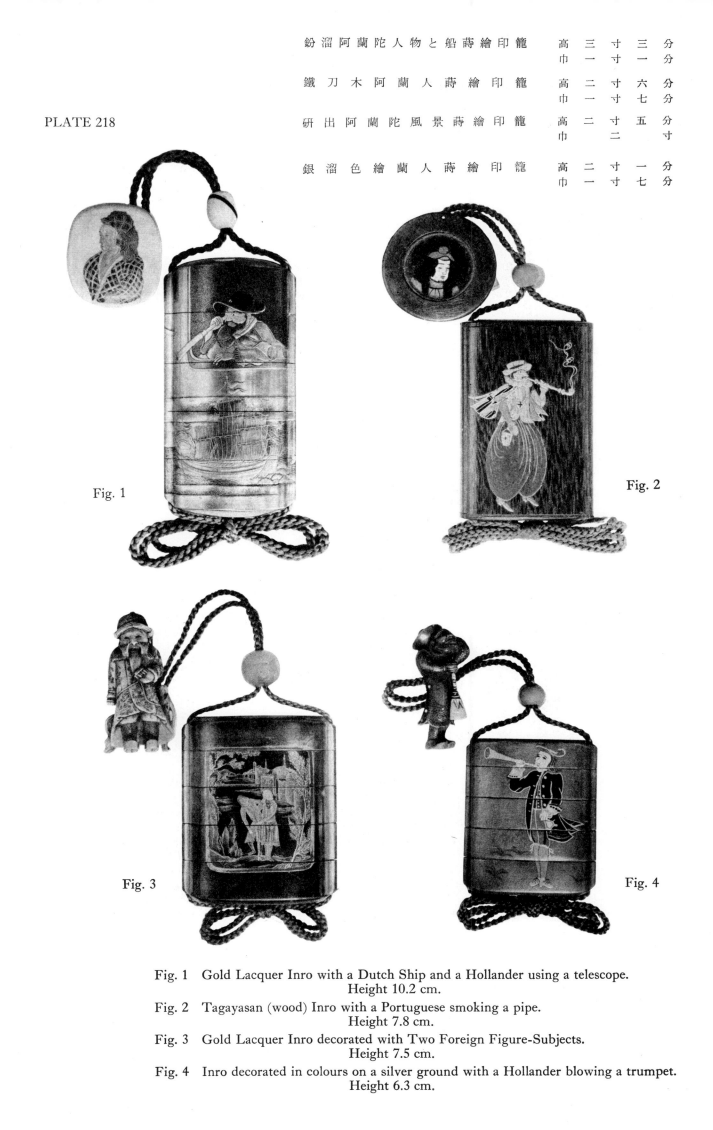

PLATE 218

粉溜阿蘭陀人物と船蒔繪印籠　高　三　寸　三　分
　　　　　　　　　　　　　　　巾　一　寸　一　分

鐡刀木阿蘭人蒔繪印籠　　　　高　二　寸　六　分
　　　　　　　　　　　　　　　巾　一　寸　七　分

研出阿蘭陀風景蒔繪印籠　　　高　二　寸　五　分
　　　　　　　　　　　　　　　巾　　　　二　寸

銀溜色繪蘭人蒔繪印籠　　　　高　二　寸　一　分
　　　　　　　　　　　　　　　巾　一　寸　七　分

Fig. 1

Fig. 2

Fig. 3

Fig. 4

Fig. 1 Gold Lacquer Inro with a Dutch Ship and a Hollander using a telescope.
Height 10.2 cm.

Fig. 2 Tagayasan (wood) Inro with a Portuguese smoking a pipe.
Height 7.8 cm.

Fig. 3 Gold Lacquer Inro decorated with Two Foreign Figure-Subjects.
Height 7.5 cm.

Fig. 4 Inro decorated in colours on a silver ground with a Hollander blowing a trumpet.
Height 6.3 cm.

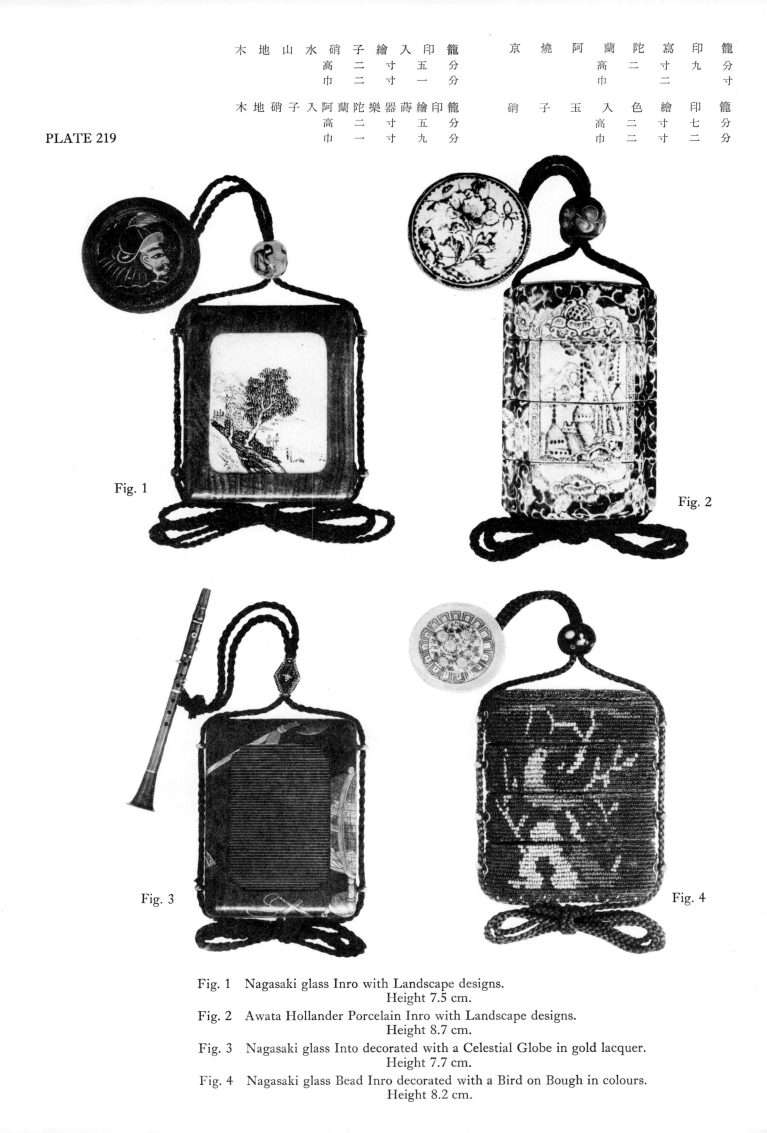

PLATE 219

木地山水硝子繪入印籠
高二寸五分
巾二寸一分

木地硝子入阿蘭陀樂器蒔繪印籠
高二寸五分
巾一寸九分

京燒阿蘭陀寫印籠
高二寸九分
巾二寸

硝子玉入色繪印籠
高二寸七分
巾二寸二分

Fig. 1

Fig. 2

Fig. 3

Fig. 4

Fig. 1　Nagasaki glass Inro with Landscape designs.
Height 7.5 cm.
Fig. 2　Awata Hollander Porcelain Inro with Landscape designs.
Height 8.7 cm.
Fig. 3　Nagasaki glass Into decorated with a Celestial Globe in gold lacquer.
Height 7.7 cm.
Fig. 4　Nagasaki glass Bead Inro decorated with a Bird on Bough in colours.
Height 8.2 cm.

PLATE 220 鐔 六 鐵、象眼

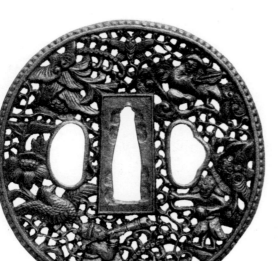

Fig. 1

Fig. 2

Fig. 3

Fig. 4

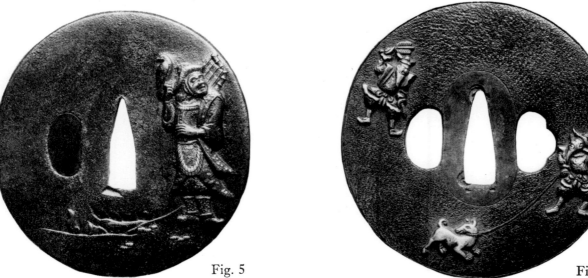

Fig. 5

Fig. 6

Six Tsuba (Sword guards) decorated with foreign designs.

Fig. 1 Diameter 8 cm. Fig. 4 Diameter 6.3 cm.
Fig. 2 Diameter 8.2 cm. Fig. 5 Diameter 6.5 cm.
Fig. 3 Diameter 6.8 cm. Fig. 6 Diameter 7.7 cm.

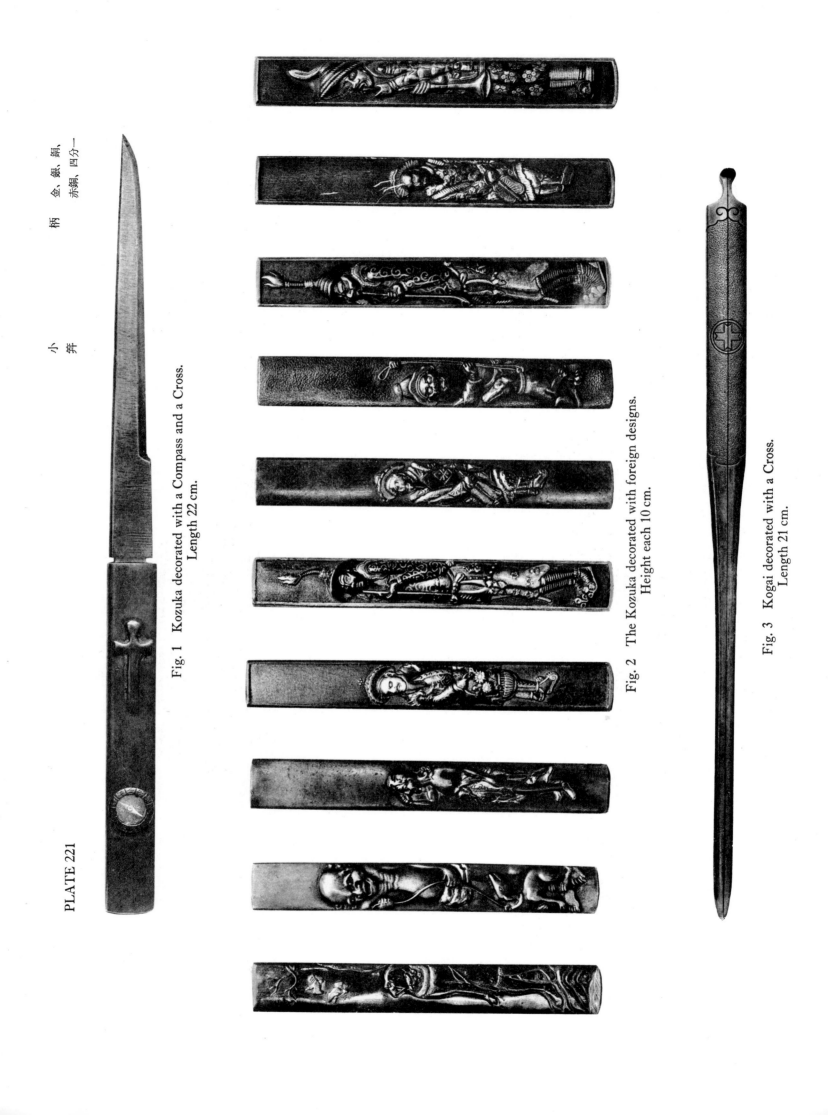

PLATE 221

柄　金、銀、銅、
　　赤銅、四分一

小
笄

Fig. 1　Kozuka decorated with a Compass and a Cross.
Length 22 cm.

Fig. 2　The Kozuka decorated with foreign designs.
Height each 10 cm.

Fig. 3　Kogai decorated with a Cross.
Length 21 cm.

PLATE 222

鐵漆塗阿蘭陀人兜　高六寸六分
永祿年間　巾一尺一寸五分

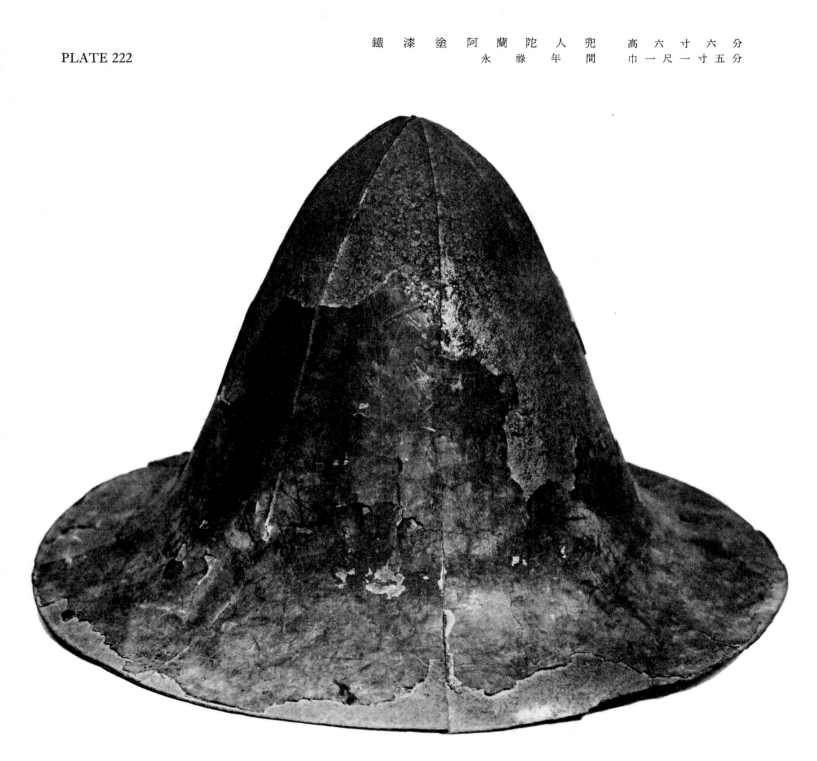

Model of a Portuguese Helmet, iron decorated with gold lacquer outside. Yeiroku era (1560–1569).
Height 20 cm.

PLATE 223

鐵 金 象 眼 入 經 筒　　鐵 金 象 眼 入 茶 入
長 一 尺 二 寸 九 分　　　　高 三 寸 三 分

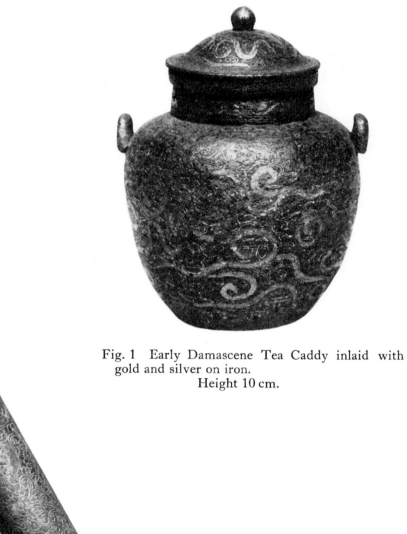

Fig. 1　Early Damascene Tea Caddy inlaid with gold and silver on iron.
Height 10 cm.

Fig. 2　Early Damascene Sutra Case in form of a sword inlaid on iron with flower designs in gold and silver.
Length 39 cm.

PLATE 224

銅蓮形筆洗　亀女　作寸
　　　　　　高二　　寸

宜德銅鶉香爐　亀女　作分
　　　　　　高四寸六分

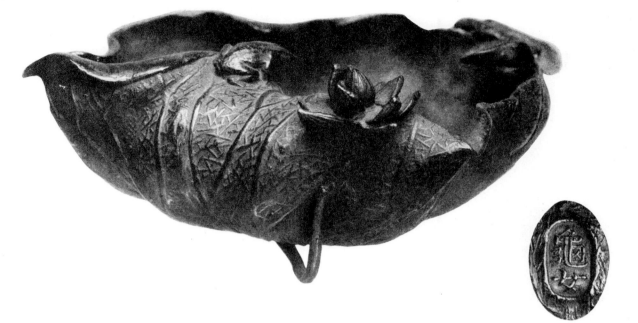

Fig. 1　Brush-Washer in lotus-leaf form with a Frog; bronze, by Kamejo, a Nagasaki artist.
(Inscription also reproduced)
Height 6 cm.

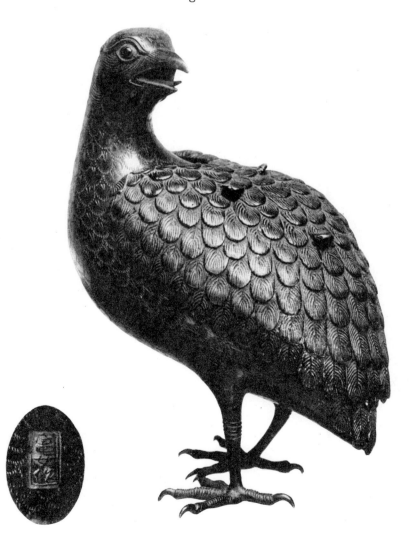

Fig. 2　Incense-Burner, in the form of a quail; bronze, by Kamejo.
(Inscription also reproduced)
Height 14 cm.

PLATE 225

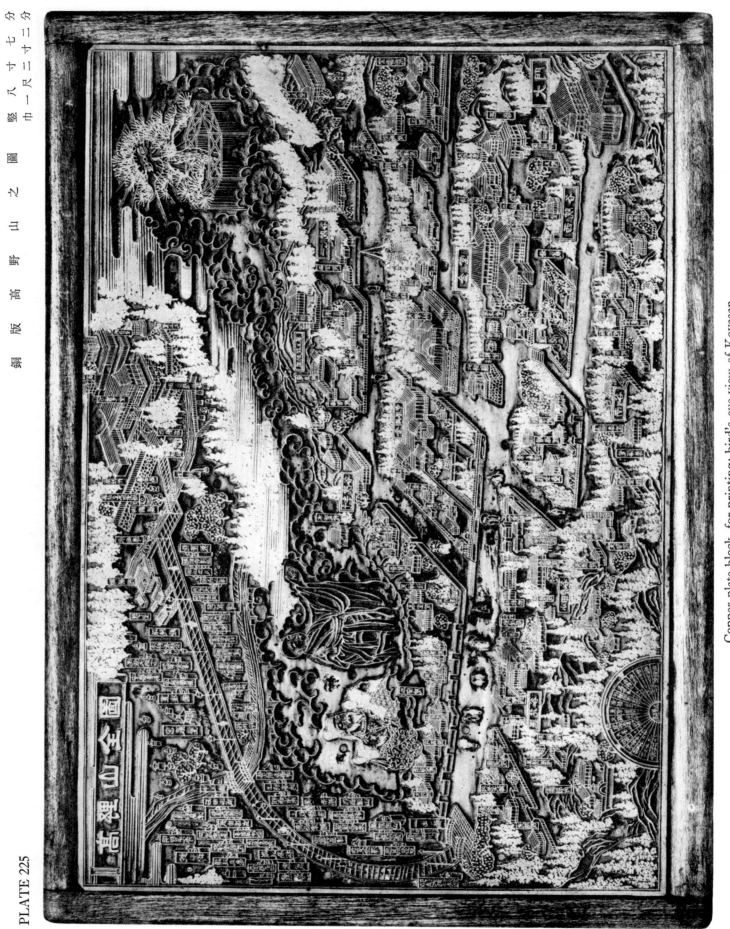

銅版高野山之圖 竪八寸七分 巾一尺二寸三分

Copper-plate block, for printing: bird's-eye view of Koyasan.
Height 26.5 cm. Width 37 cm.

PLATE 226

櫻に鳥彫金金具附煙草入　銀煙管添
巾七寸六分

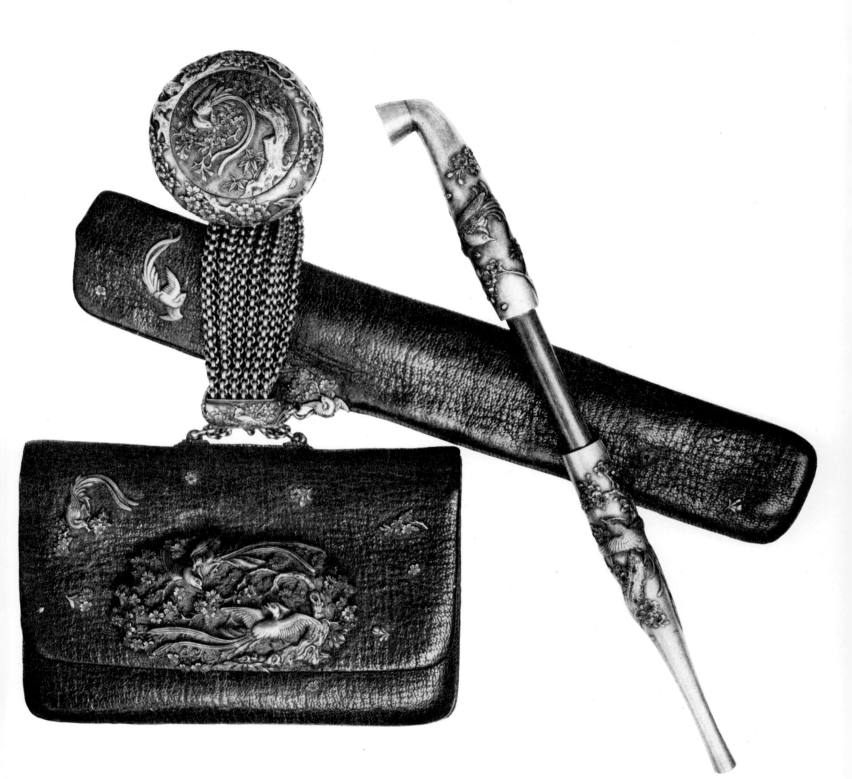

Brown Leather Tobacco Pouch, Pipe Case and Silver Pipe with gold and silver ornaments. Phœnixes flying through cherry blossoms. Eighteenth Century.

Height 23 cm.

PLATE 227

煙草入　金、銀、銅、　時計機械金具　　巾　七　寸　二　分
　　　　赤銅、四分一

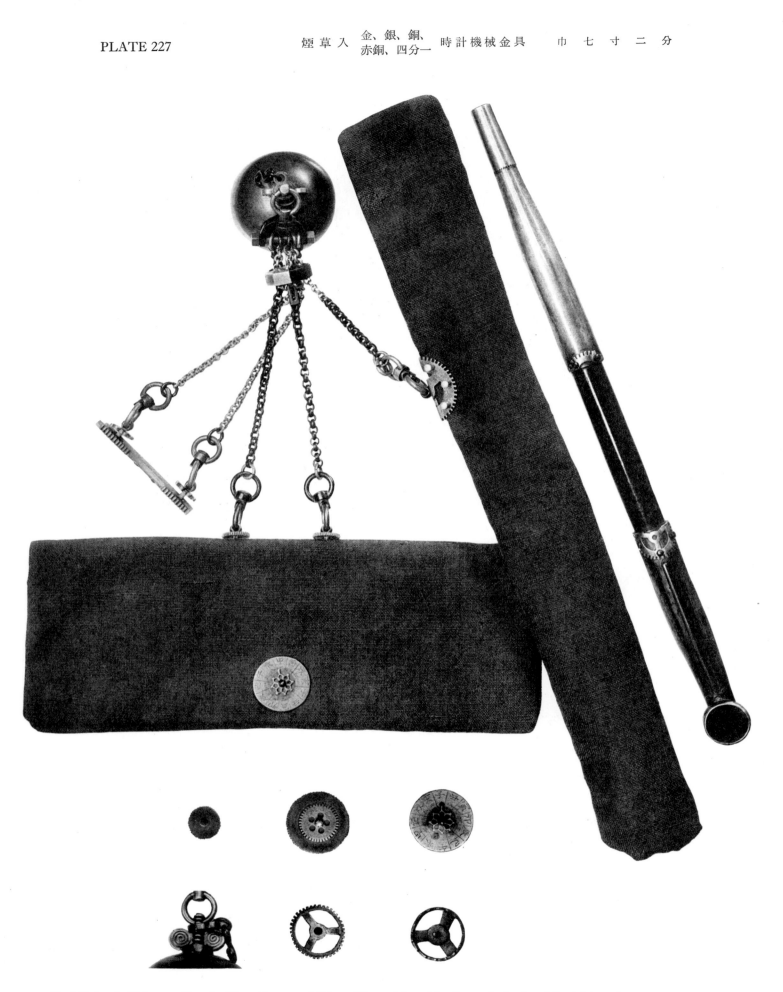

Red *Fukurin* Tobacco Pouch, Pipe Case, and Silver Pipe with gold, silver, shakudo, shibuichi and copper ornaments. The pipe, pipe case and tobacco pouch all have as ornaments parts of a Japanese Clock of the type known as Yagura-dokei.

Height 22 cm.

PLATE 228　　黑地蒔繪渾天儀　高一尺一寸五分

Kontengi (Celestial Globe). This apparatus was used in olden times by astronomers in China and Japan for studying the positions of the heavenly bodies. The globe is of black lacquer with four curved legs decorated with designs of dragons in red and silver lacquer. The inscription is in gold lacquer. The size of this kind of apparatus was not standardized. Sometimes it was very large, while at other times it was quite small. The original apparatus was called Kontengi, and this simplified form, which was invented by Nishikawa Masayasu Kyūrinsai, an astronomer of Nagasaki, was known as Kantengi. Nishikawa worked during the Gembun period (1736–1740).

Height 35 cm.

PLATE 229

眞鑰西蕃蓮唐草彫枕時計　寶曆丑甲戌歲
崎陽渡邊雄右衛門造之
西曆千九百二十七年六月
兵庫縣主催時の記念日展覽會端書添
高　四　寸　四　分
巾　三　寸　六　分

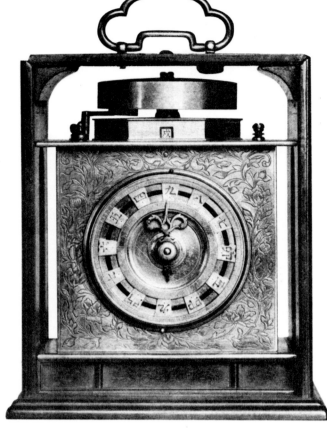

Fig. 1

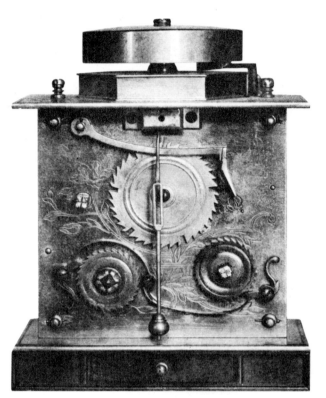

Fig. 2

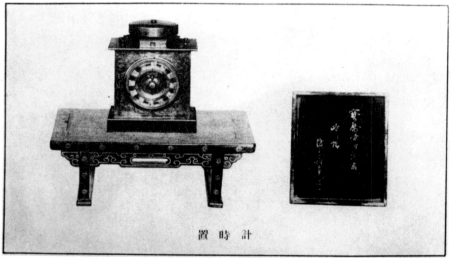

置　時　計

Fig. 3

Clock

Fig. 1　Early Bracket Clock with casing and mechanism of brass. The plates of the clock are all gilt and engraved with passion flowers. The single calendar is placed above the front plate.

Fig. 2　Shows back view of clock with verge escapement and bob pendulum swinging in front of back plate.

Fig. 3　Shows picture postcard issued by the Kobe Kencho (Prefectural Office) in connection with a Clock Exhibition at the Daimaru Department Store on the 10th June, 1927 (Showa, 2nd year). This clock was exhibited by Mr. Kobayashi, of Motomachi, as an early specimen of *Makura-Dokei*, or "pillow-clock." The clock has an original black-lacquer case, with an inscription in gold lacquer reading as follows: "Made by Watanabe Yu-uemon, living in the province of Nagasaki in the 4th year of the Horeki period, Dog-year (1754)."

Height 13.2 cm. Width 8 cm.

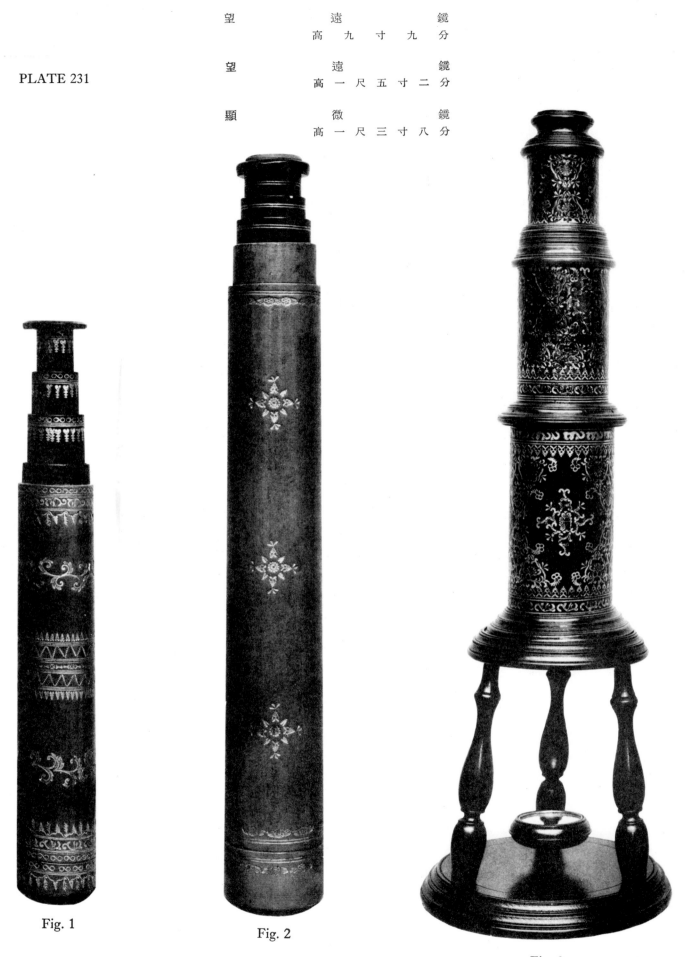

PLATE 231

望　　遠　　鏡
高　九　寸　九　分

望　　遠　　鏡
高　一　尺　五　寸　二　分

顯　　微　　鏡
高　一　尺　三　寸　八　分

Fig. 1

Fig. 2

Fig. 3

Fig. 1　Red-Lacquer Telescope with gold-lacquer decoration.
Height 30 cm.
Fig. 2　Red-Lacquer Telescope with gold-lacquer decoration.
Height 46 cm.
Fig. 3　Black-Lacquer Microscope with gold-lacquer decoration.
Height 42 cm.

PLATE 230

眞鍮西蕃蓮唐草彫衝立形枕時計　　高　三　寸　六　分
　　　　　　　　　　　　　　　　　　巾　三　寸　六　分

眞鍮卦算時計西蕃蓮透鎖引機械　　高　四　寸　二　分　半
　　　　　　　　　　　　　　　　　巾　　　六　分　半

眞鍮卦算時計鍍金西蕃蓮透鎖引機械　高　三　寸　三　分
　　　　　　　　　　　　　　　　　　巾　　　六　分

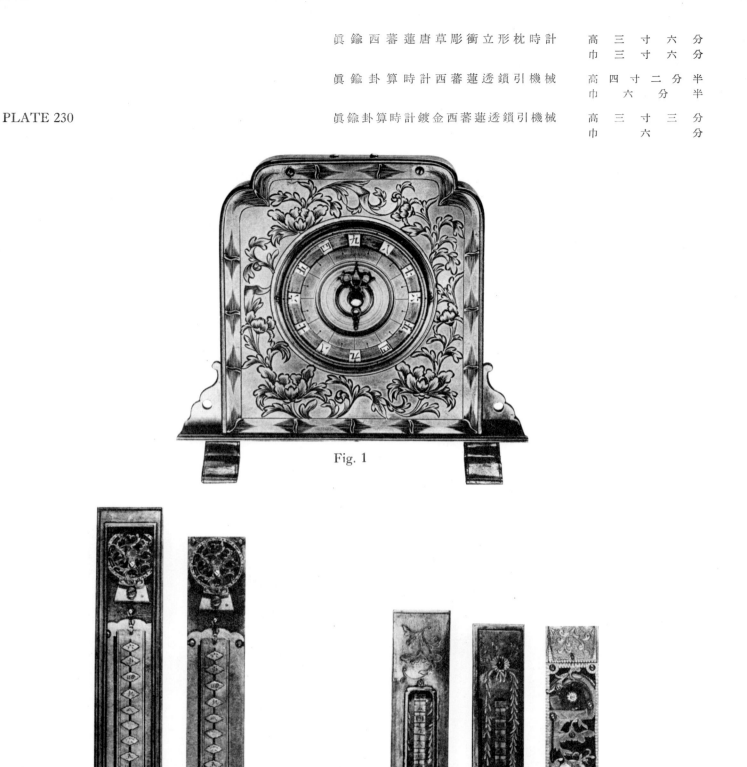

Fig. 1

Fig. 2　　　Fig. 3　　　　　　Fig. 4　　Fig. 5　　Fig. 6

Fig. 1　Screen Clock with Tokei-so design.　Height 10.8 cm. Width 10.8 cm.

Fig. 2　Paper-Weight clock.　The outer and the inner case are both of gilt brass. The clock has a spring action with mechanism of pillar-clock variety.　The clock measures: Height 13.7 cm Width 2.2 cm.

Fig. 3　Shows clock only. It measures: Height 12.8 cm. Width 1.9 cm.

Fig. 4　Paper-Weight clock. The outer and the inner case are both of gilt brass. Height 10.2 cm. Width 1.9 cm.

Fig. 5　Shows clock only. It measures: Height 9.9 cm Width 1.7 cm.

Fig. 6　Shows mechanism of clock.

PLATE 232

綴錦聖人模様見送 　堅五尺六寸一分
　　　　　　　　　 　巾三尺八寸三分

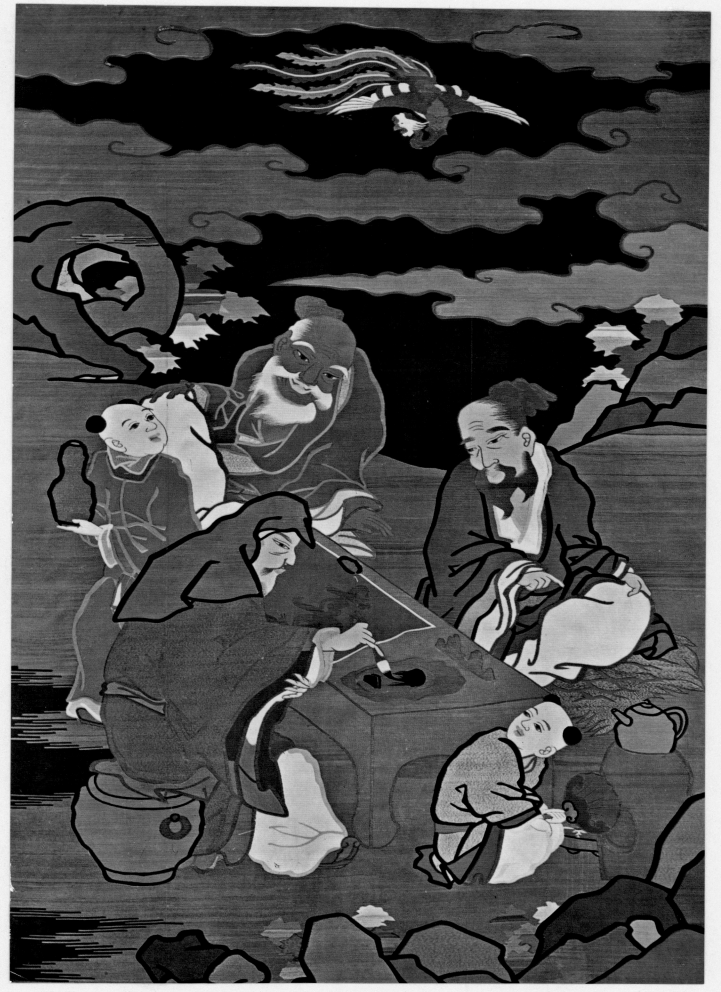

Silk Tapestry-Hanging, red, brown, blue, gold and green. A friendly meeting of Three Sages with Attendants.
Height 170 cm. Width 117.5 cm.

PLATE 233　　　　　綴錦寶船七福神模樣見送　　堅七尺一寸九分
　　　　　　　　　　　　　　　　　　　　　　　　巾三尺九寸三分

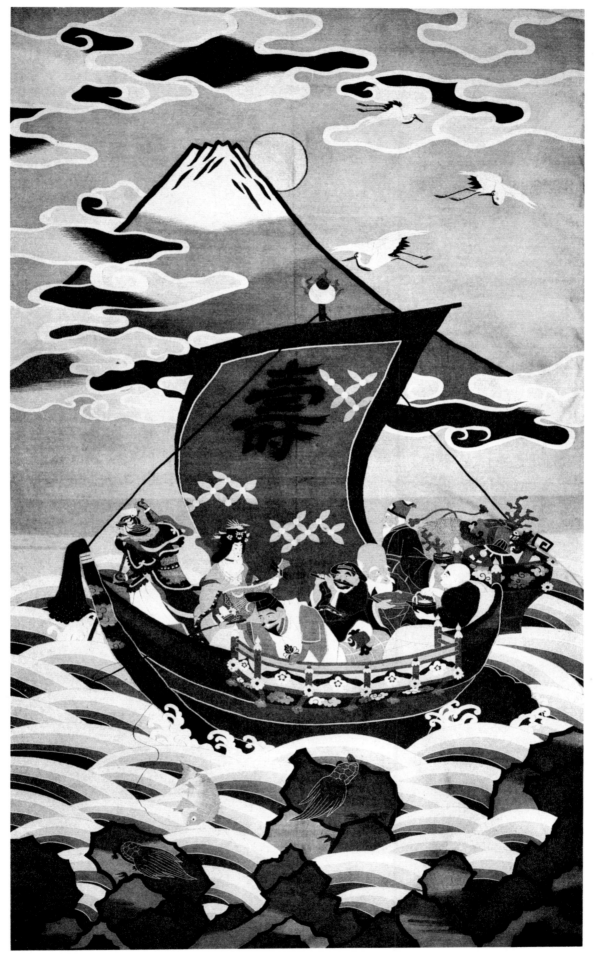

Silk Tapestry-Hanging in colours: The Seven Gods of Good Fortune *(Shichi-fuku-jin)* on a
pleasure trip, with Mount Fuji in the background.
Height 218 cm. Width 119 cm.

PLATE 234

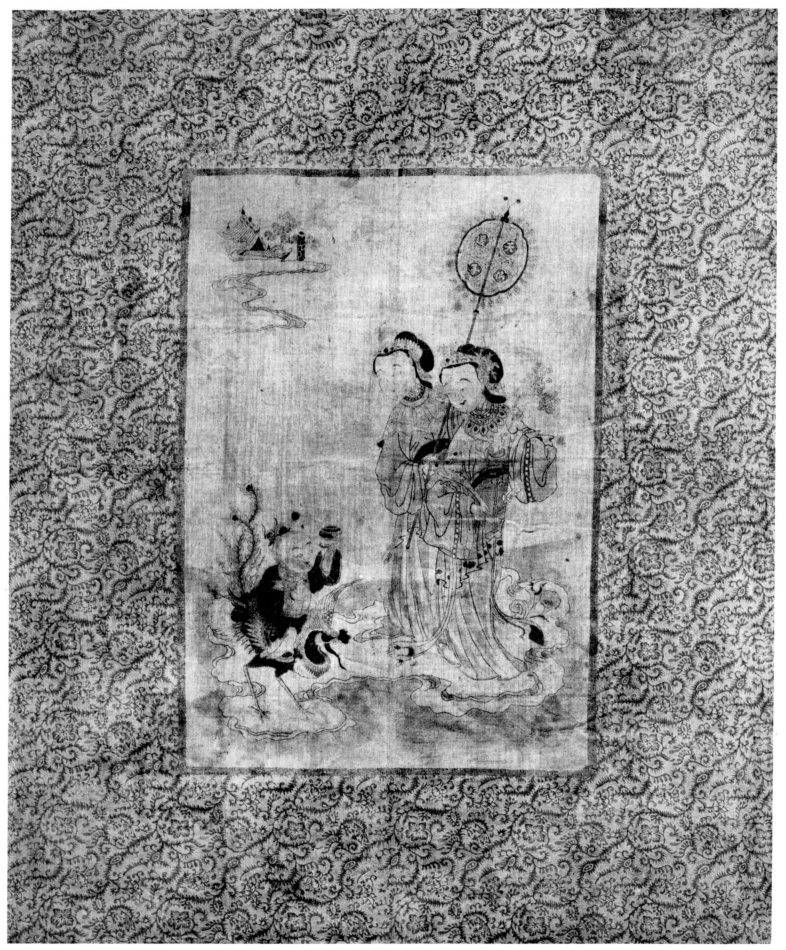

Sakai Sarasa (a textile made in Sakai) with Chinese Figure-Subjects in colours.
Height 164 cm. Width 133 cm.

PLATE 235

壁 羽 二 重 三 國 人 模 樣 帛 紗　　竪 二 尺 四 寸 六 分
　　　　　　　　　　　　　　　　　巾 二 尺 一 寸 八 分

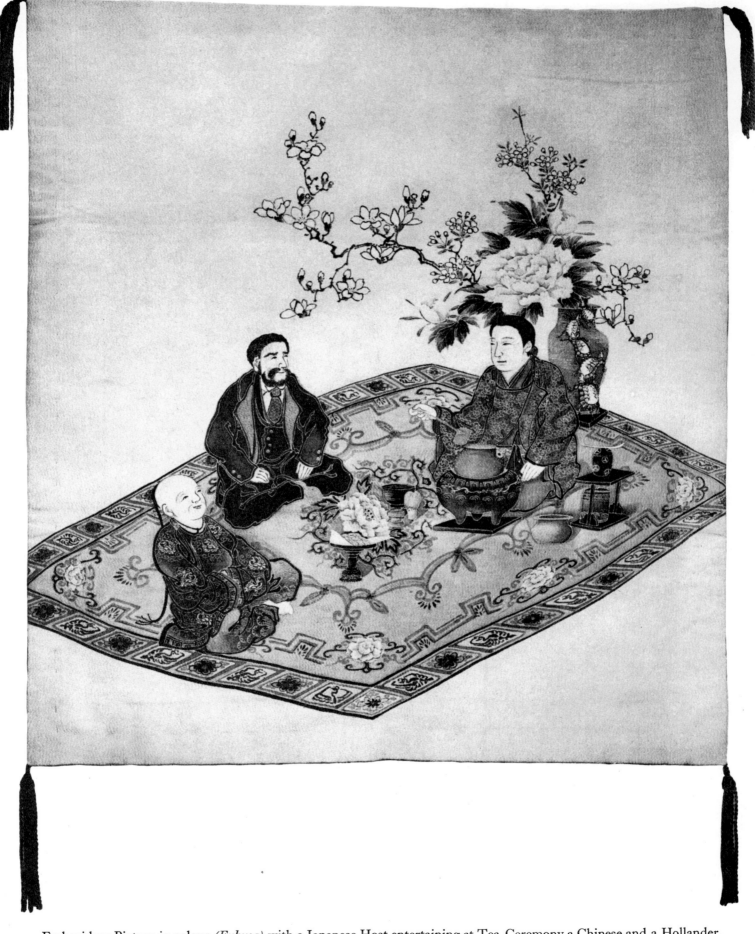

Embroidery Picture in colour *(Fukusa)* with a Japanese Host entertaining at Tea Ceremony a Chinese and a Hollander.
Height 74.5 cm. Width 66 cm.

PLATE 236

木 彫 白 象 香 爐 高 五 寸 六 分

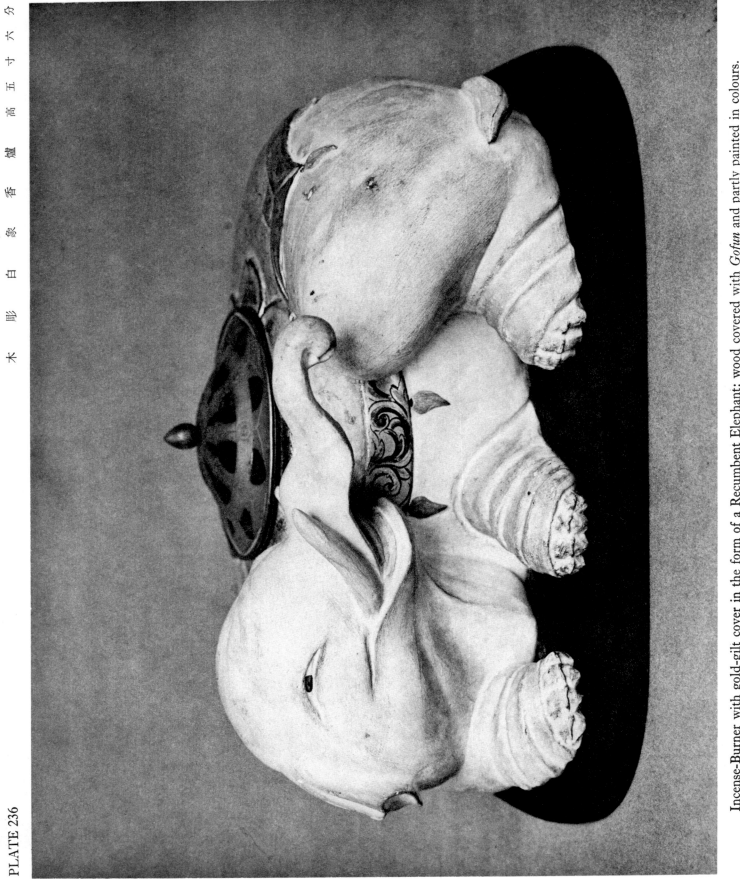

Incense-Burner with gold-gilt cover in the form of a Recumbent Elephant: wood covered with *Gofun* and partly painted in colours.
Height 17 cm.

PLATE 237

木 彫 阿 蘭 陀 人 模 様 衝 立　高二尺六寸七分
巾二尺三寸一分

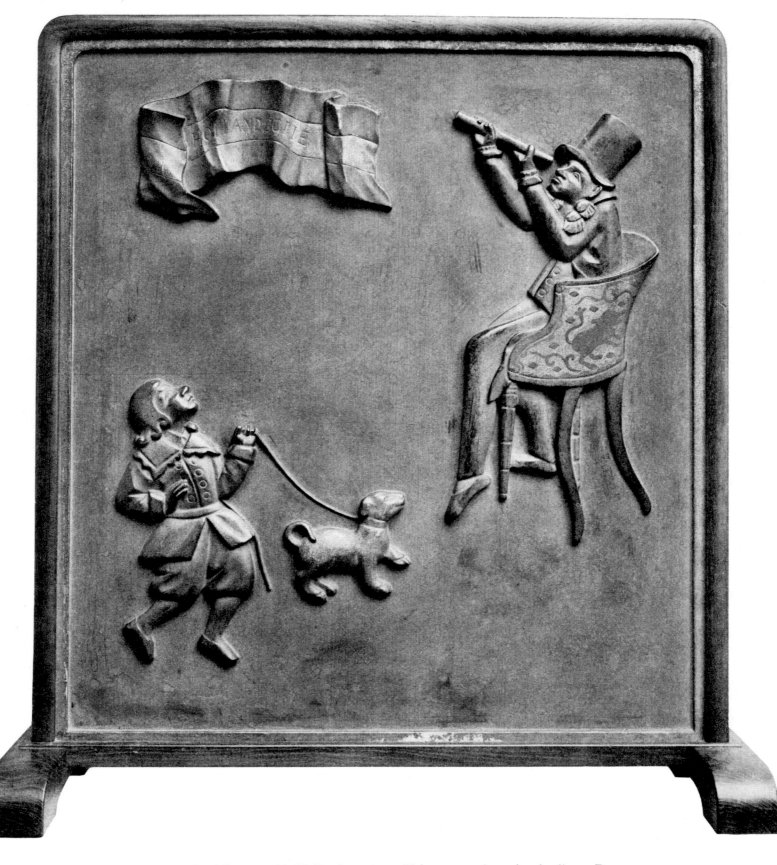

Carved Wood Screen with Hollander using a Telescope and another leading a Dog.
Height 81 cm. Width 70 cm.

PLATE 238

木 彫 人 物 高 六 寸 九 分
巾 七 寸 四 分

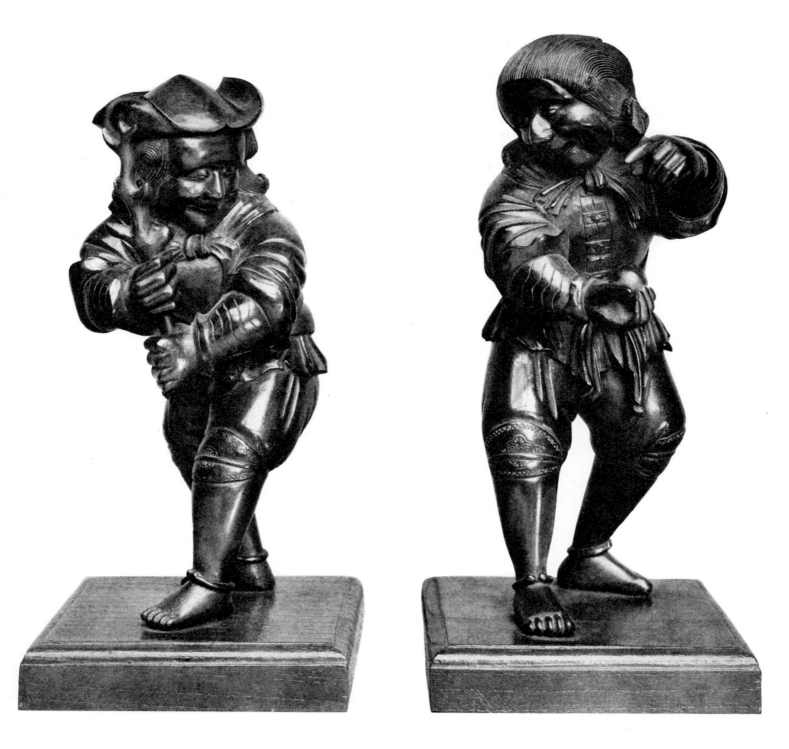

Two carved wood ornaments *(Okimono)* showing Hollanders.
Fig. 1 Height 21 cm.
Fig. 2 Height 22.5 cm.

PLATE 239　　　平　戸　燒　觀　音　マリヤに祀る　　高　六　寸　九　分

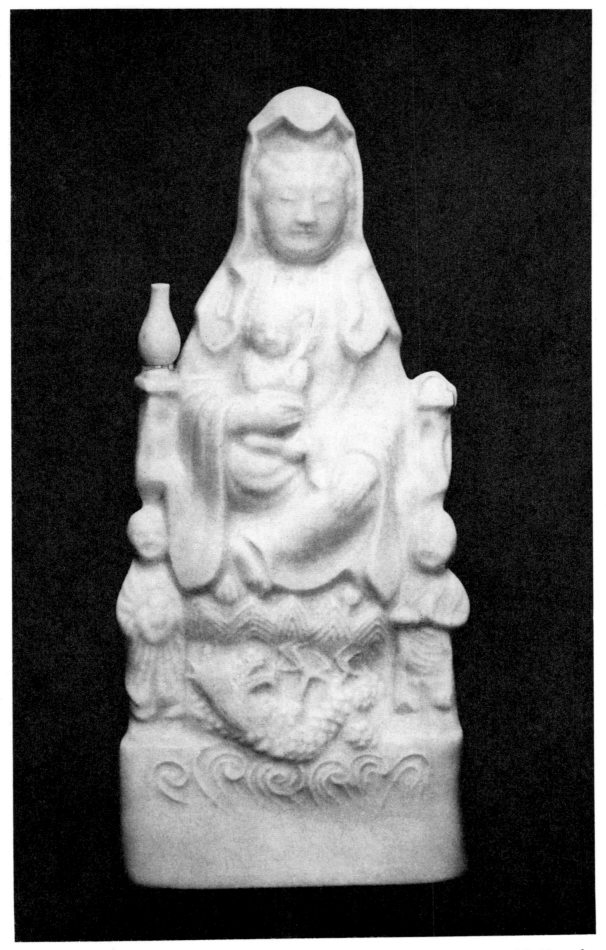

"Maria" image of the Virgin and Child made to resemble the Buddhist *Kwannon* (Goddess of Mercy) in order to escape detection by persecuting officials: porcelain, Hirado ware.
Height 21 cm.

PLATE 240

源内燒　日本地圖額皿
　　　直徑一尺四寸

源内燒　世界地圖平鉢
　　　直徑一尺二寸三分

Fig. 1　Map of Japan: pottery dish with dark green glaze, by Hiraga Gennai. Diameter 31.5 cm.

Fig. 2　Map of Western Hemisphere: pottery dish with dark green glaze, by Hiraga Gennai. The rim of the dish is decorated with the Twelve Signs of the Zodiac.　Diameter 37 cm.

PLATE 241

源　內　燒　壽　老　置　物　　高　八　寸
源　內　燒　流　釉　片　口　　直　徑　五　寸
源　內　燒　獅　子　香　爐　　高　三　寸

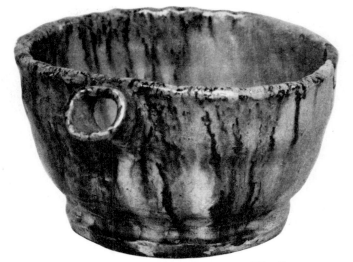

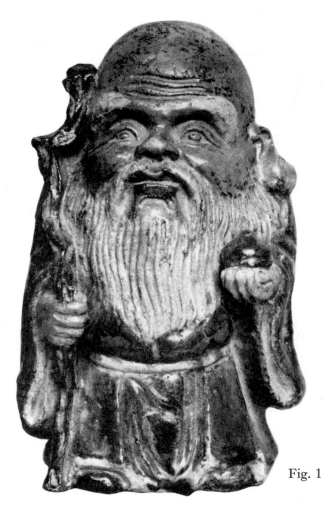

Fig. 2

Fig. 1

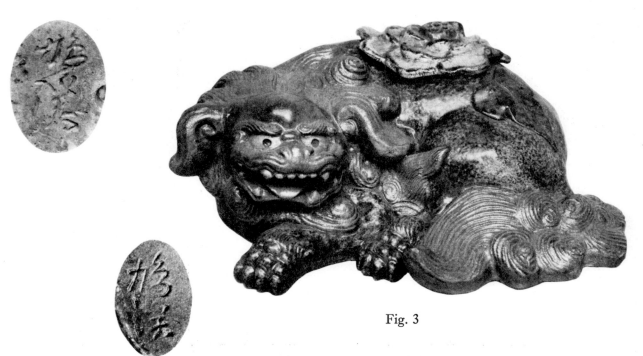

Fig. 3

Fig. 1 *Juro-Jin* (God of Longevity): pottery figure with yellow glaze, by Hiraga Gennai. (Inscription also reproduced.)
Height 24 cm.

Fig. 2 *Kata-Kuchi* (Wine Vessel): pottery with yellow glaze, by Hiraga Gennai. (Inscription also reproduced.)
Height 8 cm. Diameter 15 cm.

Fig. 3 Incense-Burner with cover in the form of a Recumbent Lion: pottery with green and yellow glaze, by Hiraga Gennai. (Inscription also reproduced.)
Height 9 cm.

PLATE 242

伊萬里赤地阿蘭人物花模樣平鉢
直徑一尺三寸

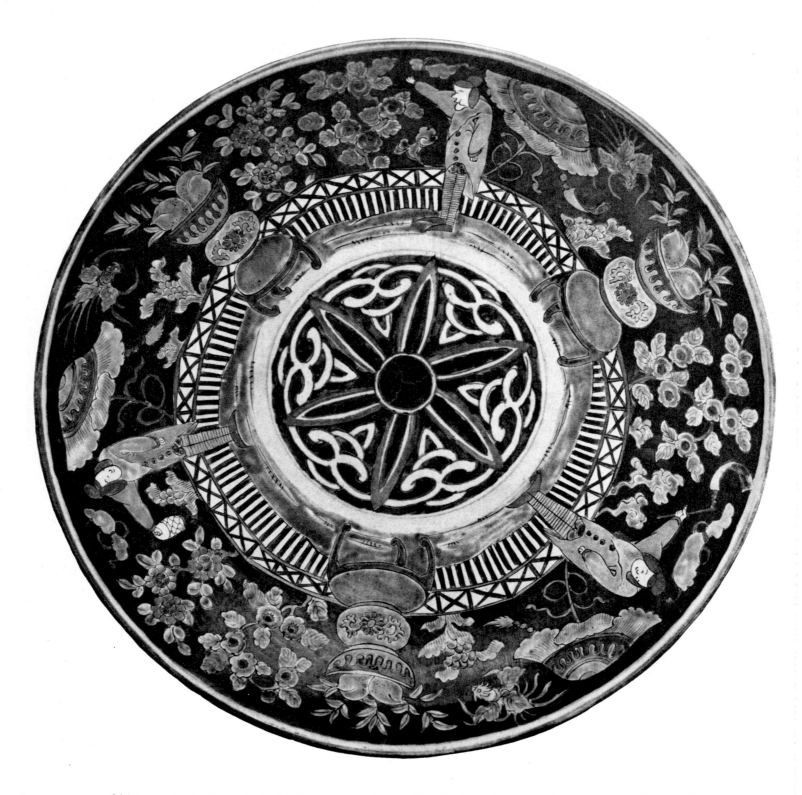

Old Imari Dish, decorated with flowers, peaches and Hollanders, in coloured enamels on red ground.
Diameter 39.5 cm.

PLATE 243

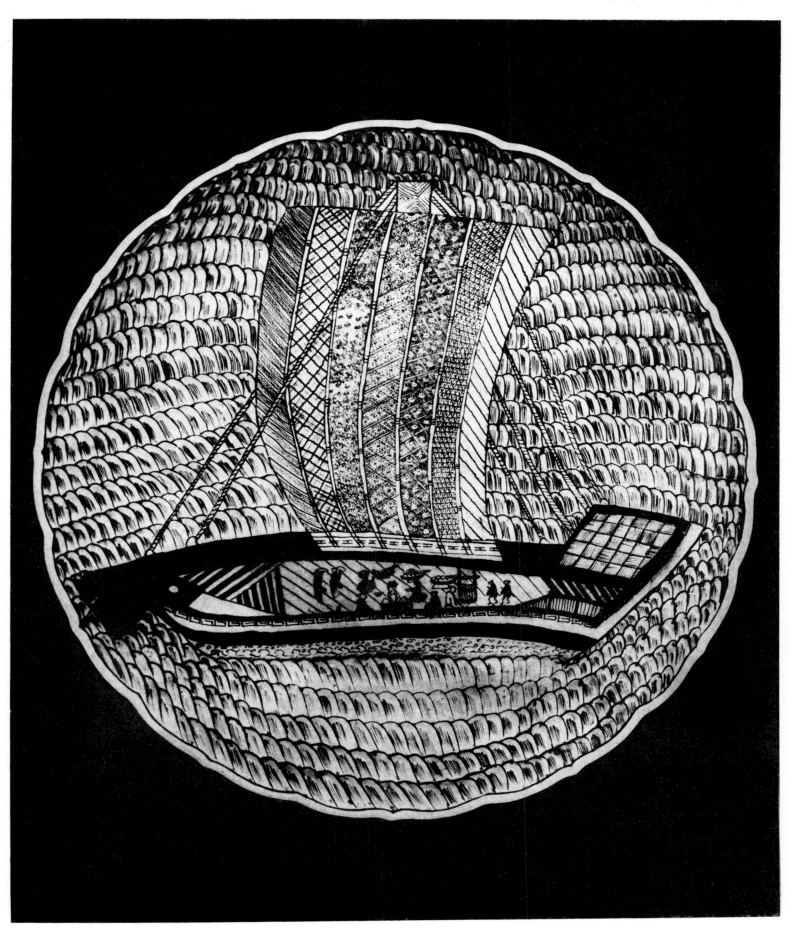

Old Imari Blue-and-White Dish decorated with a Boat and Waves.
Diameter 49 cm.

PLATE 244

龜山燒藍繪船小皿　直徑三寸二分
龜山燒藍繪樹下漁夫茶碗　高三寸六分
龜山燒藍繪七ツ組臺杯　高六寸一分

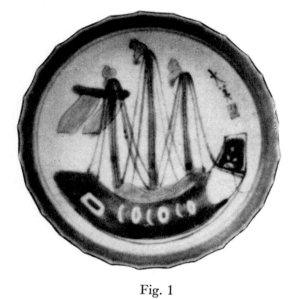

Fig. 1

Fig. 2

Fig. 3

Fig. 1　Blue-and-White Plate decorated with a Chinese Ship: porcelain, Kameyama ware.
Diameter 10 cm.
Fig. 2　Blue-and-White Cake Bowl, with Chinese fishing: porcelain, Kameyama ware.
Height 11 cm.
Fig. 3　A Set of Seven Saké Cups with Stand, landscape design: porcelain, Kameyama ware.
Height 18.5 cm.

PLATE 245

京燒阿蘭陀繪水次
高六寸六分

京燒阿蘭陀繪雲堂香爐
銀穗家雲透彫
高二寸三分

三河内燒藍繪丸紋德利
高八寸一分

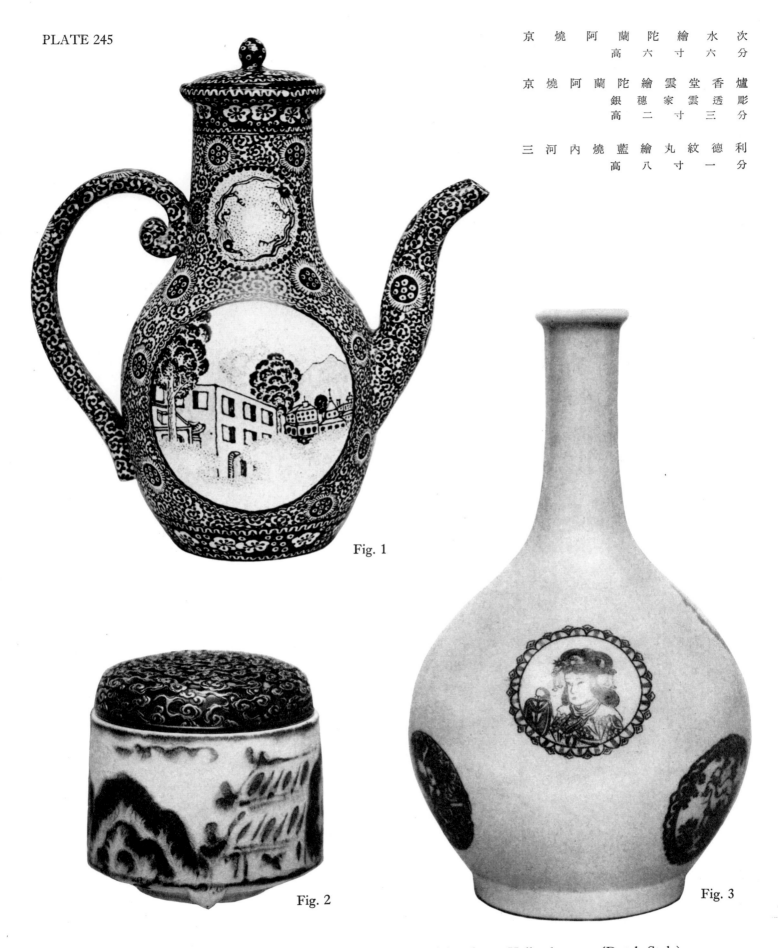

Fig. 1

Fig. 2

Fig. 3

Fig. 1 Blue-and-White Water Bottle with landscape design: porcelain, *Awata* Hollander ware (Dutch Style).
Height 20 cm.

Fig. 2 Blue-and-White Incense-Burner with wave design on the silver cover: porcelain, *Awata* Hollander ware.
Height 7 cm.

Fig. 3 Blue-and-White Saké Bottle with medallions of Foreign Figure-Subjects: porcelain, *Mikawachi* ware.
Height 24.5 cm.

PLATE 246

京燒阿蘭陀繪手焙
高　七　寸　三　分

Blue-and-White Hand-Warmer decorated with Landscape and Flower designs, porcelain, *Awata* Hollander ware.
Diameter 20.5 cm.

PLATE 247

岩倉山燒阿蘭陀人物形水次

高 八 寸 二 分

Water Jug in the form of a Hollander, decorated with coloured enamels: *Iwakurayama* ware.
Height 25 cm.

PLATE 248

古賀燒人物置物　高五寸六分
古賀燒三猿置物　大二寸八分
　　　　　　　　中二寸七分
　　　　　　　　小二寸三分

Fig. 1

Fig. 2

Fig. 1　Figure of a Chinese with a Cock: pottery, *Koga* (near Nagasaki) ware. Genroku era (1688–1703).
Height 17 cm.

Fig. 2　Three Monkeys: pottery, *Koga* ware. Genroku era (1688–1703).
Height 8 cm.

長崎信牌通商照

本國者歷有年所
稽以致奸商故違禁例今
所需甲戌年來販船隻該寧
生理在案今進港之日驗
憑據進港憑者即
其無憑照不
謹飭法決不輕貸
各宜慎之須至
牌者

長崎譯司
鎮臺憲命為擇爾等唐船通商
特奉
清法紀事照
為給牌貿易事

寧波船主周長茂
右牌給
限到
日繳

寬延元年拾貳月拾陸日給
譯司

PLATE 249

Nagasaki Tsūshō Shōhyō (Licence for Trade at Nagasaki)

This licence was given every year to the Chief (Captain and Owner) of a Chinese Ship, and when the ship came over to Nagasaki in the following year the licence was shown to the Japanese authorities on arrival. After the fifth year of the Shotoku era (1715), Chinese Ships entering the harbour without a licence were ordered to leave the port at once without landing their merchandise.

The licence illustrated was issued on the sixteenth day of the twelfth month of the first year of the Kwan-en era (1748) and was given to Shū Chōmo (Chou Chang-mao), the Captain of a Chinese Ship Navigating between Ningpo and Nagasaki. Exhibited at the opening ceremony of the Nagasaki Kencho, Meiji 44 (1911).

Height 52 cm. Width 81 cm.

PLATE 250

銀地阿蘭陀人繪屏風壹双
高　三　尺　三　寸
巾　五　尺　六　寸

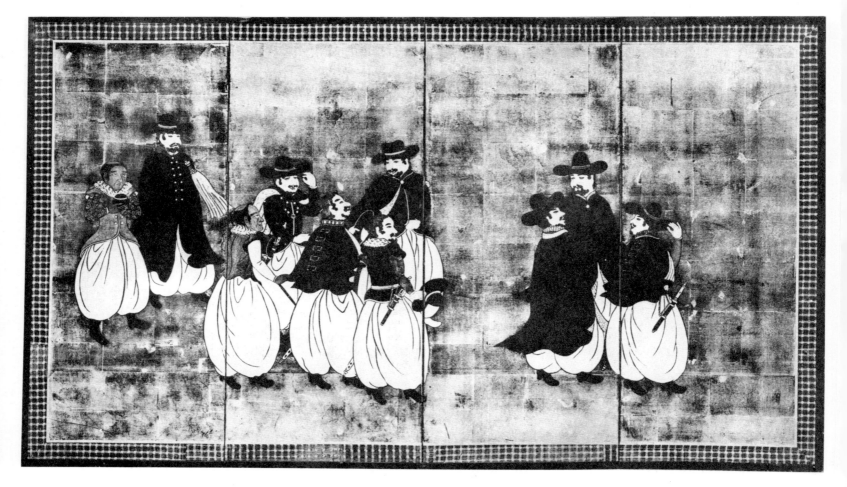

A Portuguese Procession
From a Six-Fold Screen in colour on silver ground.
Height 100 cm. Width 172 cm.

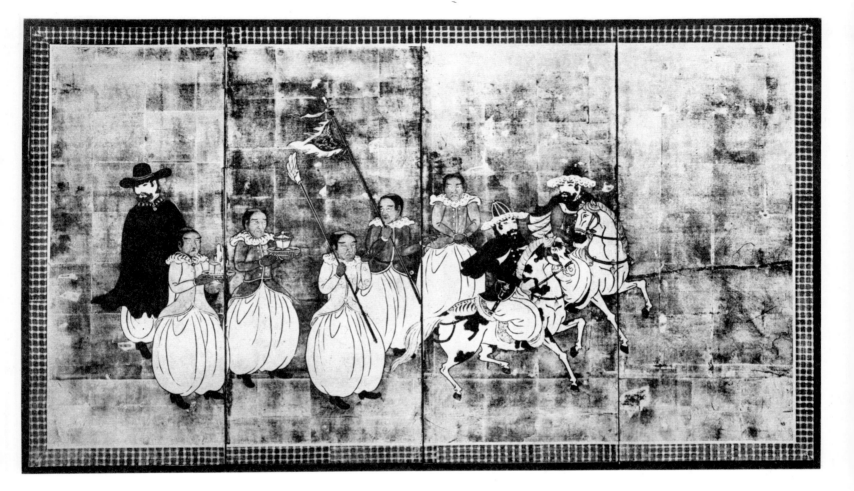

INDEX

[Roman numerals refer to pages and Arabic to plates]

Index

のなき狀態となり、ヨーロッパ風畫家の姓名の大部分は全く忘れ去られた、然し山田右衞門作の名のみは例外として傳はつた、彼は寛永十四年より同十五年に渉る島原の亂に際し天草城に包圍されたる叛徒の重なる一人であつたが彼はその罪を悔ひ幕軍の大將松平伊豆守信綱に欵を通ぜんと欲し幕府の包圍軍に向ひ矢文により通信したが間もなく發覺して城中に禁錮された、若し彼が島原城陷落の間際に救ひ出ださる〻機會がなかつたら恐らく彼は斬に處せられたであらふ、其後彼は幕軍の大將からその罪を宥恕せられ油繪製作を繼續することを許されたが自然の結果として彼其後の作品の畫題は一として宗教に關するものはなかつた、彼は西曆千六百五十五年即ち明曆元年長崎小川町に於いて死去した。

キリスト教が官命により禁壓され、これに關聯したる總ての事物が沒收され破壊された時にも尚その悉くが破壊されたものでないことは歴史上の事實である、同教に關する記念物や、それを信仰した人々の證據品の或る一部が一般沒收や破壊命令の外に逃がれ今尚存在するものも相當に殘留して居る、其例は大英博物舘(ブリテイッシュ・ミュゼヤム)所藏の日本屏風でジエスイット派の教父がボルトガル船の入港を歡迎して居る圖のものがある。

長崎先民傳に依れば生嶋三郎左、野澤久右、喜多元規、等はいづれも初期に於ける洋畫に熟達した人々であつた西川如見はその著書長崎夜話草中に南蠻(ボルトガル)と紅毛(オランダ)派の畫家に言及して居る。

支那派(明畫)も亦日本美術に於ける一大勢力の存在である、その勢力の日本に達した時期は西曆千六百六十二年明朝滅亡の時へ遡ることができる恰も歐洲に於けるベニス派が西曆十五世紀にコンスタンチノープルの陷落と同時に勃興したと同じである、コンスタンチノープルの學徒等がイタリーへ避難した如く支那(明)の學徒も亦戰亂のため彼等の社會的ならびに政事的地位が明朝の滅亡により危殆に瀕したため日本に安住の地を求めたに基く、明僧逸然は正保元年(一六四四)日本へ來朝した、彼は長崎興福寺第三代の住職であつて純正支那畫の畫風を日本人へ紹介した、彼は二十五年間日本に住し寛文八年(一六六八)七月長崎で死去した、彼の門人中から二人の有名な畫家が輩出した、河村若芝と渡邊秀碩でいづれも長崎人であつた。

沈南蘋、宋紫岩、方西園、等は明朝寫生派の代表者であつて長崎、京都、及び江戸、に分住した、沈南蘋は彼の門人中から

外國の影響を受けたる長崎畫家と其流派

日本繪畫の歴史は西暦六世紀より七世紀の間に佛敎の渡來及布敎とゝもに始まり、寺院に於いて訓育された佛敎之に始まり、寺院に於いて訓育された佛僧侶が最初の敎師であつた、元來日本と支那では書道も繪畫も同一の根元から成立したものであるから之が遂行には何れも毛筆を使用した、最初の畫家は佛敎の僧侶であつて是等の古代僧侶によつて訓育された繪畫の勢力は暫時にして衰退したけれども遠大なる結果を後世に遺し、やがて日本繪畫の大なる諸流勃興の因となつたのである。

日支兩國の美術に對する正當な觀賞にはこれに附隨する處の習俗慣例を諒解しこれに同化することが必要である、もとゝ〜實寫を構成する處の物體の明暗などは全く存在せず濃淡の試みさへなく唯描線の純潔にのみ重きを措き同時に贅筆を省くことに勉めたものである。

ローレンス・ビニョン氏は『亞細亞繪畫の總てを通じて繪畫は自然の描寫であることを知らずこれを知るものと雖も亦刹那的異端としてこれを賤しんだ、西暦六世紀の畫家で同時に批評家であつた或支那人は彼の美的本位の學說を發表し模範的出版物として人口に膾炙し、それが彼等人種の根強い本能的印象となつた、一般ヨーロッパ人の本能的觀念である、繪畫は自然の模擬ゝは自然に忠實なるものであるといふ思想とは全く反對である處の彼の學說は一種の基調として永久の地位を保つことゝなつた』と云へり。

初期長崎畫の畫題の大部分は宗敎的のものであつた、肥前有家、有馬、及九州に於けるキリスト敎の學校はヨーロッパ人の繪畫敎師等と其下に輩出した日本人畫家達によつて有名なものになつた、諸處のキリスト敎、敎會を莊嚴する處の壁畫は皆これら日本人畫家の作品であつて始めてかゝる繪畫を見た人々は勿論既にかゝる作品に馴染みある人々の眼をも驚かすと同時に深き感銘を與へた、かくの如くヨーロッパ風の初期の模範繪畫は活動的なキリスト敎敎義の宣傳と暗合的に時を同じくした。

日本人キリスト敎徒の撲滅が西暦十七世紀に行はれ從つてこれに關する油繪は恰も日月の蝕の如き狀態となり其結果西暦千六百五十年より千七百五十年に至る間の日本油繪は十八世紀末に至る迄其存在を知るも

寺ト云所山谷合百間餘方所々圍ヲ構ヱ唐人居所ト定リ安永九年庚子年迄九十三年ニ成ル」

前記二種の版畫は上述の記事の外に何れもその下方左の隅に「長崎勝山町富嶋屋文治右衛門」と版元の住所姓
名が記入してある。

尚これら二種の版畫は歴史上の稗益大なるのみならず重要なる美的價値を有するものである。

アイザック・テチンは歐洲人中最古の長崎畫蒐集家で彼は十四年間オランダ東印度會社に勤務して居つた人
である、彼が歸國する際幕府が長崎の地圖、景色、その他の版畫の國外へ散出することを禁じて居つたにも
拘はらずこれら二種の版畫をも持去ることに成功した。

阿蘭陀屋舖景の中央部ニは出嶋を鳥瞰圖に描いてありその細部の精確と共に全體としての繪畫美を發揮して
居り種々形式の異つた櫛比した家屋、ジャバ人の奴隷を從かへ差掛傘にて漫歩するオランダ人首領、日本人
の通譯を伴ふオランダ人、明放しの住居に於ける傾城などを明瞭に描出してある。

唐人屋舖景には天后寺へ參詣する支那人の群や屋形へ還る數人の傾城が描き出されてある。

黑田博士はこれらの二種の版畫の樣式は明朝時代の地理書に見る所の圖樣に酷似したものであつて後世
には名所舊跡案内記の挿畫の樣式にも大に流行した、着色法も亦富嶋屋一流の特色ある樣式によつたもので、
陰影は細密な斜線を以つて施されその重立つた色彩は朱、綠、黃、鼠、色等であり就中朱色は手彩色の方法に
よつたものであると云はれてゐる。

長崎版畫の版元（出版人）を列記すれば左の通りである。

針屋、　富嶋屋、　文錦堂、　大和屋、　益永、　牛深屋、　梅香堂（文松堂）、

紫雲堂、　耕壽堂、　鄰華堂、　笹屋、　今見屋、　扇屋、　綿屋、

五

一七四一―一七四三）に出版されたものである。

以上列記せし通り正保萬國總圖と四十二ヶ國人物圖が長崎で印刷發行されたといふ確實性に就いては殆

んど疑ひを容るべき餘地のないものとの結論に達しても少しも無理でないと信ずる。

茲に附記すべき興味ある事實は正保から寶曆十四年（西暦一七六四）に至る初期長崎地圖は西暦千八百年

以前に出版された他の長崎版畫のようにいつも大型で時の間隔を置いて時々出版されたものであるが西暦千

七百六十四年以後の長崎地圖は屢々出版された．その例は享和元年の刊記ある長崎地圖五枚が四軒の版元か

ら同年內に出版されて居ることである。

次に二種の有名なる版畫即ち「阿蘭陀屋舗景」と「唐人屋舗景」に記載されたる記事につき聊か叙述して見

よう。出嶋の圖の版畫には種々の記事があると同時に畫の様も完全に描出されて居りこれ等の記事は次の通

りである。

阿蘭陀屋舗景の記事

「阿蘭陀人來朝之始ハ慶長七年泉州堺之津ニ初テ入津内大官家康公御代之由平戸ェ入津之儀ハ慶長十四
年臺德院樣御代御奉書頂戴仕平戸ハ松浦法印在職之由長崎御奉行ハ長谷川佐兵衛樣之由」

「出嶋始之義ハ寬永十三年丙子年長崎御奉行榊原飛彈守樣馬塲三郎左衛門樣御在勤之節南蠻人惣町屋ニ
居候儀御停止出嶋ヲ町人二十五人ニ築立被仰付家藏作事仕南蠻人宿被仰付子丑寅三ヶ年出嶋ニテ商賣
仕卯年日本渡海御停止卯辰丙年出嶋空地」

「寬永十八年辛巳年長崎御奉行馬塲三郎左衛門樣御在勤阿蘭陀人平戸ヨリ御移シ出嶋ニ
御入レ被遊家賃一ヶ年銀五十五貫目ニ御極阿蘭陀人ヨリ年々差出ス出嶋藥立ヨリ安永九庚子年迄百四
十五年ニ成ル」

「從東角南角迄三十五間餘從南角西角迄百十八間餘從西角北角迄三十五間餘從西角東角迄九十六間餘」

唐人屋舗景の記事は出嶋のそれの如く多くの説明がないが次のようなことが記載されてある。

「唐人以前者町宿仕徘徊致候處元祿元戊辰年長崎御奉行山岡十兵衛樣宮城主馬樣御在番之節小島村十善

ばならぬ、しかし後世に至りその地位は全く顛倒するに到つた。

正保地圖の確實性に對する最も重要なる異議は長崎に於いて刊記の記入してある地圖が再び出版される

までの間に相當長年月の經過した點にある、この刊記のある後の地圖は寶曆十四年（西暦一七六四）長崎豊嶋

屋で出版された、それは正保地圖より百年後のことであるこの事實は正保地圖が長崎で出版されたといふこ

とに反對する最も強い論據である、しかし茲に同時に吾々が考慮に入れなければならぬことは事實正保から

長崎豊嶋屋出版の寶曆十四年の刊記ある地圖が出版されるまでの間に於いてこの期間を埋合す所の刊記のな

い地圖の出版が相當の數に上ぼつて居ることである。

筆者は非常に興味ある重要な發見をした、それは寶曆二年（西暦一七五二）の刊記ある長崎で出版された

地圖のあることである、この地圖には「長崎東濱町書肆竹壽軒中村惣三郎開板」と記されて居る、だから此地圖

は正保地圖以後最古のものと考へられて居た、豊嶋屋のものよりは少くとも十年以上古いものである。

從來一般に長崎で出版された刊記のない最古の長崎地圖と考へられたものは本書中に寫眞板が載

せてあるが、此地圖は寬文年間（西暦一六六一―一六七二）に出版されたものは決して不合理でな

いと思ふ何故なれば此地圖は又延寶年間（西暦一六七三―一六八〇）に江戸で縮刷せられてゐるからである、此

地圖の版元の名は判明せぬがその下方の部分に長崎から各地に至る里程表が附けてある、この事實はこの地

圖が長崎で出版されたといふ最も見安い證據である。

次に古い所の長崎で出版された無刊記の地圖は「神代の繪圖」と表題されたもので神社の地圖としては日

本最古のものである、神代神社は寬文二年（西暦一六六二）地震のため大破したが間もなく修繕された、そして

この「神代の繪圖」は多分寶永年間（西暦一七〇四―一七一〇）その事變の記念として長崎で出版されたもので

あらう。

三番目四番目に長崎で出版された古い無刊記の長崎地圖は竹壽軒中村三藏發行のものである、蒐集家は

これらの地圖は延享二年（西暦一七四五）に京都で出版された長崎の地圖より以前のものであると信じて居る、

第一の竹壽軒の地圖は元文年間（西暦一七三六―一七四〇）に出版され第二の分は數年後れて寬保年間（西暦

三

墨一色で印刷したものを墨繪と稱へ初期出版のこの種類には墨色を艶附けするため漆を用ひたものがあ

る、これを漆繪と稱へ他の多彩のものを錦繪といふ、江戸で出來た色版畫の寸法は大體一定して居るが長崎

版畫の寸法は區々でありあるものは長さ三尺三寸位巾一尺八寸位である、長崎版畫には江戸繪と異り其畫題

に對する記事が長々しく書かれてある、使用の紙質は粗惡で、長崎へ旅行した商人、學者、美術家、その他の

人々へ頗る安値で賣られたもので長崎土産として知られて居つた。

長崎版畫には多く外來の影響がある、現にあるものにはオランダの銅版畫から模寫したことが明瞭に認

められ又正保年間出版の萬國總圖は多分明末に支那で發行したものから復寫したものであらう。

長崎版畫の筆者の名は知られて居らぬが永見德太郎氏の說によれば多分長崎のオランダ屋舗や唐人屋舗

に勤務して居た下役人が彼等の不充分な收入の補いのために描いたものであらうとのことである。

日本の學徒や蒐集家は正保年間出版の萬國總圖と四十二箇國人物圖は長崎最古の彩色版畫であると考へ

て居る此地圖には「正保丁酉年長崎津に於いて開板」と記入されて居る、筆者はある蒐集家が正保年間かゝる

干支に相當する年のないことを論據としてその純眞性を疑ふことに反對である、疑ひもなく干支は間違つて

居るが、これを以つて長崎で出版したものでないといふ理由にはならぬ、此地圖は多分長崎へ旅行した人た

ちへ賣る目的でなく何か他に特種の目的で出版されたものであらう、ある蒐集家の說では此地圖はキリスト

教に關係あるものに對し始終眼を光らして居る幕府の役人の疑ひと憤りを避くるため京又は江戸で出版され

たものであらうと、しかし幕府の忌む所はキリスト教であつて、普通の外國のものや畫題などには涉つて居

なかつた、最初ジエスイツト派や其他の外國宣敎師たちは大層好遇されて居つたが時の經過するにつれ彼等

は漸次國の內政に干渉するようになつたため幕府は遂に意を決して彼等を國外へ放逐することになつたが、

オランダ人と支那人だけは長崎に止まることを許された。

外國の影響と文化、特にボルトガルとオランダのそれらが長崎港を通じて漸次國內へ進入し遠く且つ廣

く浸潤した、從つて支那人木版彫刻者の指導の下に大型で精巧な地圖が長崎で出來たと想像することは正し

き判斷であると思ふ、吾人は當時の支那人は木版彫刻術に於いては吾々よりは先輩であつたことを記憶せね

長 崎 版 畫

日本畫家をその流派によつて分類すれば凡左の通りである。

佛畫派、土佐派、狩野派、四條派、圓山派、岸派、支那畫派、浮世繪派、

西暦十八世紀の牛より十九世紀の牛に至る間の版畫の筆者（原圖の執筆者）は皆浮世繪派に屬し長崎版畫の筆者は浮世繪派の分派であつて木版を以つて多彩に印刷し長崎で出版されたものである、元來色版畫の需用者は殆んど皆下層社會の人達であつて、これ等の版畫が出版された當時では極めて安價なものであつた、それは之等の版畫は單に一般低級な人々の愛玩物であつたからである。

江戸―現今の東京―に於いて出版された初期の色版畫は錦繪と稱へられた、此種版畫の畫題は主としてその當時人氣のあつた俳優や吉原の花魁、舞妓、相撲の力士、藝者、などの圖であつた、その外芝居や茶屋の景祭禮や隅田川船遊びなどの圖とか或は東海道五十三次の風景山水花鳥などの圖である、これらの畫家によつて取扱はれた畫題は大抵粗雜で鄙俗であつて時には淫靡猥褻なものさへ隨分あつた。

長崎は肥前の國にあつて三方は山や岳に圍まれ繪の樣に景色の佳い港である、長崎版畫は主としてその港灣の景色や支那又はオランダの船舶やオランダ人唐人などの圖を畫題としたものでその外オランダ人や唐人によつて將來された各種の鳥類（鸚鵡を含む）駱駝、象、其他の動物の圖をも取入れた、時としては長崎丸山の遊女やオランダ人唐人の嫖客を畫題に入れたが日本人の圖は殆んどない位で、筆者は今迄に唯四枚の日本人を畫題としたものに出逢ふただけである、これらの點は全く大阪京及江戸の色版畫の畫題と反對である。

キリスト敎に關聯した畫題は幕府の命により嚴禁されて居つた此禁令は制札の寫眞（寫眞版第二〇三圖）にある通り密告者を獎勵した、この種の制札は寛永十八年（西暦一六四一）から明治十年（西暦一八七七）までの間日本の各地に建てられて居つた。

長崎版畫には一般に畫家の署名がないが後期の作品中には谷鵬、蔽月館、磯野文齋、其妻整恩女史、など署名したものがある。

一

KO KŌ
(Ancient Fragrance)

The two Chinese ideographs that serve as the Japanese title of this Catalogue were selected and written by Mr. Hashimoto Kwansetsu, the well-known Kyoto artist. In combination, the two ideographs mean, "Ancient fragrance," or "The fragrance of old and far-off things," and the great artist who has written the ideographs has written them in such a way as to suggest by his very brushwork the underlying poetry of the phrase. The blurred strokes and the broken lines suggest the tears and all the bitter-sweet memories that contemplation of the past evokes.

The inscription on the opposite page, by the same artist, reads, "Written for Mr. Mody at the time of the opening of the chrysanthemum blooms, in the year two thousand five hundred and ninety-eight, Japanese chronology (1938)." In the phrase translated "the opening of the chrysanthemum blooms," there is a delicate allusion to the sentiment expressed in the title, but this allusion is too subtle to be conveyed in translation.

皇孤二無心府

准菊色年付心

我雨灵雪花字

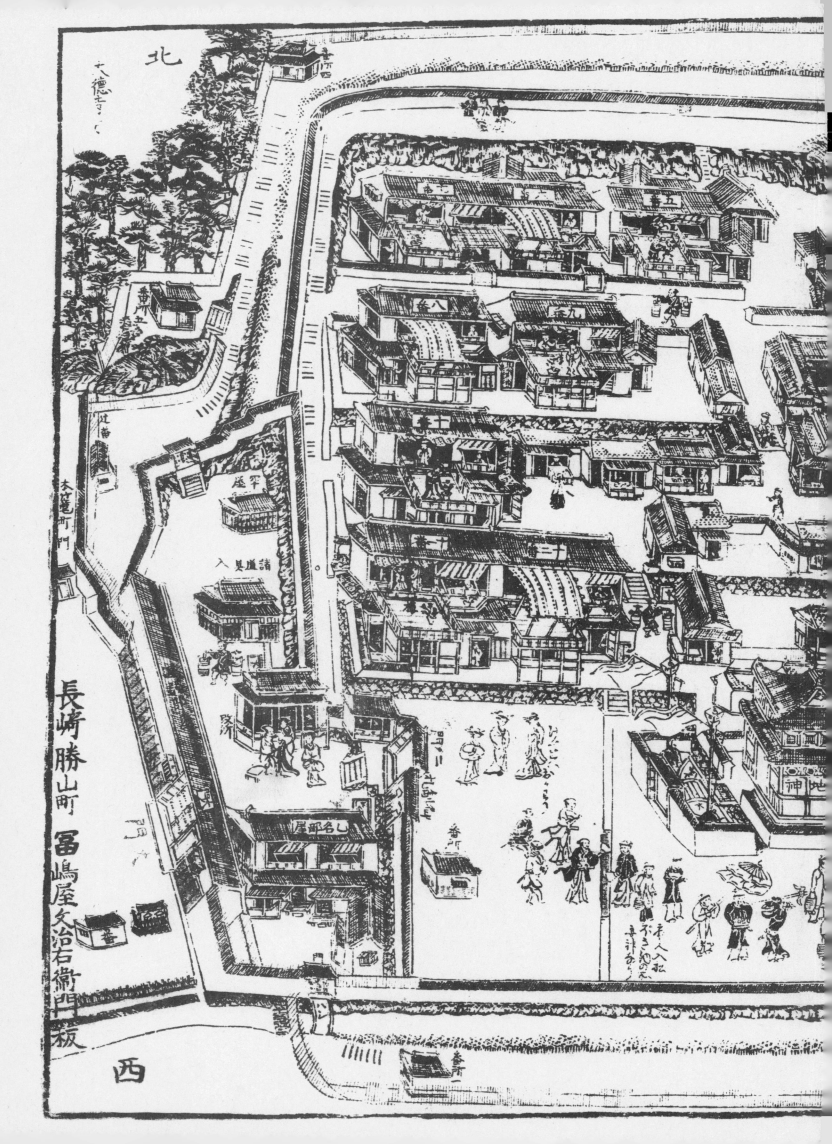